Healing Arts

of related interest

The Revealing Image
Analytical Art Psychotherapy in Therapy and Practice
Joy Schaverien
ISBN 1 85302 821 5

Gender Issues in Art Therapy
Edited by Susan Hogan
ISBN 1 85302 798 7

Art Therapy in Practice
Edited by Marian Liebmann
ISBN 1 85302 058 3

Art Therapy, Race and Culture
Edited by Jean Campbell, Marian Liebmann, Frederica Brook, Jenny Jones
and Cathy Ward
ISBN 1 85302 578 X pb
ISBN 1 85302 579 8 hb

Introduction to Therapeutic Communities
David Kennard
ISBN 1 85302 603 4

Bion, Rickman and the Northfield Experiments
Advancing on a Different Front
Tom Harrison
ISBN 1 85302 837 1

Medical Art Therapy with Adults
Edited by Cathy A. Malchiodi
ISBN 1 85302 279 4 pb
ISBN 1 85302 678 6 hb

Medical Art Therapy with Children
Edited by Cathy A. Malchiodi
ISBN 1 85302 677 8 pb
ISBN 1 85302 676 X hb

The Changing Shape of Art Therapy
New Developments in Theory and Practice
Edited by Andrea Gilroy and Gerry McNeilly
ISBN 1 85302 939 4

Healing Arts

The History of Art Therapy

Susan Hogan

Forewords by Mary Douglas and David Lomas

Jessica Kingsley Publishers
London and Philadelphia

The front cover photograph is reproduced from the *International Surrealist Bulletin No. 4*, September 1936 with kind permission of A Zwemmer Ltd. Figure 2.1 is reproduced from the Algur H. Meadows Collection, with kind permission of the Meadows Museum, Southern Methodist University, Dallas, Texas. Figures 2.2 and 2.3 are reproduced with kind permission of the Clements Fry Collection, Yale. Figure 2.4 is reproduced with kind permission of Crichton Museum, Dumfries. Figures 2.5 and 4.8 are reproduced with kind permission of Bethlem Royal Hospital Archives and Museum. Figure 2.6 is reproduced with kind permission of The Royal Society of Medicine. Figure 2.7 is reproduced with kind permission of Dr Ken Keddie. Figures 3.1, 3.4, 3.5, 4.1 and 4.3 are reproduced from the *London Bulletin* 1938 with kind permission of A Zwemmer Ltd. Figure 3.2 is reproduced with kind permission of The Melanie Klein Trust, London. Figure 3.3 is reproduced with kind permission of Whitford Fine Art, London. Figures 4.2, 4.4, 4.5 and 4.6 are reproduced with kind permission of Lee Miller Archives. Figure 4.7 is reproduced with kind permission of the Tate Gallery, London. Figure 5.1 is reproduced with kind permission of The Retreat, York. Figure 6.1 is reproduced with kind permission of Allen and Unwin Ltd. Figures 6.2 and 6.3 are reproduced with kind permission of The Stroke Association. Figure 7.1 is reproduced with kind permission of John Timlin. Figure 8.1 is reproduced with kind permission of Ken Kiff and Marlborough Fine Art, London. Figure 8.2 is reproduced with kind permission of Rita Simon (and modified at her request). Figures 9.1, 9.8, 9.9, 9.10, 9.11, 9.12, 9.13 and 9.14 are reproduced with kind permission of Anthony Stevens. Figures 9.2, 9.3, 9.6 and 9.7 are reproduced with kind permission of Norah Godfrey. Figures 9.4 and 9.5 are reproduced with kind permission of Routledge.

First published in the United Kingdom in 2001 by
Jessica Kingsley Publishers Ltd
116 Pentonville Road
London N1 9JB, England
and
325 Chestnut Street
Philadelphia, PA 19106, USA

www.jkp.com

Copyright © 2001 Susan Hogan
Forewords copyright © 2001 Mary Douglas and David Lomas

Library of Congress Cataloging in Publication Data
A CIP catalogue record for this book is available from the Library of Congress

British Library Cataloguing in Publication Data
A CIP catalogue record for this book is available from the British Library

ISBN 1 85302 799 5

Printed and Bound in Great Britain by
Athenaeum Press, Gateshead, Tyne and Wear

This book is dedicated to Eilish

The author with daughter, Eilish
Photograph by Rosy Martin, 1999.

Contents

Foreword

For the reader it is like taking the lid off an aquarium and peering into a secret marine world. In the first stage, feeble creatures are lying on the sea floor, obviously in pain, unable to move except by the movement of the water. Something happens, then they take off and swim under their own power, we can hear them singing and shouting energetically as they go. There are so many kinds of pain. This book is about the grief and rage of madness, the sorrow of depression, the bleak unreality of any sense of oneself. Tragic figures sit around inertly in a world where other people are comfortable enough to laugh and play. Hopelessness. Then art therapy enters the scene, specialists assuage the pain by training the patient to image her or his own situation. And we read the extraordinary revivifying effect of the painting, or sculpture, or photography, on the artist who produced it.

Healing Arts is about the history of the movement of art therapists. Fascinating in itself, it belongs in the history of ideas, and the history of medicine. At this moment the publication may be very well-timed. This will be partly because it tells the history of a struggle and so slots into the current catalogue of writing about marginal groups. If psychoanalysis was marginal to medicine, art therapy was marginal at another remove, more fringy than the fringe. Now they are recognised and have their place. This shift is due to perseverance of the first practitioners, but it became possible because much of the once hostile environment has been dismantled. Nowadays the assumptions that blocked them make scandalous reading. The prejudices were far reaching and went very deep. The oft-told story has a sinister poignancy in Susan Hogan's presentation: the victim is art, the villain of the piece, a politicised theory of human evolution, and the irony, that the very judges of mental sickness show signs of derangement.

In all seriousness, the evolutionary idea classed the art of the insane with the arts of primitive culture and with the art of children. One would suppose that logically primitiveness in this progression could not mean decadence, since it is placed at the beginning of evolutionary development.

But logic is not so relevant as political and moral assumptions. In the same scenario it was possible for primitive culture to mean a fall from an earlier perfection, a rejection of growth or a failure to achieve it. This chaotic grouping is well-known to nineteenth-century historians but its disastrous effects on the theory of mental illness still needs to be assessed. It is the demoded background of ideas which the early art therapists had to contest. It is also the background of the idea of degenerate art that the Fascist governments of the 1930s used to justify their censorship of dissident artists. The anthropologist finds that the same background assumptions made it impossible to make a reasonable approach to the therapies of Africa and the Orient. On the one hand the primitives had 'magic' for dealing with bodily infirmities. On the other hand they had religion and ritual for dealing with spiritual disorders. In between was a gap where modern biomedicine has no match. On this scheme alien therapies were judged to be failed medicine, evidence of weak gropings towards modern medicine. But now there is a different appreciation of what they were aiming to achieve, a new appreciation made possible by a different idea of the unity of mind and body.

Another reason for the timeliness of the book is that the west has brought its sciences of self-knowledge to a transitional point. For centuries western culture has been separating subject and object, and trying to be objective about both. As Descartes taught, mind is one thing and the material body quite another; we were compounded of two distinct elements, the idea and the thing, the spirit and the body, and the two had to be treated separately. The heresy of the art therapists was to treat them simultaneously. At this moment in history the Cartesian error is widely deplored and the effort to keep the two elements apart is flagging. The brain is recognised to be a bodily thing, with extension, weight and volume. Neither brain nor mind can operate on its own, they are one. The implications of the location of mind in the brain are a challenge currently confronted in brain sciences.

One day, not too far away, we in the west will meet on equal terms what was once called 'primitive medicine'. Now it is more respectfully denoted 'traditional therapy', or 'shamanism'. We are bound eventually to look to these distant philosophies of healing which never had a Cartesian revolution, so never thought of separating mind from body, or separating either mind or body from social context. The shaman's practice includes orienting the patient to the relevant social circle, sorting tangled relations between the living, and between the living and the dead, and between one lot of the dead with another. The process involves manipulating the body, with bleeding,

rubbing on of oils and perfumes, immersion in water or in smoke, entrancing with music or stinging with peppers. Often it involves showing pictures or drawing designs for the sick person, or requiring the patient to dramatically enact the diagnosis. The body is directly involved, and so also are the kin and neighbours of the patient who must also join the enactment which in various ways dramatises the underlying trouble. By these physical enactments lost identity is caught, and publicly affirmed. Guilt, remorse and fear are summoned, rebuked and dispersed. The patient, on the way to recovery, re-enters a responsible community which the enactments have made vividly aware of its contribution to the former disordered condition.

With a new brain science, a new aesthetic philosophy and a new psychology of awareness emerging, it is no longer absurd to teach the patient to remedy a mental sickness by picturing the disorder, pinning it down and making it concretely visible and intimately knowable. Art therapy, its achievements so painfully gained, so far from being in the margins, will very likely find itself standing in the fore of what is bound to come: a reassessment of the role of medicine following on a reassessment of the relation of mind and matter.

Asked to write an introduction to this book I was of course flattered.

'It is an honour, but I fear you are just asking me because I am your mother-in-law.'

'No, of course not. I am asking you because you are an anthropologist, and you have always been interested in aesthetic theory.'

'But will it matter that I know practically nothing about art therapy?'

'Ah, but you will know a lot about it by the time you have read the book, and you can also read my edited volume.'

I read *Feminist Approaches to Art Therapy*,[1] and was not difficult to persuade. It is easy to recommend a book on such an intrinsically interesting subject.

Mary Douglas

Notes

1 Hogan 1997.

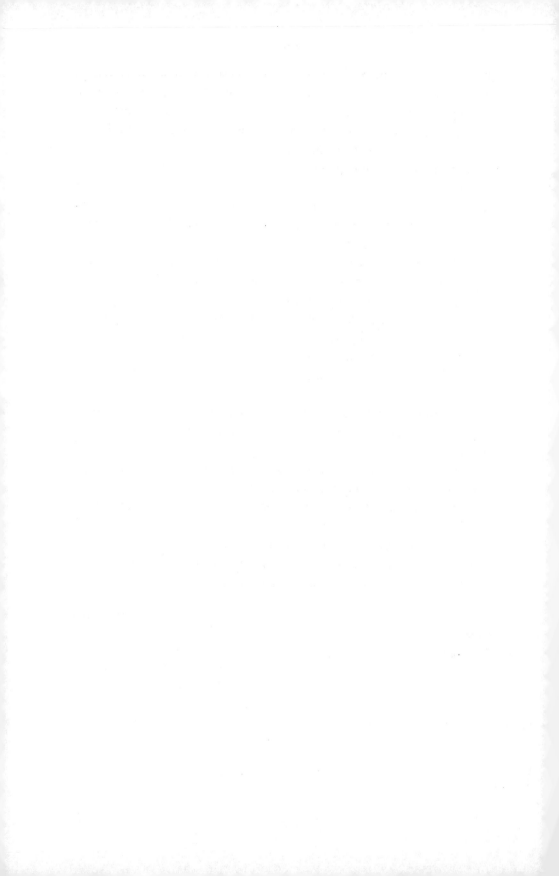

Foreword

We commonly say that healing is an art. It seems but a small step from this to claim that art itself can heal. This premise lies at the basis of art therapy as a profession. Reading Susan Hogan's wide-ranging, extremely learned study of the history of art therapy in Great Britain, as an art historian I found myself especially intrigued by the many and varied conceptions of art that have been brought into play during the relatively brief history of that discipline.

It was a revelation to me to discover that art was assigned a role in regimes of moral therapy at the end of the eighteenth century, which the book therefore argues may be regarded as the antecedent of modern art therapy. Pictures placed around the walls of the asylum were meant quite literally to bring the mad to their senses. It seems probable that the use of art in this manner draws upon older practices of placing religious pictures in hospitals for devotional purposes. No doubt it was believed that inculcating an attitude of respect for high culture would help to bring under control the disorderly passions that had produced the illness. What is striking here is that art is seen as in the service of reason and the higher mental faculties. As Romanticism took hold in the nineteenth century, and art came to be seen as a vehicle for the expression of instinct and emotion, plainly its use for therapy could no longer be justified in these same terms.

The high hopes for moral therapy were not to be realised and the latter half of the nineteenth century, Susan Hogan shows, was dominated by deep pessimism as regards the treatability of mental illness. Theories of degeneration, which became widely accepted, tended to reinforce the view of madness as irremediable and hence asylums were primarily custodial rather than therapeutic institutions. This had consequences of course for the production of art by inmates which certainly took place, but predominantly as a way of keeping them occupied and relieving boredom rather than for any therapeutic benefit. The first collections of psychotic art date from the late nineteenth century, amassed by the medical directors of these asylums. Initially, one suspects, this material was not even considered as art and its

main interest for psychiatry lay in what it could contribute to the elaborate taxonomies of mental disease that date from that era.

Gradually, attitudes amongst medical experts changed and it is clear that by the time Hans Prinzhorn's book *Artistry of the Mentally Ill* was published the work was being appreciated for its inherent artistic worth. Parallel shifts within the artistic mainstream saw the art of so-called primitives and untutored work by children and the mentally-ill valorised for its authenticity, and emulated by artists for this reason. The vast cultural transformation in the conception of art that began with Romanticism reaches its culmination in Surrealism where art, now fully identified with the unconscious and unreason, is pitched against reason and the intellect. The Surrealists were avid collectors of art by the insane which they exhibited alongside works of their own. In many respects they were the anti-psychiatry movement of their day and in books and journal articles they mounted vitriolic, sometimes personal attacks on psychiatry and psychiatrists (one of their number, Antonin Artaud, would become a *cause célèbre* for the burgeoning anti-psychiatry movement in the 1950s). For the Surrealists, freedom was not to be found outside the walls of the asylum among the so-called sane but inside in the minds of the inmates. While not unaware of the pain and isolation it brought, they firmly believed that madness contained its own consolations.

A fascinating aspect of Susan Hogan's research is the glimpses it affords of significant links between the development of art therapy and the reception of surrealism in this country. Dr Grace Pailthorpe and the artist Reuben Mednikoff, whose therapeutic alliance has been much studied of late, were both cognisant of French Surrealism. Roland Penrose and Herbert Read, prime movers within the Surrealist movement, also helped promote the cause of art therapy. In association with Professor G.M. Carstairs, the first president of the British Association of Art Therapists, they mounted an exhibition titled *Aspects of Schizophrenic Art* at the ICA in London in 1955. While it may seem more obvious to locate art therapy within a history of psychiatry, these allegiances with Surrealism are such that it would be equally valid to argue that the story of art therapy belongs to a history of *anti*-psychiatry. How far these radical credentials are compromised by its movement from fringe (epitomised by the self-contained community at Withymead, a detailed and original study of which comprises a centrepiece of this book) to the main-stream of NHS treatment is a question this study will no doubt provoke. Naturally, art therapists will not want to throw away their hard won profes-

sional status. And it could be argued that its cooption by psychiatry is evidence of a more humane and enlightened attitude toward the mentally ill. But is art therapy to be more, or other, than an artistic muse to the clinicians in white coats? A mere adjunct to the drugs they dole out?

For many art therapists their aim is to empower the weak and oppressed by giving them a voice and a means of expression. An uneasy relation to power and authority runs through the history of art therapy and can be seen reflected in the dilemma over whether or not to interpret the visual material produced by patients in therapy, an issue that crops up at more than one juncture in Susan Hogan's book. For the purpose of interpreting works of art, therapists have very often had recourse to the language and theoretical apparatus of psychoanalysis. Just as the dream has no value for psychoanalysis without interpretation, so too works of art – which Freud tended to view by analogy with the dream or symptom as the disguised representation of an unconscious wish – *must* be interpreted. The case for interpretation is forcefully put by Freud in an essay on Michelangelo's *Moses*:

> Why should the artist's intention not be capable of being communicated and comprehended in words, like any other fact of mental life? Perhaps where great works of art are concerned this would never be possible without the application of psychoanalysis. The product itself after all must admit of such an analysis, if it really is an effective expression of the intentions and emotional activities of the artist. To discover his intentions, though, I must first find out the meaning and content of what is represented in his work; I must, in other words, be able to *interpret* it.

The objection to applying this rationale in the therapeutic situation is that interpretation inevitably *dis*empowers the patient who, without the intervention of the expert, knows not what they say. Moreover, the exercise of interpretive authority by art therapists, as Hogan observes, has sometimes led to results that are dogmatic and reductive in the extreme. As a scholar of Surrealism, I found the whole discussion of this issue of great interest because the Surrealists, despite their enthusiasm for psychoanalysis, also shared the ambivalence of art therapists about interpretation. They were concerned that explanation and interpretation should not be allowed to dissipate the manifest absurdity of Surrealist art upon which its surreal effect ultimately depends. Explain the work and one risks explaining away what is essential to it. Paradoxical though it sounds, I have found it useful to think of Surrealist art as *resisting* psychoanalysis; at least, that is, psychoanalysis in the mode of interpretive reason. For art therapy, a solution to this problem may lie in

finding a style of commentary which does less violence to the work. To eschew altogether some process of reflection upon the visual material produced would be to throw the baby out with the bathwater, a step backwards to the days when the making of art by patients was a mere diversionary pastime.

For much of its history it would seem that art therapy has relied upon a theory of art as the expression of an inner self. To some extent, this may reflect the dominance of American abstract expressionism in the 1950s and 1960s art world, a key moment in the formation of the art therapy profession. Of late, the idea of art as expression has come in for much criticism and in academic art history it has tended to be supplanted by a concern with issues of representation. With the advent of postmodernism also, it has come to seem rather dated. Recently, I heard of a young artist in Liverpool who works with the hospitalised mentally ill as an artist in residence collaborating with patients in the production of exciting and adventurous art; they have an ongoing input into the art that she produces. Even patients with no native artistic ability can participate in this process which I find appealing because it is based on dialogue and interaction, rather than the pouring out of inner emotions. Is this perhaps a model others could follow?

By delving into the past of her own profession, Susan Hogan has uncovered much food for thought about how art therapy is practised now and about its future direction. As a work of cultural history her study is also of wide interest to historians from a range of disciplines. Her text is a rich tapestry weaving together elements of medical and psychiatric history, art history, as well as contributing to the history of psychoanalysis and its reception in Britain. Once regarded as fringier than the fringe, to borrow Mary Douglas's wonderful phrase, art therapy emerges as a site where these hugely influential cultural discourses are knotted together.

David Lomas

Author's Note

This book explodes the idea that artists are neurotic monstrosities indulging in compulsive acts of warped sexuality! It is therefore of relevance to the arts community in general as well as to art therapists. It explores compelling and energetic acts of artistic self-expression over three centuries with its focus on the period c.1790 to 1966.

In the late eighteenth century the arts were used as part of a moral treatment method. This research looks at the claims made by moral practitioners about the purportedly curative effects of patient engagement in art work, along with their concerns about the negative consequences of the expression of an unrestrained imagination. The book then moves on to look at nineteenth-century psychological and anthropological writings and examines how symbolism in art and language was linked to theories of degeneration and assumptions about the hierarchy of races.

Writing about psychoanalysis is rather tricky nowadays and I had no desire, whilst writing this book, to get locked into arcane arguments about its nature. Freud's theoretical perspectives changed enormously throughout his life; almost any interpretation of a text by Freud will be contestable by other rival schools of interpretation. However, psychoanalytic theories about symbolism are presented. The research then looks at the development of a 'psychopathological school', a group of psychiatrists and others who viewed art works as evincing information about underlying neurotic conflicts.

The work of analytic (Jungian) psychologists receives separate attention because the way that analytic psychology viewed art work and symbolism was very different to that of psychoanalysis and far more influential to the development of art therapy as a profession. One particular organisation receives detailed attention because of its significance to art therapy developments, but this is done with reference to the institutional and intellectual development of analytical psychology in Britain.

The research examines in detail the use of art therapy in the context of post-war (World War II) rehabilitation and the treatment of tuberculosis patients, as well as in psychiatric settings. A brief exploration of art therapy in education is also presented, along with an examination of the influence of Surrealism on art therapy.

This is the first book to examine the intellectual precursors of art therapy in Britain. The text represents what I hope you will agree is a *tour de force* of interdisciplinary research. It is likely to remain the definitive text on the history of art therapy for many years to come. It is also intended to be entertaining. Read and enjoy!

Susan Hogan, Derbyshire 1999

Acknowledgements

A cultural history is by definition the effort of more than one person and without the considerable help of other academics, archivists and art therapists (particularly the pioneers of art therapy) this endeavour would not have been possible.

I shall sketch the evolution of this project whilst thanking people along the way. Although I had been thinking about some of the themes explored for several years (first discussing them with Professor John Pick at City University, London), the project began to take shape after a meeting with the Sydney-based historian John Ward. At his recommendation I visited both Professor Joan Kerr and Associate Professor Terry Smith at the Power Department of Art History in The University of Sydney, where I registered as a Ph.D. student. My first supervisors were Dr Fry and Dr Carter (both exercised considerable patience as I floundered about, eventually changing my research topic from Australian expressionism to art therapy). Around this time I took up employment teaching twentieth-century art history and theory at the University of New South Wales, College of Fine Arts and the National Art School, Sydney, which were both very stimulating environments. However, a job offer lured me back to Britain and I finished my Ph.D. in cultural history at the University of Aberdeen; this book is based on my thesis.

Profound thanks are due to Dr Joan Pittock-Wesson for welcoming me to the Thomas Reid Institute and for introducing me to the academics at the University of Aberdeen who took an interest in my work. Historian Professor G.S. Rousseau, as my main supervisor, was responsible for helping in the overall organisation of the thesis and for maintaining an overview of the research project. He gave me invaluable advice which helped to keep me 'on track'. Others who gave me help were Ian Davidson, Nick Fisher, Mike Hepworth, and Dave Smith in particular; I had very exciting conversations with each man but specific thanks are due to David Smith (who acted as my principal supervisor in 1994) for his painstaking and scrupulous examination of the thesis; his conscientious scrutiny of successive texts and his detailed feedback which was invaluable. Thanks must also go to the examiners of the thesis: art historians Louise Bourdua and David Lomas. The progress of the thesis was considerably hastened by the race to completion I was having with Dr Alison Brown – we submitted our theses on the same day!

Particular thanks are due to cultural theorist and anthropologist Mary Douglas for her careful reading of chapters within her realm of interest and for her rigorous criticism thereof. An equal share of recognition must go to Phil Douglas for his ongoing constructive criticism; thanks to the literary critic and poet Richard Tyrrell for the same. A show of gratitude is owed to my good friend, poet and playwright Elizabeth Burns for her constructive

remarks. My former research assistant Matthew Wellard, himself a very talented researcher and lecturer, receives many thanks for his diligence in preparing the interview transcripts. Thanks also to my current research assistant Teresa Barnard for her help with the index. It is a point of great sadness to me that my mother, Fee, is not alive to see any of my achievements, not least the birth of my daughter Eilish, to whom this book is dedicated.

Since a number of academics and others have made this research possible I now have the happy task of acknowledging their contribution. Jonathan Andrews at the Oxford Brookes University was kind enough to supply me with detailed constructive criticism of my work on the 18th and early 19th centuries. I am also grateful to historian Allen Ingram for his correspondence with me. I greatly appreciated the assistance of curators of the archives of the Bothwick Institute in York; the Crichton Royal Hospital; Dave Mitchell of the York Retreat. June Murphy gave me considerable assistance in my research on Bruce Godward, including letting me have some of his papers which were in her possession. I am also very indebted to Roger Smith of Lancaster University for his reading suggestions. Furthermore, I appreciated discussing this topic with psychoanalyst Susan Budd.

With reference to my work on occupational therapy, I was assisted by Irene Catherine Paterson of the Robert Gordon University, who supplied me with an unpublished paper and allowed me an interview with her about her work with Lydiatt.

Regarding my work on Withymead I would like to thank all of the people who gave up their time to be interviewed: Rupert Cracknell, Mike Edwards, Richard Fritzsche, Norah Godfrey, Peter Lyle and Euanie Tippett. Three of this number, Norah Godfrey, Richard Fritzsche and Peter Lyle, were kind enough to read through the finished text and comment on its accuracy, which was much appreciated. Thanks are also due to all those who entered into correspondence with me on this subject, and in particular Ben Belton and Sonu Shamdasani of the Wellcome Trust for the History of Medicine. I have greatly appreciated Sonu's rigorous comments on this text, I hope I have responded adequately to them! Thanks also to my former boss Peter Edwards (MD) for introducing me to the work of Maxwell Jones and for arousing my interest in the subject of therapeutic communities in the first place. I am very grateful to Cathy Wilson for alerting me to certain texts and for assisting me to build a more favourable view of analytical psychology, and for stimulating my interest generally in the subject.

With regards to my work on other twentieth-century art therapy pioneers I am grateful to art therapist Barbara Breckman for supplying me with the address of Marion Milner, and also to Marion Milner for the frank and open interview she gave (sadly Milner died in 1998). I am grateful to Adrian Hill's son, Anthony, for his comments on the chapter which deals with his father's achievements. Thanks are also due to Joyce Laing for the interview she gave. I

was greatly assisted by Rita Simon, with whom I spent many hours talking. John Timlin and the late Edward Adamson also were of great assistance; Adamson saw me twice during his last illness. Rona Rumney very kindly let me have a copy of her thesis on art therapy at Netherne Hospital which included several interviews with Adamson's former patients this was material I was very grateful to have. Thanks are due to all those who entered into correspondence with me including Besley Naylor, Marianne Harling, Diana Halliday and Mike Pope. Thanks are also due to the British Association of Art Therapists (BAAT) for making their records available to me, and to Val Huet and Diane Waller for expediting this process. I was also greatly assisted by the librarians of the Wellcome Trust Library in London. I was helped in the writing of these chapters by the donation of material from Stanley Roman, who on abandoning his own research kindly passed on articles of interest to me, along with unpublished interview transcripts. I was also very pleased to have the opportunity to present extracts of this work to the University of Edinburgh History of Medicine Group and to receive useful constructive feedback on the text from Steve Sturdy and others. Thanks also to the University of Edinburgh Department of Anthropology for letting me sit in on their history of anthropology lecture series.

Regarding my work on Surrealism and art education I am grateful to Martin Kemp, of the University of Oxford, for putting me in touch with Tom Normand, of St Andrews University, who has given me valuable reading suggestions as well as ideas for how I may develop this aspect of the research in the future.

More thanks still are due to David Lomas for his foreword, which is intended to explain why this book will be of interest to art historians and fine artists. Mary Douglas, always ready to pick up a gauntlet thrown down, has the job of explaining why a book on a seemingly arcane subject should interest the general reader.

I wish to acknowledge financial assistance given to me by the Wellcome Trust for the History of Medicine and institutional support from the University of Derby.

The Intellectual Precursors
of Art Therapy in Britain

The creative process has the last word, and cannot be translated...a picture speaks for itself through the way it is made; image and meaning are identical. (Rita Simon, pioneer art therapist.[1])

Before describing how ideas in art therapy developed, it is helpful to ask what art therapy is, and who are its clients. Three main approaches may be discerned today in British art therapy. They indicate differences both in philosophical perspectives and in actual practice. The first main approach (though that of a minority) may be called *analytic art therapy*. As one might expect, this draws on theories from analytical psychology and, in particular, from psychoanalysis. It emphasises the *transference* relationship between client and therapist, which is given a central place in the interpretation of the therapeutic encounter. The second approach has been dubbed *art psychotherapy*. This is harder to define, since art therapists who use this term may practise a technique very similar to that of the third group, *art therapists*. Generally speaking, *art psychotherapists* emphasise the importance of verbal analysis of the art work of their patients. In extreme cases this may result in the art work becoming a mere adjunct to verbal psychotherapy, since many *art psychotherapists* have both an art therapy and a verbal psychotherapy training. *Art therapists*, the third group, may not feel that a verbal analysis is necessary and may lay greater emphasis on the actual production of art work (including cognisance of gestures made and the client's reaction to the art work). However, this is not always the case. In many instances the difference between art psychotherapists and art therapists is primarily one of nomenclature. I shall use 'art therapy' as the generic term henceforth except when distinguishing between these approaches.

In all forms of art therapy the client is encouraged to explore their feelings using art materials, usually paper and paint but also in collage, clay and sculpture. This can be done individually or in small groups. How the materials are used by the client can also contribute to the meaning of the work. The art materials themselves (their very substance) can evoke feelings in the person using them. It is possible that 'magical' powers can be invested in the image or object and that art works can take on great symbolic significance for the maker of the image or object. Therefore how the image is modified, stored, displayed or destroyed can become relevant.

Probably the dominant model of art therapy being taught in Britain today in post-graduate training courses is the *Group Interactive Model*. This approach lays great emphasis on interactions with others, which are seen as shaping the individual's basic personality structure. This view, unlike that of orthodox psychoanalysis, sees the individual as potentially in a constant state of flux and reconstruction through interactions which are constantly shaping the self. However, this approach also seeks to focus on 'characteristic patterns of interaction which constrain people in their everyday lives'.[2] The method employed involves an analysis of clients' here-and-now behaviour in the group. This is not simply a discussion of clients' difficulties but a disclosure of their present constraints which are *revealed* through their behaviour .[3]

The theoretical underpinning of this method, with its emphasis on the constructed nature of the self, is certainly preferable to dogmatic theories about human development – which have been employed, sometimes disastrously, by art therapists.[4] Whilst the group interactive method undoubtedly has some benefits, it puts the therapist in a very powerful position with regards to the interpretation of adaptive and maladapted behaviour. It also assumes that the therapist is able to interpret the situation in a reasonably balanced manner and control their own emotional responses, or at least be able to monitor and contain them. Clients in a vulnerable situation may be unable to challenge the therapist's ideas or *projections* about them. Likewise, the therapist's gut reactions or *countertransference* may get in the way of the clients expressing themselves freely. It is not my intention to provide a critique of group therapy practice here, but clearly the premise on which the idea is founded is an optimistic one: the idea that years of certain habitual ways of relating to people might be overcome or overturned by just a few weeks or months of group therapy, entailing getting (potentially distorted) 'feedback' about how one relates to others. This approach has been criticised for taking insufficient cognisance of things other than relationships, such as

institutional orthodoxies or representations of race and gender difference, which also shape the self.[5] Certainly, issues of control and power are central to debate about art therapy and psychotherapy procedures, and have been so historically also. Even these brief remarks, made by way of introduction to this topic, should be sufficient to alert the reader to the fact that art therapy practices are fraught with philosophical difficulty and involve art therapists in making decisions about issues of power and control in assessing what is normal and abnormal behaviour, and interpreting their clients' demeanour. These questions will therefore be of central importance to this research on the history of art therapy. Consequently a discussion of power relations between the client and the therapist will form part of this historical research.

Probably the best indicator of an art therapist's cultural position will be their views about the role of the therapist. The following research identifies utterly different ways of approaching the subject. One difference which has been insufficiently emphasised in literature on this subject is the profound difference between art therapists who used analytical psychology as a basis for their work and those who worked using psychoanalytic theory. Although analytical psychologists and psychoanalysts have much in common, their disposition towards the use of art and art therapy is surprisingly different. Ideas about the interpretation of art work are central here to distinguishing between different approaches and will be discussed further in the text. However, most art therapy pioneers, as I shall illustrate, were resolutely opposed to the idea of the therapist furnishing interpretations of the client's art work, although there were a few interesting and notable exceptions.

Art therapy may also take place on a one-to-one basis, in small groups (which may or may not employ the 'interactive' method), or in an 'open studio' format. The latter approach entails making studio facilities available to clients so that they can 'drop in' as they choose. This open studio approach has been popular because it relies on the clients' own volition, though clients may be coerced into attendance and sometimes such groups are difficult to contain and can become volatile.

More needs to be said about the art therapy clients (called 'lunatics' and then 'patients' in the period I shall be exploring). Many art therapy posts exist today within large National Health Service trust psychiatric hospitals in Britain; these are the main employers of art therapists, though art therapists are increasingly working in other contexts too. In these hospital settings the ethos may vary, depending on the consultant psychiatrist and other staff employed. It is not uncommon for art therapists to receive their client popula-

tion by referral from consultant psychiatrists or in some cases psychiatric social workers, senior nursing or occupational therapy staff. Most art therapists have the opportunity to appraise the client's suitability for art therapy through an assessment period, though they may be under pressure to accept clients referred to them. Referral procedures vary. Clients may be sent to an art therapist without being fully consulted about their wishes or without the art therapy process being properly explained to them.

The *aim* of art therapy may be decided in consultation with colleagues in a particular institutional setting. Or the clients may themselves have a very clear idea about what they wish to achieve in art therapy: for example, a client may wish to come to terms with a recent bereavement. At times art therapists may be working with clients who are not clear what they wish to get out of art therapy. Some art therapists use psychological paradigms as a basis for their work (Freudian, Kleinian and so forth) and may conceptualise the art therapy encounter within the terms of these theoretical frameworks.

The art objects made in therapy are usually kept by the therapist in a place where the client can easily gain access to them when they choose. Usually such works are not exhibited and remain the private property of the client. However, there have been many recent examples of former clients exhibiting their art work. Indeed, there is also an overtly political use of the arts where the therapy is used to express and critique the sociocultural context in which pain, illness, disability, social stigmatisation or inequality are experienced. Such work is frequently produced with the intention of exhibition.[6] This political or 'social art therapy' approach contrasts sharply with that which seeks to apply psychological models. This latter approach may address psychological constructs such as the Oedipal complex, for example, regardless of whether the client has an interest in this kind of exploration. It is problematic both intellectually and morally since it can impose a theoretical framework onto the therapy situation which has not been explicitly negotiated. Subsequent interactions between the therapist and client may be viewed by the therapist through the lens of a reductive theory.

In these pages, I have introduced the technique of art therapy and indicated where art therapy fits in to the medical profession. I have also ventured to explore how art therapy procedures are problematic. I hope that I have not given the reader an overly negative impression of art therapy in these initial remarks. Much art therapy work is empowering and deeply rewarding to those who participate in it.

Literature on the history of British art therapy

The term 'art therapy' was coined in 1942 by an artist called Adrian Hill, but therapy employing the use of image-making work was carried out before this date in the context of moral treatment, psychoanalysis, and arguably as part of experiments in modern art. There exists only one book on art therapy history: *Becoming a Profession;*[7] this detailed institutional history deals specifically with the formation of the British Association of Art Therapists (BAAT) as a professional body and its continuing developments to 1982. BAAT's first AGM in 1966 is therefore the obvious point to conclude the focus of this research in order to avoid overlap with Waller's text. It is not my intention to duplicate or challenge Waller's work on this subject, but rather to produce complementary research concentrating on pre-BAAT developments. (Although there is a small amount of overlap in the two research projects, I indicate where this occurs in the text, and present an account of Waller's contribution to the subject.)

Writing and interpreting history

I have noted that current art therapy practices are heterogeneous in nature and have different philosophical and practical implications. Although in the period under discussion in this book (c.1790–1966) the three main modern approaches to art therapy did not exist, we can begin to see the emergence of these different models of thought. I will not be attempting to apply present day theory to past practices, but rather shall present the claims made by practitioners as to the therapeutic efficacy of their method in a critical manner. It is not my aim to attempt to prove that current practices are superior to past practices or vice versa.

In history there has been a move away from the emphasis on individual men of genius, and from large-scale historic generalisation. The first of these emphases has been described by historian G.S. Rousseau as *thinker histories.* These are approaches following 'the Carlyean tendency to view the history of human achievement as a succession of inexplicable geniuses arbitrarily bestowing knowledge upon mankind', an approach which George Rousseau argues has never been abandoned.[8] However, historians increasingly see history as consisting of many histories spoken by many voices.[9] These new 'deconstructionist' and 'social constructionist' approaches challenge traditional disciplinary boundaries through a critique of dominant hegemonic structures such as language and accepted forms of knowledge.[10] The writing

of Foucault in particular has been influential in its insistence that the work of the historian must examine the interrelation between institutions, discourses and practices.

George Stocking, a historian of anthropology, has pointed out that within professions when a particular school of thought becomes dominant it influences views about the history of that school. Such views about past paradigms 'become part of the conceptual and methodological ideology' of the group. It is likely to be communicated through the pedagogical tradition. He argues that 'when countercurrents later reassert themselves, they are often accompanied by a relegitimating historiography, which seeks out textual evidence of the rejected ancestor's "better moments" to disprove the accepted stereotypic picture'.[11] Stocking is of course referring to the work of an individual 'ancestor' in this example, but his idea can be applied equally well to schools of thought as to the work of individuals. As Stocking's argument makes clear, history can be seen as constructed. It has become apparent to me during the course of this research, and I explore this in the text, that the influence of psychoanalysis has been greatly overemphasised in claims made about the history of art therapy. It is outwith the scope of this research to explore in detail precisely why this has occurred, as this shift took place largely after the period under discussion in this text; an exploration as to why links between psychoanalysis and art therapy have been emphasised by art therapists will make an interesting piece of future research.

I shall now move on to a discussion of oral history as this is relevant to my research methodology. The advantages and disadvantages of using an oral history approach have been well documented and since there is now extensive literature on this subject I shall simply summarise some of the main points of argument. Paul Thompson has pointed out a disadvantage of history that relies exclusively on textual analysis: 'The more personal, local, and unofficial a document, the less likely it was to survive.'[12] This is relevant to the early professional development of art therapy in Britain, much of which was *ad hoc* and informal; the lack of written records is a justification for the use of oral history. When used in conjunction with extant records, oral history can help to create a richer picture of events, allowing a multiplicity of standpoints to be represented.[13]

Oral history relies on the use of qualitative research methods, particularly the in-depth interview. The advantages of this technique have been described by Valerie Yow as enabling the interviewee to answer questions as they choose, as well as introducing new topics.[14] Thus the interviewee can reflect

upon the content of the interview and offer interpretation as well as facts.[15] The end result can therefore be regarded as a more collaborative process, in which non-professionals play a critical part.[16]

The scope of this research

Chapter Two opens towards the end of the 18th century. It looks at the development of the 'moral treatment' method which arose out of a convergence between utilitarian philosophy and non-conformist religion, and the use of the arts as part of this method in Britain. This is a subject that has been largely overlooked by historians in general and completely ignored in art therapy literature. The chapter starts with an examination of morality as a system of rules defined by culture. In it, I look critically at the assumptions underlying the moral approach, including the idea of the authority of the physician, the subjugation of the 'mad' subject, and Foucault's idea of 'abasement' (the idea that in order to be cured the insane person must recognise themselves as mad). I shall contextualise these ideas within the discussion of changing views of insanity during this period. Drawing on the archives of the Crichton Royal Hospital and York Retreat, in particular, this chapter illustrates conclusively that popular assumptions amongst art therapists about the origins of art therapy lying only in psychoanalysis are quite misplaced.

In Chapter Three I explore how, in the discourse of degeneration, madness and artistic genius became conflated and how expressive types of art (that of so-called 'primitive' peoples and certain forms of modern art) came to be seen as indicating a degenerated or pathological person or society. This too is a subject that has been ignored in art therapy literature, which has only acknowledged some psychiatric writings on the arts (notably that of Hans Prinzhorn). Art historian John MacGregor (1989) has written an impressive text, *The Discovery of the Art of the Insane*, but his concern is less with art therapy than with discovering mad 'geniuses'.

The chapter opens with an examination of theories of heredity reflected in early psychological and anthropological writings, which influenced art therapists both directly and via Surrealism. Theories of degeneration are explored alongside assumptions about the hierarchy of races evident in nineteenth-century biological determinism, as reflected in ideas about the cultural significance of symbols in early anthropological and psychological writings. Around the 1860s the idea crystallised that 'primitive society' is related to 'primitive mentality'.[17] Writers such as the Italian psychiatrist Lombroso equated symbolism in art and language with primitive mentality,

as did Sigmund Freud. These ideas are of pivotal importance to what became
dubbed by many psychiatrists in the twentieth century as 'the psycho-
pathological school', a group of analysts, psychiatrists and others who saw
symbolic images in dreams and paintings as evidence of underlying neurotic
conflicts. The chapter briefly surveys how symbolism was viewed by particu-
larly influential writers such as Lombroso (as primitive or atavistic expres-
sion), Haddon (as a sign of degeneration), and Sigmund Freud (as an expres-
sion of a primitive part of the psyche).

The second part of this chapter then moves on to look at the influence of
psychoanalysis on early art therapy developments and on the growth of this
'psychopathological school'. Its implications will be examined critically,
with some examples of dogmatic interpretation. I will survey the work of
Pfister, Fairbairn, Pickford, Milner, Pailthorpe, Kris, Baynes, Naumberg and
Susan Bach. Again, there has been an almost complete lack of critical
research within art therapy on this subject.

Chapter Four includes a presentation of art therapy exhibitions and an
examination of the impact of Surrealism on art therapy development (a topic
entirely overlooked by Waller).

In Chapter Five I look critically at statements made by moral practitio-
ners, and their successors, about the curative power of the arts. The chapter
provides an examination of the work of several occupational therapists who
identified themselves as art therapists in the twentieth century. Drawing on
secondary texts, I illustrate the similarity of approach between these occupa-
tional therapists and the moral practitioners to underline the point that it is
incorrect to assume that the origins of art therapy lie exclusively in psychoan-
alytic discourse.

In Chapter Six I explore how, during the Second World War and post-war
period, art therapy was used in the rehabilitation of tuberculosis sufferers as
well as soldiers. The chapter gives a detailed account of the work of Adrian
Hill, who coined the phrase 'art therapy' in 1942. Hill began practising art
therapy whilst he was himself recovering from tuberculosis in 1938. He
managed to convince the hospital authorities of the benefits of the method,
and continued to work as an art therapist after his discharge as a patient. Hill
was responsible for the development of the first institutional supports for art
therapy as a profession and assisted in the creation of sessional posts through
the auspices of the British Red Cross Society and the National Association
for the Prevention of Tuberculosis. The chapter surveys these professional
developments in detail along with Hill's work in promoting art therapy

through exhibitions of patients' art work, inter-sanatoria competitions and conferences. Although Waller's text does touch on Hill's work (and I explore her contribution further in the text), this chapter represents a more detailed and comprehensive evaluation of his work than previously existed.

The text then moves on to look at the development of art therapy in the context of medical research being carried out in neuroscience and visual perception. Psychophysiological researchers employed artists to make paintings whilst under the influence of mescaline. In addition to this, the art works of psychiatric patients were analysed to yield information about the perceptual disturbances they experienced during the course of their illness. Chapter Seven, 'Pioneers of Art Therapy: Research at Maudsley and Netherne Hospitals', will also give a detailed account of an art therapy research post established at Netherne Hospital in 1946. Edward Adamson, who was appointed to this position, worked using standard conditions capable of being reproduced elsewhere for research purposes. The research, conducted by Dr Cunningham Dax, represents the first rigorous attempt to ascertain the usefulness of art as therapy. The chapter will explore in detail how Adamson worked and how he perceived his role, as well as examining the research objectives of those who established the position.

Chapter Eight gives a brief historical outline of the development of psychiatry and social psychiatry, in order to provide a context for these art therapy developments. The work of a number of art therapy pioneers active between 1935 and 1965 will then be presented. Developments within social psychiatry settings are then examined, including accounts of the work of Rita Simon and Sigmund Heinrich Foulkes. The chapter ends with an account of early art therapy meetings which took place prior to the first AGM of the British Association of Art Therapists in 1966, which is the cut-off point for this research.

The impact of analytical psychology in Britain and the formation of Withymead is the subject of Chapter Nine, 'Withymead: Britain's First Therapeutic Community Dedicated to Art Therapy'. Withymead, a residential community established in 1942, was set up with analysis and art therapy as the central treatment methods. Analytic psychology and art therapy were considered to be complementary methods. Art therapists saw Jung's idea of 'active imagination' as pivotal to their approach. This chapter will explore how, in analytic psychology, the idea that the unconscious could be self-regulating through the use of the arts (which were therefore viewed as curative) was important in the perception and value placed on art therapy as a

treatment method at Withymead. In particular I will examine Jung's work on the 'transcendent function' and produce a detailed analysis of how 'Jungian' art therapists conceptualised their work. To do this I will draw on interviews I completed with pioneer art therapists who worked at Withymead, as well as with reference to primary source material.

Because Withymead was a therapeutic community it will be necessary to produce an account of the community as a whole, and explore how it functioned in order to give a true picture of how the art therapy studios worked. In particular it is imperative to understand the interaction between analysis and art therapy, because these were the principal methods employed. Also germane is an analysis of religious sentiment at Withymead, and an exploration of the power relationships within the community. The philosophy and approach of the Withymead studios will be presented along with their history and development, referral systems and practice. This chapter represents the first detailed research on art therapy at Withymead. The central significance of Withymead to art therapy developments in Britain has received no acknowledgement in art therapy literature to date.

Chapter Ten looks at how the arts were perceived in, and prior to, the period in which the first art therapy posts were developed. It moves on to examine how ideas developing in the field of art education influenced art therapy and how art therapy was used in this context.

Chapter Eleven contains my conclusions about these matters, which I shall not preempt here.

This introduction has attempted to point out some of the difficulties inherent in art therapy, which is by no means a single unified procedure but a variety of practices which have different practical and philosophical implications. I have also briefly outlined the scope of this research and indicated some points of its originality.

The research identifies a number of aspects of art therapy development which have been ignored in writing on the subject, and attempts to elucidate these. For example, the religiosity of much of the early art therapy work (a topic ignored by Waller). No doubt as attempts were made to 'professionalise' art therapy the more spiritual aspect of the work, so characteristic of much pioneering art therapy, came to be negated. The essentially subversive attitude of many early art therapists has also been ignored by writing on art therapy in general.

Notes

1 From *The Iconographic Collection of Art Therapy*, The Wellcome Trust Medicine and Society Library.
2 Waller 1993, p.22.
3 Waller 1993, p.23, my italics.
4 See Hogan (ed) 1997 for examples.
5 Hogan 1997.
6 Lupton, foreword in Hogan 1997.
7 Waller 1991.
8 Rousseau 1980, p.161.
9 Hogan 1992; Lupton 1994.
10 Tong 1989, p.219.
11 Stocking 1987, p.291.
12 Thompson 1988, p.3.
13 Thompson 1988, p.5.
14 Yow 1994, pp.5–6.
15 Yow 1994, p.10.
16 Thompson 1988, p.11.
17 Kuper 1988, p.2.

Taming the Passions
Moral Contagion, the Curative and Transformative Power of the Arts in Moral Treatment

The 'moral' treatment of the insane arose out of utilitarian philosophy. In Britain it also developed out of a non-conformist religious tradition which was not only outside of the medical establishment but outside of traditional religious orthodoxy too. Although there has been a long tradition of hostility from the medical establishment to sectarian activity in the religious consolation of insanity, I have chosen to begin my research on the development of art therapy at this point (c.1790) because this is the period in which institutions were developed for the care of the insane and the period in which the medical establishment began to embrace moral techniques. This historical period (c.1790–1816) may be viewed as the point in which two previously hostile discourses started to become interwoven.

Morality can be defined as a system of rules and values constructed by culture. 'Moral development' has usually been conceived of as the increase in the internalisation and assimilation of basic cultural rules. Individuals show this assimilation to cultural rules through 'conformity or resistance to temptation'. This has been described as implicit in the common sense notion of 'moral character'.[1]

Much modern psychotherapy (particularly that which uses group methods) is based on the same principles. The radical experiments which have occurred in the twentieth century, which I explore in further chapters, were based on the individual's assimilation of cultural rules, which may to some extent be generated by the community itself. Certainly some of these community developments ran with more libertarian frameworks than operated in society at large. However, conformity to, and assimilation of, group norms played an important part in the rehabilitation of patients.

Moral treatment as it emerged in the period under discussion was based on utilitarian philosophy (e.g. that of Hume, Smith and then Mill). The utilitarians assumed that moral values were generated individually through a process of people making judgements about the actions of others:

> The utilitarians suggested that actions by the self or by others whose consequences to the self are harmful (painful) are naturally deemed bad and arouse anger or punitive tendencies, and actions whose consequences are beneficial (pleasant) are naturally deemed good and arouse affection or approving tendencies. Owing to natural tendencies of empathy, to generalisation, and to the need for social agreement, acts are judged good (or bad) when their consequences to others are good (or bad), even when they do not help (or injure) the self.[2]

This is the philosophical basis on which the moral treatment method was largely based. It provided the foundation for a different way of relating to the insane, one which assumed that they too were capable of such 'natural' responses. Treatment prior to this period had relied heavily on the use of physical methods and, as historian Andrew Scull has pointed out, this new approach constituted a 'rather damning attack on the medical profession's capacity to deal with mental illness'.[3] The other major influence on the development of moral treatment stemmed from the non-conformist religious tradition, with its emphasis on mental unrest as the consequences of sin representing trials of conscience. This approach also used a model of mental illness considerably at odds with somaticist interpretations. It did pave the way for the use of the arts. Although there was some ambivalence about the unrestrained use of imagination in art-making, it is clear from the examples I shall give that the arts were seen both as curative in their own right and as useful for preparing the patient to receive moral treatment.

The now popular idea that art therapy developed out of psychoanalysis is incorrect. The development of art therapy within the 'moral treatment' regime, rather than emphasising the expression of underlying psychological conflicts as in the psychoanalytic model, saw the arts as appealing to the more refined sensibilities of patients. The discipline required for artistic accomplishment was also a factor which was stressed. It is my intention to explore how the instilling of self-control, identified by historians as a key characteristic of moral therapy, was also an important aspect of the use of the arts to treat insanity.

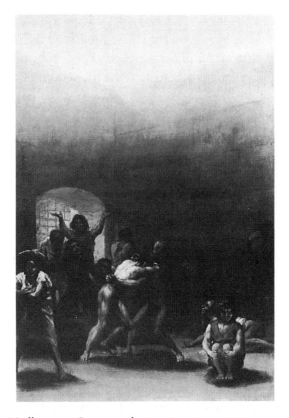

Figure 2.1 The Madhouse at Saragossa *by Francisco Goya, 1794*

Moral treatment

It is evident from many eighteenth-century descriptions of asylums that conditions in them were often brutal and appalling. At the end of the eighteenth century a report on the care of the insane by Deportes describes La Salpêtrière asylum in Paris. What made the cells...

> ...more miserable and often fatal, was that in winter, when the waters of the Seine rose, those cells situated at the level of the sewers became not only more unhealthy, but worse still, a refuge for a swarm of huge rats, which during the night attacked the unfortunates confined there and bit them wherever they could reach them: madwomen have been found with feet, hands, and faces torn by bites which are often dangerous and from which several have died.[4]

Another late eighteenth-century writer described the Bicêtre as follows: 'Even the air of the place, which can be smelled four hundred yards away – everything suggests that one is approaching a place of violence, an asylum of degradation and misfortune... It has become the receptacle for all the most monstrous and vile things to be found in society'.[5] Although these examples may represent extremes, it is hardly surprising that moral treatment (which may now seem punitive in some of its aspects) was heralded as humane and just. Similar conditions were reported in Britain by W.A.F. Browne in his 1837 publication and series of lectures *What Asylums Were, Are and Ought to Be*.[6] However, in a later publication, *The Moral Treatment of the Insane* (1864), Browne was also deeply critical of some of the 'barbarous' practices employed by moral practitioners in the nineteenth century and earlier. He noted that such 'Immoral Treatment' employed the use of 'cruelty, and chainings, and drownings, and rigid confinement...to quench the spirit [of the insane person], to frighten men into their senses, to subdue and train, to overcome and tame the passions'.[7]

The historian Nikolas Rose argued that it was the very intractability of madness to physical treatment that led physicians to concentrate on the idea of a more humane 'management' of the insane.[8] However, as the above quote illustrates, it is not possible to make a clear distinction between regimes which employed 'management' and those which used physically based methods. Other theorists argue that the shift towards moral management was more the result of a change in how insanity was perceived: 'Madness is now understood more as a disturbance of feeling and less a disturbance of thought'.[9] This developing acknowledgement of an imbalance of feeling meant that treatment had to address this imbalance. Patient engagement in art-making was introduced as part of humane treatment methods. It was part of a growing emphasis from the end of the eighteenth century on occupation and rehabilitation in moral treatment. The arts were viewed as a way of tapping the emotions, but in a controlled manner. It has also been noted that the reformer Pinel, for instance, directed attention to the patient's 'story'. From this he hoped to derive information about the precipitatory emotional circumstances of the individual, as well as ideas for possible behavioural interventions.[10] The patient's 'story' is a mainstay of modern psychotherapy treatments, including art therapy, so Pinel's approach is of significance.

Foucault has argued that prior to the end of the eighteenth century the insane were considered bestial and subject to unreason; they were not subject to moral condemnation to the same degree.[11] However, towards the end of

Figure 2.2 Pinel Freeing the Insane. *Engraving by Tony Robert Fleury, 1887*

the century madness came to be viewed differently. The mad became the
subject of 'moral condemnation if they refused to recognise their state or if
they did not control the signs of their madness and so disturbed the rest of
society.[12] It is when the insane became subject to moral condemnation that
'moral therapy' was also possible. The mad were no longer seen as totally
unreasonable but as having some reason which could be appealed to. Moral
treatment assumed that the 'deranged shared with all others a common core
of reason, to which the treatment was directed, and which it could use as its
first foothold on the pathological condition'.[13]

Jan Goldstein has argued that the strategy of gentleness adopted by moral
treatment practitioners was rooted in Enlightenment philosophy. Goldstein
is referring to the cult of sensibility which developed from around the 1750s
and 1760s in British literature and culture, in contrast to the more traditional

unsympathetic and brutalising conceptions of insanity. Goldstein agreed with Rose (1985) that insanity was not viewed by 'mad doctors' (those who treated the insane) as obliterating the patients' rational faculties, but that a vestige of 'humanity' was seen as remaining, which could be appealed to and reinforced.[14]

This developing belief in the moral causes of insanity moved away from eighteenth-century doctrines of physical causes of insanity (clogging or weakening of fibres, imbalance of bodily fluids). It emphasised the 'moral' sources of illness – desires, lusts, vices and other unruly passions.[15] The moral treatment method was to use the peculiarities of the mad individual in the curative process. Their wants and fancies would be targeted as part of an appeal to the conscience and the will of the insane person. Kindness became regarded as a therapeutic tool.[16] This emphasis on individual psychology was crucial in the development of art as therapy which has been overlooked in writing on the subject.[17]

The eighteenth-century view of insanity put forward by Foucault, and Rose, has been challenged by historians such as Porter (1987) and Ingram (1991). Allan Ingram, for example, in *The Madhouse of Language*, has noted different attitudes evident in the eighteenth-century debate about insanity and has pointed out that the transition from eighteenth-century practices to moral treatment is not so clear cut as has sometimes been claimed. He has called opposing attitudes evident in the eighteenth century 'suppressive' and 'endorsing'. Whilst extremist opinion held that madness was incurable, explanations for it varied. For example, those with suppressive tendencies looked upon madness as a departure from the norm of a healthy mind because of impaired judgement or diseased imagination, whereas those more inclined towards 'endorsement' saw the particular form of madness more in terms of a response to a specific set of circumstances or a way of life.[18] These different attitudes led to different approaches to treatment. As Ingram puts it: '…suppression and endorsement differed over whether the experience of madness contained any kind of truth…if…madness was saying something *about* normal life, and was also a commentary upon itself then the mad could offer important clues for the understanding both of themselves and of the world of the sane'.[19]

The origins of moral treatment

Historian Michael MacDonald (1990) has pointed out that although scepticism was gaining ground, particularly amongst the educated classes in the

mid- eighteenth century, many people still believed that religious therapies cured madness more effectively than medical remedies alone. MacDonald argues that dissenting sects, Catholic priests, and non-conformist divines met the popular demand for faith healing and exorcism. He describes the dissenters' methods of psychological healing thus:

> They practised three kinds of treatments, all of which were non-violent and supportive: spiritual counsel, charismatic healing, and prayer and fasting. Prominent clergymen preserved the Puritan tradition of practical divinity, visiting the homes of the sick and unhappy people and offering them counsel and consolation...all of the dissenting groups seen [sic] to have comforted mad and melancholy people by congregational prayer and fasting. The practice evidently began as a method for helping victims of demonic possession.[20]

MacDonald argues that the dissenting tradition of psychological healing may have been more influential than is commonly realised. The treatment of lunatics began to be reformed by Quakers in particular, who were active as leaders of the moral approach which incorporated elements of the practices of the dissenters.[21]

Moral treatment was of particular significance in the development of the medical specialisation of psychiatry. Moral treatment in Britain was developed largely by people who did not possess a medical training. In France Pinel, who was a trained physician (not a Quaker), emphasised the role of the non-medical concierges in the care of the insane. Goldstein (1993) argues that it was the developing medical speciality's adoption of moral treatment which was of pivotal importance in their ability to gain control over the laissez-faire economy of madhouses. The Parliamentary Select Committee of 1815–1816 was of particular importance in discrediting physical treatments used at the time, forcing members of the British medical profession to accommodate moral treatment within their therapeutics.[22]

Although commonly associated with the Society of Friends, with William Tuke (1732–1822) proposing the York Retreat in 1792 and Philippe Pinel (1745–1826) supposedly releasing patients from their shackles at the Bicêtre in 1793, the work of Tuke and Pinel was part of a general movement.[23] By the time the York Retreat opened on 11 May 1796 moral treatment was not a new phenomenon. Historian Anne Digby described the York Retreat as a 'successful practitioner of received ideas'.[24] Thus in 1758 a treatise on madness recommended confinement aimed at 'checking the unruly appetites and the pursuits of a quiet, well ordered life'.[25]

Pinel, admiring the work of Francis Willis (1718–1807), a prominent proponent of this method who had treated King George III of Great Britain, saw the process as requiring the patient to submit to the 'sovereign authority' of the doctor which Rose describes as 'authority assuming mastery...the madman is bent to the will of the doctor and comes to accept his will as his own'.[26] The male physician assumed an unprecedented position of power and control in a 'family' structure (the York Retreat staff often referred to it as a 'family'). Foucault has emphasised the way that moral treatment revived the prestige of patriarchy in what he calls a 'bourgeois notion of family'.[27] In other words, male power was reasserted by such an approach. According to Goldstein, whilst moral practitioners preferred gentle means, the alienist [another term for 'mad doctor'] was 'obliged' to undertake 'regretfully and without anger – the task of repression or subjugation' of the subject when such methods failed. For this purpose, the alienist's very presence was supposed to exude authority. Francis Willis, Goldstein noted, was renowned for his piercing gaze. It was this gaze, she argues, 'that infallibly conveyed to lunatics the message that he was their master; as Willis himself put it, he commanded by the EYE'.[28]

In Sander Gilman's view, Tuke was directly influenced by the mesmeric tradition in which 'the relationship between the magnetizer and the patient was a personalized one of trust and belief'.[29] Whilst Tuke advocated very different approaches to 'psychotherapy', he adopted 'the close, personal sense of rapport which marked the tradition of mesmerism without the overt use of mesmeric treatment'.[30,31]

Tuke described his approach in 1796:

> It may greatly tend to advance and establish the patient's recovery, to perceive himself under the direction of persons who, whilst they are careful to promote cheerful and salutary amusements, will be concerned, at suitable seasons, to cherish in them strengthening and consolatory principles of Religion and Virtue.[32]

Tuke also acknowledged a 'principle of fear' as a controlling device.[33] Foucault has pointed out that religious observance itself could provide a 'constant principle of coercion'.[34] He describes the system at the Retreat as relying on a 'self-restraint' in which the patient's freedom was curtailed by work, whilst they were also under the observation. The patient 'was ceaselessly threatened by the recognition of guilt...it must be recognised that one was in the grip of a positive operation that confined madness in a system of rewards and punishments including "moral consciousness"'.[35]

Historian Theodore Brown has noted that moral treatment drew on asso-
ciation psychology which postulated that the patient's faulty mental associa-
tions could be carefully re-educated in the humane and orderly regime of the
reformed asylum.[36] These mental associations or erroneous ideas could be
challenged. Attempts by doctors were made, by Pinel in particular, to
discredit particular delusional beliefs. However, the idea of 'virtue' or
'self-restraint' was also to play a key role. Rose has argued that to those
following the moral treatment approach there was nothing ambiguous about
the relations between moral conduct, moral processes and moral derange-
ment.[37] Moral treatment, by definition, drew upon a set of culturally and his-
torically specific social norms. Gender norms, for example, were ferociously
enforced in this system of care of the mentally ill. For example, women who
had entered into the sphere of politics could be incarcerated for their
deviance.[38] The moral principles employed by asylums included 'deference,
modesty, compliance, industriousness, regularity of habits'.[39] Likewise,
modern psychotherapy reinforces both social and gender norms, possibly to
an oppressive degree. In the moral regime women in particular had to keep
their perceived stronger sexual desire in check.[40] This latter point is agreed by
Goldstein who argues that unlike European sensationalist 'psychologists'
who represented insanity as a 'type of error', moral treatment practitioners
insisted that 'viscerally based passions' also played a part in the aetiology of
disease.[41]

Moral treatment functioned in some senses like an early form of behav-
ioural therapy utilising 'the pursuit of pleasure, the avoidance of pain, the
ability to form associations. Thus the moral order could be constructed,
shaped, organised and re-educated through disciplining the body, imposing
habits and regularities through the tactile utilisation of this utilitarian
calculus.'[42] Although the principles of the Quaker religion were of crucial
importance in the methods used by the York Retreat, a widespread system of
restraints was in operation and no doubt had a regulatory effect upon
behaviour.[43] However, the emphasis of this approach was on self-restraint
rather than on the use of enforced physical methods (manacles, etc.). Hill, the
medical officer resident at Lincoln Asylum in England, described 'moral
treatment with a view to induce habits of self control' as 'all and every-
thing'.[44]

Jan Goldstein has argued that useful labour or listening to music were
employed as part of moral treatment as a 'distraction from the psycho-
pathological idea'.[45] Goldstein is right insofar as most nineteenth century

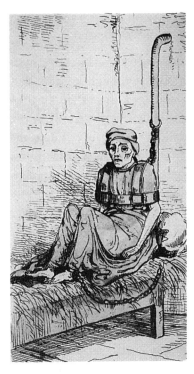

Figure 2.3 William Norris at Bedlam. *George Arnald, 1814. William Norris became well known after he had been discovered in 1814 in the basement of the Bethlem Asylum, where he had been locked in restraints for at least ten years*

asylums were designed with galleries. Paintings were hung on the walls which were intended to have a subliminal effect on patients' emotions, leading them through contemplation of the art works to pleasant thoughts and reflections. This type of milieu therapy (which included attention to interior decoration as well as the provision of paintings) worked on the patient as an observer.[46] However, as I shall illustrate, the arts were considered more than a mere distraction in the treatment of insanity, but rather as a tool in the acquisition of self-control, and as a means to the elevation of the spirit.

The use of the arts in moral treatment

Historian Roy Porter has described how the imagination was viewed:

> …classical theory, as modified by Enlightenment empiricist psychology, insisted that imagination should not be wayward, idiosyncratic and visionary but should abide by the solid information of the senses and be

tempered by judgement. Thus genius was a healthy organic impulse for combining the raw materials of the mind.[47]

The arts were approached with caution by some physicians. The unrestrained expression of imagination was thought to have detrimental effects which could disrupt moral conduct.[48] Others thought the use of the arts was of central importance to the 'moral' approach. W.A.F. Browne, of the Crichton Royal Hospital in Scotland, in 1841, for example, thought that engaging in art had two main benefits: 'It contributes primarily to impart healthy vigour to the body and secondarily, to expel delusions, and to establish that tranquillity which allows and facilitates the operation of rebuke, remonstrance, threats, encouragement or reasoning'.[49] Here is a clear statement made by a medical superintendent about the purported curative value of the arts.

Michael Clark (1988) has pointed out that artistic creativity and moral treatment did not sit comfortably together:

...although it was recognised that imagination and reason were creatively blended together in the highest products of civilisation and culture, there remained a fundamental antithesis or at least a tension between the unmodified character of imagination, and those intellectual and moral qualities of right reason, sound judgment [characteristic of moral treatment].[50]

John Abercrombie in his text entitled *Culture and Discipline of the Mind* (1837) emphasised the importance of gaining control over thoughts of a frivolous or degrading nature. He wrote that 'the vitiated and corrupted mind may continue to the last the slave of its impure and degrading passions'.[51] Clearly, within the moral regime, the expression of such passions in works of art would not be thought useful as the emphasis, at least in Abercrombie's schema, was on self-control and self-discipline. George Man Burrows MD in his 1828 text on the causes and treatment of insanity also noted the need of such restraint. He wrote that many patients 'would, if permitted, find ample amusement in their pen. But this can seldom be allowed: for it is apt to run in the sense of their delirium or delusions...the poet at length raves'.[52] John Barlow (1843) also saw the arts as potentially damaging. He wrote: 'An irregular and injudicious cultivation of poetry and painting has often concurred to produce madness, but nothing is rarer than to find a mad mathematician'.[53] Barlow believed that misdirected intellect was often the source of insanity. He argued that those who most exercise the facilities of their minds

were least prone to insanity. By this he meant 'all their faculties, their attention, reflection, or comparison, as well as their imagination and memory, are least liable to insanity'.[54] Therefore if the arts were to be useful they would have to be pursued with diligent application.

It is this 'tension' between imagination and reason which was later to be reinforced by psychoanalysis in Freud's (1856–1937) ideas of 'primary processes' (non-verbal non-discursive modes which are imaginative and symbolic) and 'secondary processes' (analytical modes of thought which are verbal and rational). In psychoanalysis imagination was to become placed within the category of primary processes. Freud associated primary processes (except in children) with neurosis, regression, wish fulfilment and general ill health. Thus a division was made between reason and imagination which led to the conjecture of artists as evincing psychopathology.[55]

However, moral treatment provided an alternative way of thinking about imagination to that of psychoanalysis, one in which creativity was seen as having beneficial qualities despite the reservations expressed by Clark earlier as to the compatibility of imaginative creativity with moral treatment. As illustrated, some physicians saw art-making and moral treatment as highly compatible. Others stumbled across the therapeutic potential of art-making quite by chance and were whole-heartedly enthusiastic about its effects. William Saunders Hallaran (1765–1825), for example, describes a young man in Cork who had had acute mania and who 'betrayed an imbecility of mind that bordered closely on dementia'. Hallaran had encouraged him to engage in light work without success. It had been noted that the man had made crude drawings on the walls of his room:

> On being furnished with the necessary apparatus for painting, he imme-diately commenced a systematic combination of colours, and having completed his arrangements, he requested one of his attendants to sit for him... He soon became elated with the approbation he had met with, and continued to employ himself in this manner for nearly two months after, with progressive improvement as to his mental faculties...[56]

This example shows that engagement in art work was thought to have definite rehabilitative effects.

The therapeutic potential of the arts was being used in private hospitals long before the term 'art therapy' was coined. At the Crichton Royal Hospital in Scotland, W.A.F. Browne appointed artists to work with patients as early as 1847.[57] He believed that 'when engaged in drawing an amelioration' in the patient's condition takes place and that such 'occupation is prescribed, not

Figure 2.4 Art work from the Crichton Royal Hospital collection, late nineteenth century.
Anonymous

merely as in itself a means of cure, but as a preparative to all other attempts to remove mental disease'.[58] In 1847 he wrote 'Drawing has been prescribed as a medicine in four cases, and appeared curative in two'.[59] In 1852 he wrote that painting constituted an instrument for 'the removal of disease' and he gives the example of

> a mind [that] has recently grown up to its former stature, and to compara-
> tive strength, under the revived cultivation of a taste in drawing. This
> inspiration was drawn from the example of associates, who converted the
> public room into a studio...covered the walls with mementos of their
> taste and talents, and gave to the pursuits of asylum life, a tone, and
> elegance, and beauty, which is at all times desirable.[60]

However, even when a cure did not accompany such artistic undertaking, the art works themselves were thought to 'show how near an approach is made to excellence and reason, and how many must be the hours stolen from languor and misery by such pursuits'.[61] The art objects themselves are conceptualised as being potentially curative through a process of moral contagion. In other words, mere contact with such art work was seen as able to elevate the spirits.

Anne Digby (1985) has persuasively argued that what made moral treatment at York so elusive was that it was above all dependent on interper-

sonal relationships between staff and patients. It was not the effect of occupation alone which was thought to be curative, but activities which took place within a certain set of social relations. Activities were linked to the gender and social class of patients. Some physicians believed that activities differed qualitatively in what they could offer, as Browne noted in 1837: 'The more elevated...the occupation provided then, the better', and with such sentiments the fine arts were well regarded.[62]

Foucault noted that in moral treatment mad persons were made to observe themselves. He calls this the phase of 'abasement' which is aimed at forcing recognition of the person as objectively mad.[63] He argues that 'abasement' played an important part within the moral regime. In Foucault's view, madness is ceaselessly called upon to judge itself; this was certainly one of the purported benefits of art therapy to be espoused in the twentieth century.[64] These ideas, evident in the moral regime, extended into the psychiatric photography of the nineteenth century which was produced for therapeutic effect. Presented with a portrait of themselves in a deranged state, the image was thought to provide a salutary reminder of the patient's personal appearance.[65]

Hugh Welch Diamond (1809–1861), who worked at the Surrey Asylum from 1848, also used the psychiatric photograph as a diagnostic guide to insane physiognomy – that is, physical traits characteristic of lunacy.[66] Similarly, in art therapy, the art object reflects back to the patient their condition, and allows for introspection; we can see art therapy emerging out of these ideas.

A further impetus to the use of the arts in hospitals in the nineteenth century may have been the revival of an art and crafts movement in Britain, led by William Morris (1834–1896), who after attending the Exposition of 1851 campaigned against the divorce between designer and craftsperson.[67] Described as 'one of the outstanding figures of British Socialism', Morris was concerned with the relation between the arts and crafts and life. He proposed that the arts were important in enriching the quality of life and set up companies to produce largely handmade, good quality products. He also postulated that engagement in the arts was a means of personal satisfaction as part of his general argument about the importance of work bringing happiness to the worker.[68]

At the Royal Montrose Mental Hospital in Scotland a Shetlander called Adam Christie was admitted in 1901. The hospital at that time was a highly regulated environment but Christie was given his own studio in the hospital

Figure 2.5 Richard Dadd (1817–1886) painting Contradiction. Oberon and Titania *at his easel, Bethlem. Undated photograph by Henry Hering c. 1956 (Dadd was an artist before his incarceration for life for patricide)*

grounds in the 1920s where he worked mostly in stone, making over 200 hundred pieces of sculpture.[69]

His work was finished using a slow laborious method of scraping at the stone surface using fragments of glass from broken bottles, rather than with conventional tools. He also completed works in wood carved with a nail, as well as paintings which were produced using matchsticks to apply the paint rather than brushes. He produced a number of religious works on the back of cigarette packets.[70] This spontaneous sort of art-making by the insane (or social isolates) using found objects or found materials has been dubbed *art brut* or 'raw art'.

Keddie's (1985) book on Adam Christie does not give a rationale for why he was given the freedom of a studio and release from the tight military-style routines of hospital life. However, it is noted that he produced toys which hospital staff gave to their children and it seems likely that his productivity in this area was a determining factor in his gaining special status amongst the hospital inmates.

Figure 2.6 Example of the work of Diamond, c.1850

Conclusion

In this chapter, I have noted that moral treatment arose out of utilitarian philosophy and also from a non-conformist religious tradition. I have recorded some of the differences in scholarly opinion on how moral treatment arose and defined its essential characteristics.

Whilst it is problematic to compare practices of one century with those of another, I wish to suggest that some of the work carried out in institutions such as the York Retreat and the Crichton Royal Hospital may legitimately be viewed as the precursors of modern art therapy. In a later chapter I shall underline this point by comparing statements made by moral practitioners with those of twentieth-century pioneer art therapists. I have contended that there are broad similarities between the use of the arts by moral practitioners and by modern art therapists. Both were concerned with the internalisation and assimilation of basic cultural rules. The moral treatment practitioners, like their twentieth-century counterparts, employed an individualised treatment which required the active co-operation of the patient for success.

I have also argued that the moral emphasis on insanity being ceaselessly called upon to judge itself had links with the psychiatric photography of the nineteenth century. It also has echoes in the stated aim of many twentieth-century art therapists, who saw the art object as reflecting back important information about patients' conditions to them. In their view, it is only through a recognition of their state that the twentieth-century art therapy patient can hope to make progress. This is similar to the idea, put forward by Foucault, that the mad subject had to objectively recognise their condition before moral management could take root. There is a fundamental similarity between Foucault's idea of 'abasement' and the modern art therapist's insistence that the art object can act as a mirror; both ideas assume that the patient will see themselves more objectively and that delusions can therefore be overcome and rationality brought into play.

This chapter has, I hope, dispelled the idea that art therapy is a practice that arose exclusively out of psychoanalytic theory. I have illustrated that the

Figure 2.7 Methusela, *stone carving by Adam Christie*

moral treatment practitioners viewed patient engagement in the arts positively. As Clark's remarks about the tension between reason and imagination illustrated, an absolutely clear-cut separation between the discourses which formed moral treatment and psychoanalysis cannot be made. Anxiety about the unrestrained expression of the imagination preceded the development of psychoanalysis. However, psychoanalytic thinking was to absorb this anxiety about the opposing nature of reason and imagination into its schema of primary and secondary processes. In my view, psychoanalysis was to perceive the arts as evincing psychopathology. This is the subject that I take up in a following chapter. The analytical (Jungian) psychologist's view of art was, however, very different to that of the psychoanalyst. I shall explore in further chapters how Jung created a theoretical model in which artistic engagement could be viewed as both positive and curative and also as yielding information about unconscious processes.

Notes

1 Kohlberg 1968, p.487.
2 Kohlberg 1968, p.487.
3 Scull 1979, p.132.
4 Deportes cited in Foucault 1965, p.70.
5 Louis-Sebastien Mercier in *Tableau de Paris* 1783, cited by Foucault 1965, p.202.
6 Reprinted in Scull 1991.
7 Browne 1864, p.310.
8 Rose 1985, p.23.
9 Russell 1995, p.8.
10 Brown 1993, p.442.
11 Foucault 1965, p.70.
12 Russell 1995, p.8.
13 Rose 1985, p.30.
14 Goldstein 1993, p.1353.
15 Rose 1985, p.26.
16 Rose 1985, p.23.
17 Diane Waller's (1991) text, for example, does not mention moral treatment.
18 Ingram 1991, p.11.
19 Ingram 1991, p.18.
20 MacDonald 1990, pp.74–75.
21 MacDonald 1990, p.75.
22 Goldstein 1993, p.1355.
23 Pinel has been depicted in paintings and written texts literally unchaining lunatics at the Bicêtre during the French Revolution. Jan Goldstein (1993, p.1353) has pointed out that the image of the furious lunatics instantly becoming calm and tractable after their liberation by Pinel, along with much of the legend surrounding him, is largely fictitious.
24 Digby 1985, p.53.
25 W. Battie 1758, *A Treatise on Madness*, cited in Rose 1985, p.2.
26 Rose 1985, p.25.
27 Foucault 1965, p.253.

28 Goldstein 1993, p.1353.

29 Gilman 1993, p.1031.

30 Gilman 1993, p.1031.

31 Gilman 1993, p.1029. The term 'psychotherapy' came into common usage in the late 1880s through French-language publications.

32 Tuke 1796, p.4.

33 Tuke cited in Digby 1985, p.68.

34 Foucault 1965, p.244.

35 Foucault 1965, p.250.

36 Brown 1993, p.443.

37 Rose 1985, p.24.

38 Russell 1995, p.13.

39 Rose 1985, p.26.

40 Russell 1995, p.19.

41 Goldstein 1993, p.1354. It may be that Goldstein's argument is overstated as, for example, Roy Porter's research on madness (1987) indicates passion was important in views of madness (Porter 1987, pp.42–43).

42 Rose 1985, p.26.

43 Russell 1995, p.14.

44 Hill cited in Russell 1995, p.17.

45 Goldstein 1993, p.1353.

46 Browne (1864), for example, wrote that asylum interiors should 'teach and elevate' but that they might also appeal to the 'former pursuits and natural proclivities' of patients. Thus he emphasised 'homeliness' encompassing 'sights and sounds of happier days' (Browne 1864, p.313).

47 Porter 1987(b), p.62.

48 Clark 1988, p.76.

49 Second Annual Report of the Crichton Royal Institution for Lunatics, Dumfries, 11 November 1841, p.18.

50 Clark 1988, p.76.

51 Abercrombie 1837, p.159.

52 Burrows 1828, p.707.

53 Barlow 1843, p.167.

54 Barlow 1843, pp.59–61.

55 Freud's work (1923 and 1930) 'derived moral sentiments and beliefs from respect for, and identification with, individual parents and such moral sentiments were based on instinctual attachments (and defences against such attachments), rather than respect of groups. Moral rules (superego) were seen by Freud as countering instinctual forces' (Kohlberg 1968, p.487).

56 Hallaran 1818. Extract of his writing printed in Hunter and Macalpine 1963, p.648.

57 Groundes-Pearce 1957, p.19.

58 Second Annual Report of the Crichton Institution for Lunatics, Dumfries, 11 Nov 1841.

59 Crichton Royal Annual Report 1847, p.32.

60 Browne, Crichton Royal Annual Report 1852, p.37.

61 Browne, Crichton Royal Annual Report 1847, p.32.

62 Browne 1837, p.94.

63 Foucault 1965, p.264.

64 Foucault 1965, p.265.

65 Gilman 1976, p.9.

66 Gilman 1976, p.9. This emphasis on inherited causes of insanity is in conflict with moral treatments.

67 Park 1968, p.225.

68 Cole 1968, p.21. William de Morgan, an outstanding ceramicist, held similar views and was one of Morris's circle. His tile works in Chelsea were model employers.

69 Keddie 1985, p.67.

70 Keddie 1985, pp.68–78.

Mad, Bad and Degenerate
Art Therapy, Degeneration, Psychoanalysis and the 'Psychopathological School'

In the last chapter I examined the influence of 'moral treatment' on the development of art therapy. In this chapter, I examine a very different set of discourses. In the nineteenth century, analogies were made between natural and social life because it was hoped that a social science of human character could be developed which would include knowledge of both humankind's behaviour and physiology.[1] I will begin by investigating the nineteenth-century concept of biological determinism: the idea that shared behavioural norms, and the social and economic differences between groups (primarily races, classes, and sexes), arise from inherited inborn distinctions. Certain sets of social relations existed and evolutionary theory was used to justify them. The application of evolutionary theories was simply a matter of analogy. Equated through supposed likeness were women, criminals, children, beggars, the Irish and the insane – all of whom were lacking in social power and were likened to 'primitives' or to 'savages'. It was in the 1860s and 1870s that the idea crystallised that 'primitive society' is based on 'primitive mentality'.[2]

I will explore how, in the discourse of degeneration, madness and artistic genius became conflated; also how expressive types of art (that of so-called 'primitive peoples' and certain forms of modern art) came to be seen as indicating a degenerated or pathological person or people. It is these ideas in particular that were to inform psychoanalytic thought which, as I shall illustrate, saw art in general, and pictorial symbols in particular, as indicating pathological conditions. I shall argue that the idea of symbolism indicating degeneration (the degenerate type being prone to madness or criminality – or indeed artistic genius) was popularised by the work of Cesare Lombroso (1835–1909) in particular, and later by Max Nordau (1849–1943), and

then in a modified form by the Viennese neurologist, Sigmund Freud (1856–1939).

For centuries medical practitioners and the public had believed that the arts could contribute to the alleviation (and sometimes the exacerbation) of mental and physical conditions.[3] But during the early twentieth century, art-making by patients became a subject for scientific research. Prior to the 1940s and the emergence of art therapy as a profession, the analysis of the art of patients was already used in several schools of psychology and psychiatry. For example, within a psychoanalytical perspective, Otto Pfister viewed art as an expression of wish fulfilment in the Freudian sense.[4] The idea of a cathartic value in art-making, and art as an alternative form of communication, is apparent in this and other works of the period. Ernst Kris, a prominent Freudian psychiatrist and trained art historian, explored psychopathology in certain creative professions.[5] In this theoretical model, the artistic activity illustrates underlying illness and has a diagnostic emphasis. This chapter will elucidate the implications of such approaches. I will then survey theorists who used psychoanalytical ideas as a basis for their work who influenced art therapy (who are cited by art therapists or noted as influential in the interviews I undertook). I will examine how their work was used by the few prominent individuals who applied such ideas to early art therapy.

Degeneration

Degeneration was a dominant nineteenth-century idea which informed speculation in both the arts and the sciences.[6] It was also a preoccupation of the early twentieth century. I shall now present some examples of how the concept was applied.

> Equally obvious it must appear to the cosmopolite of some generation of the future that quality rather than mere numbers must determine the efficiency of any given community...and it will no longer be considered rational to keep up the census at the cost of propagating low orders of intelligence, to feed the ranks of paupers, defectives and criminals. On the contrary it will become thought fitting that man should become the conscious arbiter of his own racial destiny to the extent of applying whatever laws of heredity he knows or may acquire in the interests of his own species, as he has long applied them in the case of domesticated animals. The survival and procreation of the unfit will then cease to be a menace to the progress of civilisation.[7]

As the quote illustrates, and as argued by Chamberlin and Gilman, 'the concept of the mentally ill as degenerate became part of a perception and a rhetoric of difference, which in turn sustained a powerful if perverse idea of progress'.[8] Greta Jones argues cogently in her book, *Social Darwinism and English Thought*, that fear of degeneration and alarm about the decline of civilisation reached its peak at the beginning of the twentieth century.[9]

The notion of degeneration was biblical in origin and posed a methodological threat to the popular evolutionist view of human origins. So-called savages and the mentally ill were considered to be the degenerate descendants of superior ancestors.[10] The technical term for this is 'monogenism', which is the belief of the unity of all peoples in the creation of Adam and Eve. In this model of thought humans are seen as having degenerated from Eden's perfection as a result of their sinful behaviour.[11] Some races were thought to have deteriorated more than others.[12] George Stocking, in his book *Victorian Anthropology* (1987), describes the Bible's 'psychological and epistemological assumptions' as 'innatist and a priori', its 'principle of human diversification' as 'genealogical', and its 'principle of change' as 'degenerationist'.[13]

Count Arthur de Gobineau, writing before Darwin (1809–1892) had published his major works, applied the idea of degeneration to societies at large. In his work of 1854, he deplored the adulteration of the blood through marriage with other (often conquered) peoples, which allegedly caused a diminution in the quality of the superior race.[14] The superior peoples were, in his view, those of Europe and South West Asia; the rest of humankind he described as 'a pestilent congregation of ugliness'.[15] Through cultural inertia the society might seem relatively unchanged as the result of adulteration of the blood. However, it resulted in a situation in which 'the customs, laws, and institutions have quite forgotten the spirit that informed their youth...'[16]

A number of social groups were classified together as a result of these theories (evolutionism as it was popularised). These included peasants, labourers, children, women and the insane who were likened to primitive humans.[17] All were thought to share 'mental characteristics' which placed them on a 'lower point on the unitary scale of intellectual and moral development: governed more by impulse, deficient in foresight, they were in varying degrees unable to get beyond this'.[18] Indeed, Paul Crook (1994) noted that certain 'classes or races of human beings were seen to be little better than the animals, which were assumed to be unreasoning and motivated by simple primal instincts, aggressive and territorial'.[19]

Those interested in social reform viewed the problem of poverty from this perspective. Friedrich Engels applied the term to the working classes whom he saw as 'physically degenerate, robbed of all humanity, reduced morally and intellectually to near bestial condition, not only by economic exploitation, but by competition and association with the coarse, volatile, dissolute, drunken, improvident Irish, who slept with their pigs in the stinking slums of Manchester'.[20] Similar examples are quoted by Greta Jones (1980). For example, W.R. Greg (1886) compared the Irish unfavourably with the Scots: 'The careless, squalid, unaspiring Irishman, fed on potatoes, living in a pig-stye, doting on superstition, multiplies like rabbits or ephemera; the foreseeing self-respecting Scot passes his best years in struggle and celibacy'.[21]

Generally, the high birth rate among the lower classes became seen as a threat to evolutionary progress.[22] Greta Jones has argued that eugenics 'was able to integrate two aspects of late nineteenth century culture – fear of working class disorder and discontent and the rise in their numbers'.[23]

In mid-Victorian Britain, the notion of sexual restraint was thought to indicate individual and racial development. Women in particular were thought to be 'quintessentially sexual' beings. Stocking wrote: 'Like self improvement, progress consisted not simply in a growth in reason, but in a repression of sexual instinct'.[24]

Jan Goldstein noted that in the late nineteenth century, asylum populations 'swelled with chronic patients demonstrably impervious to moral treatment', and that asylums became custodial rather than fundamentally therapeutic institutions. She argued that coincidental with this institutional shift was an intellectual shift which resulted in psychiatrists conceptualising insanity as a form of degeneration. 'Psychiatrists,' she wrote,

> came to theorise insanity not as a psychological or psychosomatic disorder (a conceptualisation appropriate to the therapeutic asylum), but rather as an irreversible brain condition and as a product of degeneration – that is, 'taint' or sickly deviation from the norm initially caused by a pathogenic environment, poor nutrition, or alcoholic abuse, and subsequently transmitted in the Lamarckian manner through heredity, becoming progressively more severe with each generation until the family line became sterile and, finally, extinct.[25]

Elaine Showalter (1985) argued that a deterministic psychiatry dominated England from around 1870 up to the Second World War. According to her, these theories regarded 'hereditary organic taint' as responsible for madness. Showalter called this tendency 'psychiatric Darwinism', which is rather

misleading, since these theories were more influenced by degeneration than by Darwin. However, the terms 'social Darwinism' and 'psychiatric Darwinism' have been used by a number of theorists to refer to how Darwin's work was popularised.

As for the developing eugenic debate, Darwin himself did not equate evolution with progress. It was Darwin's adherents who propagated this idea, in particular Ernst Haeckel (1834–1919) and Thomas H. Huxley (1825–1895).[26,27] The eugenics movement emerged from the work of Francis Galton, who was a Lamarckian. Stephen Jay Gould explains Darwin's work thus: 'According to the Darwinian imperative, individuals are selected to maximise the contributions of their own genes to future generations, and that is all. Darwinism is not a theory of progress, increasing complexity or evolved harmony for the good of the species or ecosystems'.[28] Paul Crook (1994) agreed that Darwinism 'denied that evolutionary change worked purposefully towards a long term goal (teleology) or that it proceeded in a single direction (orthogenesis)'.[29]

Anthropologist Adam Kuper (1988) argued that Darwin's ideas, put forward in *The Origin of Species* (1859), were not shared by many of his contemporaries. Most agreed with Herbert Spencer (a Lamarckian) that 'human history was a history of progress and that all living societies could be ranked on a single unitary scale'.[30] Stocking, in contrast to Kuper, noted that it was degenerationalist thought that posed 'a serious methodological threat to those committed to an evolutionist view of human origins'.[31] Stephen Jay Gould noted that creationists (Agassiz and Morton) and evolutionists (Broca and Galton) exploited Darwin's work to make 'invalid and invidious distinctions between groups'.[32]

Adam Kuper has argued that the notion of primitivism is one that emerged out of the last Victorian surge of imperialism and offered a notion of progress. The interest in primitivism was fuelled by the development of professional anthropology.[33] Stocking, too, has argued that imperial expansion was relevant to the rise of evolutionary theories in general and that they 'functioned ideologically to buttress exploitative relationships both at home and abroad'.[34]

Similar ideas to those of Lombroso, which are discussed below, were propagated in Britain by Francis Galton, who claimed in 1869 that heredity governed not only physical features but also character and talent.[35] Galton saw eugenics as 'practical Darwinism' and believed that the application of eugenics could improve the physical and mental level of the races. Galton,

who first used the term 'eugenics', believed that there was an unequal distri-
bution of desirable physical and mental qualities throughout the population.
Second, he believed that those who had the desirable characteristics should
be encouraged to multiply faster. Furthermore, as Greta Jones argues, in
Darwin's theory of natural selection there was only one criterion of the
'fittest', those who left the most progeny. To Galton this was impossible to
reconcile with the fact that in mid-nineteenth-century Britain the poorest
classes were the most fecund. He wrote that this idea 'seems to spoil and not
to improve our breed'.[36] As Jones opined: 'Galton had substituted Darwin's
idea for a highly subjective criterion of eugenic worth...[using] highly
partial and contentious social judgments on the relative worth of different
sections of the population'.[37] According to Kevles, by the late nineteenth
century in Britain a growing number of social Darwinist writings showed a
belief in the idea that heredity determined character, that criminals bred
criminals and paupers bred paupers.[38]

The period in which the first art therapy posts were created was not
immune from such thinking. In Britain the Brock Committee (1934) argued
that sub-normals (the insane, paupers, epileptics, criminals, alcoholics, pros-
titutes and the 'unemployable') could be eliminated by segregation and steri-
lisation. Injury arising from birth (called 'secondary amentia') was considered
to be treatable through medicine. Since segregation was much more costly
than sterilisation a committee was established in 1934 to consider the issue
of legal sterilisation. This study was carried out by Dr Leon Penrose and Dr
Douglas Turner who were considered to be authorities on the subject.
Kathleen Jones (1972) identified problems with a policy of sterilisation: first,
that it was unacceptable on religious grounds to certain groups; second, that
it would make doctors reluctant to certify a patient as mentally defective;
third, that it could have disastrous effects on the individual's self-confi-
dence.[39]

Symbolism and degeneration

Degeneration theory and art had been combined in the work of A.C. Haddon
(1855–1940), a prominent late nineteenth-century anthropologist. He had
the idea that more ornate and naturalistic carvings were original and
primitive whilst more abstract designs were degenerate. This assumption was
made without any historical evidence. His work gives a good idea of the prej-
udices and assumptions of the late nineteenth century and is worth elaborat-
ing on for this reason.

The evolutionist frame of mind is evident in Haddon's assertion that in order to understand civilised art we must first study 'barbaric' art. Haddon recognised three stages of artistic development: origin, evolution, and decay.[40] He felt that the decorative art of a people does, to an extent, reflect their character: 'A poor, miserable people have a poor miserable art'.[41] He assumed that 'primitives' did not depict plants in their art work because of their insensitivity to them: 'Backward people have to be taught to see beauty in nature, and it is very doubtful if the elegance of the form of a flower leaf appeals to them',[42] whereas the geometric patterns common in 'barbaric art' were considered by Haddon the result of plagiarism. The more copied a design, the more likely he thought it was to degenerate into abstract pattern.[43]

This idea of how a design comes to life, only to lose its distinctive features, degenerate and die, has been noted as intellectually problematic by anthropologist and cultural theorist Mary Douglas, who wrote: '...for one, it assumes that the scholar knows when a design is alive or dead; for another, he has already judged its degeneration by his own criteria of stability and simplification'.[44] Haddon believed that creativity is easily overwhelmed by inertia. He wrote: 'We Europeans are abundantly energetic and creative, much less convention-ridden than the primitives known to be dull and uninventive'.[45]

A quite different line of thought was put forward by Cesare Lombroso, an Italian psychiatrist and anthropologist and founder of criminology as a specialist branch of anthropology, described by art historian MacGregor (1989) as being 'among the most influential and prominent figures in psychiatry in the generation preceding Sigmund Freud'.[46] His L'Uomo Delinquente of 1879 was described by Gould as 'probably the most influential doctrine ever to have emerged from the anthropometric tradition'.[47] Lombroso perceived the value of the art of the insane as providing visual evidence of mental pathology. He was one of the first psychiatrists to make an extensive collection of the drawings and paintings of the insane.[48] Lombroso regarded the insane, along with the 'congenital criminal', as an example of atavism, 'a revival of the primitive savage'.[49] This notion had come to him when he had examined the skull of a famous brigand by the name of Vilella. The skull resembled those of rodents, having a particular depression where the spine is found on the normal skull! He wrote of this 'revelation' that it indicated 'the problem of the nature of the criminal – an atavistic being who reproduces in his person the ferocious instincts of primitive humanity and the inferior animals'.[50]

Lombroso's ideas on art were different to those of Haddon, and preceded them. He saw symbolism in particular as a degenerated form. Though Haddon also refers to symbolic stylisation, he is talking about a 'degeneration' of form which he believed was created not by aesthetic intention but by copying. Lombroso, on the other hand, saw symbols as a form of throw-back or atavism, as a more primitive means of self-expression. He also thought that imagination appeared in inverse proportion to intellect in 'megalomaniacs'.[51] In his work, *The Man of Genius* (1891), he interpreted the bourgeois sensibilities of many well-known artists as degenerate.[52] This aspect of his work was described by MacGregor:

> Lombroso and his followers piled up vast quantities of 'evidence' to support the thesis that genius was a form of 'moral insanity' and that all geniuses should be diagnosed as suffering from a degenerative psychosis. No major figure in the arts, philosophy, or even natural science could escape the vilification of these mudslinging pathographers.[53]

The idea that artists are a little mad was certainly propagated in Lombroso's work and so was the idea that madness could promote genius:

> One of them, a painter, who had formally only reached mediocrity, attained such perfection through this malady [monomania], that a copy of one of Raphael's Madonnas, executed by him during one of his attacks, gained a prize medal at the Exhibition.[54]

He went on to add: 'It is more usual, however, for insanity to transform into painters persons who have never been accustomed to handle a brush... Individuals who previously had not the remotest idea of art are impelled by disease to paint'.[55]

Lombroso pointed out how the insane could depict their experiences in art-making. He wrote: 'A monomaniac, who laboured under the delusion that he was being persecuted, drew his enemies perusing him on one side of the picture and Justice defending him on the other'.[56] However, he saw these manifestations as atavistic. In particular, he believed that visual hallucinations explained this propensity, for 'it is easy to reproduce what one sees clearly. Moreover, the imagination is most unrestrained when reason is least dominant'.[57]

Lombroso thought that the art of the insane evinced an 'exaggerated predilection for symbols'.[58] When artists and writers used a similar style to that of the insane he thought that it indicated that they were degenerate. He

believed that degeneration was not only indicated by the use of symbolism in art but also in language. He wrote:

> The ancient Chinese represent *malice* by means of three women, *light* by the sun and the moon, and the verb to *listen* by an ear between two doors. This primitive writing shows us that the rhetorical tropes and figures of which our pedants are so proud are expressions of poverty rather than wealth on the part of the intellect.[59]

The use of such symbolism and hieroglyphics, he noted, was characteristic of the art of the insane as well as that of 'savages'.[60] He argued that the use of symbols and hieroglyphics therefore 'affords one more proof that, in the visible manifestation of their thoughts, the insane frequently revert (as do criminals) to the prehistoric stage of civilisation'.[61]

The insane, the savage and the degenerate are all, therefore, equated in Lombroso's thought because of their predilection for the use of symbols, an expression of primitive mentality. His ideas were further popularised in Britain by Max Nordau.

Max Simon Nordau was a Jewish German philosopher and trained physician born in Budapest. He attempted to apply the idea of degeneration to various intellectual and artistic endeavours, arguing: '...in art, literature and social evolution there is a decadence and hysteria...all alike indicate the vain spasmodic struggling of an effete civilisation'.[62] These ideas he got directly from Lombroso who, in *The Man of Genius* (1891), identified pathological elements in the art of the insane (minuteness of detail, complication of inscriptions, use of symbolism, excessive predominance of one colour, licentious subject matter) and went on to note the preponderance of such features in art work generally.[63]

The importance of biological determinism and anthropological thought upon Sigmund Freud's work has been noted by theorists such as Edwin Wallace (1983) and Sander Gilman (1993). The latter described psychoanalysis as

> a therapeutics of psychopathology initially based on hypnosis but quickly evolving to the use of Bernheim's suggestive psychotherapy; a theory of the mind employing the model of hidden or subconscious levels taken from German Romantic psychiatry and philosophy; and a research agenda...which reflected the importance of anthropological models as well as biological models to fin-de-siècle medicine.[64]

Sigmund Freud's views on symbolism were somewhat different to those of
Lombroso. Freud's ideas about symbolism arose out of his interest in
language. Forrester (1980) argues that he was primarily interested in linguis-
tic usage which was 'individual *and* collective at the same time'.[65] Forrester
stresses that Freud retained his interest in the 'precise locus of the symbol in
the psychic life of the dreamer'.[66] Nevertheless, during the period
1905–1910, under the influence of Wilhelm Stekel, Freud's initial reluc-
tance to accept the idea of universal symbolism and the use of *a priori* inter-
pretive methods dissipated, leaving him willing to 'concede that a significant
amount of the work of dream interpretation could be conducted in a
universal and imagistic code of dream symbols'.[67]

There are some clear similarities between the views of Lombroso and
Freud. The notion of a more primitive level of mentality was embraced by
Freud in the idea of 'primary processes' which are imaginative, symbolic and
non-discursive, indicating regression or neurosis. Freud's theory of symbol
formation, as described in his *Interpretation of Dreams*, is complicated, but
commonly symbols in dreams were seen as 'disguised representations' of
'latent thoughts',[68] especially wish fulfilments.[69] Involuntary ideas (with a
repressed sexual aetiology), he argued, would often emerge in a visual form
in dreams.[70] Such images arise from the primary processes which contain

*Figure 3.1 Freud and the sculptor Nemon discussing Balinese sculpture. Undated photograph
c.1938*

'wishful impulses from infancy, which can neither be destroyed nor inhib-
ited'; these 'irrational' primary processes force their way through the repress-
ing tendencies of the secondary processes and are 'charged with uninhibited
energy from the unconscious'.[71] Freud expressed his interest in the 'regressive
archaic character of the expression of thoughts in dreams'.[72] Lombroso's idea
that symbols indicate a primitive reversion or degeneration are extremely
close to Freud's idea that the 'irrational' and 'uninhibited' expression of the
unconscious is achieved through symbol formation.[73]

By the 1890s, Freud had developed parallels in his work between
primitive and neurotic behaviour.[74] He pathologised 'primitive' or 'atavistic'
tendencies, writing in 1900, 'a good deal of symbolism is shared by dreams
with psychoneurosis'.[75] In *The Introductory Lectures in Psycho-Analysis*
(1916–1917), Freud conceptualised dream symbolism explicitly as a survival
of prehistoric modes of expression.[76] He drew on the work of a philologist,
Hans Sperber (1912), who suggested that sexual needs played an important
part in the development of human speech. The first speech summoned the
speaker's sexual partner, and when speech was later used in other contexts it
retained its sexual connotations. Thus 'sexual interest became attached to
work' which was accompanied by rhythmically repeated utterances.[77] Freud
applied these ideas to dream symbolism. He wrote:

> We should understand why dreams, which preserve something of the
> earliest conditions, have such an extraordinarily large number of sexual
> symbols, and why, in general, weapons and tools always stand for what is
> male, while materials and things that are worked upon stand for what is
> female. The symbolic relation would be the residue of an ancient verbal
> identity; things which were once called by the same name as the genitals
> could now serve as symbols for them in dreams.[78]

He then reiterated his position that the 'psychology of the neuroses has
stored up in it more of the *antiquities* of human development than any other
source'.[79]

Both Freud's work and that of Lombroso assumed that sexual impulses
were at play in primitive mentality. Savages, like women, were thought to be
closer to animals and 'quintessentially sexual'.[80] Indeed, Stocking demon-
strates that in much nineteenth-century anthropology primitives were often
documented as promiscuous, passionate[81] or as evincing a 'violent sexual-
ity'.[82]

The implications for art therapy of such theorising are essentially
negative. Expressive art work may be seen as pathological or psycho-

pathological or both. Indeed, such ideas were bad news for modern art in general. Carl Jung, for example, given somewhat to hyperbole, described modern art in 1932 as characterising 'anti-Christian and Luciferian forces' and 'the demoniacal attraction of ugliness and evil' which results in

> an all pervading sense of doom – veiling the bright world with the mists of Hades, infecting it with deadly decay, and finally, like an earthquake, dissolving it into fragments, fractures, discarded remnants, debris, shreds, and disorganised units. Picasso and his exhibition are a sign of the times, just as much as the twenty eight thousand people who came to look at his pictures.[83]

Jung's opinion of Picasso is strikingly similar to that of Max Simon Nordau, who in *Degeneration* (1895), which was dedicated to Lombroso, had said that many artists might be regarded as degenerates. He wrote that the enthusiasm from their admirers 'is for manifestations of more or less pronounced moral insanity, imbecility, and dementia'.[84]

In 1928 in Germany, Schlitz-Naumburg had placed self-portraits by modern artists next to photographs of mentally ill or retarded people in his book *Kunst und Rasse*. This juxtaposition was intended to show a similarity between the physical appearance of the retarded and/or ill and the portraits produced by the artists. The equation between the artist and the degenerate became a particular preoccupation in Germany during the Third Reich.[85] Chamberlin and Gilman consider that many European artists at the beginning of the twentieth century embraced some of these ideas. They appropriated the label of degenerate, and revelled in their difference, picking up the Romantic legacy of the artist as outsider. The artistic avant-garde regarded the mentally ill 'as kindred souls, like themselves incarcerated within an oppressive society. Thus, writers as Ernst Stadler, Georg Trakl, Carl Einstein, Alfred Döblin, and the Dadaist Richard Huelsenbeck all used the voice of the madman as the poetic alter ego of the avant-garde'.[86]

This idea was taken up again in 1937 by the Minister for Culture in Germany, Joseph Goebbels, in the conception and design of the notorious exhibition called '*Entartete Kunst*'.[87] The exhibition, which opened on 19 July 1937, was organised by Aldolf Ziegler (head of the Chamber of Fine Art). Seven hundred and fifty objects were exhibited in the Munich Anthropological Museum. These included examples of primitive art and art by the mentally ill along with examples of modern art by artists such as Marc Chagall and Emil Nolde, which were labelled as the products of psychologically or racially degenerate individuals.[88] Hitler described Expressionist

works as 'creations of a diseased imagination'.[89] Art historian J. MacGregor writes that 'working from a primitive concept of the nature of mental illness, they attempted to create an environment expressive of psychopathology... The word degenerate was not casually chosen and...was directly linked to the Nazi obsession with racial superiority. For the Nazis mental disturbance was seen less as a form of illness than as a mark of genetic inferiority'.[90] No longer was there simply an analogy between madness and artistic creativity. From July 1937 the removal of 'degenerate' art from public museums and galleries began in Germany. Expressionist artists were particularly suppressed. Some 16,000 works of art were identified as degenerate and removed from public collections. Approximately 4000 works were burned in 1939. Laws were introduced to prohibit the production of art works by those deemed 'degenerate' and also to prevent these artists from teaching or exhibiting their art work. MacGregor describes how the Gestapo visited former artists and searched their homes for evidence of artistic activity. 'Armed with absolute dictatorial power, Hitler and his Minister of Culture, Dr Joseph Goebbels, were able to all but obliterate the last traces of the German Expressionist movement'.[91]

In 1933, a Eugenic Sterilisation Law was passed in Germany by Hitler's cabinet for the compulsory sterilisation of all people with alleged hereditary disabilities. By 1935, the Nuremberg Laws made marriage between 'Germans' and 'Jews' illegal. In 1939, the Third Reich inaugurated 'euthanasia' on certain classes of the mentally diseased and disabled in German asylums, and the murder of Jews *en masse*.[92] In Britain the critique of racialist assumption and biological determinism was stimulated by the threat of Nazism in the 1930s.[93] However, the idea of a link between pathology and artistic expression was by this time firmly established.

The influence of psychoanalysis

In the first part of this chapter I explored how symbols in particular were described as both primitive and pathological in the work of Freud and others. How were the ideas of Freud and others taken up and used by theorists influential in the development of art therapy in Britain? To understand this, it is best to present a brief outline of the reception of psychoanalysis in Britain.

It has been shown by historian Malcolm Pines (1991) that a great impetus to psychoanalytic psychotherapy development was provided by the interest in the psychogenesis of so-called 'shell shock' in World War I. Both the Tavistock Clinic and the Cassel Hospital were founded in the post-war

years.[94] However, this post-war development in the use of psychotherapeutic techniques rebutted the Freudian argument for a sexual aetiology of mental disturbances, replacing it with a theory of multiple conflicting instincts. Nikolas Rose records that the work of Freud and Janet influenced a range of treatments from rational reeducation, persuasion and hypnosis, to psycho-analysis.[95] Two main British approaches developed. The first approach supported a dynamic conception of psychological processes using ideas such as the unconscious and repression, but, as noted, rejected the Freudian argument for a sexual aetiology of mental disturbance, approving instead a theory of multiple conflicting instincts (for example, one's duty to fight coupled with the natural impulse to run away from danger). Indeed, as one commentator pointed out, such 'neurosis was seen at the time as simply a failure to adapt to army routine and discipline'.[96] The second main approach emphasised the social significance of minor mental disorders. There was therefore a disjunction in views about the aetiology of mental illness between psychiatry and the orthodox psychoanalytic establishment. It was the work of W.H.R. Rivers (1864–1922) in particular which is recognised as having caused this change in thinking. In his book, *Instinct and the Unconscious* (1920), he challenged Freud's libido theory.[97]

The work of Freud, in its orthodox form, was introduced to an English audience in 1914 at the Royal Medico-Psychological Association. Dr Isabel Hutton has described the stormy reception given to these ideas, with doctors heckling the speaker with calls of 'rubbish', 'preposterous', 'vile' and 'filthy'.[98] However, the reception of psychoanalysis in Scotland was slightly more favourable. The tenets of psychoanalysis had begun to have an impact on Scotland during the years 1908 to 1911. In 1915 W.H.B. Stoddart intro-duced 'the new psychiatry' to a Scottish audience at the Royal College of Physicians, Edinburgh. Stoddart's assertion that psychiatrists should them-selves undergo psychoanalysis was somewhat controversial.[99]

Professor J. Shaw Bolton, who held the chair of psychiatry at the Univer-sity of Leeds, published *The Myth of the Unconscious Mind* in 1926. In it he called psychiatrists to reject the 'seething mass of foulness' propagated by Freud, Jones, Stoddart and others.[100] Conversely, Bernard Hart's (1879–1966) book, *The Psychology of Insanity*, was considered 'obligatory reading' amongst trainee psychiatrists up to the 1930s. Berrios argued that the popu-larity of Hart's book demonstrated that psychoanalysis 'was being assimi-lated into the epistemology of British alienism'.[101]

Pines (1991) saw the MBA Committee report of 1926 as pivotally important in the reception of psychoanalytic ideas. On this committee were the Freudian Ernest Jones, H.G. Baynes (a Jungian), T.R. Rees representing the Tavistock Clinic, T.A. Ross for the Cassel, Dr Hutton and others. Although opposition to psychoanalysis was evinced by comparisons drawn by committee members between psychoanalysis and Christian Science, the committee was 'converted' by the persuasive power of Ernest Jones. The report confirmed psychoanalysis as an 'authentic form of treatment' and suggested that the term not be used for any other techniques or theories apart from those advocated by Freud'.[102]

During this period, the Tavistock Clinic gained in prominence partly due to its director (from 1933) Dr J.R. Rees being appointed to the directorship of Army Psychiatric Services, even though he was considered by some commentators to be 'out-of-touch' with mainstream medicine and psychiatry and with developments in psychoanalysis.[103,104] He was active in the National Council for Mental Hygiene. A number of prominent people worked in the army with Rees including W.R. Bion and Dr John Bowlby.[105]

Psychoanalytic ideas received a cautious welcome from Edward Mapother, Professor of Psychiatry at the Maudsley, who thought that a positivist framework was necessary for the further development of psychotherapy. He wrote:

> If psychotherapy is to rise like other branches of biology from the anecdotal to the scientific level, and if psychotherapy is to become rational and define its limitations, then uncontrolled clinical findings must clearly be supplemented by observations as to the effect of standard experiences under experimental conditions capable of repetition.[106]

Although a psychotherapist rather than an analyst, C.P. Blacker, a member of the Tavistock staff, acknowledged the influence of Freud in their work.[107]

In Britain, Ernest Jones founded the British Psychoanalytic Society in 1919. He was responsible for inviting Melanie Klein to England, and helped both Sigmund and his daughter Anna Freud to move to Britain in 1938. The impact of Melanie Klein was felt within psychoanalysis and psychotherapy with the increasing prominence of object-relations theory. This theory was concerned with the developing infant's relationship with its mother. Donald Woods Winnicott was of particular significance to the discussion of how children differentiate themselves from the world and construct an ego and superego. During the post-World War period, there emerged a renewed emphasis on very early childhood (pre-Oedipal) development as being of

[handwritten top margin: Objects relations thinking in treatment of BPD + narcissistic]

central importance in the formation of psychopathology, such as 'borderline' or 'narcissistic' personality disorders.[108] Historian Nikolas Rose described the reception of psychoanalytic ideas during this period in Britain: '…psycho-analysis was to become a theory of development, and, what is more, a theory of the role of the mother in the development of the adjusted and maladjusted ego'.[109] These ideas were propagated, in particular, by the Tavistock Institute. Indeed, unconscious hostility of the mother towards the infant was now pos-tulated as significant in the aetiology of later disease, and theorists such as Bowlby, who helped to popularise the idea of 'maternal deprivation', argued that if women went out to work their offspring could suffer irreparable psy-chological damage.[110] In a period of post-war reconstruction in which there was a closure on a massive scale of wartime nursery provision, Bowlby's ideas were perfectly suited to the dominant ideology of the moment.[111] These ideas about a 'maternal complex' led to an increased regulation of mother-hood, which has subsequently been called into question by sociologists and historians.[112]

[handwritten left margin: Is adaptable for present society, may be more so today]

[handwritten: Maternal deprivation – and teenage pregnancy]

A psychopathological approach

Oskar Pfister

Oskar Pfister, a Protestant pastor (1873–1956), was the first analyst to publish a detailed work on the psychoanalytic treatment of an artist.[113] This approach was described by two psychiatrists, Guttmann and Maclay, as a 'psychopathological' approach to images. Those practising this approach interpret drawings and paintings either immediately or after the patients have been encouraged to express themselves. Guttmann and Maclay noted that such products were regarded as equivalents of free associations or fantasies which were then scrutinised with regard to their expressive character. Since Pfister's work is of historical significance, a brief summary of his main arguments will be presented. Those readers acquainted with modern art therapy will note contemporary resonance in some of his ideas.

Pfister argued that 'expressionism' is concerned with the 'inner self' – though he was not always positive about Expressionist art, referring to it at one point as 'diseased'.[114] Pfister noted a number of advantages of using images: first, that they provide an opportunity to express the individual's instincts (thirst for vengeance, sadistic and masochistic tendencies, etc.). He speculated that the production of images can satisfy 'instinct hunger'.[115] Second, that the making of images gives an opportunity for the expression of

wish fulfilments in the Freudian sense.[116] Pfister believed that repressed (unconscious) wishes were represented in the images produced: these can include both 'base' wishes, and wishes of 'metaphysical import' – for example, the process of coming to terms with death. The picture provides a means for 'objectification', the process whereby feelings can be seen objectively by their owner in the symbols used.

Pfister suggested that such symbolic representation of unconscious material is a positive process because projecting distress outwards can prevent the individual from becoming consumed by their feelings; the process of making images provided the opportunity for clients to 'socialise' their predicament.[117] Pfister also suggested that making an image allows individuals to explore the metaphysical dimensions of their lives. He felt that making an expressive image gave an opportunity to the individual to depict their innermost soul, and argued that making such an image can communicate feelings better than with 'dry words' or the 'conventional language of art'.[118] The painter may shape their world in a way that allows them to assert themselves within it.

Pfister summarised the advantages to be gained in expression through the visual image. These are that the pleasure to be gained in the act of creativity may strengthen the 'life will' or 'life force' of the individual. He does not specify particular client groups, but if we accept the validity of this idea, then the implications for working with depressives with suicidal impulses is worth noting. Another advantage stated is the act of 'objectivation' [objectification] of the inner conflict. Through this process he sees the possibility of overcoming the conflict. Yet another advantage stated is the social character of artistic work, which by its nature is a form of communication. A final advantage advanced was that a solution can be clarified and made fully conscious ready for critical examination by the image-making process.[119] Pfister also identified some disadvantages to the making of images, in which the influence of Freud appears to be evident. The artistic process may stimulate avoidance in that so much pleasure may be derived from dealing with life in one's imagination that acting in 'real life' might seem unnecessary. Another objection is that the artistic solution may fail. Pfister stated that 'like the dream the improvised picture is a most unreliable counsellor'.[120] Although Pfister did not use this point to argue for the involvement of a therapist it is clear that it could be used in this way. What he does say is that 'keen, fully conscious criticism' has to be applied to the picture to identify those aspects of it that should be trusted. It is therefore perfectly clear that Pfister sees a discussion of the

picture as essential. Pfister also questioned whether patients benefited from projecting and venting feelings stemming from childhood onto or at people in their present. He seems to be referring to the notion of working with 'transference'. He was certainly very suspicious about the benefits to be gained from the mixing up of the present time with the past.[121] It is clear that Pfister's work was known by some pioneer art therapists, since he is cited in early texts.[122]

Melanie Klein

Melanie Klein was amongst the first analysts to use art work with children as an adjunct to analysis. Her most detailed published account of an analysis using art is *Narrative of a Child Analysis: The Conduct of the Psycho-Analysis of Children as Seen in the Treatment of a Ten-Year-Old Boy*. This is an account of a wartime analysis but it was not published until 1961.

It is hard, on reading this text, not to feel that the patient's sense of reality is utterly negated in the analytic exchange. Whatever the child said, Klein deftly interpreted it as an aspect of his relationship with his mother. For example, in the second analytic session, the child attempted to express his distress about the war (which doubtless was very disturbing) and the devastation of Poland. When the boy used the phrase 'the precious earth' Klein immediately interpreted this as representing 'mummy'.[123] Klein in this account is utterly convinced of the veracity of her version of reality. In the opening session the boy talked about a fantasy in which he defends his mother from a tramp. Without clear justification, Klein's interpretation was that this desire to protect his mother referred to his being 'afraid that when his parents went to bed something could happen between them with their genitals that would injure mummy'. In Klein's note accompanying the text she wrote 'the boy had no name for genital functions... Similarly, the expression for sexual intercourse had to be introduced to begin with by describing *what he actually unconsciously expected his parents were doing at night*'.[124] She went on to suggest that 'at night when he, Richard, could not see his parents did not know what they were doing in bed, he might have felt that *Daddy was bad and dangerous*'.[125] I am tempted to suggest that these ideas, put forward by Klein, could have introduced such fears. Her interpretation of images is similar in emphasis, with 'genitalia' being apparent in the periscope of submarines or in the architecture of ships.[126]

Figure 3.2 Illustration from Narrative of a Child Analysis

W.R.D. Fairbairn

Eclecticism characterised the inter-war period in Scotland and Fairbairn's rigid Kleinian stance resulted in him being intellectually isolated.[127] W.R.D. Fairbairn saw the development of the individual in three stages: infantile dependence with its identification through the internalised object (external objects are internalised to remain 'good'); a transitional stage (adolescence) in which struggle for autonomy is undertaken; and a final stage, that of maturity, with its differentiation between self and other. If an individual becomes fixed at the infantile or transitional stage it is due, in his view, to the actual (rather than fantasised) relationship with the mother.[128]

Fairbairn seems inadvertently to make a case for discrete training in art therapy when he argues that the 'psychological aspect' of techniques must be seen as falling outside the expertise of the general psychologist, except in so far as it determines the emotional make-up of the artist. His interest is the effect of the work of art on the person who makes it.

He divided artistic production up into two categories, that undertaken for the satisfaction inherent in the art activity and, second, activities undertaken for satisfactions independent of those inherent in her activity; in other words, with more 'serious' aims. Employing psychoanalytical terms he describes activities of the first class as mainly determined by the 'pleasure principle', which he likens to play, those of the second class being mainly determined by the 'reality principle', which is linked more to worldly success or propagating a cause (though there may be an element of each of varying degrees). He blames 'puritanical attitudes' for what he sees as an intolerance to activities undertaken for pleasure. In psychoanalytical terms, he sees the puritan as dominated by a tyrannical super-ego.[129]

Fairbairn agreed with Freud's view that the dream is a product of unconscious trends which are repressed. Because they are repressed this unconscious material is denied both direct expression in action and also direct access into consciousness. The repressed urges exist in fantasies which are also repressed except in the content of dreams where they achieve expression.[130] Fairbairn argued that Freud saw the primary function of dreams as providing a means of expression for the repressed urges and that this resulted in a reduction of psychical tension. He then pursued an analogy between the work of art and the dream, arguing that both perform a similar function. He stated that art works must be regarded as essentially unconscious in their character: the making of an image 'precedes' the emergence of the creative fantasy into the artist's consciousness, and the creative fantasy which emerges is thus analogous to the manifest content of the dream. 'It is through the agency of art work that the repressed fantasies of the artist, in the form of manifest content, are placed at his conscious disposal for embodiment in works of art'.[131]

For Fairbairn, the conscious disposal of such manifest content is analogous to the process of 'secondary elaboration' which Freud ascribes to the conscious mental activity of the dreamer. Therefore, the repressed urges can obtain some outlet and satisfaction in the making of an image without unduly disturbing the equanimity of the artist.[132]

Fairbairn also made reference to the quality of art work. He argues that if there is a pressure of repressed urges combined with weakness of repression then the quality of the art work will suffer. He made reference to the avowed aim of the Surrealist movement to break down the barriers existing between the unconscious and the outer world, arguing that the 'comparative poverty' of much of the Surrealists' work substantiates his view.

A priori interpretative approaches

One of the founder members of the British Association of Art Therapists, a Scot by the name of R.W. Pickford (later Professor of Psychology at the University of Glasgow), was a Freudian. He had become interested in art therapy in the early 1930s. He had become intrigued by an image submitted to him by one of his psychology students, and discussed the work with the student as representing aspects of his personality and problems.[133] His interest in art therapy deepened after he attended a lecture by the late W. Ronald D.F. Fairbairn to the Scottish Branch of the British Psychological Society, in Glasgow in 1937. In this lecture, Fairbairn presented an interpretation and analysis of several modern paintings, including works by Surrealist artist Salvador Dali.[134]

Ralph Pickford

Pickford's interest in art therapy developed as part of a wider interest in visual perception which was characteristic of many psychiatrists and psychologists in this period. This interest in neuroscience within psychiatry in particular provided the impetus for experiments and heightened interest in art. Indeed, Pickford had not regarded himself as an art therapist until he was approached for his articles as examples of art therapy practice.[135] In the 1940s he entered into analysis with Dr Winifred Rushforth in Edinburgh and, as part of this analysis, he produced images which he took along to sessions.

Working with Dr Rushforth in Edinburgh in the 1940s at the Davidson Clinic was an artist who was also a psychotherapist by the name of Miss Romanes. Pickford noted, 'They didn't really consider themselves art therapists, they were just psychotherapists who were using art materials as a bridge in the process of psychotherapy...'[136] Indeed such therapists generally regarded themselves as analysts who were using art works as an adjunct to a verbal analysis; the term 'art therapy' was not used amongst analysts to describe their work using art materials. Margaret Romanes had undergone psychoanalysis with Rushforth, who (several years after her training analyst retired) was the only practising psychoanalyst working in Edinburgh. Romanes had not therefore completed a full psychoanalytic training.[137]

Pickford was later a founder member of the Scottish Society for the Study of Art and Psychopathology in the 1970s. Established in 1970, this was a small talking shop for a few psychiatrists and others (such as art therapist Joyce Laing) who had an interest in the subject. The association was aptly

named, as this group of people were particularly interested in the notion of art works evincing disease, particularly sexual conflicts, which were perceived and described in Freudian terms.

It is clear from Pickford's writings that he believed psychological information about the subject to be evident in the picture. In his later work he attempted to make generalisations about the way materials were used to indicate psychological states. For example: 'painting spread all over the page' is seen as evincing 'general immaturity' in some children but in others an 'assertive and self-reliant personality'.[138] There is still a subjective assessment taking place despite his attempts at categorisation.

Pickford often got his patients to paint and draw pictures which he then analysed. Furthermore, Pickford also suggested that pictures already produced, to which the patient could free associate, provided both an opportunity for therapy (through a process of regression and integration of repressed material) and diagnosis. The pictures, he argued, could be interpreted to illustrate unconscious conflicts. He presented these findings to the British Psychological Society Scottish branch in 1958.

It is worth giving a detailed example of his work, as it represented one strand of thinking which influenced art therapy and provides a particularly clear example of dogmatic interpretation. Here is an example of a child's response to a picture at the Notre Dame Child Guidance Clinic in Glasgow:

> The child didn't know what a key was, but put the bright thing in her bag, and when they came home her mother couldn't find the key, but a big dog came and knocked her down and the key fell out and the door was opened.

His interpretation reveals:

> ...a complex system of conflicts, including resistance at the phallic level against the father's sexuality, which is expressed in the fantasy that the little girl did not know a key. This is a defence by unconscious denial. It is coupled, however, with the wish to rob the mother of the father's penis by putting the unknown bright object into her own bag or womb, and guilt over the wish... The dog is the punitive super ego.[139]

Another story told by a different child, a girl, about another picture in the series follows: 'This little boy stole apples from the farmer's orchard and was chased, but escaped only to have a tummy-ache. So he never stole apples again.' On the face of it a simple moral tale against the perils of theft. Pickford's interpretation of this finds the child:

stealing the father's apples – his sexuality... Stealing apples has a repressed genital meaning, and 'tummy-ache' as its consequence in the form of a fantasy of incestuous pregnancy... The wish to rob the father of his sexuality is also a wish to swallow his sexual organs. Instead of being fully displaced to the vaginal form of swallowing, which would be normal for a girl... Her enuresis was an unconscious expression of the wish for masculinity.[140]

His second interpretation finds the subject 'trying to be boyish'. However, the principal actors of most adventure stories in this period were boys. The third person singular pronoun was conventionally 'he'. There is no attempt made by Pickford to access the effects of cultural norms upon his subjects. All of the interpretations have a monotonously similar quality usually involving some aspect of penis envy with female patients or Oedipal dilemmas with boys. Such a reductive and dogmatic response to imaginative story telling or art work is by no means typical of art therapy practice either in the period under discussion or in contemporary art therapy practice.

Ernst Kris

Historical circumstances in which images are made.

Another psychiatrist, Ernst Kris (1900–1957) became interested in the psychoanalytic investigation of art because of the influence of a medical student, Marianne Rie (1900–1980), whom he later married. He went into analysis with Helene Deutsch (1884–1982) and later trained as an analyst at the Vienna Institute of Psychoanalysis. He began to practise as a psychoanalyst whilst also working as a curator and publishing works on the history of art.[141] As a Jew he was forced to flee his curatorial post at the *Kunsthistorisches Museum* when in March 1938 Vienna was occupied by the Nazis.[142]

Kris had wide intellectual interests and published psychoanalytically based articles over a twenty-year period prior to the publication of a collection of essays under the title *Psychoanalytic Explorations in Art* (1953) by Yale University Press.[143] In his introduction, and quite possibly as a reponse to H.G. Baynes and other Jungians, Kris emphasised the importance of the historical circumstances in which images are made which 'both limit and determine the artist's mode of expression'.[144]

Kris argued that the Freudian system of psychoanalysis was opposed to simplification. He identifies three main areas in which psychoanalysis has contributed to the study of art:

1. in identifying the 'ubiquity' in myths and literary tales of certain themes known from or related to the fantasy life of the individual

2. in the close relationship between the artist's life history (in the psychoanalytic sense) and the work produced

3. in a relationship between the creative imagination, the productive capacity of humans and thought processes.[145]

On the first point, that of mythological themes, Kris pointed out that interdisciplinary research was required to ascertain how traditional themes vary under specific cultural and socio-economic conditions.[146]

On the second theme, that of links between the psyche and artistic works, he argued that patterns of conflict and their solution or their defence may influence the thought processes which form dreams and artistic creations. He argued that in most cases such investigation remains imprecise, but that with psychoanalysis it is possible to identify the motivation of the individual, or how certain predispositions developed.[147] Pertinent to current art therapy practice was his argument that psychoanalytic procedure does not accept a division between form and content. He suggested a value in establishing an interrelation.[148]

Kris believed that the artist has a capacity for gaining easy access to 'id' material without being overwhelmed by it. As well as this, he saw the artist as able to retain control over the primary processes, and having the ability to make rapid shifts between levels of psychical function.[149] He noted Freud's hypothesis (of 1917) that there is a 'certainly flexibility of repression' in the artist.[150] However, Kris argued that these characteristics are not confined to the artist but are shared with 'those conditions in which the id impulses intrude upon the ego and this leads to the question of the extent to which pathological dispositions may be part of what constitutes the artist'.[151] He justified this train of thought citing Freud's (1905) view that a 'considerable increase in psychic capacity results from a predisposition dangerous in itself'. Kris agreed with Freud's concept that protection against these dangers lies in the ego's capacity for sublimation.[152]

It is clear from his writings that Kris supports Freud's view that the artist is not far from being a neurotic. Freud felt that the artist has an introverted disposition and is urged by 'instinctive needs which are too clamorous'. The artist uses his 'unsatisfied longing' and his 'libido' on the creation of his wishes in fantasy. Freud wrote that the artist knows how:

to modify them [his fantasises] sufficiently so that their origins in prohib-
ited sources is not easily detected. Further, he possesses the mysterious
ability to mould his particular material until it expresses the idea of his
fantasy faithfully; and he knows how to attach to this reflection of his
fantasy life so strong a stream of pleasure that, for a time at least, the
repressions are out-balanced and dispelled by it. When he can do all this,
he opens out to others the way back to the comfort and consolation of
their own unconscious sources of pleasure, and so reaps their gratitude
and admiration; when he has won through fantasy – what before he
could only win in fantasy, honour, power, and the love of women.[153]

Kris's view appeared to correspond with the above quote, since he saw art as
acting, as a form of sublimation for the unsatisfied instincts of the artist. He
also agreed with Freud that the energy that goes towards producing art may
be sexual in its nature.[154] Given that Freud described 'love of women' as a
reward for the artist he clearly saw the role as being a masculine one.

Kris regarded the sublimation in creativity as having two main character-
istics: '…the fusion in the discharge of instinctual energy and the shift in
psychic levels'.[155] He argued that a degree of energy neutralisation (through
sublimation in the creative activity) provides favourable conditions for the
fusion of libidinal and aggressive energy and hence 'for a mastery of even
particularly intense instinctual demands'.[156] In other words, making art can
act as a defence against neurosis.

He concluded that specific forms of psychopathology are linked with
certain creative professions. Thus the actor may have problems linked with
rapidly changing identification, and the dancer problems with exhibition,
and so on.[157] However, he didn't rule out the possibility of wish fulfilment
and argued that these tendencies merge with wishes rooted in the person's
history. Artistic success in his view is dependent on the degree to which the
activity has become 'autonomous' or 'detached from the original conflict
which may have turned interest in to a specific direction'.[158] The creative
activity may have an autonomous role in the ego or alternatively it may be
serving as a defence in a mental conflict. Therapy in Kris's view may bring
about a detachment of creative ability and the urge to create from immediate
conflict involvement.[159] So Kris did not see therapy as necessarily destroying
the creative impulse except in those cases where creativity was the direct
result of a mental conflict. Certain gifted artists in what he called 'higher'
artistic activity are predisposed to detachment from conflicts – in other words
non-psychopathological art is thought to be possible and the preserve of 'a

selected few'.[160] He argued that the study of such artistic gifts should be in relation to the conflict in which they may have been rooted and from which they emerge, but also in relation to the structure of the activity itself.[161] Generally, he saw those artists whose creative capacities are close to potential pathology as being more attracted to romantic than classical themes.

Kris did not see power, honour and the love of women as the only motive for creative endeavour. But he did stress the importance of artistic 'acknowledgement', which seems to be a slightly toned-down version of Freud's view. Unlike the psychotic who is overwhelmed by the primary processes, the artist harnesses the primary processes and produces a narcissistic shift to the art work. Kris stressed the communicative aspect of art-making. He saw two levels of communication operating in the making of an art work. First, the 'id' communicated to the 'ego' and, second, the art work revealed these processes to the outside world. On looking at an art work the viewer experiences a shift in psychic levels similar to that experienced by the artist during the making of the piece; Kris called this process 'unconscious identification'.[162]

Kris provided a more sophisticated application of Freud's ideas to the art than that developed by Pickford. However, he, like Freud, viewed art negatively as evincing disease, and in terms of a dogmatic schema. Kris was aware of the work of Margaret Naumburg (1890–1983) in the USA and the role of the art therapist. However, since his ideas were primarily concerned with the application of psychoanalytic ideas to art works, rather than with developing models of art therapy, Kris's work had relatively little influence on the first generation of art therapies.

Grace Pailthorpe

A medical doctor, Grace Pailthorpe[163] had an interest in British Surrealist art and in the mid-1930s had collaborated with a young artist, Reuben Mednikoff, who made paintings which Pailthorpe then analysed.[164] Her approach differed slightly from that of Pickford in that her interpretations were made according to object relations theory, focusing on Mednikoff's feelings towards her as a symbolic mother figure.[165]

Pailthorpe claimed in 1938 that a series of 'scientific' experiments, carried out by Mednikoff and herself, demonstrated the therapeutic value of Surrealist art. She believed that psychoanalysis and Surrealism shared the common aim of freeing the individual of conflict. The artistic productions made, she opined, not only evinced unconscious fantasy but were quite 'in-

telligible'.[166] The result of such art-making allowed the individual to function more freely. Painting in a traditional manner is equated with 'early enforced restrictions on the infant's excretory functions' which, she argued, inhibits the development of fantasy life. In her view, traditional art conformed to 'parental wishes' and lacked vitality. Free painting (that is, Surrealist painting), in contrast, allowed full expression to excretory fantasy including 'the making of a mess or a diarrhoea' and consequently freed the imagination repressed by the associated inhibition.[167]

Pailthorpe presents a number of pictures including the following description:

> This drawing of a man having his eye gouged out has in it the wish to get into the father... The reason for the need for flight is also stated in the picture. The man's tongue is torn out by his own teeth, in a disapproval of himself. The drawing is expressing fear... And so a hole is bored into the man and a hideout is found in his body. The act portrayed by the infantile unconscious, about which this fear has arisen, was that of stealing milk from the mother.[168]

Basically here Pailthorpe attempts to ascribe a theoretical formulation to the art work. The interpretation is fanciful and there is meagre evidence, in terms of pictorial content, for it. The image depicts an assault, but the severed tongue could equally well be 'read' as blood issuing from the mouth. Likewise, the image does not reveal a desire for flight or indeed mother's milk.

Of another picture Pailthorpe says:

> The unconscious fantasy-picture depicts the artist as a child... The house is a symbol of mother. He has stolen the ball, a breast symbol, and the father tree is after him to punish him for the theft. The branch projecting from the tree in the direction of the ball is the father's hand stretching forward to feel the breast-ball to see if he, the child, has damaged it... [169]

Again this interpretation bears little to the pictorial content. Pailthorpe's assertion that 'every mark, shape and colour is *intended* by the unconscious and has its meaning' certainly has implications for art as therapy.[170] However, her assertion that 'making a mess' will bring happiness to all humanity is problematic. The 'scientific' value of this sort of analysis is also extremely doubtful.

Pailthorpe's approach has been criticised by Paul Ray (1971) in his scholarly analysis of the development of Surrealism in England, in which he points out her misunderstanding of Surrealism:

It is obvious that in her demonstration of the scientific aspect of Surrealism, the picture has been reduced to the level of a symptom, and psychoanalysis to the level of simple equation-making...what is puzzling in her approach is her view of psychoanalysis; one can agree with her statement that psychoanalysis 'strives to free the psychology of the individual from internal conflict,' but not with her contention that the goal of psychoanalysis, like that of Surrealism, is 'the liberation of Man'... It is clear from even the most cursory reading of Freud that the whole purpose of his therapy is to reconcile Man to the demands of reality, not to free him from these demands. *It is precisely on this point that the Surrealists had parted company with Freud*... Some of the analyses she supplies are so facile that one wonders whether the pictures were not painted for the sake of the analysis. (Ray 1971, pp.220–221. Italics added for emphasis.)[171]

The type of work carried out by Pailthorpe is not very different from dream analysis carried out by B. Dattner (1911), which Freud reproduced in a revised edition of *Interpretation of Dreams*. Pailthorpe's is a slightly more complex version using neo-Freudian theory, but shares with Dattner and Pickford a reductionist tendency.[172] Her work is fundamentally banal and

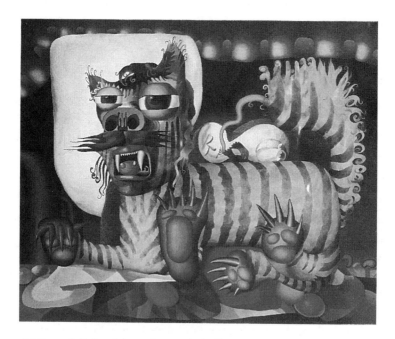

Figure 3.3 Bengal Colonel *by Reuben Mednikoff 1945–1947*

simplistic, with the pictorial content of the art work being subject to dogmatic interpretation.

Figure 3.4 Grace Pailthorpe. Undated photograph c.1938

Images as diagnostic tools

Susan Bach

A pioneer of art therapy in Britain, Susan Bach (1902–1995) was energetic in the early informal meeting which took place prior to the formation of the British Association of Art Therapists.[173] She was also involved in the early art therapy working parties which met in the 1950s to discuss professional issues, such as the development of and requirements for art therapy training.

Her influence on early art therapy was very strong. For example, she was a consultant to doctors Reitman and Cunningham Dax at Netherne Hospital in Surrey, where one of the first full-time art therapy appointments was made (that of Edward Adamson).[174] It is possible that Bach influenced

Cunningham Dax's research approach to art therapy. Interest arose within psychiatry in the art of the mentally ill as part of increasing medical interest in neuroscience, visual perception, and the reception of images to the brain. At Netherne Hospital, pictures were viewed as giving information about 'fundamental disturbance' and information about the progression of an illness. Edward Adamson worked using standard conditions capable of being reproduced elsewhere for research purposes. The research conducted by Cunningham Dax represented the first rigorous attempt in British psychiatry to ascertain the usefulness of art as therapy.

Susan Bach (nee Michaelis) was born on 13 June 1902 in Berlin, the second child to a Jewish doctor and his wife. Hasidism was always important to her. The household to which she was born was intensely musical, and this may have been an influence in her later decision to work as an art therapist.[175] Bach commenced a medical training but was adverse to certain aspects of the work, particularly dissections, and abandoned her medical training.[176] She

Figure 3.5 Oil painting by Reuben Mednikoff to which Pailthorpe is referring, 19 September 1935

then took quite a different career path, pursuing studies in gold- and silver-smithing and the expanding science of crystallography.[177]

By the 1930s she had married and entered into a Jungian analysis. It was around this time that she first met C.G. Jung. It was Jung who introduced her to Toni Wolff (Irene Champernowne's analyst and one of Jung's closest associates), with whom she maintained a lasting friendship until Wolff's death in 1953.[178]

When Hitler came to power in Germany it was to her former analyst Wü that she and her husband, Hans, turned to for help. The Bachs arrived in Britain in 1939 with virtually no possessions save a trunk they managed to post via Holland. In England, Susan worked in a Quaker home as a housekeeper, while Hans (formally an editor and concert pianist) found employment as a handyman. Hans was then interned on the Isle of Man, while Bach, drawing on her husband's anti-Nazi writings, campaigned for his release.[179]

Bach went on to work for the Jewish Refugee Association before embarking on her career of hospital work and private practice as a Jungian analyst.[180] By her own account, she became interested in 'spontaneous drawings' as early as 1936. She noted finding a discarded doodle produced by an 'uprooted' nine-year-old evacuee. This picture gave her an understanding of the child's 'inner conflict'.[181]

Bach described her therapeutic interest in the use of painting as extending from the private consulting room of a Jungian analyst to the broader basis of mental hospitals. It was in 1947 that Bach first saw a picture series produced by a psychiatric patient. She immediately realised the potential of looking at a succession of images. She wrote: '…not only the mental and psychological state was reflected but also the condition of the body'.[182]

Shortly after Edward Adamson's appointment at Netherne Hospital, Bach commenced a therapeutic painting group conducted over three years at St Bernard's Hospital, Southall, London. This inter-disciplinary group was comprised of 'clinical artists' from ten mental hospitals as well as psychotherapists of various theoretical persuasions, psychiatrists and nurses. She wrote of this experience: 'In the course of our investigation we found specific states of mental illness reflected in definite and recurring colours, symbols and motifs.' The notion of recurring symbolism which has intrinsic *a priori* meanings even across class, race, gender and cultural divides is one that Bach had got from Jung. She wrote that it was Jung's

> discovery that the basic symbols of a universal nature, recurring in differ-
> ent epochs of human history and in civilisations otherwise unrelated to

each other – the Collective Unconscious – are expressed in such sponta-
neous manifestations. This opened up an understanding and scientific
approach to, and evaluation of, such pictures.[183]

This is an aspect of Jungian theory which has been increasingly called into
question in recent debates which assert that the meanings attached to
symbols are historically and culturally specific and subject to changing
'readings' and definitions.

It is possible that Bach's adherence to archetypal Jungian theory set her
apart from other colleagues interested in art therapy, even though many of
them were very interested in Jung's ideas. For example, in 1996 Rita Simon
recounted in an interview with me that at early art therapy meetings Susan
Bach did not seem particularly interested in art therapy as an ongoing
process, but was more concerned with gaining pictures that would then be
handed over to doctors or be interpreted. Her approach therefore was not
typical of Jungian art therapists in this period. Certainly, Bach was aware of
art work as a useful tool in communication between those concerned with a
patient. She wrote that 'the "reading" and evaluation of spontaneous
drawings could be an aid to diagnosis, treatment and early prognosis. It has
also become a means of communication in the doctor–patient–family rela-
tionship, a bridge over which each of them can reach the other'.[184]

Bach was able to earn her living after the war as an Jungian analyst. She
became friends with Culver Barker, an analyst who worked both at
Dartington Hall and at the Withymead Centre as well as in his private
practice in London.

Following the work of theorists such as Fritz Mohr, who tried to connect
certain characteristic types of designs with specific forms of mental illness
early in the twentieth century, Bach's interest in art therapy remained focused
on its use as a diagnostic tool, particularly with those suffering from physical
illnesses, such as cancer. Her book *Life Paints Its Own Span: On the Significance of
Spontaneous Pictures by Severely Ill Children* (1990) contains guidelines on
'reading and translating' such pictures. Though extremely interesting, her
diagnostic and interpretative emphasis was not generally taken up by other
art therapists.

Towards art therapy

Marion Milner

Another analyst, Marion Milner, who in the 1940s wrote an influential book entitled *On Not Being Able to Paint* (published in 1950), told me categorically in an interview that she did not regard herself as an art therapist but as an analyst who sometimes used images as an aid to analytic treatment. Indeed, she felt that images were often subject to over-interpretation in art therapy.

Milner had become interested in using images to explore the unconscious after seeing an exhibition of the work of analyst and painter Grace Pailthorpe and her collaborator at the Guggenheim Jeune Gallery, Cork Street, London in 1939.[185]

Undoubtedly her work was to have some influence on the later generation of art therapists. (Her influence on the work of pioneer art therapist Rita Simon is noted in a later chapter.) In the foreword to the second edition of Milner's book is a description of it written by Freud's daughter Anna:

> It is fascinating for the reader to follow the author's attempts to rid herself of the obstacles which prevent her painting, and to compare this fight for freedom of artistic expression with the battle for free association and the uncovering of the unconscious mind which make up the core of the analyst's therapeutic work.[186]

Milner's accessible writing style and her detective-like way of approaching her subject made the book a success. Indeed, it is still in print, which is testament to its popularity. Milner discovered that painting is concerned with feelings conveyed by space and wrote:

> ...as soon as I did begin to think about it, it was clear that very intense feelings might be stirred. If one saw it as the primary reality to be manipulated for the satisfaction of all one's basic needs, beginning with the babyhood problem of reaching for one's mother's arms, leading through all the separation from what one loves that the business of living brings, then it was not so surprising that it should be the main preoccupation of the painter.[187]

Such sentiments appealed to art therapists, most of whom were trained artists who felt that they were already dealing with profoundly emotional subject matter. The publication of the book also coincided with post-war interest in object relations theory.[188]

Milner met Irene Champernowne of Withymead, who tried to persuade her to train as a Jungian analyst. Milner, however, opted for a Freudian training with the independent school in London. She had a particular interest in child development, and believed that this was better covered in the Freudian training. Milner felt in need of more analysis in the 1940s, as her training had been rushed because of the war. Donald Winnicott offered her analysis with him. However, the situation was complicated by the fact that Milner was already giving analysis to one of Winnicott's patients called Susan. Indeed, Winnicott's wife, Alice Winnicott, herself a painter, had come across art work by Susan at Mill Hill Hospital and had been much impressed with it. Donald Winnicott was experimenting at this time with the idea of 'environmental treatment' and, with his wife's encouragement, invited Susan to live with them in their home in Hampstead. Alice became very fond of Susan (they had no children). However, soon after the arrangement was made the Winnicotts' marriage began to break up. This and the effects of the ECT Susan had opted to take brought things to a breaking point. Milner said:

> ...the marriage broke up, it sent Susan round the bend... I couldn't stand this. I couldn't stand analysing her while she was breaking down because of him [Winnicott] and him analysing me.[189]

The surprising thing is that Milner made it clear that she did not know very much about art therapy although she had strong views on the subject. (She asserted that she agreed with the art therapist Martina Thomson that too much analysis of the images was being done by some art therapists.) Indeed, Milner had changed her view on the matter of interpretation since the writing of her influential books. She agreed to become Honorary President of the British Association of Art Therapists (BAAT) succeeding Adrian Hill in this title.[190] She said of her relationship with BAAT, 'I don't do anything for them or with them but they use my name'.[191] Clearly, she was sympathetic to the aims of art therapy to allow this.

Margaret Naumberg

A rather different approach was taken by Margaret Naumberg. An American, she lived most of her life in the USA. However, she lived briefly in Britain, studying at the London School of Economics, where she came into contact with the social reformers Beatrice and Sydney Webb.[192] She is particularly significant to the British context because her book *Schizophrenic Art: Its*

Meaning in Psychotherapy (1950) became well known in British art therapy circles after 1955.[193]

Although a Freudian, Naumberg was also sympathetic to the work of Jung.[194] Her text is significant for its 'survey of the significance of psychotic and neurotic art'. Although she makes reference to the work of Max Simon and Lombroso, she ignores Lombroso's elucidation on the nature of symbols, preferring Freud's theorisation. She asserted that clinical studies into such art work 'only became possible after Freud's exploration of the unconscious offered clues to the *nature of sexual and archaic symbolism*'.[195] However, she pointed out that psychoanalytic studies of art had been 'explanatory rather than therapeutic'.[196]

Figure 3.6 Marion Milner

Naumberg sought to create an art therapy practice which was founded in psychoanalytic theory. She had discovered this way of working from Nolan Lewis who she claims was the first psychiatrist in the USA 'to employ analysis

of the art productions of patients either singly or in a series, as an *adjunct to psychoanalytic therapy*.[197] Naumberg was keen to embrace this way of working as her own, laying emphasis on 'communication by means of visual symbols.'[198] She delineated her approach in some detail, agreeing with Ernest Jones (1923) when he wrote:

> Only what is repressed is symbolised; only what is repressed needs to be symbolised. This conclusion is the touchstone of the psychoanalytical theory of symbolism… Symbolism arises as the result of intrapsychical conflict between the repressing tendencies and the repressed.[199]

Naumberg makes a direct analogy between Freud's theory of symbol formation in dreams and the symbols that appear in the art work of her patients:

> Freud, throughout his writings, developed his approach to symbolism upon the forms of dream-image discoverable in the unconscious. The translation of such symbols, which were originally visual, into verbal expression by the patient, became a basic element of psychoanalytic therapy.[200]

Naumberg went on to note that these 'archaic symbols' appear first as visual images. The role of art psychotherapy, like that of psychoanalysis, she saw as translating these images into words. However, unlike the psychoanalyst, she saw her role as helping patients to express themselves verbally, rather than to dispense interpretations. Finally, and in contradiction to an orthodox Jungian approach, she saw symbolic expression as 'limited to concrete ideas concerning the personal life of the patient, which…act as a substitute for direct verbalization'.[201] This indicates, I feel, that Naumberg was not interested in attempting to apply the idea of 'archetypes' to her work, and also a belief that not everything that can be pictured can necessarily be expressed in words, even though this was her stated goal.

Like Lombroso and Freud, Naumberg saw unconscious symbolism as a more 'primitive' form of expression 'evoking images which preceded words'.[202] The aforementioned negative connotations attached to symbolism are therefore evoked in such an approach.

Although her method is broadly similar to that of Pickford, in that she is using 'art therapy' as an adjunct to psychoanalytically based psychotherapy, there are important differences between their approaches. First, Naumberg took issue with orthodox psychoanalysis and argued 'That the inner meaning of a symbol or image is not communicable by verbal explanation', a

view she shared with analytic (Jungian) therapists. Naumberg understood 'a symbol to be an image or construction which reaches into dimensions beyond the intellectualised grasp of speech'.[203] Therefore, unlike Pickford and Pailthorpe, she did not interpret her clients' work, believing instead that 'some patients do not immediately recognise the significance of their spontaneous art; but as it proceeds they usually arrive at awareness of its symbolic meaning. This is the reason that it is unnecessary for the therapist to interpret directly to the patient what his spontaneous actions mean'.[204]

Naumberg's work is particularly significant in providing a model of clinical practice which art therapists could use, and her work was highly influential in the USA. In Britain, however, this type of art therapy, rooted in psychoanalytic theory, did not become the dominant style in the period under discussion.

Conclusion

The idea of a 'primitive mentality' emerged during the nineteenth century. This was characterised by its primitive characteristics, namely those which were attributed to so-called primitive peoples (and other social groups thought to have similar qualities including women, children, the mad, and the improvident Irish). Such characteristics included lack of self-restraint, particularly lack of sexual restraint, and volatility of nature.

In Lombroso's view, this savage or primitive mentality was evident in large sections of the population (including the insane, the gifted and criminals), and, in Freud's view, it was evident in all people (though he believed that it could be more or less successfully repressed, through the influence of society's civilising processes — the development of rationality and learned behavioural rules). In both the work of Freud and Lombroso there is an emphasis on this primitive mentality being expressed through pictorial symbolism. Both models of thought point to visual images as pathological and Freud's followers (notably Kris and Pickford) represent slightly different ways of applying his theories (Pailthorpe's work is very similar to that of Pickford in approach but used neo-Freudian theories). These approaches did not have a significant influence on the development of art therapy practice.

Although a trained Jungian analyst Susan Bach's approach was influenced by a broad range of theory, in particular by the work of Fritz Mohr. Hers was not an approach to which art therapists were particularly sympathetic, as she was not interested in the ongoing production and analysis of art works. Her

method of furnishing interpretations of art works did not become a norm within art therapy.

Psychoanalysis was to have some influence on art therapy via the object-relations school, and the work of Marion Milner was certainly to have some later influence (it was *de rigueur* to read Milner by the time I trained as an art therapist in the mid-1980s). However, Milner repudiated the label of 'art therapist' and saw herself clearly as an analyst who used art work as an adjunct to psychoanalysis.

I have argued that to regard images as evincing pathology, rather than as healthy expressions of individual emotions, had negative implications not just for art therapy but for the reception of modern art in general. Had this 'pathological' or 'psychopathological' approach become the dominant theoretical model in British art therapy we would have expected to see a strong emphasis in the use of art for diagnostic purposes (with art works seen as evincing particular forms of illness), as well as the dispensation of interpretations of art work by art therapists as the norm within the therapeutic encounter.

The most influential application of psychoanalytic theory to art therapy practice was that developed by Margaret Naumberg, though it is clear that she used some of Pfister's ideas as a basis for her theory. I have noted that in terms of psychoanalytic theory her approach was not entirely orthodox, since she rejected the idea that it was desirable or possible in all cases to translate visual images into words.

Notes

1 Jones 1980, p.2.
2 Kuper 1988, p.2.
3 Rousseau 1993.
4 Pfister 1922.
5 Kris 1952.
6 Chamberlin and Gilman 1985, p.290.
7 Henry Smith Williams MD 1910, p.408(d).
8 Chamberlin and Gilman 1985, p.290.
9 Jones 1980, p.103.
10 Stocking 1987, p.154.
11 Stocking argues that the Bible was a major conditioning influence on the development of social evolutionary thought during the middle of the nineteenth century (Stocking 1987, pp.11–12).
12 Gould 1985, p.39.
13 Stocking 1987, p.12.
14 de Gobineau 1854, pp.24–25.
15 de Gobineau 1854, p.107.
16 de Gobineau 1854, p.33.
17 Gould (1981, p.115) argues that recapitulation was particularly influential in biological determinism. In this model of thought the adults of inferior groups were seen as being like the children of superior groups,

for the child represents a primitive adult ancestor. Blacks and women were viewed as living representations of an ancestral stage in the evolution of white males by many nineteenth-century theorists. Such ideas were challenged by writers; for instance, by Havelock Ellis.

18 Stocking 1987, p.230.

19 Crook argues that such ideas were not new with Darwin's work, pointing out the longevity of the myth of the 'beast within' sustained by the classical tradition, and originating in the work of Plato (Crook 1994, p.8). However, Crook argues that such ideas were given fresh impetus by works such as Darwin's *The Descent of Man* (1871) and *The Expression of the Emotions in Man and Animals* (1872).

20 Engels cited in Stocking 1987, p.12.

21 W.R. Greg in *Fraser's Magazine*, cited in Jones 1980, p.102.

22 The 1904 Committee on Physical Deterioration argued for voluntary restraint on population growth amongst the working classes (Jones 1980, p.103).

23 Jones 1980, p.103.

24 Stocking 1987, p.220. Stocking suggests that to Victorian intellectuals evolutionary thinking provided a resolution to the dilemma of social inequalities. This point is agreed by Gould (1981, p.21) who sees biological determinism as justifying the status quo as an extension of nature.

25 Goldstein 1993, p.1363

26 Showalter's excellent analysis of the writings of nineteenth-century psychiatrists illustrates that 'the insane temperament' (as Maudsley called it) was becoming more subtle in its appearance as psychiatrists turned their attention towards 'incipient lunatics' or those with 'latent' brain disorders. Only the trained specialist was able 'to patrol this mental and sexual frontier…saving society from their dangerous infiltration' (Showalter 1985, p.105).

27 The eugenics movement emerged from the work of Francis Galton, who was a Lamarckian.

28 Gould 1981, p.326.

29 Indeed, Darwin himself was wary of using terms such as 'higher' or 'lower' implying progress up or down an evolutionary ladder (Crook 1994, p.10). However, Crook is more critical of Darwin's work than Gould, pointing out that 'elements of natural theology (which was teleological) persisted in his thought, and much of his language was reminiscent of the Victorian 'doctrine of progress'. Thus Crook argues that 'Darwin raised the alarm taken up by eugenists and degenerationists, that advanced societies risked decay because they over-protected the weak, the poor, building asylums for the imbecile and sick, keeping alive those with poor constitutions…' (Crook 1994, p.10).

30 Kuper 1988, p.2.

31 Stocking 1987, p.154.

32 Gould 1981, p.113.

33 Kuper 1975, p.92.

34 Stocking 1987, p.187.

35 Kevles 1985, pp.37–8. Galton's ideas differed from those of Lombroso in that he believed that the aristocracy in Britain contained the seeds of genius (Kevles 1985, p.9). He firmly believed that no education or training could create intelligence and that it could only be bred (Kevles 1985, p.34). Galton was elected honorary president of the National Eugenics Society which was founded in Britain in 1907.

36 Galton cited in Jones 1980, p.100.

37 Jones 1980, p.101.

38 Kevles 1985, p.71.

39 Jones 1972, p.225.

40 Haddon 1895, p.9.

41 Haddon 1895, p.9.

42 Haddon 1895, p.131.

43 Haddon 1895, p.140.

44 Douglas 1980, p.21.

45 Haddon 1895 cited in Douglas 1980, p.21.

46 MacGregor 1989, p.93.

47 Gould 1981, p.123.

48 MacGregor 1989, p.93.

49 Lombroso in Ferrero 1911, p.xii.

50 Lombroso in Ferrero 1911, p.xvi.

51 Lombroso citing the work of Max Simon 1876 in Lombroso 1891, p.181.

52 Lombroso 1891, p.29. He gives spurious examples such as Beethoven's forgetfulness or Mozart's inability to carve meat without cutting himself as evidence of their degenerated state. Dr Johnson's compulsive desire to touch each post he passed is a more convincing example of a neurotic tendency.

53 MacGregor 1989, p.94.
54 Lombroso 1891, p.181.
55 Lombroso 1891, p.182.
56 Lombroso 1891, p.181.
57 Lombroso 1891, p.205.
58 Lombroso 1891, p.181.
59 Lombroso 1891, p.190.
60 Lombroso 1891, p.190.
61 Lombroso 1891, p.191.
62 Nordau cited in the Encyclopaedia Britannica 'EB', p.739.
63 Lombroso 1891, pp.359–360.
64 Gilman 1993, pp.1033–1034.
65 Forrester 1980, p.73.
66 Forrester 1980, p.80.
67 Forrester 1980, p.77.
68 Freud, *Interpretation of Dreams*, 1977 edition, pp.469–470.
69 Freud 1977, p.280.
70 Freud 1977, pp.470–473.
71 Freud 1977, pp.763–768.
72 Freud, Standard Edition, XI: 158, cited in Forrester 1980, pp.97–98.
73 In Freud's *Studies in Hysteria* (1895), he attributed hysterical symptoms to real events, memories of sexual seduction, which were forgotten by the conscious mind but retained on another level within the psyche. However, by 1897, Freud had revised his views on the origins of neurosis. He postulated universal psychological drives, including sexual fantasies, which were not linked to a real event but imagined. In particular, repressed incestuous desires experienced in childhood were both hidden in, and emanated from, the unconscious mind (Gilman 1993, pp.1033–1035).
74 Wallace 1983, p.22.
75 Freud 1900, p.343 cited in Wallace 1983, p.26.
76 Wallace 1983, p.12.
77 Freud 1963, p.167.
78 Freud 1963, p.167.
79 Freud 1916–1917, p.371 cited in Wallace 1985, p.35.
80 Stocking 1987, p.199.
81 Stocking 1987, p.225.
82 Stocking 1987, pp.202–203.
83 Written at the time that Jung was interested in National Socialism: 'Picasso' in *Collected Works*, Vol. 15, 1966, pp.135–139.
84 Nordau 1895, pp.vii–viii.
85 Chamberlin and Gilman 1985, pp.290–291.
86 Chamberlin and Gilman 1985, p.291. Roger Fry through publications on primitivism in the first and second decades of the twentieth century helped to make primitive objects the focus for an emerging modernist aesthetic (see Torgovnick 1991, p.87).
87 Translated as 'Degenerate Art'. This exhibition was to provoke a counter exhibition at the New Burlington Galleries in London in 1938 of modern German painting.
88 Chamberlin and Gilman 1985, p.292.
89 MacGregor 1989, p.33 describes the famous 'Degenerate Art' exhibition, and cites Hitler on page 238.
90 MacGregor 1989, p.242.
91 MacGregor 1989, p.240.
92 Kevles 1985, pp.116–118.
93 Stocking 1987, p.292.
94 Maghull Hospital near Liverpool gave training for the treatment of psychoneurosis between 1917 and 1919 to sixty-seven officers including W.H.R. Rivers (1864–1922). Rivers is cited by Pines (Pines 1991, p.215) as describing the hospital as 'a society in which the interpretation of dreams and the discussion of mental conflicts formed the staple subject of conversation'. According to Berrios (1991, p.254) this interest helped to domesticate psychoanalysis to a British audience. Shell shock convinced many beyond any doubt that the aetiology of nervous disorders was not that of repressed sexuality.
95 Rose 1990, pp.20–21.

96 Slater 1946 cited in Rose 1990, p.231.
97 MacCormack 1993, p.1441.
98 Hutton 1960, p.128, cited in Pines 1991, p.208.
99 Henderson 1964, p.254. In 1932 David Kennedy Henderson was appointed Physician Superintendent of the Royal Edinburgh Hospital for Nervous and Mental Diseases and Professor of Psychiatry at the University of Edinburgh.
100 Pines 1991, p.219.
101 Berrios 1991, p.233.
102 The proceedings of the committee are described by Dr Hutton, who is cited by Pines (1991).
103 Dr H.V. Dicks 1970 cited in Jones 1972, p.272.
104 The Tavistock Clinic worked using psychodynamic principles and used interdisciplinary teams. Set up in 1920 as a private clinic, it became part of the National Health Service in 1945.
105 A list of staff is provided by Jones 1972, p.272.
106 Mapother 1927–31 report, cited in Pines 1991, p.225.
107 Pines 1991, p.226.
108 Gilman 1993, p.1042.
109 Rose 1990, p.164.
110 Rose 1990, pp.165–167.
111 Denise Riley's (1983) interesting book on wartime nursery provision makes the point that Bowlby's work argued as innate what was prominent and controversial public policy at the time. In other words, the post-war government was committed to close down public nurseries even in the face of public opposition. There was a mass movement of women out of the 'public sphere' and back into the home.
112 Professor Kathleen Jones (1972) identified one text in particular as having been particularly influential in the post-war period. This was research instigated by the clinical director of the Maudsley Hospital (Dr Aubery Lewis) and published as *Neurosis and Mental Health Services* by Dr C.P. Blacker in 1946. The book identifies widespread prejudice against psychiatry amongst general practitioners (GPs) and particularly psychoanalytic work, which was considered to be a decadent fad.
113 MacGregor 1989, p.247.
114 Pfister 1922, p.64.
115 Pfister 1922, p.181.
116 All dreams are fulfilments of wishes (Freud 1977, p.179). In the psychoanalytic approach the motive force of dreams is seen as wish fulfilments which are derived from infantile sexual impulses. Because of the psychical censorship to which they are subject during the process of their formation, the wishes in dreams may not be immediately evident – they may be 'repressed'. The symbolic form of wishes arises out of a necessity to evade censorship, and several ideas may be condensed into one symbol (Freud 1977, p.746).
117 Pfister 1922, p.182.
118 Pfister 1922, p.184.
119 Pfister 1922, p.186.
120 Pfister 1922, p.186.
121 Pfister 1922, p.187.
122 For example, Maria Petrie had read widely and was aware of the work of Pfister, Prinzhorn, Rudolph Steiner, Jung and Baudouin. However, other pioneers of art therapy, such as Rupert Cracknell, came across art therapy through reading an article on art therapy in newspapers or popular magazines and were not well read in the psychiatric literature on art, though Rupert was aware of some of Freud's work when he started his art therapy career.
123 Klein 1989, p.24.
124 Klein 1989, p.22, my italics.
125 Klein 1989, p.22, my italics.
126 Klein 1989, p.59.
127 Walmsley (1991, p.302) argues this point. This eclecticism was also the impetus for Winifred Rushforth to open the Davidson Clinic for psychotherapy in 1940.
128 Gilman 1988, p.223.
129 Fairbairn 1938a, p.292.
130 Fairbairn 1938a, p.293.
131 Fairbairn 1938a, p.294.
132 Fairbairn 1938a, p.294.
133 Waller 1991, p.73.
134 Pickford 1967, p.vii.

135 Waller 1991, p.78.

136 Pickford in interview with Waller 1991, p.78.

137 Rushforth 1984, p.89.

138 Pickford 1972, p.217.

139 Pickford 1963, p.32.

140 Pickford 1963, p.30.

141 MacGregor 1989, p.251.

142 Freud thought that if a woman underwent analysis and her husband didn't that it would cause trouble in the relationship. The implication seems to be that women shouldn't have more insight than their partners. On the face of it this appears to be straightforward sexism since Freud did not make the opposite recommendation (Dr Marianne Kris 1977 in interview with MacGregor 1989, p.251).

143 For a detailed account of his published works see MacGregor 1989, pp.250–270.

144 Kris 1953, p.15.

145 Kris 1953, p.17.

146 Kris 1953, p.18.

147 Kris 1953, p.22.

148 Kris 1953, p.3.

149 Primary processes are non-verbal, non-discursive modes which are imaginative and symbolic.

150 Freud 1917 cited in Kris 1953, p.25.

151 Kris 1953, p.26.

152 Kris 1953, p.26.

153 Freud 1973, p.423.

154 Kris 1953, p.28.

155 Kris 1953 p.28.

156 Kris 1953, p.28.

157 Kris 1953, p.25.

158 Kris 1953, p.29.

159 Kris 1953, p.29.

160 Kris 1953, p.29.

161 Kris 1953, p.29.

162 Kris 1953, p.61.

163 Grace Pailthorpe (b.1890 in London) studied medicine at Cambridge and lived in France from 1922 to 1935. She was also a member of the British Surrealist Group in London after her return from France.

164 Reuben Mednikoff (b.1906) studied at St Martin's School of Art in London. He joined G.W. Pailthorpe in 1935. In 1936 he exhibited with the Surrealists.

165 Maclagan 1995, p.207.

166 Pailthorpe 1938–1939, p.10.

167 Pailthorpe 1938–1939, p.10.

168 Pailthorpe 1938–1939, p.11.

169 Pailthorpe 1938–1939, p.11.

170 Pailthorpe 1938–1939, p.16.

171 Ray 1971, pp.220–221. Italics added for emphasis.

172 'The Male Organ Represented by Persons and the Female Organ by a Landscape.

 ... Then someone broke into the house and she was frightened and called out for a policeman. But he had quietly gone into a church, (i) to which a number of steps (ii) led up, accompanied by two tramps. Behind the church there was a hill (iii) and above it a thick wood. (iv) The Policeman was dressed in a helmet, brass collar and cloak. (v) He had a brown bread. The two tramps, went along peaceably with the policeman, had sack-like aprons tied around their middles. (vi) In front of the church a path led up to the hill; on both sides of it there grew grass and brushwood, which became thicker and thicker and, at the top of the hill, turned into a regular wood.

 i. or chapel (= vagina)

 ii. symbol of copulation

 iii. mons veneris

 iv. pubic hair

v. according to an expert, demons in cloaks and hoods are of a phallic character.

vi. the two halves of the scrotum' (Dattner 1911).

173 She died aged 93 years old on Friday 21st June 1995 at the Royal Free Hospital in Hampstead, London.

174 Dax 1953, p.19.

175 She had also been a keen horsewoman in her youth.

176 Beswick 1995 (unpublished paper).

177 She often wore pieces of jewellery she had designed and made herself which contained stones such as opals, agate or amethysts.

178 Beswick 1995.

179 Beswick 1995.

180 For some of the war years Susan and Hans, and a boy they fostered called Ernest, lived in Wild Hatch in a house which was sparsely furnished save for a grand piano.

181 Bach 1990, p.7.

182 Bach 1990, p.8.

183 Bach 1990, p.8.

184 Bach 1990, p.9.

185 Hogan interview with Milner 1994.

186 Freud, A. 1957 edition of Milner 1950, p.xiii.

187 Milner 1957, pp.11–12.

188 I have suggested that this post-war theoretical emphasis on object-relations was ideologically in tune with the government's desire to get men being demobilised from the armed forces back to work and women back into the home, since psychological problems were conceptualised as stemming from the earliest relations between mother and infant. Women became morally condemned, under the influence of such theory, for leaving their children and going out to work, even though it is well documented that the children's health in WW2 creche facilities was generally improved by such provision.

189 Hogan interview with Milner 1994.

190 Waller 1991, p.73.

191 Hogan interview with Milner 1994.

192 Born in 1882, Naumberg was educated at Vassar and Barnard Colleges and also Columbia University where John Dewey was teaching. Her son described her living in artistic and literary circles in New York City (her husband Waldo Frank was a writer). She was also influenced by her sister's work as a teacher (Frank in Detre *et al.* 1983, pp.112–113).

193 An exhibition, which I shall discuss further, took place at the ICA in London. The catalogue contained a bibliography which listed her work along with that of Prinzhorn, Petrie, Reitman, Kris, and Herbert Read. Her book, in turn, was influential because it contained a survey of literature: discussed were Max Simon, Lombroso, Fritz Mohr, Prinzhorn, Pfister, as well as works by lesser known writers such as Morgenthaler, Laforna and Pfeifer. As a German speaker she was able to translate texts not available in English at that time, which she did for the purposes of quotation.

194 Both Naumberg and her sister, Florence Cane, underwent analysis with a Jungian-influenced analyst called Beatrice Hinkle. Borowsky Junge and Pateracki Asawa 1994, p.13.

195 Naumberg 1950, p.3. Italics added for emphasis.

196 Naumberg 1950, p.3.

197 Naumberg 1950, pp.13–14, my italics.

198 Naumberg 1950, p.14.

199 Jones 1923, p.183 cited in Naumberg 1950, p.15.

200 Naumberg 1950, p.15.

201 Naumberg 1950, p.15.

202 Naumberg 1950, p.37.

203 Naumberg 1950, p.16.

204 Naumberg 1950, p.36.

Casting off the Shackles
of the Intellect
Is Modern Art Mad Art?

The previous chapter examined theories of heredity reflected in early psychological and anthropological writings. It explored the notion of degeneration in relation to pictorial imagery with particular reference to ideas relating to the cultural significance of symbols. Links between symbolism in art and language and the notion of primitive mentality were highlighted with reference to psychoanalysis.

An interest in the degenerate, atavistic or primitive was not confined to psychoanalysts however, as artists were to explore these areas. This chapter will investigate an artistic movement which was inspired by psychoanalysis and psychoanalytic thinking, particularly the technique of free association.

I shall also present a brief account of three particularly prominent exhibitions which were organised with the help of art therapists, exhibiting the work of their patients.

Casting off the shackles of the intellect

Many pioneers of art therapy had an interest in Surrealism. This artistic movement sought to reveal 'the real process of thought', thought 'freed from logic and reason'.[1] In the *Premier Manifeste* of 1924 André Breton described Surrealism as:

> Pure psychic automatism by which it is intended to express, verbally, in writing, or by any other means, the real process of thought, without any control exercised by reason, outside of all aesthetic or moral preoccupations.[2]

Breton's technique of 'automatic writing' was similar to that of 'free association' employed in psychoanalysis.[3] He described it thus:

> ...the writer is to put himself in the most passive, most receptive state possible and start writing without preconceived subject in mind, rapidly enough not to be tempted to look back on what he has written... But the most serious obstacle to surmount...is the continual irruption of purely visual, and therefore incommunicable, elements in the verbal flow.[4]

Figure 4.1 Souvenir de l' Exposition Internationale du Surrealisme, Londres, 1936 (Yves Tanguy, Roland Penrose, André Breton, Max Ernst)

It is easy to see from the above statement why these ideas were to be of interest to art therapists, even though Breton felt that the technique of automatic writing had failed in liberating people from 'the shackles of the intellect'.[5]

The International Surrealist Exhibition of 1936 was to popularise Surrealism and provide an impetus for the further development of art therapy. Two of the organising committee in particular were to be influential to the development of art therapy: Roland Penrose and Herbert Read.[6]

Penrose had got to know Surrealist artists whilst he was living and working in Paris as a painter. On his return to Britain in 1935 he met Herbert Read, who at that time was living in Hampstead where a 'colony' of intellectuals had formed, including Henry Moore, Ben Nicholson, Barbara Hepworth and Paul Nash. Refugees who moved to the area included Mondrian, Gabo and Gropius.[7] Norbert Lynton's account of the exhibition described Penrose as the 'prime impresario' of the show.[8]

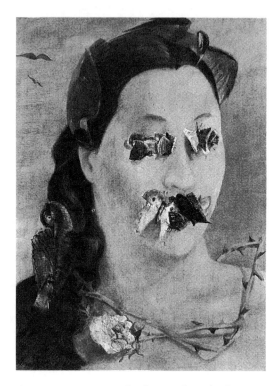

Figure 4.2 Winged Domino: Portrait of Valentine *by Roland Penrose, 1937*

Read's preface to the exhibition catalogue equated primitive, child art and Surrealism. He wrote:

> In justifying such art the superrealist will point to the irrational art of the savage races, so powerful in its effects on the sensibilities of civilised people. He will point to the strong appeal of various kinds of folk art, and of the unconscious art of children…he will demonstrate the fantasies of nature and will ask everyone to admit the vividness of their dreams.[9]

The exhibition, held at the New Burlington Galleries in London between 11 June and 4 July 1936 contained 390 exhibits, and the opening was attended by an estimated 2000 people, with the average attendance for the whole of

Figure 4.3 Herbert Read with his son c. 1938

the exhibition period being 1000 visitors per day.[10] The exhibition was well publicised in advance, and on the opening day crowds disrupted traffic in Bond Street and Piccadilly.[11] It gained a mixed critical reception, but this probably added to its allure. The writer J.B. Priestley, for example, denounced the exhibitors as 'truly decadent' and as standing 'for violence and neurotic unreason'.[12] Herbert Read, in contrast, argued that the work illustrated a liberation from aesthetic conventions 'which prevent and restrict the free operation of the unconscious forces in life, *on which alone the vitality of art depends.*[13] Of course, the criticisms of the exhibition were by no means without precedent with regards to the reception of modern art in Britain, as J.B. Bullen's (1988) research on reactions to Post-Impressionism makes clear.[14] Press attacks on modern French art shown in Britain emphasised the offensive crudeness and 'childishness' of such work and some critics

Figure 4.4 Roland Penrose c. 1932

suggested parallells between Post-Impressionist art and the art of the insane and that of 'degenerates'.[15] Bullen wrote of reactions to Post-Impressionism:

> It was not just that the subjects of Post-Impressionist art were new or different; the principles of mimesis itself – perspective, representationalism, the articulation of the picture surface – all seemed to have been reorganised. To many commentators this shift in the ontology of art looked like regression, degeneracy, even lunacy; to others it was liberating – freeing art from traditions which had become stifling and constraining.[16]

The International Surrealist Exhibition also marked the formation of a Surrealist art movement in Britain and further exhibitions of Surrealist art work.[17] Indeed, an exhibition of Salvador Dali's work was shown concurrently at the Lefèvre Gallery. In addition to works by British Surrealist artists, such as Paul Nash, Roland Penrose, and Julian Trevelyan, children's

Figure 4.5 Photograph of the International Surrealist Exhibition, New Burlington Galleries, London, 1936

drawings were shown along with art by the insane, as well as *objets trouvés,* Oceanic, African, and American primitive art. This selection was justified by André Breton in his description of Surrealism: 'It tends to give even greater freedom to instinctive impulses, and to break down the barrier raised before civilised man, a barrier which the primitive and the child ignore'.[18] The inclusion of art works by the insane was not incidental as the Surrealists drew on a Romantic idea of insanity. The mad were seen by many Surrealists as primitive, savage, or in some sense 'natural' and uninhibited by the restraints imposed by conventional morality, reason, or societal norms.[19]

One of the lectures in the series accompanying the exhibition given by Hugh Sykes Davies appears to make a case for art therapy when he said:

Through all means at our disposal, through painting, through poetry… our purpose is this. As long as this world of dream and phantasy remains

buried in the breast of each one of us, hidden, unseen, not understood, so long is it a potential danger. It is a private world, and when it invades the conscious life of any man who knows nothing of its strange shapes and images, he is hapless against it. He imagines that he alone in the world suffers from such feelings and such dreams. His loneliness provides the essential condition for his illness.[20]

Here is an argument for the externalisation of the unconscious through engagement in the arts. The message is that through acquisition of knowledge and understanding of unconscious processes mental illness can be overcome.

Figure 4.6 Installation of the International Surrealist Exhibition, New Burlington Galleries, London, 1936

Similar sentiments had been expressed by W.H. Auden a year earlier when he argued that psychology was useful to individuals in 'drawing their attention to what the impersonal unconscious is trying to tell them, and by increasing their knowledge of good and evil, to render them better able to choose, to become increasingly morally responsible for their destiny'.[21] Auden's speculation about the corollary of psychology is an optimistic one: that the subject will be better able to distinguish between irrational and rational impulses as a

result of their increased self-knowledge. In a period of global instability the implications of this proposition were significant not just for the individual but for society at large.[22]

Art therapy exhibitions

Roland Penrose, whom I have noted as being an important proponent of Surrealism, and one of the organisers of the International Surrealist Exhibition, became chairman of the management committee of the Institute of Contemporary Art (ICA) in 1947, holding this post to 1969, when he became its president until 1976. (He held the post of president again

Figure 4.7 Max Ernst, The Elephant Celebres, 1921. One of the works exhibited in the International Surrealist Exhibition, New Burlington Galleries, London, 1936

between 1980 until 1983.) An exhibition of patients' art work held at the Institute of Contemporary Art in 1955 helped to promote further awareness of art therapy. Its reception also gives a good indication of the debates taking place in the period about modern art and mad art. The exhibition was entitled 'Aspects of Schizophrenic Art', and was opened by Kenneth Robinson (later to become Minister for Health). The pictures were mostly watercolours from the collection of Professor G.M. Carstairs who curated the show (see exhibition catalogue 1955) and who was to become the first President of BAAT.[23] Carstairs stated his intention for the exhibition:

> It may also appear to visitors unfamiliar with the work of mental patients that there is nothing in this show which they have not already encountered in other exhibitions of modern art. This is indeed what we hope will be the case, because the exhibition is intended to show the affinities of schizophrenic art with experiences which normal people have shared, and not to assert only its abnormality.[24]

Four themes were illustrated in the exhibition. First were the alterations in visual perception occurring in patients' art work during an acute attack of illness, including a series by the cat painter Louis Wain. Second, a group illustrating symbolism in psychotic painting was shown. The third group of art works showed types of stylisation to be found in psychotic art work. The last group of art works illustrated the 'interpretation of visual imagery' (see exhibition catalogue 1955). Herbert Read, in his introduction to the exhibition catalogue, questioned whether the distinction between normal art and psychotic art was justified. He argued that most artists are 'schizoid', their art representing a mediation between reality and fantasy.

Read, a prominent supporter of art therapy, had expounded his views on psychology and art in several earlier publications. In his text entitled *Art and Society* (1936) he had agreed with Freud's theory about artistic expression put forward in his *Introductory Lectures on Psycho-Analysis*. Artists, like neurotics, were unable to satisfy their needs through their personal attributes and therefore compensated for this by indulging in fantasy. Read wrote: 'That way lies self-delusion, hallucination, madness – the state of neurosis and psychosis'.[25] However, the artist is saved from madness through their capacity for sublimation. He wrote that '*the psychotic who is also an artist* can so project his fantasies... He elaborates them into a form which not only disguises their purely personal origin, but more precisely their origin in forbidden and repressed desires and instincts'.[26] Read clearly regarded artists as psychotic. Though essentially in agreement with Freud's theory, Read goes on to

Figure 4.8 Cat Paintings *by Louis Wain*

suggest that Freud provided insufficient explanation for why we can be affected by art works. He postulated that the artist has a 'capacity to materialise the instinctual life of the deepest levels of the mind. At that level we suppose the mind to be collective in its representations and it is because the artist can give visible shape to these invisible fantasms that he has power to move us deeply'.[27] Here Read appears to be drawing on Jung's idea of the collective unconscious. Certainly he saw this part of the mind as both irrational and immutable, as his further remarks make clear. He wrote:

> Ideas, and all the rational superstructure of the mind, can be conveyed by the instruments of thought or science; but these deeper intuitions of the mind, which are neither rational nor economic, but which nevertheless exercise a *changeless* and *eternal* influence on successive generations of men – these are accessible only to the mystic and the artist, and only the artist can give them objective representation.[28]

Read's writing here clearly equates artistic and religious experience. The 'changeless' and 'eternal' nature of the deep layers of the psyche also have positively religious overtones. In his work a psychopathological emphasis mingles with an understanding of art as essentially religious or spiritual in its power to move.[29]

The Times newspaper review of 'Aspects of Schizophrenic Art' questioned whether objects produced under conditions of extreme mental disorder could be called works of art at all; indeed, the reviewer felt that Carstairs' attempt 'to draw connexions [sic] between certain types of modern painting and psychotic drawings is misleading rather than helpful'.[30] The review ended by questioning the aesthetic quality of the art work and suggested that it would be 'futile' for artists to use such work as the source of either style or content of their work.

This exhibition prompted further coverage in *The Times* newspaper which looked at the way that modernism had been portrayed as a pathological phenomenon. The review gave an example from the USA of six psychiatrists, who in 1921 analysed an exhibition of modern art and found the artists, Cubists and Fauvists, to be victims of flagrant mental disturbances! Modernism, they had declared, was an aesthetic perversion and degradation of human dignity.[31]

The counter-argument, that similarities between the paintings of mental patients and those of artists are more apparent than real, was felt difficult to defend by the reviewer since art was, after all, 'a matter of appearances'. The argument that

> illogical content or distorted form in paintings by modern artists acknowledged to be sane [were] the result of an aesthetic 're-structuring' ...of the ordinary aspects of things and not from that incapacity to distinguish the world of imagination from the world of reality, a defect which may be symptomatic of schizophrenia

was examined. The reviewer went on to note that such a broad distinction held sway in modern psychiatric literature on the art of the insane and that of modern artists. However, the writer was of the view that

> the industry with which writers have laboured to create distinctions between the art of the sane and that of the insane may well be misapplied; and it might be said that *since art is not necessarily the product of reason*, the artistic productions of those who have contrived to retain and tho. who have lost their reason are not necessarily different kinds.[32]

It was to the Surrealist movement that was attributed the subsequent 'liberation of the artist's conceptual facilities from the restraints of logical symbolism or allegory', asserted as 'the most influential artistic development of the first half of the present century'.[33] The article concluded by arguing that all art is the product of unconscious processes.

Another exhibition was held at the ICA in 1964 entitled 'Art as Communication'. In the catalogue of the exhibition of clients' work John Henzell, in keeping with the exhibition's theme, stressed the importance of art therapy as a means of communication to both people and objects, leading to increased network of relationships. Mrs A. Arnold, working with children and adolescents, saw art work as being useful as a form of psychotherapy, ranging from a sensuous use of paint in a non-representational manner to a more complex 'projection' of fears and 'phantasies' to the art object.[34] R. Robinson at Horton House thought that art therapy was confidence building. He had a slightly more flamboyant description of his techniques for encouraging patients to relax with the art materials. He wrote:

> I find it helpful to take a large sheet of paper and spatter it with paint and at times to spread the paint with my fingers, conversing at the same time on the theme that it is the way the patient wants to paint that is important and not how someone else thinks he should paint. I take care not to represent an object while spreading the paint, for I feel it would lessen the stimulant value of colour and pattern.[35]

It is clear from the language used by these therapists to describe their work that some of them had been influenced by psychoanalytic theory by this time. (Mrs Arnold's vocabulary indicates an influence of psychoanalysis in her approach which is more marked than in the other descriptions.) The exhibition catalogue contained interpretations of images by therapists and clients and these interpretations differed qualitatively from each other. The art therapists' interpretations point to the 'persecution', and 'paranoid mechanisms' or 'obsessions' of the clients; the obsessions were described as 'defences against anxiety' of patients. These descriptions, replete with psychological jargon, were sharply contrasted with a patient's own interpretation of his work, which found him 'feeling very lonely' and 'longing for a girl of his own'. The exhibition content seems to represent a shift taking place within art therapy towards art therapists using diagnostic and psychological terms and applying them to their patients' art work.[36]

In the summer of 1968 another exhibition was organised at the Commonwealth Institute, London, entitled 'Art and Mental Health'. This comprised the work of emotionally disturbed children as well as art work by adults. The introduction to the exhibition catalogue was written by G.M. Carstairs, who was by this time Professor of Psychological Medicine at the University of Edinburgh. He started his introduction by remarking on the Surrealist claim that all great art was the product of the unconscious, noting

the success of Surrealist art to be the degree to which it was able to 'evade the censorship of the adult, rational, waking intelligence'; he likened this to the work of young children. Carstairs then went on to bemoan an educational system which allowed 'rational judgment to take priority over their intuitive feelings', thus destroying the eloquence of the children's art work. He also criticised the philistinism prevalent in British society when it came to an appreciation of the arts. Nevertheless Carstairs felt that there were 'few works of art' being produced in art therapy departments. Of such work he wrote: '...again and again one can perceive, shining through gross technical imperfections, a spirit of excitement, a liberation of pure feeling such as we see over and over again in the paintings of "unspoilt" five- and six-year-old artists'.[37] It is also clear from Carstairs' account that he did not see interpretation of images as necessary for therapeutic success. He wrote:

> Sometimes patients and their therapists work together discussing the content of the patient's paintings, and turning both their manifest and their unconscious content to account in the course of treatment. Even where this is not done, however, there are many patients who are led through painting to a rediscovery of the capacity both to feel, and to give expression to their feelings; and often this proves to be not merely a recreational, but a healing experience.[38]

His introduction finished with an appeal for the audience to identify the art of the psychiatrically disturbed with other forms of art acknowledging 'the shared repertoire of imagery and the common need to give visual expression to our feelings'.

The first essay in the catalogue was written by a psychiatrist, Dr Frank Tait. It began with an attack upon 'uniformed and philistine' attempts to denigrate twentieth-century painting by comparing it with the work of children. He emphasised that it is the 'spontaneity and immediacy of feeling' that is important in the work of children which is often both 'primitive' and 'urgent'. He then went on to argue that children's painting can yield very precise information about their relationship with their environment, and about their perceptions of themselves: '...the threatening, hazardous landscape of the child with paranoid anxieties; the bleak, isolated, heartless house of the severely emotionally deprived'.[39] Tait argued against labelling images with diagnostic categories and viewing them out of context: '...to regard them in isolation is to negate their meaning, their value...' The usefulness of images was seen by him in their ability to yield information about the child's 'response to both his internal and external worlds', both depicted in

the art object. This libertarian yet cautious attitude about viewing images in human terms as providing information about an ongoing process of discovery and change was unfortunately and ironically undermined by the exhibition's catalogue, which described pictures as 'paranoid imagery' or 'psychopathic'. Descriptions accompanying paintings went thus, to give a typical example: 'Boy age 8. WISC full scale I.Q. 98. Mother rejecting; father immature, unstable. Prominent feeding difficulties and temper tantrums in infancy. Learning and behaviour difficulties.' The child's experience is reduced to an IQ rating and a set of behavioural problems. The idea of degeneration also re-emerges in the layout of the exhibition with works arranged to illustrate either degeneration into insanity or cure.

Included in the catalogue was a short essay by Alexander Weatherson, who by this time was a senior lecturer at Leeds College of Art. Weatherson, who had formally been opposed to the use of art work for diagnostic purposes, appears to have changed his position on this issue, albeit tentatively. He wrote in the catalogue: 'These paintings may be used to provide an accurate record of day-to-day changes in clinical symptoms, a record of response to chemical or psychotherapeutic treatments, and also, from time to time, information relevant to diagnosis'.[40] E.M. Lydiatt was included, discussing a Jungian approach. She wrote:

> These pictures and models should not be judged as art. The aim of producing them is to set free a vitalising force, something that in itself can be helpful towards restoring health...The uniqueness and originality of the product are the result of obedience to an inner unconscious force which commands or co-operates and produces results often surprising to the producer. This surprise can itself be therapeutic...painting and modelling are always stimulating the self-regulation of the psyche.[41]

Lydiatt's emphasis on the self-regulating psyche was typical of Jungian art therapists in this period. An essay by Edward Adamson was also included, which emphasised the personal freedom of expression afforded to patients by art therapy.[42]

The *Observer* review of the exhibition by Nigel Gosling commented that the art works enabled the viewer to share the patients' suffering. He went on to note many 'striking similarities' between the work in the exhibition and that produced by modern artists, which indicated 'what stress artists endure to produce the utterances we all dismiss so airily'.[43] The general emphasis of the review was on the powerful nature of the imagery.

Edward Lucie-Smith's review of the exhibition for *The Times* newspaper noted that it raised many issues for the reception of modern art in general, as well as raising questions about what may be regarded as normal and abnormal behaviour in society at large. Artists, he argued, are encouraged to confront our perceptions of social normality: 'The artist impresses us by challenging our view of what is normal. One might even say, he impresses us because he threatens us'.[44] Lucie-Smith's article went on to suggest that the work in the exhibition should be regarded as art, much of the work being 'both moving and beautiful'. He agreed with Carstairs, that it is the immediacy and lack of 'self-censorship' in the art work displayed that is responsible for its ability to move the spectator. (His remarks echo those of André Breton, who in the preface to the catalogue of the International Surrealist Exhibition had written: 'The only domain that the artist could exploit became that of purely mental representation, in so far as it extends beyond that of real perception without therefore becoming one with the domain of hallucination'.)[45] Lucie-Smith concluded by suggesting that there is a similarity between the mad artist and the modern artist: 'The completely original artist,' he wrote, 'is entirely exposed in his work, just as the mental patient is.' He accused modern artists of retreating from the unconscious into minimalism and pop art because of 'the fear which the artist now feels of plunging into the full flux of the unconscious, even though contemporary doctrine seems to command him to do so'.[46]

Conclusion

This chapter has provided a cursory look at art therapy in the contexts of the arts with reference to the impact of Surrealism, and prominent exhibitions of patients' work. The subject could legitimately form the basis of a more detailed study. However, it is not within the scope of this research to do more than present a sketch of events as this is a large and complex topic.

The Surrealists argued for the expression of the personal unconscious, and two of their number, Penrose and Read, assisted in promoting art therapy. Another Surrealist, Conroy Maddox, was invited to address the first AGM of the British Association of Art Therapists.[47] Read argued that all great art was derived from unconscious processes.

The reception of early art therapy exhibitions illustrates the division of opinion between those who accepted the idea that the expression of the unconscious was legitimate as art, and those who regarded art as illustrating and appealing to the higher sensibilities of 'Man'. The texts accompanying

the first two exhibitions are psychopathological in their emphasis, indicating that psychoanalytic ideas were penetrating the thinking of art therapists, as indeed they were permeating the sphere of modern art in general through the influence of the Surrealists and writers such as Read. The second *Times* review of the 1955 exhibition emphasised that art work was *not* the product of reason but of unconscious forces; it clearly equated modern art with mad art. The third exhibition, that held in 1968, emphasised the immediacy of expression of the art of the disturbed. Carstairs saw art-making as curative even without discussion of art work. He certainly did not advocate the use of psychoanalytic theory, nor did he suggest that interpretations of art work are necessary or useful. His emphasis was on the free expression of emotions through art-making. *The Times* review of the exhibition argued that it was this spontaneity and lack of restraint that the modern artist shared with the mad artist, a view which is held by many art therapists today.

Notes

1 Ray 1971, p.8.
2 Breton: *Premier Manifeste. Manifestes du Surréalisme*, Paris; Jean-Jaques Pauvert, 1962, p.40, cited in Ray 1971, p.3.
3 The Surrealists' interest in psychoanalysis is well documented (e.g. MacGregor 1989, p.271). André Breton was not just influenced by theory, but by his experience of working directly with patients in psychiatric hospitals during World War I.
4 Breton cited in Ray 1971, pp.8–9.
5 Ray 1971, p.11.
6 Penrose was a painter and exhibited with the Surrealists himself. He had attended Cambridge University, graduating in 1922. Between 1922 and 1935 he had lived in France and worked as a painter.
7 Penrose 1981, p.75.
8 Lynton 1980, p.9.
9 Read 1936b, p.13.
10 *International Surrealist Bulletin* 1936, p.2.
11 Ray 1971, p.136.
12 Priestley cited in Symons 1960, p.94.
13 Read 1936, p.11.
14 The term Post-Impressionism was first used in Britain in 1910.
15 T.B. Hyslop's essay on this theme is reproduced in Bullen 1988, p.209.
16 Bullen 1988, p.1.
17 *International Surrealist Bulletin* 1936, p.2.
18 Breton cited in Ray 1971, p.142.
19 MacGregor 1989, p.69.
20 Davies 1936, p.15.
21 Auden 1935, p.18.
22 Later in July 1936 Franco seized power in Spain, overturning the democratically elected Republican government, and the Spanish civil war began.
23 Waller 1991, p.103.
24 Carstairs in exhibition catalogue cited in *The Times* 24.11.1955.
25 Read 1945, p.86.

26 Read 1945 p.87. My italics.
27 Read 1945, p.95.
28 Read 1945, p.95. My italics.
29 For a detailed analysis of how Read's ideas changed over the course of his successful career see Ray
 1971.
30 *The Times* 24.11.1955.
31 *The Times* 21.08.1956.
32 *The Times* 21.08.1956. My italics.
33 *The Times* 21.08.1956.
34 Arnold 1964.
35 Robinson 1964.
36 ICA exhibition review 1964. This shift within British art therapy may have been partly the
 consequence of publications arriving from the USA to Britain. For example, Margaret Naumburg, a
 psychologist and psychotherapist, used concepts from psychoanalysis as the basis for her art therapy
 approach. She used art therapy as psychotherapy with clients who could not put their feelings into
 words. Professor Plokker's text entitled 'Artistic Self-Expression in Mental Disease: The Shattered
 Image of Schizophrenics' was also translated into English in 1965.
37 Carstairs 1968, p.2.
38 Carstairs 1968, p.3.
39 Tait 1968, p.4.
40 Weatherson 1968, p.7.
41 Lydiatt 1968, p.9.
42 Adamson 1968, p.11.
43 Gosling 1968, p.46.
44 Lucie-Smith 1968, p.9.
45 Breton 1936, p.7.
46 Lucie-Smith 1968, p.9.
47 Henzell 1997, p.186.

In the Tradition of Moral Treatment

This chapter will introduce some of the important features of the circumstances in which art therapy developed in the twentieth century, which will be explored in greater detail in the following chapters. In particular, I shall look at the appointment of Bruce Godward, one of the first art therapists in Britain to use the term of himself, at the York Retreat. Finally, I shall explore the interaction between occupational therapy and art therapy in the period in which the first art therapy appointments to the National Health Service were made. Some of the claims made by these pioneer art therapists about the curative nature of the arts are remarkably similar to those made by the practitioners of 'moral treatment'.

The twentieth century

As Chapter Three explored, in the nineteenth century the expansion of the asylum movement and the increasing numbers of lunatics in custodial care, along with further changes in how insanity was viewed, resulted in a movement away from individualised treatment. A new phase of psychiatric development occurred in the twentieth century in the post-World War I period which was relevant to art therapy. This included a move back toward individualised treatment (particularly with reference to psychoanalysis) and an increased interest in the psychology of the individual (with regards to wartime morale, as well as in response to the high incidence of shell shock), though group therapy methods were increasingly employed (particularly after World War II). The development of welfare legislation between the wars, which precursored the development of the 'welfare state', as well as the growth of occupational therapy as a paramedical profession, is relevant to the climate in which modern art therapy began. Another factor of particular relevance was the pseudo-religiosity of the analytic psychology movement.

Hence, although there are profound differences between the late eighteenth century and the early to mid-twentieth century, there are also points of comparison which can be made. The specific historical circumstances in which art therapy arose as a discrete and recognised professional practice will be the subject of further detailed analysis in subsequent chapters. However, I shall now move on to examine the period immediately preceding that in which the first art therapy posts were established, for it is my intention to illustrate how very similar early art therapy was to the moral approach.

The tradition of using the arts endured, and a Miss J. Crawford DA, an art teacher, was appointed instructress and therapist at the Crichton Royal in 1928 at a salary of £200 pa.[1] Miss Crawford had been trained at Edinburgh College of Art and she offered two hour-long 'classes' for 'tuition and treatment'. She was encouraged not only to work with those who had an interest in art work but 'specially' with 'those who cannot be induced to occupy themselves in any way', concentrating on this group of difficult patients, 'the object of this *specialised form of occupational therapy* being...with a view to arousing interest and energy and activating the mind and behaviour into a normal healthier mode of working'.[2] It is interesting that Miss Crawford's role was seen as a specialised form of occupational therapy. This statement precedes later debates about whether art therapy should be regarded thus by several decades. Miss Crawford might, therefore, be described as the first art therapist in Scotland.

The art instructress' brief at the Crichton Royal was described in the 1940s by another medical superintendent at the hospital as not merely to amuse patients but to 'encourage interest in external reality as well as to arrest tendencies to regression to lower levels of behaviour, to direct destructive tendencies into constructive channels'.[3] It is clear that these art instructors are the precursors of art therapy if not the first art therapists.

The appointment of an art therapist to the York Retreat

The notion of moral insanity has been criticised because it redefined madness as deviance from socially accepted behaviour, rather than as a loss of reason. Emile Durkheim (1858–1917), in a posthumously printed work of 1925, highlighted the cultural relativism of moral values. He pointed out that morality is based on respect for fixed rules and the authority underlying those rules, and emphasised that moral rules and attitudes develop at the group rather than the individual level. More recently, Elaine Showalter and Andrew Scull have pointed out that the definition of moral insanity was used

to cover almost any behaviour regarded as abnormal or disruptive to community standards.[4] Nevertheless it was ideas about moral treatment that paved the way for the appointment of art instructors and the formation of recreational and occupational therapy departments in which much early art therapy work developed. It is not surprising that the York Retreat was home to one of the first formal art therapy appointments in Britain, that of Bruce Godward (1916–1992).

Figure 5.1 Bruce Godward c.1955 (probably posed with nursing staff)

The York Retreat was not immune to the technological treatment methods and drugs which became widely used in the twentieth century. For example, electro-convulsive therapy (ECT) was introduced in 1940, and ultraviolet rays were also used for their purported therapeutic effects.[5] Prolonged narcosis was also employed dubiously as a treatment method.[6] Despite these developments an emphasis on occupation and industriousness in a moral approach was retained. For example, in 1934 Miss Hadfield, a crafts instructor, emphasised that the therapeutic effect of engaging in a craft activity became lost once the activity became 'mechanical'.[7] A wide range of arts and crafts were on offer including country dancing, play reading and amateur

dramatics, all of which were regarded as 'psycho-therapy'.[8] Such activity was regarded as particularly useful for 'psychoneurotic patients'.[9] This was thought to combat 'moping and morbid introspection'.[10] Such statements were not dissimilar to those made at the foundation of the Retreat. For example, in 1797 the annual report stressed the benefit of such activities: 'To relieve the languor of idleness, and prevent the indulgence of gloomy sensations'.[11]

Emphasis was also laid on the environment and on selecting a nurse with a suitable temperament to spend time with the patient.[12] Patients were to be restored to 'physical, mental and spiritual health' and it was still the aim of the Retreat to enable patients 'to find a spiritual basis and a religious philosophy of life'.[13]

Psychoanalytic ideas were explicitly rejected by the Retreat. However, analytic psychology was to have some later influence through the work of Carl Jung. Medical Superintendent Arthur Pool discussed the importance of the Quaker foundations of the Retreat and enthusiastically quoted Jung's *Modern Man in Search of a Soul* in which Jung claims of his older patients: '...there has not been one whose problem in the last resort was not that of finding a religious outlook on life'. Pool keenly endorsed Jung's view, emphasising 'the value of religion in the synthesis of a fully developed personality'.[14] The advertising for the Retreat published in this period emphasised it as a place compatible to those with Christian values: '...those managing the Retreat hold that psychiatric treatment, to be successful, must be based on spiritual understanding, with faith in God and the healing power of Divine Love'.[15]

'Community therapy' continued to be emphasised and it was conceived that mental illness was due to 'failure in personal relationships'. It is in this context that the first self-professed 'art therapist' was appointed to the Retreat. Bruce Godward arrived in Britain from New Zealand in the 1940s and was appointed art therapist to the York Retreat in 1952. He lived at the Retreat in staff accommodation along with other professional and nursing staff.

Almost immediately following his appointment Godward, a Jungian who had undergone analysis in Zurich, had a large number of patients engaged in painting therapy which was described as not 'merely' diversional but as part of a therapeutic procedure.[16] The importance of the 'painting therapist' having 'some knowledge of his own mental processes' was noted at the outset. This was regarded as beneficial in allowing him to accept emotionally

laden work produced by patients. He is described in the 1952 Annual Report as providing art therapy mainly through painting 'which is in the charge of a fully qualified teacher of art who also brings to bear upon his work a psychological approach'. The paintings were regarded as being a spontaneous expression of their makers' mood and therefore to have a diagnostic as well as a therapeutic value. With this aim the art therapist encouraged patients to paint 'at random' in an unrestrained manner.[17]

Art therapy is described thus:

> On admission to the hospital, patients who are well enough are given a drawing board and paint box and are encouraged to paint...freely for the joy of experimenting with colours and shapes. The painting therapy studio is open all day, and some wonderfully beautiful paintings, showing imagination and originality, are produced. It is amazing how many people, while spending a few months at The Retreat, find within themselves a buried talent for painting.[18]

By December 1952 there were 'forty-five painters' in the hospital as well as two outpatients coming in for regular art sessions. These 'painters' varied in output 'from one who does two or three paintings every day to one who takes three weeks over a single painting, or who can only be persuaded to paint now and again'.[19] Clearly, there was quite a flexible attitude to the use of the painting studios. Art therapy was noted as being particularly useful in promoting an 'optimistic and co-operative attitude in the patient'; this echoes the earlier statements of W.A.F. Browne.[20]

By 1953 the art therapist's position within the institution appeared to be slightly ambiguous. In the 1953 Annual Report Bruce Godward is listed as 'technical staff' but his work is referred to as 'general therapy' and is listed alongside the achievements of occupational and recreational therapists. There was an emphasis put on the enthusiasm of both patients and staff for 'occupations and pastimes' in the commissioners' report of that year. Claims made about art therapy in the years preceding Godward's appointment are fairly modest and mentioned in the context of 'ancillary treatment' which was thought to be 'indirectly curative'.[21]

Bruce Godward was keen to promote understanding of art therapy and he was not averse to giving public lectures. Like other art therapists working in this period, he staged exhibitions of patients' work. One such event showed a series of pictures produced by a man who had been sexually assaulted. Bruce Godward's case notes give an indication of his responses to images. For

example, of the twelfth painting made in a series, depicting a sexual assault, he wrote of the image as follows:

> It represents the incident which precipitated his breakdown, and brought him into hospital... A few hours after his final exam, a fellow student...had assaulted him sexually... A most interesting feature of this painting is that violet is used for the first time. This would have interested Jung, for violet has been the colour of confession in the Christian Church since 800 A.D., which the patient could scarcely have known consciously, as neither he or his mother ever darkened a church doorway. So when he makes his big confession, he introduces violet. And as the unconscious often employs puns to gain its ends, it might be that the patient felt 'violated'. This confession required a long session of very tactful counselling...'.[22]

Bruce did not furnish his patients with interpretations of art works, writing: 'Self-expression through paintings is very therapeutic, but staff should not tell patients that paintings can be useful for diagnosis, or even hint that there can be more in a picture than meets the eye! Nothing could be more damaging to the patient's self-respect'.[23]

Art therapy continued to get a small mention in further annual reports up until the time of Godward's departure in 1975. His notable successes included a boy of 12 years whose speech was almost 'unintelligible' who had 'gained self-expression and self-confidence from daily painting sessions', and a 'girl whose speech was inhibited (apparently by shock) who was able to reveal the cause of her shock, which she was quite unable to do in any other way...'.[24] The physiotherapy and art therapy departments were closed in 1975 due to financial constraints. Bruce Godward had worked for the hospital for 23 years by then. The final report on art therapy at the Retreat noted that he had produced many 'interesting interpretations' (presumably to medical staff) and that he had assisted 'patients by giving them freedom to express themselves in painting'.[25] Godward referred to the art therapy room as 'an asylum within an asylum'.[26]

The interaction between occupational therapy and art therapy

A number of theorists have explored the relationship between moral treatment and occupational therapy (OT), arguing that they have a shared philosophy[27] or indeed that OT developed out of moral treatment.[28] In Chapter Two I argued that art therapy practice was developed in part from the moral

tradition; in the following section I shall examine the contribution to art therapy of a group of therapists originally trained as occupational therapists who later came to identify themselves as art therapists and explicitly adopted the term in their job titles. I shall explore the similarities of approach between these art therapists and the moral treatment practitioners as well as producing a profile of these pioneers.

An important impetus to the development of art therapy during World War II, and in the post-war period, was the interest of occupational therapists in art therapy. Although many OT departments in this period had an arts and crafts activity on offer (and in some cases their work may have been almost indistinguishable from that of art therapists) some OTs came to identify themselves as art therapists rather than occupational therapists for a number of reasons which I will now explore, and it is the work of such art therapists which will be surveyed. Two trained OTs were particularly influential in the early development of art therapy. These were Maria Petrie and E.M. Lydiatt. For example, Hansi Bohm, who was another pioneer art therapist (and also a trained OT), was introduced to art therapy though the work of Petrie.[29]

Maria Petrie, who moved to the United States towards the end of the 1950s, had some influence before her departure. She felt that the art therapist was part artist, part teacher and part healer.[30] Petrie saw a strong link between her work and that of Adrian Hill (whose work I shall discuss in detail in the next chapter). She saw 'industrial art therapy', with its emphasis on the reha-bilitation of muscle power, and occupational therapy, with its emphasis on diversional techniques, as complementary to art therapy. However, she regarded art therapy as the *'purest technique'* because it responded more directly to the patient's emotional and imaginative life; thus 'he can be made anew from the contact with nature, the handling of form and colour and the meeting with himself'.[31] This technique of 'art practised for the sake of the delight and fulfilment and renewal of the individual' she attributed to Adrian Hill.[32] Petrie also described art therapy as the 'finest motive for healing through art', a remark which echoes W.A.F. Browne's nineteenth-century assertion that engagement in the arts employs the higher sensibilities of the practitioner.

Petrie had very definite ideas about what should constitute the necessary training for therapists (be they occupational, industrial or art therapists). In a paper in which she argued the case for discrete art therapy training she put forward the idea that prospective trainees should be good artists who are able to set a high standard. Then she argued that trainees should have some of the

personal qualities demanded of doctors and nurses, notably a sympathetic attitude. Therapists also need some basic understanding of physiology as well as knowledge of basic forms of handicap and illness. Thus they would be equipped with an 'all-round and not too specialised training' which she felt could take three years.[33] Her description (apart from the emphasis on physiology) sounds very much like the early art therapy training established in the late 1960s and 1970s in Britain.[34] As already noted, moral practitioners had recognised that engagement in the arts had physical benefits, restoring the body as well as the mind. Petrie thought that art therapists should be trained to be able to offer a range of services from physiotherapeutic arts activities to industrial therapy to art therapy, and should not specialise. Thus she advocated

> a combined training in painting, modelling, appreciation of art, design for industry and one or two crafts, plus some lectures on physiology and nursing in a diploma course of three years, incorporating and widening the existing courses for occupational therapy, which must be credited with a great deal of power and spade work. Candidates would have to be carefully selected for such personal qualities as one looks for in the nursing profession...[35]

Indeed, during World War II special courses were developed to train extra OTs to meet the increase in demand for their services. Petrie describes the course as divided between the acquisition of technical skills in a particular creative medium combined with the theoretical study of anatomy and elementary psychology. The students were seen as able to use different art media in a way to exercise and rehabilitate injured muscles or to relieve 'nervous strain' depending on the emphasis required. Petrie saw the fine arts as being qualitatively different from the crafts. She wrote: 'The arts of painting and sculpture command elements of a *purer, more concentrated and more direct healing power* than those inherent in the crafts.' Use of crafts could be supplemented by the '*vitalizing effect*' of the more spontaneous and personal use of colour, form and rhythm in painting.[36] It is indicative of the period in which she wrote that Petrie felt that patients and ex-patients could assist in this work (an idea which has become taboo today). She favoured engaging 'unmarried female patients'. These women would have a greater understanding of the patients' difficulties as a result of their own experience.

Petrie is notable in recommending the use of art therapy with mentally handicapped people at a time when few art therapists seemed interested in this area of work.[37] She put forward the now unfashionable view that

'mentally deficients' (MDs) could sublimate their sexual impulses through making art work rather than propagating more of their kind.[38] Similarly, she thought that the 'civilising influence' of the arts could be useful with delinquents.[39] Prison environments were described by her as places where art as therapy might be of value. She regarded prisons as inhumane, brutalising and indicative of a 'primitive wish' for revenge and punishment rather than reformation. This tendency she felt had been powerfully stimulated by the recent war crimes trials at Nuremberg.[40] Alternatively art therapy might be useful for mothers as an alternative to watching American films which, she felt, would just make them 'more dissatisfied with their own drab life'![41] (Petrie did not seem to question the subservient or 'drab' role performed by women.)

Maria Petrie's book of 1946, *Art and Regeneration*, opened with an introduction by the prominent art critic Herbert Read who suggested that art may serve a biological function, though exactly what this might be was not fully elucidated by him. He argued that art is an 'integrative force' which can soothe frayed nerves, cure the sick or even 'reform the brutalized mind of the criminal'. With children art is seen as able to '*induce a natural bias toward moral virtue*'.[42] The arts, therefore, represent a cure-all for a wide range of disorders from brutalisation to faulty morals. Petrie was certainly not averse to polemicising and she was keen to emphasise a wide range of applications for art as therapy. Benefits espoused by her ranged from the expression of unconscious impulses by those with mental health problems to the 'civilising influence' of art-making, generated by the 'order, symmetry and precision' of composition, which could make it easier to teach 'manners' and 'cleanliness' to those with a mental handicap.[43] Some of these statements bear a striking similarity to those made by W.A.F. Browne in the nineteenth century.

Essentially Petrie saw the crafts as having a calming influence and the fine arts as more rousing and stimulating. Indeed, with those of a nervous disposition she felt that art was 'homeopathic' in the way that it functioned.[44] A wide range of symptoms from 'hysteria' to 'manic depressive psychosis' could be dispelled through the integration of the personality by art-making.[45]

Like other art therapists of the period (such as Edward Adamson), Petrie was uneasy about the 'mechanisation' of society. Factory work, she felt, militated against 'spiritual renewal' because of the harsh conditions endured by workers.[46] To become 'fully human', it was necessary for the expression of the 'soul' to be enabled. Although Petrie is positive about the work of the Committee for Encouragement of Music and the Arts (CEMA) in the Second World War period, she felt that working conditions made it impossible for

workers to respond to its efforts to bring art to the people. She wrote: '…whether nerves exhausted or blunted by constant noise of machinery are capable of reacting to the subtleties of modern art is doubtful'.[47] This resistance to 'mechanisation' is partly the result of Petrie's view that the 'spiritual and emotional growth' of the human race had lagged behind material developments. It is through the arts, in her view, that 'the soul may play an equal part, with body, mind and spirit, in a whole human being'.

Petrie was an intelligent writer who was aware of legislative developments and was well read. (Amongst writers cited in her book were Baudouin, Cyril Burt, Dewey, Jung, Pfister, Piaget and Prinzhorn.) Had she not left for the USA she would undoubtedly have been a key figure in the emerging profession of art therapy in Britain. She had a strong religious belief and employed a spiritual emphasis in her art therapy. For the non-believer, 'listening to music, reading of poetry, looking at pictures and still more the active practice of these arts are also a way to God'.[48] She saw the fine arts as serving a deeper purpose as both an expression of 'man's spirit' and as a channel to God through which '*healing cosmic forces are at work*'. Thus the fine arts were seen by her as holding real potential for regeneration.

Hansi Bohm was an artist who subsequently trained as an occupational therapist. She joined the staff of Shenley Hospital in 1957 to set up an art department under the direction of the then medical superintendent Dr Fitzgerald.[49] Hansi Bohm referred to art therapy as a 'branch of OT'.[50] She worked at the hospital until 1963 and left because she felt that her art therapy work was impinging on her own professional practice as an artist. Although she never met Adrian Hill, Bohm was very influenced by his first book, *Art Versus Illness*.[51]

Bohm's team at Shenley Hospital was comprised of thirteen occupational therapists. There was no consensus amongst the medical staff about how art therapy should be used so it was decided that it should be 'non-analytical'. In other words, Bohm should not seek to analyse or interpret the imagery of her patients. She was also advised to be 'open minded and experimental in her work', not follow any of the schools of psychology exclusively, but adopt and develop methods deemed suitable for the hospital and particular patients. Unlike many art therapists working in this period, she had access to all medical staff as well as psychologists and psychiatric social workers. She also liaised with nursing and other staff as necessary and worked within all of the OT departments within the hospital.[52]

Referrals to art therapy groups came via a variety of routes, from doctors directly, from the OT departments, and from nurses; self-referrals were also accepted.[53] She was helped in her work by two patients who worked as assistants in the art, pottery and modelling groups.[54]

Bohm worked with groups of up to twelve patients at a time in the art rooms or on the wards. She also encouraged patients to take art materials away with them so that they could work independently on the wards if they wished to do so. The art rooms were also made accessible to patients when she was not present. She wrote:

> New patients stick to the timetable for a short period of intensive instruction. Once they have acquired a certain degree of skill and also integrated themselves in the existing group, they are free to use the art or pottery rooms at all times until the department has to be locked up.[55]

The art group took some time to become consolidated due to a heterogeneous client group. In the art rooms, Bohm gave casual and unscheduled supervision to studio users in between the timetabled sessions. She described her 'open studio' approach:

> The continuity of creative interests and the rapport with the therapist – even when not actually present – has in fact made these rooms into a home and a refuge for quite a number of patients. This state of affairs, which developed on its own, has been sanctioned as part of the general permissive policy of the hospital.[56]

Her approach was to encourage patients to choose a medium to work in and discover their own interests and abilities without her making suggestions about subject matter. For those unable to respond to this method, she suggested that they 'paint patterns of line and colour, even the merest doodles. If still nothing was forthcoming, vague general subjects were suggested such as thunderstorm or a dream, a memory from childhood or any imaginary scene'.[57]

Bohm noted that those who had most difficulty responding to her method tended to be depressed patients lacking in energy, those who recognised their lack of creative ability (such self-criticism she thought quite realistic and reasonable), and those frustrated by lack of technical skills with which to express their ideas. She noted that 'those who could not find emotional release in this activity, who were discouraged by failure, drifted off'. However, those that stayed revealed their moods both through their choice of subjects and use of colours.[58]

She did not regard the pictures as without diagnostic significance. She wrote:

> 'Free' painting lends itself well to interpretation...and can often be used profitably as a complement to the psychologists' findings. In a number of cases these paintings have been found to correspond to the results of Rorschach tests and have been of clinical and diagnostic interest.[59]

Not all clinical staff were sympathetic to art therapy; Bohm described one neurotic client as making symbolic images which she then interpreted herself. However, 'this sort of self expression was rejected by a therapist as an undesirable diversion from the consulting room'.[60] Indeed, where pictures were being used as an aid to psychotherapy by medical staff, production of art work would be stimulated. Likewise, Bohm noted that lack of interest on the part of medical staff could have an inhibiting effect on the flow of production of art works, especially the pictorial representation of unconscious material. She wrote: 'The most important factor in the production of such works is, however, the attitude of medical staff'.[61] This 'permissive' (to use her term) method of art therapy was largely abandoned at Shenley Hospital because most doctors were not keen to use such material either diagnostically or as an aid to psychotherapy. Bohm summarised her experience of using this form of art therapy at Shenley:

> The permissive method of free expression was found successful in comparatively few cases, where it would happen anyway if patients are given opportunity to paint. It remained at best either cathartic or as pictorial shorthand for the consulting room. Certain patients were apprehensive about revealing too much; the 'open market' atmosphere of the existing art room might not be conducive to this technique; better results could perhaps have been achieved in more secluded quarters or in a more homogeneous group of patients, or over longer periods in which transference might pave the way to pictorial confessions.[62]

Bohm found a 'disciplined' method based on study and 'realistic' work to be more profitable in her work situation. This included landscape, life (model) drawing and still-life groups. Individual instruction was given on basic techniques and through tackling 'real' subjects, Bohm still felt that there was plenty of scope for individual interpretation.[63]

The 'realistic' method had a number of benefits in pinpointing patients' difficulties, such as 'perceptual disturbances'. However, most difficulties experienced by patients in art-making (lack of concentration, frustration etc.)

could, she argued, be countered by using a more structured approach. Furthermore, 'the task of organising parts into a whole, that is, of devising the structure of pictorial composition, made strong demands on the integrated effort of the whole personality and brought rewards on just these lines'.[64] She found tolerance towards frustration and criticism to be increased by success, and this led to an increased tolerance of others.

She described the general result of a 'disciplined' approach as being to move the focus away from the self to an object: 'Thus a realistic painting could express personality and individual experience, but of the outside world, not of the subconscious material alone'.[65]

Bohm clearly believed that this structured 'disciplined' approach to art therapy was more beneficial than a 'spontaneous' or 'permissive' approach. The latter she described as 'sterile' whereas the former 'showed that achievement in art is possible despite illness', producing feeling of pride in patients, building their 'defence mechanism' and 'ego'.[66] Her emphasis on positive feelings of pride and self-confidence aroused via this structured approach to art-making are not dissimilar to those made by Hallaran in the early nineteenth century, in which he emphasised the elation his patient felt when hospital staff praised his artistic efforts.

Bohm was against the idea of art therapists furnishing interpretations of art work. This was not merely an intellectual objection but based on a bad experience. A patient who was usually aggressive in hospital became calm in the art therapy room and painted peaceful paintings there. One day Bohm decided to reflect back to him the fact that he was not evincing anger in his art work. The patient, taken aback by her observation, reacted by attempting to strangle her and had to be forcibly removed by nursing staff! Bohm was understandably shaken by this experience.[67]

E.M. Lydiatt ('Liddy' to her close friends), another trained occupational therapist, attended Birmingham School of Art and from 1934 to 1950 she taught art in a school, worked in a hospital and also taught in teacher training colleges. A friend of Irene Champernowne, the founder of Withymead, Lydiatt had become interested in the work of C.G. Jung in 1935 and had undergone Jungian analysis. She was an energetic woman who worked from the 1950s as a pioneer of art therapy, founding art therapy departments at Fulbourne Hospital in Cambridge, Runwell in Essex, Leavesdon in Hertfordshire, St Marylebone Hospital for Psychiatry and Child Guidance and a private clinic called Bowden House in Harrow.[68] Lydiatt was described by a

former friend as short, stout with thick wiry hair and intense eyes. She was excitable, fervent and brimming with enthusiasm. She was also direct, forthright and forceful.[69]

In the 1960s she worked in Paddington Clinic and Day Hospital and Halliwick Hospital in London. Halliwick was a new hospital unit with 121 beds which had a high staff–patient ratio and a 'therapeutic community' regime. Lydiatt worked at both hospitals on a part-time basis, but the art rooms were open for patients to use in her absence.[70] Her art therapy department at Halliwick Hospital consisted of one large room in a hut in the hospital grounds with an adjacent storage area. The room had a studio ambiance and nurses and OTs were expected to join in and paint at the easels alongside the predominantly voluntary patients. Some of the patients referred for art therapy were patients who had been seeing consultants in private Harley Street practices and were admitted to Halliwick when they were perceived as needing a period of hospital admission. There was therefore a preponderance of middle-class, articulate patients in this particular setting.[71] However, it is clear from Lydiatt's later book (1971), which describes her 20 years of art therapy experience, that she worked with a wide range of client groups in a variety of settings.

Pioneer art therapist Rita Simon, who visited Lydiatt in her studio and was familiar with her work, described her ability to empathise with her patients: 'She would have been acutely sensitive to those who would want her to approach… She would follow the patient in that sort of way… She was sensitive to their needs', whereas all her 'rumbustiousness would not be [directed] towards the patient. It would have been to her bosses if to anyone, or to her peers'.[72]

Catherine Paterson, an OT who worked in the art therapy studio with Lydiatt at Halliwick, remembered that patients were given the opportunity to talk about their paintings but that this was never done in a coercive manner. Such discussions of art work were informal and generally unstructured and done on an *ad hoc* basis. Patients talked about their art work with Lydiatt herself or an OT or nurse helper.[73] Lydiatt confirmed this close co-operation with other staff: 'The occupational therapists were staunch and active collaborators, and without their help the satisfaction of painting afternoons would never have been achieved'.[74]

Staff supervision included staff talking about the pictures they had made in the studio.[75] Indeed, even those staff who were not regularly involved in

the life of the studio were invited in and given the opportunity to experience art-making for themselves. This invitation was also made to consultants.[76]

A review of patients' art work took place from time to time. This entailed looking at a body of work produced by an individual which would be discussed with Lydiatt whilst other patients and staff got on with their art work. The review of art work gave the opportunity for discussion, but also allowed for a further assimilation of the content of art works by the patient who might only have looked at isolated pieces of work up until that point.

The emphasis of art therapy was in giving patients an opportunity to express feelings and to explore their relationships with family members. For example, patients were encouraged to produce a clay model of their family group and then talk about the relations that existed between figures.[77] Lydiatt also used sand play with clients.[78]

Catherine Paterson recalls working in a small room at Halliwick with Lydiatt and a group of adolescent children. They lined the walls with paper and got the children painting on a large scale. Although only a small group, it was a highly charged situation, with anger being expressed in the paintings.[79]

Lydiatt was a Jungian and talked about Jung's work to staff. Indeed, she referred to him as 'a pioneer of art therapy'.[80] At Halliwick Hospital both the part-time art therapist and an OT who was working closely with Lydiatt were undergoing Jungian analysis.[81] Although a trained OT, Lydiatt identified herself as an art therapist, though she worked harmoniously with OTs.

In her influential book, *Spontaneous Painting and Modelling: A Practical Approach to Therapy*, she emphasised her reluctance to furnish interpretations of clients' art work. This reluctance was influenced by her observation that people looking at pictures project their own ideas upon the artist. She wrote: '...it is terrifyingly easy to project one's own problems onto patients and to add to their burdens and bewilderment'.[82]

Lydiatt also felt that furnishing interpretations of art work may act as a 'limitation' to the patient's self-expression. Furthermore, she argued that not all imagery could indeed be translated into words. In addition to this, she felt that interpretations were potentially 'highly upsetting' to the patient. She wrote: 'Often those who see the pictures feel impelled to point out symbols of every kind; but such expositions may well represent the projections of the spectator'.[83] For these reasons, Lydiatt refrained from furnishing interpretations of her clients' art work.[84] Likewise she did not see diagnosis as being the concern of the art department. Indeed, she positively disliked diagnostic labels and jargon and she emphasised that she saw her patients as human

beings.[85] Although Lydiatt had undergone a Jungian analysis she did not believe that art therapists were or should be psychotherapists. She wrote that 'the art therapist must be clear that he is not a psychotherapist and must be skilled in not interfering with medical treatment and not be too curious'.[86]

Although the theoretical underpinning of a Jungian approach to art therapy will be explored in depth in the chapter on Withymead it is worth looking at how Lydiatt understood this. In 'spontaneous painting' she felt that the conscious mind became linked to the unconscious but without becoming overwhelmed by it.[87] Lydiatt saw the art therapist's role as creating an environment in which a process of 'active imagination' (a term used by Jung) could take place and the content of pictures be 'morally assimilated'; an intellectual understanding of images was not sufficient.[88] Lydiatt described the essence of her approach as being geared to helping a patient 'express his own individual links with the activity of the mind below the surface of consciousness'.[89] This activity she saw as 'health giving and restoring' in its own right.[90] Her approach, like that of other Jungians, also had a spiritual dimension. The art works produced through the use of 'active imagination' she saw as 'expressions of elements of our nature that have forever been cared for by ritual and religion. To allow them life and form, however simple, seems to be vitalising'.[91] Sometimes she talked about 'active imagination' as though it is the Holy Spirit: 'one can be touched by active imagination and life may be rekindled'.[92] Lydiatt noted that she was astonished by the perceptiveness of a psychiatrist whom she overheard explaining to a group of hospital staff 'that spontaneous painting was a modern form of prayer'.[93]

Like other Jungians, Lydiatt was also wary of the force of the unconscious mind. Akin to some moral treatment practitioners, she felt that spontaneous painting was potentially overwhelming and that it should be balanced by more prosaic activities such as going for a walk.[94] She wrote:

> ...newfound vitality may be used in ways destructive to oneself and to others. In fact the consequences of practising spontaneous painting, if wrongly handled, can be very disturbing, even devastating. Making oneself meet satisfactorily the demands of everyday life can be a wonderful corrective and a balancing factor when the unconscious sweeps along too violently.[95]

However, she remained resolutely convinced of the efficacy of art as therapy.

Lydiatt tended to work with fairly small groups.[96] She used a variety of models by working. In one hospital, the walls of a small room were for painting and 'messing on'. This was done on the understanding 'that suc-

ceeding patients might later destroy their contributions... There were innumerable paintings superimposed in layers, scribbles, scratching and daubs of clay; for these the walls themselves seemed responsible, as they called forth something that paper would never produce'.[97] She also used an open studio format where patients could use the facilities whenever they liked. To this kind of session up to thirty 'painters' of different ages came. Her role was to welcome patients, to provide them with materials, and to 'acknowledge' their work.[98] Despite the fact that working with such a large group meant that Lydiatt could spend only a small amount of time with each individual, an atmosphere of creativity was nurtured.[99]

Lydiatt noted that whilst some patients could paint for hours, others tired or lost concentration much more quickly. Consequently, she adapted her sessions, as far as possible, to the needs and capabilities of her different client groups.[100] She worked in different settings with a wide range of clients, from the mentally handicapped to chronic mental patients. Consequently, she experienced a wide range of behaviours.

The enthusiasm of medical staff was essential to the development and continued growth of art therapy departments. In one of the settings in which she worked, the art therapy department had been set up through the encouragement of one particular doctor, who made referrals to Lydiatt. He also liaised closely with her about her patients' progress. When this doctor left, referrals to art therapy tailed off.[101]

Lydiatt's effort, when encouraging spontaneous painting, 'to let a mood speak without seeking to control it and without being overwhelmed by it' received a sympathetic reception in *The Times* on the publication of her book. The reviewer distinguished her approach from 'art therapy in the conventional sense of the term', as 'popularized' by Adrian Hill. This statement assumes that the public were aware of art therapy, if only in the field of rehabilitation. Despite the fact that Lydiatt did not regard her work as 'psychotherapy', the review concludes by saying that spontaneous painting 'is a form of psychotherapy' that 'should be practised much more widely than it is'.[102] Here perhaps is the beginning of a public debate about terminology which is still prominent in art therapy today.[103]

In Diane Waller's (1991) brief but useful account of Lydiatt's work she equates 'spontaneous painting' with 'non-directive art therapy'.[104] Non-directive therapy has been described by Nikolas Rose as 'the reflection back of the speaker's own words by the voice of the therapist with the implication, I understand that, I accept you'.[105] Waller's remarks illustrate a misun-

derstanding of the nature of a Jungian approach which is quite different from a 'non-directive' method, despite superficial similarities. The Jungian method, as will be explored in further detail, saw the making of artwork as inherently curative and not requiring verbal analysis, or exchange. This point is explored in detail in Chapter Nine.

Conclusion

Clearly, the institutional practices and structures in place in the late eighteenth century are quite different to those of the twentieth century. Sensibilities have changed profoundly; a caveat needs to be put into place here regarding the intellectual difficulties inherent in making connections between the early moral treatment practitioners' use of art as therapy and that developed in the twentieth century. However, broad parallels can be drawn between the different periods under discussion. Both moral treatment and the development of the profession of art therapy in the twentieth century employed a form of individualised treatment, which required the active co-operation of the patient for its success. Both are concerned with the internalisation and assimilation of basic cultural rules.[106] The moral treatment practitioners asserted that engagement in the arts made patients more amenable to moral treatment. Similarly, Godward, for example, in the twentieth century emphasised that art therapy engendered a 'co-operative attitude' in patients. It also needs to be pointed out that I have lumped together influential art therapists who also happened to be trained occupational therapists, for organisational convenience. Many of the parallels drawn between this group of art therapists and the nineteenth-century moral treatment practitioners could well apply to other art therapy pioneers in Britain, not only those with a training in occupational therapy. Indeed, the group of art therapists discussed is, arguably, reasonably representative of much art therapy work being done in the period, as will become evident.

There are close similarities between the statements made by W.A.F. Browne, in the nineteenth century, and those of Petrie, Read and Bohm in the twentieth century. For example, Petrie's belief that engaging in the fine arts could 'induce a natural bias towards moral virtue' strongly echoes several of Browne's earlier remarks. There are similarities between Browne's idea of the arts as an 'elevated' activity and Petrie's remarks about the fine arts being the 'purest' form of self-expression. Petrie, in addition, stressed the 'civilising influence' of engaging in fine arts practice.

Lydiatt shared with Petrie and the moral treatment practitioners an interest in the spiritual dimensions of human existence, and saw this as being stimulated by art-making. Godward too seems to have worked comfortably in the Christian atmosphere of the Retreat, though unlike Lydiatt and the others he was willing to interpret clients' work, at least for the benefit of the medical staff.

Bohm (unlike Petrie and Godward) explicitly rejected the 'spontaneous' approach much favoured by Lydiatt, emphasising the importance of a structured disciplined approach to art-making. This places her closer in emphasis to the moral treatment practitioners' approach than the others. However, structured activities were seen as having an important role too by Petrie, Lydiatt and Godward. In this respect their work can clearly be seen as related to the moral tradition.

Lydiatt's views were not dissimilar from, and highly influential to, those art therapists practising in this period who discovered art therapy by routes other than an occupational therapy training (most art therapists had an art school background). She highlighted the importance of spontaneity in art-making, an emphasis which came directly from the work of C.G. Jung.

As I illustrated in Chapter Two, the moral treatment practitioners viewed patient engagement in the arts positively. I have noted similarities between the views of some of the first generation of art therapy practitioners and the proponents of moral means.

Notes

1 Groundes-Pearce 1957, p.24.
2 Crichton Royal Report of the Board of Directors 1928, p.509. Italics added.
3 Medical Superintendent McCowan in the 1943 Annual Report, p.21.
4 Showalter 1985, p.29 points to the model of 'moral insanity' as a deviance from socially accepted behaviour.
8 Report of the Retreat York 1930, p.5.
9 Report of the Retreat York 1937.
10 AR 1934, p.8.
11 AR 1934, p.8.
9 AR 1936, p.13.
10 AR 1937, p.10.
11 1797 annual report quoted in Digby 1985, p.63.
12 Report of the Retreat York 1937, p.10.
13 Report of the Retreat York: Medical and Spiritual Aims leaflet, c.1954
14 Report of the Retreat York 1942, p.5.
15 Report of the Retreat York: Medical and Spiritual Aims leaflet, c.1954.
16 Report of the Retreat York 1952, p.4.
17 Report of the Retreat York 1952, p.4.
18 O'Mennell 1955, p.434.

19 Report of the Retreat York 1952, p.3.
20 Report of the Retreat York 1953.
21 Report of the Retreat York 1953.
22 Case notes written by Bruce Godward, courtesy of June Murphy.
23 Case notes written by Bruce Godward, courtesy of June Murphy.
24 Report of the Retreat York 1966, p.16.
25 Report of the Retreat York 1975, p.28.
26 Biographical note written by June Murphy 1995.
27 Paterson 1995.
28 Bing 1981 cited in Paterson 1995, p.2.
29 Bohm cited in Waller 1991, p.85.
30 Petrie 1946b, p.137.
31 Petrie 1946b, p.138.
32 Petrie 1946b, p.139.
33 Petrie 1946b, p.138.
34 The first training course was established by Michael Edwards at Birmingham Polytechnic in 1969.
 Art therapy training was a one-year PG.Diploma until 1994 when training became two years
 full-time.
35 Petrie 1946b, p.140.
36 Petrie 1946a, p.87. Italics added.
37 Petrie 1946a, p.88.
38 Petrie 1946a, p.88.
39 Petrie 1946a, p.100.
40 Petrie 1946a, p.105.
41 Petrie 1946a, p.119.
42 Petrie 1946a. Italics added.
43 Petrie 1946a, p.91.
44 Petrie 1946a, p.92.
45 Petrie 1946a, p.91.
46 Such statements evince an anti-war sentiment. Many people in this period felt that technology was in
 some sense to blame for the war, that the technological and emotional development of the human
 race had gotten out of kilter, hence an anti-technological emphasis in the writing of many early art
 therapists.
47 Petrie 1946a, p.118.
48 Petrie 1946a, p.92.
49 Bohm 1958b, p.21.
50 Bohm 1958, p.11.
51 Bohm in unpublished interview, Roman 1986.
52 Bohm 1958, p.11.
53 Bohm 1958, p.11.
54 Bohm 1958, p.12.
55 Bohm 1958, p.12.
56 Bohm 1958, p.12.
57 Bohm 1958, p.13.
58 Bohm 1958, p.13.
59 Bohm 1958, p.13.
60 Bohm 1958, p.14.
61 Bohm 1958, p.14.
62 Bohm 1958, p.14.
63 Bohm 1958, p.14.
64 Bohm 1958, p.14.
65 Bohm 1958, p.14.
66 Bohm 1958, p.15.
67 Bohm in unpublished interview, Roman 1986.
68 Waller 1991, pp.87–88.

69 Rita Simon in interview with Susan Hogan 1994.
70 Lydiatt 1964.
71 Paterson in interview with Susan Hogan 1994.
72 Rita Simon in interview with Susan Hogan 13.08.1996.
73 Paterson in interview with Susan Hogan 1994.
74 Lydiatt 1971, p.35.
75 Paterson in interview with Susan Hogan 1994.
76 Lydiatt 1971, p.23.
77 Paterson in interview with Susan Hogan 1994.
78 Lydiatt 1971, p.42.
79 Paterson in interview with Susan Hogan 1994.
80 Lydiatt 1964.
81 Paterson in interview with Susan Hogan 1994.
82 Lydiatt 1971, p.28.
83 Lydiatt 1971, pp.37–38.
84 Paterson in interview with Susan Hogan 1994.
85 Lydiatt 1971, p.5.
86 Lydiatt 1971, p.28.
87 Lydiatt 1971, p.3.
88 A term used by Jung in the Collected Works Vol. 16 p.15.
89 Lydiatt 1971, p.136.
90 Lydiatt 1971, p.138.
91 Lydiatt 1971, p.138.
92 Lydiatt 1971, p.139.
93 Lydiatt 1971, p.139.
94 Lydiatt 1971, p.28.
95 Lydiatt 1971, p.8.
96 Lydiatt 1971, p.29.
97 Lydiatt 1971, p.7.
98 Lydiatt 1971, p.35.
99 Lydiatt 1971, p.36.
100 Lydiatt 1971, p.41.
101 Lydiatt 1971, p.40.
102 'Art as Psychiatric Therapy' in *The Times,* 3 March 1971.
103 The terms 'art therapy' and 'art psychotherapy' are still used interchangeably today by many art
 therapists whose practice is very similar or identical. Some published debate has taken place as to
 how the philosophy and/or practice of 'art therapy' versus 'art psychotherapy' is different without, it
 seems, much consensus. The 'analytic' art therapists' practice does seem genuinely to differ from the
 rest in their adherence to ideas from psychoanalysis and emphasis on 'transference'.
104 Waller 1991, p.18.
105 Rose 1990, p.246.
106 It was not within the scope of this chapter to produce the kind of detailed, specific, and
 contextualised analysis I should have liked about attitudes to the arts in the different historical
 periods under discussion. This will be the subject of future research. However, a more detailed
 analysis of attitudes to the arts in the twentieth century is provided later in this text.

Beyond X-Rays: Adrian Hill and the Development of Art Therapy within Sanatoria

How did art therapy develop in origins other than psychology and psychiatry? An artist, Adrian Hill, became interested in the therapeutic value of art when he was a patient in a tuberculosis sanatorium in 1938. Consequently, art therapy was employed as part of rehabilitation programmes for tuberculosis sufferers. Hill later practised art therapy in the rehabilitation of tuberculosis patients and injured soldiers. The National Association for the Prevention of Tuberculosis and the British Red Cross played an important role in supporting early art therapy programmes. It was with the help and encouragement of the medical profession that early art therapy posts were created leading to the employment of artists as auxiliary medical staff.

There are no detailed published works on the subject of the intellectual development of art therapy. However, Diane Waller's text, *Becoming a Profession*, covers the period from 1940 to 1982, and it is very concerned, as the title would suggest, with process of professionalisation of art therapy which she documents thoroughly; hers is essentially an institutional history. The formation of the British Association of Art Therapists (BAAT) in the 1960s is dealt with comprehensively, as are the negotiations of BAAT to gain a place on the Whitley Council, BAAT's campaign for recognition within the NHS, and the setting up of the first art therapy training courses. It is an invaluable record of these events. However, Waller only makes cursory mention of the development of art therapy within psychiatry, the topic I take up in my next chapters, and her account is lacking in intellectual context. Furthermore, her

book does not adequately illustrate the centrality of the art therapy in TB sanatoria to the development of art therapy as a whole.

There seems to be a general misconception amongst many practising art therapists today that the origins of art therapy lie only in psychoanalysis. For example, although Diane Waller is aware of Hill's work, her brief 1993 account emphasises the work of Bion and Foulkes at Northfield Hospital in the 1940s.[1] Though not irrelevant, these events were peripheral to the initial development of art therapy in Britain. Waller also makes passing mention of Joshua Bierer and the social psychiatry movement and the formation of the Group Analytic Society. Other recent literature which introduces art therapy (for example, Case and Dalley 1992 and Gilroy and Dalley 1989) also stresses the historical link with psychoanalysis. A recent text emphasises that 'early British pioneers' worked largely 'within a Jungian framework' and such a statement, though correct, is potentially misleading as it overlooks other major influences.[2] Dalley's 1987 account emphasises the work of an American writer, Margaret Naumberg, in its introduction, but Naumberg's work, which was psychoanalytically based, was not well known in Britain until the mid-1950s, by which time many art therapy posts had become established.[3] Of course, these texts are not serious attempts at writing history. However, they are relevant in illustrating how art therapy is viewed and portrayed today, a portrayal which is largely historically biased.

This chapter will illustrate how art therapy developed in sanatoria with particular reference to the period in which the first art therapy posts were established.

Adrian Hill: Rehabilitation through art therapy

Adrian Keith Graham Hill (1895–1977) was born in Charlton, Kent, on 24 March 1895, and educated at Dulwich College. He then studied at St John's Wood Art School (1912–1914) before moving on to the Royal College of Art (1919–1920). He served during the First World War as an official war artist on the Western Front (1917–1919). Hill was a practising painter and also visiting art master to Hornsey School of Art (1926). His art work was described as comprising landscapes and 'some rich and powerful interiors painted impressionistically, the best of which might have marked him out as a painter likely to follow the tradition of Sickert'.[4] He then taught life drawing and anatomy at the Westminster School of Art, London (from 1935), until he contracted pulmonary tuberculosis.

Hill was an enthusiastic proponent of modern art prior to his illness, writing on the need to enlighten the public by exposing them to Surrealism and abstract art.[5] The effects of his illness did nothing to diminish his own creative work; a critic wrote in 1945:

> Now illness served to bring him into touch with a deeper source of inspiration which for many is reached only through neurosis. It is, perhaps because the cause of the disturbance was primarily illness that with health again has come balance, though a different and richer balance than the one that he had before. The permanent effect of this period on Adrian Hill's work has been fundamental. In a sense he had to start again … Adrian Hill seems undoubtedly to have reached a period when he is doing better work than he has ever done before.[6]

Figure 6.1 How it All Began *by Adrian Hill, 1938*

Adrian Hill is historically significant because he coined the phrase 'art therapy' in 1942.[7] He described this work as a 'novel form of diversional therapy'.[8] A small man physically, Hill made up for his stature through his boundless energy which could be seen in his enthusiasm in promoting the technique of art therapy.[9] His enthusiasm is evident when he describes his activities, and those of his wife Dorothy (with whom he collaborated), as 'spreading the gospel'. Adrian Hill first practised art therapy at King Edward VII Sanatorium at Midhurst and helped to initiate several part-time appointments, including that of Edward Adamson.

Hill had the idea of art therapy whilst recovering from tuberculosis himself in 1938.[10] He had been admitted into hospital for a minor operation, which necessitated him lying in bed on his side for protracted periods of time. He found himself facing a flowering cyclamen which, when he was able to move more freely, formed the basis of an early composition. Thereafter he regularly drew or painted the objects which appeared on his bedside table.[11]

The concept of art therapy had come to him as a potential stimulus to counteract the mental and physical atrophy engendered by long convalescence. Hill postulated the need for creative expression as a deeply rooted 're-surgent instinct'.[12] Whilst still an outpatient in 1939 he started encouraging other 'invalids' to paint, first on a ward for service casualties, and afterwards in the more permanent departments for civilian patients. He found patients keen to try this method for the alleviation of morbid introspection.[13] Hill wrote: 'As soon as I was fully recovered, I started canvassing for likely talent, visiting "the bedders", giving talks and doing demonstrations on the black board to the "up patients" – showing reproductions and generally getting the sanatorium Art conscious.'[14]

Hill used the term 'art therapy' because he hoped to gain the support of the medical profession and he thought the term 'therapy' would appeal.[15] Surprisingly, he used the term despite his dislike of it. Hill thought 'art therapy' had a 'quackish sound'. This is also a period in which 'occupational therapy' was gaining professional ground and this may have influenced him in his choice of the term.

Hill, like many art therapy pioneers, was keenly aware of the destructive effects of the Second World War. Though there were many urgent needs to be met he felt that 'the extent of war damaged minds, bodies and hopes far exceed that of property and estate' and therefore represented an insistent need.[16] On another occasion, after lecturing to the Army Educational Corps, he wrote:

...it is natural that the soldier as much as the artist should turn to seek
mental refuge in the creative arts and thence to hope. When the world is
seething with death and despair the man in the street and his brother at
arms crave for such antonyms as expressed by life and faith: Art provides
nourishment for such longings.[17]

Such remarks indicate a spiritual dimension to Hill's beliefs regarding the
regenerative potential of the visual arts.

An emergency ward for service casualties opened in 1941 at the King
Edward VII Sanatorium, thus increasing the number of such patients there.
Pictures painted by the men varied in content between escapist portraits of
brunettes and depictions of horrific war scenes. (Hill disapproved of soldiers
copying from 'men only' pornographic magazines and such work was 'soon
abandoned' after his 'bored indifference to such dull and senseless trials of
skill' became apparent.)[18] Aeroplanes were also popular subject matter and
were often drawn with a high degree of accuracy.[19]

It is clear that Hill saw art therapy as something other than a merely
diverting or diversional occupation. When he referred to art therapy as a
highly specialised form of 'teaching', his use of inverted commas indicated
that 'teaching' did not quite convey his meaning.[20] In a paper of 1951 he
wrote that art

can no longer be dismissed as a mere diversional or recreational hobby
... Art therapy lays no claim to usurp the present diversional aids in any
way nor belittles the benefits derived from occupational therapy. But it
looks perhaps a little deeper in order to ascertain and alleviate the *essential
causes* of introspection and despondency.[21]

This is one of a number of statements made by Hill which attempts to distin-
guish art therapy from other methods available. That he was interested in the
'essential causes' of distress clearly differentiates his approach from
diversional therapy. It is interesting to note that in the early 1940s Hill
encountered opposition to the use of the term 'art therapy' from occupational
therapists. The use of the word 'therapy', according to the OTs who discour-
aged him from using it, implied a definite curative benefit to all individuals
who tried the method.[22]

In his book *Painting Out Illness* (1951) Hill noted that art therapy posts
were not clearly defined. However, he saw the role of the art therapist as
providing 'unique opportunities for bringing to light certain hidden mental
conflicts, which, through the right contact with the patient and under the

ameliorating creative impulse, are naturally translated in terms of picture making and thereby exorcised of their dread'.[23] Certainly the idea of exorcism suggests catharsis. In another text he explained more clearly what he meant by 'the ameliorating creative impulse' which he saw as a fundamental and integrative force; this integrative force seems to be linked to basic impulses. On this point Hill cites Herbert Read who refers to art as an 'instinct' of 'incalcuable power'.[24] In another text, Hill sees engaging in art work as stimulating 'honest animal spirits and riotous impulses'. These 'energies' he felt were beneficial to the patient.[25]

Tuberculosis was a stressful illness for a number of reasons. First, it was potentially fatal and some of Hill's work was concerned with people who were preparing to die. However, even those who were making a good recovery might be unable to resume their familiar employment, because of permanent disability, or because of the social stigma surrounding tuberculosis which resulted in sufferers being ostracised, even by friends and family who were afraid of contracting the disease. Employment for ex-tuberculosis patients could be very difficult to obtain and the social consequences of the disease could be as catastrophic as its physical manifestations.[26] Recuperation was often extremely slow which meant that men who were used to providing support for their families were frustrated by not being able to do so. Bedrest for months on end was a trial for many. Sometimes, in the case of a patient with a throat infection, they might be instructed not to speak. One patient at Tor-na-dee wrote of his experience '...two of the things I had to do...were stop speaking and, of course, stop smoking – that was hell'.[27] Hill was acutely aware that the temperament and character of the patient were of crucial importance to how they reacted to a physical illness; these personal factors, he argued, are 'more important than the symptoms of a disease like tuberculosis, which can assume amazingly different forms'. To produce good clinical effects he argued that it was essential to study the patients themselves, rather than looking at the individual as a 'theoretical problem of disease'.[28]

Adrian Hill also believed that art therapy had a role in mental hospitals as well as in sanatoria, where the 'subliminal outpourings' he felt were of diagnostic value in indicating the source of the problem. Patients using imaginative painting could, he argued, reveal 'an unsuspected self when "talking" with a pencil or brush'.[29] Hill was certainly willing to try almost any argument to promote his obsession, including that art therapy might make the difference between life and death: 'Who can tell,' he asked, 'at what moment a lethargic patient suddenly takes on a new zest for living, and who

can tell what frail straw will prove a "lifeline" to recovery?'.[30] However, some of the more ostentatious claims about the efficacy of the arts in hospitals were made by other people. For example, in 1948, a Mr Cosin, Medical Superintendent of Orsett Lodge Hospital, Greys, argued that geriatric patients suffering from rheumatoid arthritis might benefit from 'gentle movements in warm glowing colours' as manifest in pictures such as *Venus and Adonis* by Veronese.[31]

Hill attributed the successful introduction of art therapy at King Edward VII Sanatorium to Sir Geoffrey Todd, medical superintendent, and the enthusiasm of the nursing staff for the idea.[32] This was prior to the introduction of occupational therapy at the hospital in 1941. Nurses, he claimed, recognised 'artistic activity as an instrument for the restoration of the patient's personality whilst undergoing the discipline of protracted hospital treatment'.[33]

Hill's descriptions of providing art therapy at this institution sound exhausting. He worked there from 2.30 in the afternoon to 6.15pm. It was a huge building on five floors. His patients were widely dispersed and not always 'in' when he called which necessitated a return visit. Transport was frequently disrupted, art materials always in short supply. Hill described himself as walking many miles of corridor with his trolley of art materials and as suffering from fits of depression and frustration which resulted from 'mental strain', which he shared with patients, caused by wartime conditions.[34]

Hill usually invited patients to work on a theme such as 'view from my window' to get them started. He also recommended making rough sketches to plan the composition. If that seemed too daunting to the patient at first, he recommended that they start off by doodling. However, his methods varied depending on the interest and physical capacity of each patient. The onus was on them developing a personal way of expressing themselves. He said of his approach that 'I am loath to impart a textbook way of doing it, and only pass on such technical "asides" as will enable them to develop their ideas with greater coherence'.[35] As early as 1942 Hill had noted that art therapy presented the opportunity for patients to express 'the bitterness and resentment' that they felt about their condition by putting it into a pictorial form. However, in other cases he felt that the patient was more likely to develop a positive mental attitude by doing the very opposite type of painting[36] – for example, painting that was geared towards the depiction of outward reality or escapist fantasy which stopped one brooding on one's situation.

Institutional support for art therapy through the British Red Cross Society

In 1943 art therapy was started at the County Sanatorium in Milford with A.C. Eccott, a visiting art teacher from Charterhouse School, and a Miss Salvin who was responsible for art therapy.[37]

The Red Cross Picture Library Scheme had been instigated by a letter written by Hill to *The Times* in August 1943 about his work at the King Edward VII Sanatorium. It outlined his use of art not only to alleviate the mental and physical atrophy of long-term illness but to sow the seeds of a 'real and lasting appreciation of art'.[38] He also mentioned a lecture series in preparation. (In a further letter to *The Times* of 2.8.1943 Hill also mentioned the benefits of having reproductions of art works for hospital walls.)

This letter prompted further correspondence in *The Times* and a meeting between officials of the British Red Cross Society (BRCS) and Adrian Hill on 27 January 1944 at Grosvenor Crescent in London, and the formation of an art therapy advisory committee. At the meeting the decision was made to form a library of reproductions of well-known artists' work. These were to be shown, on an experimental basis, in six selected long-stay hospitals. The decision was also made to appoint visiting speakers who would visit the hospitals to talk about the works on show, and a table of fees was agreed for this work.

The director of the Courtauld Institute, CEMA (Council for the Encouragement of Music and the Arts), the Association of Industry and Design, and the Keeper of the National Gallery were amongst those who promised their co-operation and support regarding speakers and representatives. The scheme was put into operation in March 1944 when the first pictures were hung on the 31st of that month.[39] In addition to this, a sub-committee was established in 1945 to deal with administering the scheme; the formation of this sub-committee represents the first move towards the professionalisation of art therapy in Britain. Moreover, Millicent Buller, who was primarily responsible for administering the scheme, had visited Withymead and had been inspired by the work she had seen there.[40]

The British Red Cross Society Planning Sub-Committee identified two clear results of their pilot programme:

1. The first was the interest aroused among a very large number of patients, their desire to talk about the pictures shown them, and to ask questions.

2. The second result was the awakening, among some of the patients, of a desire to draw and paint themselves.[41]

Hill was very forthright about what he considered to be the benefits of the scheme, asserting that the provision of prints 'both modern and traditional – provide the cultural or art appreciation side of art therapy and are of equal remedial value to the actual picture making'. He quoted Florence Nightingale's *Notes on Nursing* in support of this claim: 'The effect in sickness of beautiful objects, of variety of objects and especially of brilliance of colour is hardly at all appreciated'.[42]

Mary Campion OBE is cited as responsible for the success of the early stage of this scheme (despite the fact that several of the selected hospitals were bombed).[43] For example, the London County Hospital received bomb damage closing five wards and destroying two entirely.[44] Millicent Buller described lack of available transport obliging Mary Campion to take to her bicycle: 'She went to the hospitals herself, in all weathers, often on her bicycle, the basket loaded with pictures and her person hung round with satchels full of art books; she was deterred by nothing – fog, blitz nor blackout'.[45] Hill's wife Dorothy also became involved with the BRCS picture lending library scheme as a 'picture lady'. Hill described Dorothy and himself discussing the patients and giving each other mutual support.[46]

Hill gave lectures to patients on the work of well-known artists such as Cézanne, Picasso and William Blake.[47] Works mentioned are Renoir's *La Lodge*, Constable's *Haywain*, Van Gogh's *Young Man, Annunciation* by Fra Angelico, *The Lady at the Virginal* by Vermeer, Brueghel's *Wedding Feast* (which produced lots of speculation), landscapes by Claude, as well as a series of lithographs produced by CEMA.[48] Hill recalled in one hospital taking down prints produced by the British Museum of the work of Cotman, Turner, Girtin and Sandby and replacing them with works by Manet and Alan Walton.[49]

The BRCS picture lending scheme proved to be popular. By 1946 it was servicing 100 hospitals, and by June 1950, 195 hospitals including mental and general hospitals as well as sanatoria.[50] There were also schemes run by the Welsh and Scottish branches of the BRCS. The pictures (over 4000 by 1950) were sent out from BRCS headquarters. No institution was canvassed by the BRCS but by 1950 there was a waiting-list of hospitals waiting to join the scheme.[51]

Buller felt that the pictures were important as a focus of discussion and debate. Lecturers were employed to help direct and expand such debates, visiting hospitals on a weekly basis. (Buller noted that on arrival patients were consulted about what picture they would like in their room. Even after the picture-library representative had left 'animated discussions took place' leaving the atmosphere of the ward 'quite altered and enlivened in consequence'.)[52] Initially, the institutionalised men showed little interest in either looking at or discussing pictures. However, it was the quality of the speakers which aroused interest.[53] Hill described a lecturing experiment which took place at one mixed-sex hospital in the sittingroom of the women's ward: 'Men came in, and one or two of the cripples from the cripple ward. This did not go well; the men were shy of coming over, the girls were inarticulate and the sister-in-charge disapproved!'.[54] It is clear from such descriptions that the lecturers needed great resilience and tenacity. Hill notes as particularly successful artists who demonstrated their techniques as well as giving a talk. Examples were a sculptor who modelled a head while the audience watched her. Another artist drew portraits of some of her male audience while the others watched attentively.[55]

Lecturing costs were met by the hospitals which made use of their services. The presence of pictures was seen as providing a catalyst to patients to produce their own imaginative painting which might reveal their attitude to their illness. Teachers were funded by the BRCS at those institutions not already provided with art teaching by the National Association for the Prevention of Tuberculosis (NAPT).

In February 1944 Hill started to give a regular criticism of patients' work. He involved those nursing staff who had an interest in art, particularly with the more 'difficult' patients.[56] On 17 June 1944 Hill started art therapy at the Holy Cross Sanatorium, Haselmere. Also in 1944 Hill met with Mr Gomme of the Ministry for Education, with the hope of art therapy 'creeping under the shelter of the government umbrella'; however, this meeting was not a success.[57]

On 20 December 1944 Hill opened an exhibition of patients' work at Mount Sanatorium, Hants. He was by this time regularly accepting invitations to visit hospitals and write articles for medical magazines.

Around 1945 he visited Withymead, though the effect of this visit upon his work is not very apparent.[58] He continued to praise the work of Herbert Read and Maria Petrie in particular and was not converted to a Jungian approach.

In 1945 Hill also published the first book on art therapy entitled *Art Versus Illness* which described his work in tuberculosis sanatoria. The book gained a mixed critical reception. *The Journal of the Royal Society of the Arts* reviewer worried that the benefits to be gained by art-making might be diminished by patients' lack of technical skills.[59] The reviewer complained of the 'fallacy in denying the desirability of appropriate (proper) skill of execution to make conception manifest'. *Studio* magazine was unenthusiastic about Hill's 'sanatorium pictures' (those that he had painted himself whilst a patient); the works were described as follows: 'The drawings are nearly all of solids; flowers, tulips for instance, assume the most sinister form. Fantasy…when it comes into the drawings is accompanied by nostalgia and bitterness'.[60] *The Journal of the Occupational Therapy Association* regarded the book as a 'challenge to our profession'. The jacket of the book, one of Hill's own paintings, stimulated the reviewer 'to examine one's own reactions to current exhibitions of contemporary art'.[61] Moreover, the OT journal felt that Hill was not unique in his promotion of the curative benefits of artistic engagement during illness, claiming of 'art therapy' that 'others, particularly in our own profession, have already attempted and sometimes achieved similar results'.[62] However, the review went on to talk about the difficulties of OTs facilitating this kind of work; namely, that OTs are 'not sufficiently qualified as artists' to assist patients with the technical aspects of art-making. Second, OTs were noted as lacking in time to undertake this work. In general the idea of art therapy was looked upon favourably and the review was sympathetic, noting its usefulness as a 'mental purge'. Not altogether surprisingly, the National Association for the Prevention of Tuberculosis (NAPT) liked the book, describing it 'as genuine, sympathetic and humorous as Mr Hill's own personality'. However, the review emphasised the practical aspects of art therapy in teaching skills which might help the discharged patient earn their living as draughtsmen [sic], craftsmen [sic] and designers, what has been called 'industrial art therapy'.[63]

An assessment of the use of art therapy under the auspices of the British Red Cross Society (BRCS) took place on 28 January 1948. This was largely a back-patting exercise. The opening address by Dr Balme OBE, Director of Welfare Services of the BRCS, emphasised the importance of taking a holistic approach to patients. Rehabilitation, he argued, was a new branch of social medicine and 'healing' no longer confined to the expert treatment of a particular organ of the body affected by disease or injury but aimed at 'the whole man or woman concerned, and their refitting for a useful place in the

community'.[64] Another presentation was given by Dr Maclay (Medical Senior Commissioner of the Board of Control). Maclay showed art work done by mentally ill people as part of their process of recovery.[65]

Promoting art therapy

In May 1946 Hill assembled 180 pictures produced by forty patients (thirty-five of whom were bed-ridden). These were displayed for the royal visit at King Edward Sanatorium. Hill took HRH the Queen around the exhibition during her visit and explained art therapy to her.[66] Shortly afterwards, he spoke at the first exhibition of 'invalid' art at the County Sanatorium, Milford, Surrey.[67] Hill was so impressed with the quality of the work on show that he mooted the idea of an inter-sanatorium art competition and the challenge was issued to Midhurst Sanatorium (which won the challenge), with other institutions joining in.[68]

Hill received numerous invitations during the 1940s to demonstrate his techniques at other sanatoria. His technique, he wrote, was able to 'go beyond the usual leisured diversions it was possible to show by the patient's pictures and the pleasure and relief they found in such free expression was often reflected in the medical reports of their improved medical condition. In other words they were actually made better…'.[69] In his frequent public lectures he often used the 'provocative' (in his words) title, 'Can Art Cure?' It was from 1946 onwards that he began to receive a large number of invitations to lecture to interested organisations. A shy man, Hill often found these occasions excruciating.[70] He was frequently introduced by well-intentioned chairmen as 'Doctor Adrian Hill' or a 'well known medical superintendent' and would then have to explain to his audience that he was 'but an artist!'.[71]

Hill had persuaded the Medical Superintendent at Hill End Hospital, St Albans, Dr Kimber, to employ an artist by the name of Norman Colquhoun.[72] This was on a part-time basis to run groups with patients.[73] Exhibitions of patients' art work from Hill End Hospital were exhibited in Foyles Art Gallery in London in the late 40s (the first exhibition of work from the hospital was held in February and March 1948). Dr Kimber, the Medical Director of the Mental Treatment Centre at Hill End Hospital, emphasised in the exhibition catalogue that 'free expression' through painting was 'becoming increasingly realised' as a form of 'rehabilitation' (Kimber 1948). In another publication he highlighted that the 'inner-resources' of the patient 'which make for healing and recovery' are activated by the process of art-making.[74]

Dr Kimber spoke of the success of the scheme in 1949. Kimber felt that in most cases the paintings transmitted 'understanding' and elicited 'sympathy' in the viewer. Exceptions to this were to be found, he believed, in works where 'a turbulent unconscious' threatens to 'overwhelm a patient'. Such a representation, he felt, might antagonise or disturb the viewer. However, in the main, Kimber felt that art was able to release 'internal forces' which may be unconscious. For him there was also a spiritual dimension to the use of art therapy, which opens 'a channel of communication with others – other spirits'. This he felt could lead to a feeling of relatedness and assurance. The process of change engendered by art-making might be only dimly conscious or the subject might be totally unaware of it. Be that as it may, Kimber asserted: 'Though the individual may be unaware of the process of change, the results of this process are realised as a change of mind, and heart, a release and integration'.[75]

In July 1947 Hill organised another exhibition of patients' art work for the Commonwealth and Empire Health and Tuberculosis Conference, Central Hall, Westminster, where he also gave a talk entitled 'The Human Factor'.[76] At this event 124 drawings and paintings were exhibited from all over the British Isles and prizes awarded to Milford and Yardley Green Sanatoria. It was also announced at this conference that Hill was to be awarded the honour from the French National Academy of Medicine of 'Laureat de l'Académie de Médecine'.[77] In 1948 he was invited to speak on art therapy in hospitals. Another exhibition of hospital art was arranged, this time not by Hill, for the Professional Nurses' Conference at Seymour Hall. (Not surprisingly at this event Hill emphasised in his talk that co-operation between medical and nursing staff and the visiting art therapist was essential to the success of the venture.)[78] He also showed Princess Louise around the exhibition.[79]

Yet another exhibition was held with the support of the NAPT in 1949 and 500 drawings and paintings from nearly 30 sanatoria were exhibited. The former director of the Royal College of Art, Mr P. H. Jowett, opened the exhibition and expressed surprise at the quality of the work exhibited, as this was the first art therapy work he had seen. The President of the NAPT HRH the Duchess of Kent visited the exhibition and paid tribute to the standard of work.[80]

At the conference Hill gave the talk entitled 'The Human Factor', in which he argued that art therapy could yield improved medical results. He noted the growing interest amongst psychologists in patients' art work as a

diagnostic rather than a therapeutic tool. He was willing to concede that 'a closer study of the patient's mind, through the spontaneous testimony of their symbolic ideographs which they subconsciously create, may help us to unwrap the tremendous mystery of the mind'. However, his interest was firmly on the therapeutic benefits to be derived in helping 'bewildered' patients adjust to their predicament and 'build up a strong defence against physical disability'.[81] This separation of the notion of 'therapeutic' from the idea of 'analysis' was later to get Hill into trouble with the British Association of Art Therapists (BAAT), which became increasingly analytically orientated from the mid-1960s and was perhaps briefly dominated by this outlook. Certainly, Hill felt that it was the exhibitions in particular that were responsible for the official recognition that art therapy subsequently attained.[82]

Another tuberculosis patient, Frank Brakewell, had engaged in art therapy under Hill's guidance whilst ill. Brakewell became one of the first people to assist Hill in his work at King Edward Sanatorium and was soon to be appointed visiting teacher in two hospitals.[83] Brakewell had undergone major surgery and was left with only one lung. His particular area of interest was with patients who did not fully recover and, like himself, had to learn to live with permanent disability. He was very concerned with the use of art therapy in after-care. He worked at a number of hospitals including St George's Hospital for Chest and Heart Conditions.[84]

Immediately after the end of the Second World War Hill was making fortnightly visits to several institutions but he could not cope with the work load. He felt that local artists should be appointed to sanatoria so that more frequent visits could be made to sustain patients' interest. It was this frequent contact between the patient and the art therapist that Hill regarded as absolutely essential to the success of the work.[85] By 1948 several teachers had been appointed to sanatoria. Occasionally a patient would become so enthusiastic about the use of art therapy that they would offer to assist him in his work after they had recovered from the worst of such illness. Some went on to become art therapists; Hill recounts the story of one such patient, called Daphne.[86]

On one visit made toward the end of the 1940s, Hill was greeted by a diffident medical superintendent who told him that he '"would find no artistic talent or interest in this type of sanatorium", but that if I cared to "wander round a bit" I was perfectly free to do so... I felt very much like a commercial traveller on a bad day'.[87] However, by the 1950s Hill notes an improvement in the climate towards art therapy. Perhaps Winston Churchill's

book *Painting as a Pastime* (1948) had some influence in the development of interest in art therapy. In his book Churchill recommends painting as an aid for coping with stress. Hill notes surprise at the number of doctors he met who painted in their spare time.[88]

Hill continued his campaign for art therapy throughout the years that followed. This included trips abroad and radio broadcasts. Although he used 'art therapy' as a term to appeal to the medical profession, and clearly he was socially acceptable enough to meet royalty, he remained antagonistic to the depersonalised atmosphere of sanatoria and hospitals. He described his own hospital room as 'bleak and hygienic'.[89] Quoting an unnamed author, he approved a military metaphor:

> Art therapy has recently been likened to 'a very big gun which has fired a thunderous cannonade in support of aesthetics versus so-called scientific medicine'. I am delighted to hear this and only hope it is true, and that I have sufficient ammunition to sustain the bombardment![90]

In February 1949 Hill was invited to become chairperson of the art therapy committee set up by the South West Metropolitan Hospital Board. Hill was 'elated' by this measure of official recognition. The board was concerned to assist in furthering artists in hospital schemes and supplying materials to hospitals in need of basic equipment, as well as providing a forum for the interchange of experience. He said of this appointment that 'to be able to discuss future problems with such medical experts as Sir Geoffrey Todd and Drs Cunningham Dax and Louis Minsky in a spirit of friendly co-operation is for me a real reward'.[91] In April 1949 a questionnaire on art therapy was circulated in the South West Region and the overall response to the idea of art therapy was positive.[92] Indeed, in those cases of sanatoria in which art therapy had already been established, responses to the questionnaire were entirely favourable. There was a slight note of warning about patients painting '*too* enthusiastically!'

After the report had been analysed three distinct aspects of art therapy were identified. In summary, in sanatoria and long-stay hospitals the advantages were seen to be gained by the recreational and occupational aspects of painting. Second, in mental hospitals art therapy was noted to have diagnostic and therapeutic value. Third, in hospitals (particularly long-stay hospitals) the provision of 'good pictures' or reproductions on the walls of the ward were considered to have benefits as already outlined.[93]

The National Association for the Prevention of Tuberculosis art therapy scheme

The National Association for the Prevention of Tuberculosis (NAPT) has been described, by a leading historian of tuberculosis,[94] as a 'middle-class organisation' which had its 'emphasis on individual responsibility and education rather than on broader social and economic conditions detrimental to health'.[95] Given this accent to its activities, it is not surprising that the NAPT should embrace the use of individualised therapy. The NAPT became committed to the use of art therapy. Hill had first approached the organisation in July 1944 and the initial response of the NAPT had not been favourable; indeed, Hill had been upset by their lack of enthusiasm.[96] However, he had supporters within the NAPT from the start, as clearly evinced by a provocative editorial in the NAPT *Bulletin* of October 1944, which enthused about art therapy and then noted lack of support for art therapy developments: 'There have been rumours that such an experiment is considered impossible by high authorities. If so, will they come out into the open and produce reasons for their objection? Or is this a case of red-tape masquerading as high principles?' asked a provocative editorial.[97]

Hill was keen to get the support of the NAPT because he was 'lacking some central authority' to which he could refer when 'wishing to give official weight to the scheme'.[98] He felt that with the backing of the NAPT the scheme could be greatly extended to hundreds of patients throughout the network of sanatoria dedicated to the treatment of tuberculosis and to which the NAPT had easy access.

Hill's meeting with the NAPT did have some effect, as it aroused interest. The October 1944 issue of the NAPT *Bulletin* contained an account of his work. Shortly afterwards the NAPT received an offer from an unnamed artist who was prepared to teach patients. She was appointed to teach both directly and by correspondence.[99]

Under the auspices of the NAPT a 'conference' on the topic of art therapy was held in 1946. It included several medical superintendents, representatives from the Arts Council as well as several artists, and speakers included the Duchess of Portland (chair), Sir William Crawford, Mr Philip James (Director of the Arts Council) as well as the medical directors of Pinewood and Papworth Hospitals. Indeed, an odd mixture of people were invited to join a panel of authorities to judge work presented in the sketch club competitions, including the editor of *Studio* and *The Artist* magazines, a Lady Beaman who worked for *Punch*, and R.K. Jamieson who was principal of St Martin's

School of Art. Artists invited to join the panel included John Farleigh, Sam Spencer and Adrian Hill.[100] It is not clear from the meeting notes whether Hill was actually in attendance at this 'conference' but his work was mentioned.[101]

Another larger event was held at Tavistock House in November 1948, where ideas about the development of art therapy were discussed with the NAPT officials and a number of artist visitors, including Hill. There followed a series of meetings. By the end of 1948 several art teachers had been appointed to thirteen sanatoria, arranged and paid for by the NAPT, and these included Sam Spencer.[102] In some cases the hospitals concerned took over the cost of the art therapy.[103]

The NAPT also gave support to another scheme initiated by Mr and Mrs Sefton to introduce industrial art therapy into hospitals.[104] The emphasis of 'industrial art therapy' was less on diversion and more on teaching new skills in art and craft to the tuberculosis sufferer. This was done with the aim of securing some training and future employment for those who, because of permanent disability, could not return to their former employment.[105]

The benefits of art therapy were seen by the NAPT as giving 'creative occupation' to the tuberculosis patient who, 'however courageous', however lucky, 'has to brace himself for months of idleness and anxiety'. Art therapy is stated as being useful for the expression of bottled-up energy: '...it can purge away emotions that have to do with depression, pessimism, and illness' during both the treatment period and during convalescence. Their leaflet proclaims that 'art therapy (or curing) is correctly named, for it may contribute a definite factor in the long and tedious process of arresting the disease, its influence penetrates deep. Art can get to places in the human organism beyond the reach of medicines, beyond X-rays'.[106]

The NAPT art therapy scheme is noted to have completed work with a relatively small number of tuberculosis invalids. Their work included the encouragement of art works for competitions.[107] After Hill's initial approach to the NAPT, in order to encourage patients in remote sanatoria to paint, regular art competitions were introduced in the latter half of 1945. In a report produced about the scheme in June 1949 by the welfare secretary, Nancy Overend, it was noted that art competitions occured at least six times a year in 120 sanatoria from Cornwall to the North of Scotland. The average number of entries per competition was around 300 paintings. The art works were judged by a panel of experts including Sam Spencer and Adrian Hill. The panel did not just award prizes but gave advice to patients about their

work in the form of a critique. Adrian Hill and Spencer also engaged in teaching.[108] Between January 1946 and June 1949 the NAPT had sponsored around 400 visits to sanatoria. By 1952 ten artist teachers were engaged in this work.[109]

The competitions were organised under sections including still-life works, landscapes, design, imaginative composition and a separate children's section. Four or five times a year themes were suggested by two of the art panel, John Mennie and Sam Spencer, such as 'a winter landscape' or 'a greengrocer's window'. By 1952 the scheme had extended to 190 sanatoria and to 240 patients in their own homes.[110] Patients were given a month to send in their art work and then some 500 art works were classified ready for the opinions of the 'panel of experts'. Between twenty to thirty prizes would be awarded per batch. Then all the works were re-packaged and returned to the patients.

Although in 1946 Hill noted a shortage of art instructors, by 1948 he was receiving a steady stream of letters from artists and art teachers keen to teach in hospitals.[111] Hill described visiting art instructors. He asserted that they 'must be in love with the work, understand sick people, be tolerant and sympathetic, and able to inspire confidence and maintain [art] output'.[112] In addition to these activities murals were also painted in some hospitals, an activity Sam Spencer was particularly enthusiastic about.[113]

In 1948 the NAPT scheme was expanded and more staff employed including Catherine Bridge, Jean Fox, John Mennie and Rita Sowerby (Rita Simon). Visits had been extensive, involving artists travelling as far as Tor-na-dee in Aberdeenshire.

An informal meeting of some of the artists who visited sanatoria was facilitated by Nancy Overend of the NAPT on 25 October 1950. Amongst those present at this meeting were Otway McCannell (Milford), N.C. Colquhoun (Hill End), Rita Simon (Benenden) and Miss Outram (Pinewood). The report of the meeting emphasised the high sense of vocation found amongst the artists visiting sanatoria. It is clear that they saw their visits as performing something other than pure diversion. The report states that demonstrations were given by artists and that 'stress was laid on the opportunity afforded to the sympathetic visitor to help in the psychological or spiritual fields'.[114] Adrian Hill himself theorised that the lyrical outpourings which often accompany the serious stages of an illness were to do with a 'contemplative attitude' and a 'spiritual urge' developed in such circumstances.[115]

Figure 6.2 NAPT leaflet on art therapy c.1946

Adrian Hill went on to work for the BBC, presenting an art programme
called 'Sketch Club' from 26 September 1962. He appeared on screen in the
series resplendent in beret and smock, with palette in hand. The programme
had a practical emphasis and Hill would get to work conjuring up an image
with a few simple marks. He had acquired skills in demonstrating the funda-
mentals of composition whilst promoting art therapy. He had often arranged
for a blackboard or flip-chart to be set up when he was lecturing to not
always sympathetic audiences. On the television programme Hill would
become so engrossed in his work that a gong would have to be sounded to
remind him that the programme was about to end![116] Unfortunately he was
forced to give up his work on this programme due to a worsening heart
condition. This left him saddened.[117]

Hill's inspiration and institutional developments got a number of people
interested in pursuing a career in art therapy. Diane Waller's text on the

history of art therapy is rather dismissive of Hill, whom she sees as using art as a distraction[118] or promoting high art as a cultural missionary worker[119] when, as she says herself, he was essentially a populist, best known for his 'how to paint' books which are hardly avant-garde or overly intellectual.[120] However, she does give him some credit for his work as an organisational leader, culminating in his presidency of the British Association of Art Therapists.

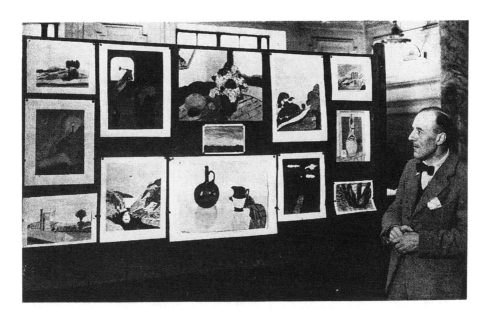

Figure 6.3 Art therapy exhibition with Mr Adrian Hill, RBA RI, ROI, in the foreground

Other sanatoria art therapists

Another pioneer of art in sanatoria is Elsie Davies. She worked as an art therapist at the City Sanatorium in Birmingham and based her approach on that of the late Arthur Segal. Segal had used painting as a cure for people with nervous disease in London.[121] This method, which she referred to as 'the Arthur Segal method', differed from that practised by Adamson, for example, in that it was not aimed at free self-expression or catharsis but represented a structured, 'methodical' use of art materials. Important features of this method Davies stated as the development of form in paintings through

observation of light and shadow and the development of an appreciation of objects in these terms. Students would acquire an understanding of '*objective optical laws*'. Composition planning was considered to be important as a means of introducing 'order into the chaos of feeling'. This, Davies felt, influenced the patient's own sense of inner order and harmony.

Davies summed up the benefits to be derived by her approach thus:

> It has already been proved that nervous or invalid people reacted beneficially when practising this methodical way, which is the combination of order and pleasure and concentration with the aim to develop the personality and unite the individual with reality, so often lost. In this way self confidence is re-established and a balance between reason and emotion beneficially achieved.[122]

Davies emphasised the importance of a structured approach because paintings which were 'subjective or unconsciously painted', although useful for diagnostic purposes, were painted for the psychologist or psychiatrist and therefore did 'not give the greatest pleasure or satisfaction to the patient'.[123]

Joyce Laing commenced work in sanatoria in Scotland some years later in 1956. Although by this time many art therapists were working in English institutions, relatively little activity had taken place in Scotland and Laing is significant for this reason, though she did not use the term 'art therapist' until the 1960s. She had been inspired by the example of a fellow-student who had contracted tuberculosis and who was then invited to do some teaching in the sanatorium on his recovery. Following his example, Laing became interested in work in sanatoria.[124]

Since Tor-na-dee had been part of the NAPT visitor scheme since about 1948, Laing was by no means the first art therapist working in Scottish sanatoria. The initial staff of the NAPT scheme included Adrian Hill, Catherine Bridge, Sam Spencer, Jean Fox, John Mennie, Rita Simon and Walter Alcott. Several of the staff made regular visits to Tor-na-dee.[125] This team was joined by Walter Spadbery in 1949.[126]

Laing felt attracted to medical environments because there were some doctors in her extended family. She worked under the NAPT scheme in the late 1950s in two sanatoria in Deeside, one of which housed male ex-military personnel, mainly from the Glasgow area; these men had contracted tuberculosis during their national service. (These sanatoria were maintained by the Scottish Branch of the British Red Cross Society.) Apart from Tor-na-dee

near Aberdeen, there was also a sanatorium named Glen-o-dee in the town of
Banchory.[127]

Laing was appointed sessionally as a 'cultural visitor' and sought to see all
of the patients who were interested or sufficiently well to do some art work or
engage in a chat. In addition to her NAPT work she administered the British
Red Cross picture lending scheme at the sanatoria, which included the
hanging of art works. This precipitated her first-ever experience of conflict
with other staff, who had strong feelings, she discovered, about art. She
recounted hanging a Rembrandt portrait in a corridor and having a nursing
sister approach her and say, 'You're not going putting that dreary thing
outside my door are you?'[128]

Laing entered about 80 per cent of the art work produced by patients for
the NAPT competitions. This was done as much for the written review of the
work that always came with the returned works as for the cash and other
prizes. Her responsibilities were wide ranging and included talks about art,
hanging the Red Cross picture loans, organising exhibitions of patients' art
work, and getting involved in the making of sets and costumes for the
Christmas 'panto' and other festive and theatrical events.

Sundays were chosen as the day to broadcast internal hospital radio
programmes which had been pre-recorded because there were no ward
rounds or other events on that day. Records were played by a DJ, or the
hospital chaplain would give a talk. Laing used this opportunity to commu-
nicate with the patients en masse. Often her broadcasts were utilitarian, sug-
gesting a theme on which art work might be produced and informing
listeners of the deadline for uplift of art works for the next NAPT competi-
tion. However, she was also more adventurous in producing talks on
paintings which she had previously hung in the canteen. Reproductions of
work by artists such as Van Gogh were discussed and those patients with the
physical ability and inclination could station themselves in front of the art
work for the best effect.[129]

Laing was only in her early twenties when she started this work. She said
that she found it hard to know quite what the men made of her visits. Men in
a single room were much more likely to share their feelings than those in a
shared space. One man with bad hearing thought she was the 'heart special-
ist' rather than the 'art specialist' and was subject to some worrying specula-
tion about his condition because of this misunderstanding! She said of her
work at Glen-o-dee, 'I was a woman coming into an all male environment —
so you were onto a winner, weren't you?'

Laing didn't work with a system of referrals, playing the situation 'by ear', and her contact with doctors was limited. Her main contact with sanatoria staff was with nurses, particularly with the matron and nursing sisters. These women would tell her how the men were and alert her to anyone in particular need of attention, or those too ill to be disturbed. Passing in a corridor, doctors might ask her about a particular patient or his art work.

Laing described herself as well integrated into the hospital routine and having a good relationship with staff. She was appalled when she later met art therapists, such as Adamson, who were relegated (as she saw it) to huts in the hospital grounds.[130] This indicates an important philosophical difference between herself and Adamson.

Dr John Collee (referring to the career of Nurse Avis Hutt which started in 1935) recalls conditions in hospitals at the time as being rigid and authoritarian:

> Hospitals back then were run on the military model. If you broke a thermometer you were outside matron's office waiting, terrified, for a reprimand. If a telephone message came for one of the doctors, then a junior nurse wasn't allowed to relay it herself. She spoke to the staff nurse who spoke to the sister and so on up the chain of command until the message finally reached the Great Man.[131]

Adrian Hill confirmed this view, referring to 'God-like medicos';[132] Bryder's (1988) research on the history of tuberculosis confirms that many tuberculosis hospitals were highly regulated authoritarian regimes.[133] Edward Adamson, as I have noted, felt that the placement of his studio in the hospital grounds was essential in distinguishing his work from the highly regulated norms of hospital life. He attempted to create an atmosphere of freedom where patients could truly be 'themselves'. Laing, on the other hand, felt entirely at ease in the authoritarian atmosphere of the military sanatoria. She was essentially conformist in her attitudes, obedient to authority and obsequious to the medical profession.

Laing later met Winifred Gaussen and Irene Champernowne from Withymead and attended some of the first art therapy meetings in London and some the early training courses at 'butcher' Cumberland's Lodge. Though not a notable intellectual, Laing felt a sympathy with her predominantly male clients. Laing was to found the first art therapy department in a psychiatric hospital in Scotland, at the Ross Clinic in Aberdeen at the Royal Cornhill Hospital, which was one of the earliest art therapy projects in Scotland.

Another artist who became interested in art therapy through his own experience of tuberculosis was Hyman Segal, who was blind for over two years as a result of his illness. Born on 26 May 1914 in London, he studied at St Martin's School of Art, becoming a professional painter specialising in oils and pastels. He then moved to St Ives in Cornwall. Segal became involved in art therapy after he was invited to give a lecture at the local tuberculosis sanatorium. An article on his work appeared in *The Artist* magazine in 1951. It remarked that the magazine had received a number of enquiries from people wishing to become art therapists, and noted the lack of formal training in art therapy. It went on to opine on what qualities and experience were needed for art therapy:

> ...the most important qualifications for this type of work: namely, the ability to draw and paint and to teach these subjects; and further, a sympathetic understanding of the sufferings of others combined with a keen desire, often born of suffering oneself, to give one's best to help others overcome grave disabilities.[134]

Conclusion

Adrian Hill was a tireless and obsessive pioneer of art therapy, creator of the term and initiator of the first art therapy posts in Britain. Although, as I have noted, he used the term 'art therapy' to win the favour of the medical profession, he disliked the term and psychiatric jargon in general. However, he was willing to work closely with the medical profession and was perturbed by attempts in the 1960s to align art therapy with education. He did not, however, believe that it was the art therapist's role to initiate the production of images for the purpose of analysis or as an adjunct to psychoanalytic psychotherapy, whether this be carried out by the art therapist or a psychiatrist, although he acknowledged that images could be used as a diagnostic aid, indicating the general state of mind of patients. This, in turn, could have implications for the most appropriate treatment patients might be offered. Nevertheless, Hill saw art therapy as a form of therapy, offering much more than mere diversion. I have also noted an underlying interest in spiritual matters in the attitudes of many of the art therapy pioneers. It may be that this spiritual accent was underplayed because of Hill's enthusiasm for art therapy to develop a professional footing. However, institutions sympathetic to holistic medicine were likely to tolerate an interest in things spiritual.

Hill was keen for art therapy to gain official recognition, and it is largely his efforts which were responsible for the first formal institutional supports that art therapy gained in Britain. He was charismatic and charming, and able to move comfortably in the upper-class circles in which he promoted art therapy with so much enthusiasm. He certainly did not consider himself an 'outsider' to the hospital regimes in which he worked in the way that Edward Adamson clearly did, though he saw art therapy as countering the objectification and depersonalisation of the patient in the medical model.

Adrian Hill's fervour towards art therapy can be accounted for by the fact that he himself had had tuberculosis, had suffered in a TB sanatorium, and seen fellow patients die from the disease. When Hill talked about art therapy making the difference, in some cases, between life and death, it was not just rhetoric but a heartfelt belief. This clearly had a persuasive effect on his audience.

Adrian Hill worked mainly with individuals in their rooms or by their beds, though group discussions about art works were encouraged. When it came to patients talking about their feelings with Hill, this tended to take place on a one-to-one basis.

As I shall explore in the next chapter, in the late 1960s the prevailing opinion within the newly formed British Association of Art Therapists (BAAT) began to swing round to viewing an analytical approach as desirable for art therapists. It is a cruel irony, but as a result of this change of mood Hill felt increasingly ostracised. Indeed, it has been suggested that Hill was actively rejected from BAAT by those in control. Rita Simon, a pioneer art therapist, said, 'I was in Ireland at the time and maybe this is just my impression that he was more or less pushed out. I think it is tragic...'[135]

Notes

1 Waller 1993, p.5
2 Case and Dalley 1990, p.2.
3 Dalley et al. 1987, p.2.
4 Lukas 1945, p.78.
5 Hill, letter to The Times, 1.12.1939.
6 Lukas 1945, pp.80–81.
7 Hill 1951, p.13.
8 Hill 1946, p.21.
9 Naylor, personal correspondence 9.12.1995.
10 Hill 1951, p.14.
11 Hill 1948, p.13.
12 Hill 1946, p.93.
13 Hill 1943, p.48.

14 Hill 1946, p.93.

15 Hill 1951, p.13.

16 Hill 1948, p.viii.

17 Hill 1947b, p.56.

18 Hill 1948, p.27.

19 Hill 1948, pp.26–27.

20 Hill 1951, p.43.

21 Hill 1951b, Italics added.

22 Hill 1948, p.88. (Hill was advised not to call his work 'diversional therapy' but held on to the term 'art therapy' nevertheless. 'Diversional therapy' was a term used during this period by OTs so Hill's use of language may have been seen as encroaching on the OTs' occupational territory.)

23 Hill 1951, p.43.

24 Hill 1947, p.55.

25 Hill 1948, p.96.

26 Bryder 1988, pp.5–6.

27 Jock 1950, p.186.

28 Hill 1948, p.35.

29 Hill 1951, p.43.

30 Hill 1951, p.31.

31 This particular experiment was carried out with great enthusiasm. Murals were painted, reproductions of art works hung and colour introduced to all the wards, including ceilings which were 'colour washed' to give them the appearance of 'rippling water' (Marshall, M. 1948, p.277).

32 Art therapy was started with the permission of the chairman of the hospital board, Sir Courtauld Thomson (letter to *The Times* 21.08.1943).

33 Hill 1951, p.13.

34 Hill 1951, p.16.

35 Hill 1943, p.49.

36 Hill 1948, p.33.

37 Hill 1947, p.55.

38 Letter to *The Times* 21.8.1943.

39 Hill 1948, p.89.

40 Hill 1946, p.21.

41 BRCS Planning Sub-Committee Report, October 1945.

42 Hill 1946b, pp.5–6.

43 Buller in Hill 1951, p.46.

44 Hill 1948, p.89.

45 Buller in Hill 1951, p.46.

46 Hill 1951, p.44.

47 Hill 1943, p.49.

48 Hill 1948, p.97.

49 Hill 1948, p.92.

50 In addition to their work in Britain the British Red Cross Society used art with survivors of concentration camps. For example, art was used with children from the Belsen extermination camp in Germany following its liberation in the spring of 1945 (*BRCS Quarterly Review,* April 1946, Vol. 33. No. 2).

51 Buller in Hill 1951, p.48. Buller's statistics may have slightly exaggerated in this account as in an official report of 1947 she noted that the picture library scheme was established in 40 hospitals and that 37 enquiries had been received from other hospitals (Buller 1947, p.43). These figures are more in line with those presented by Hill who in 1946 noted that 28 hospitals were being serviced by the scheme (Hill, letter to *The Times* 02.05.1946).

52 Buller 1947, p.42.

53 Hill 1948, p.89.

54 Hill 1948, p.91.

55 Hill 1948, p.91.

56 Hill 1951, p.17.

57 Hill 1951, p.18.
58 Waller 1991, p.99.
59 I.M. [unnamed reviewer] Royal Soc. of Arts 1946.
60 Lukas 1945, p.80.
61 English 1946, p.12.
62 English 1946, p.13.
63 Hill 1946, 'Art Versus Illness' p.32.
64 Balme 1948, p.1.
65 BRCS report on the Picture Library Scheme, 28.01.1948.
66 Hill 1951, p.18.
67 Hill 1947, p.55 and Hill 1948, p.104.
68 Hill 1947, p.55.
69 Hill 1951, p.15.
70 Rita Simon in interview with Susan Hogan, 1995.
71 Hill 1951b.
72 Colquhoun was born at Ventnor on the Isle of Wight in 1912. He attended Warwick School and then Bristol University, graduating in science in 1933. After the war he dedicated himself to art therapy.
73 Roman 1986, p.36.
74 Kimber 1949.
75 Report on Kimber's speech in *Rehabilitation* 1949, p.18.
76 Hill 1951, p.27.
77 NAPT *Bulletin*, Oct. 1947, p.103.
78 Hill 1948, p.xii.
79 Hill 1951, p.29.
80 NAPT Conference Report, p.104.
81 Hill 1947b, p.201.
82 Hill 1951, p.29 and NAPT *Bulletin,* July 1949, p.131.
83 Hill 1951, p.15.
84 Rita Simon in interview with Susan Hogan 20.12.95.
85 Hill 1951, pp.32–33.
86 Hill 1951, p.97.
87 Hill 1951, p.23.
88 Hill 1951, p.24.
89 Hill 1948, p.18.
90 Hill 1951b.
91 Hill 1951, p.41.
92 Hill 1951, p.41.
93 Hill 1951, pp.41–42.
94 Bryder 1988.
95 Bryder 1988, pp.19–21.
96 Rita Simon in interview 13.08.94.
97 NAPT *Bulletin* editorial, Oct. 1944, p.2.
98 Hill 1951, p.25.
99 NAPT *Bulletin,* Dec. 1944.
100 NAPT *Bulletin,* Feb. 1946, p.27.
101 Diane Waller's account of 'The first art therapy conference' is therefore incorrect as this event predates the conference in 1949 which Waller claims to be the first (Waller 1991, p.95).
102 Spencer 1946, p.23.
103 Hill 1951, p.26.
104 Petrie 1946, p.137.
105 Hill 1946, p.95.
106 NAPT leaflet on art therapy c.1946.
107 NAPT leaflet on art therapy c.1946.
108 NAPT leaflet on art therapy c.1946.

109 NAPT 'Art by Post' Report 1952, pp.679–680.

110 Artist visitors travelled to hospitals not already serviced by art therapists including: Barrowmore Hall, Chester; Didworthy, Devon; Broomfield, Essex; Baguley; Brenden; Care Hall; Danesbury; Godalming; Grove Park; Pinewood; Redhill, Middx; Chard; Cheshire Joint Sanatorium; East Fortune; Highroyds; Kettlewell; Marguerite Hepton Hospital, Yorkshire; Paddington; Tor-na-dee, Aberdeenshire; Quantock Sanatorium; Royal Naval Hospital; Plymouth; Southend; Wrightington (NAPT Art Therapy Scheme 1948, p.122).

111 Hill 1946, p.95 and Hill 1951, p.42.

112 Hill 1948, p.xii.

113 Spencer 1947, p.33.

114 NAPT *Bulletin* Report 1950, p.451.

115 Hill 1946b, p.4.

116 Hartley 1983, p.138.

117 Conversation with Hill's son Anthony Hill (April 1996).

118 Waller 1991, p.7.

119 Waller 1991, p.48.

120 Waller 1991, p.48.

121 Petrie 1946b, p.137.

122 Davies 1936, pp.18–19.

123 Davies 1936, p.20.

124 Joyce Laing in interview with Susan Hogan, 1995.

125 NAPT *Bulletin,* October 1948, p.193.

126 NAPT *Bulletin,* June 1949, p.103.

127 Joyce Laing in interview with Susan Hogan, 1995.

128 Joyce Laing in interview with Susan Hogan, 1995.

129 Joyce Laing in interview with Susan Hogan, 1995.

130 Joyce Laing in interview with Susan Hogan, 1995.

131 Collee 1995, p.46.

132 Hill 1951, p.31.

133 Bryder 1988, p.205.

134 *The Artist* 1951, Vol. 54, p.33.

135 Simon 1986, p.6.

Pioneers of Art Therapy:
Research at Maudsley and Netherne Hospitals

In the last chapter I argued that it was the art in the tuberculosis sanatoria movement that provided the 'motor' for subsequent art therapy appointments in psychiatric hospitals and other locations. These rehabilitation programmes were of central importance in raising the profile of art therapy and in creating the first institutional supports for art therapy as a profession.

This chapter will examine the 'clinical descriptive' approach to images made by psychiatric patients. As will be noted, Erich Guttmann and Walter Maclay, psychiatrists who worked at the Maudsley Hospital during the 1930s, published several studies on the art of psychotic patients. These researchers viewed art as a visual description of 'fundamental disturbances', and they attempted to use art to examine how patients perceive and express change in themselves. Guttmann also studied mescaline intoxication and its effects upon perception. Interest in the art of the mentally ill may therefore be viewed as developing partly within the context of increasing medical interest in neuroscience and in visual perception. This emphasis is particularly evident in the work of the psychiatrist Francis Reitman, whose 1950 publication on 'Psychotic Art' stresses his interest in art as a manifestation of cognitive ability. In this 'psycho-physiological' approach all mental processes were seen as related to cerebral function and structure.[1] Given that Reitman was instrumental in the development of Edward Adamson's art therapy post his work, along with that of his colleagues, will be examined in detail.[2] This chapter will examine psychiatric interest in imagery in the period immediately preceding the formation of an art therapy department at Netherne Hospital.

Historical background to the development of psychiatry

Kathleen Jones, a prominent medical and social policy historian, identifies three approaches evident in mid-nineteenth-century mental health care. These she describes as a 'social approach' with an emphasis on human relations, a 'medical approach' with an emphasis on physical treatment and a 'legal approach' with an emphasis on procedure, which held sway until about 1890.[3] She points out that the law was a well-established profession, unlike medicine, which achieved professional registration only in 1858.[4] Social work and social therapy was carried out by 'compassionate amateurs' until well into the twentieth century. This social emphasis was to provide an important impetus for the development of early art therapy programmes.

The preoccupation of the Enlightenment, namely that of 'freedom', dominated much of the nineteenth-century debate, which centred around methods for detention of individuals and wrongful detention (a focus on those who should not be subject to incarceration) and mechanisms for appeal and release.[5] Legislation providing greater regulation of private asylums and hospitals was also introduced.[6] (Historian Andrew Scull documents these developments in great detail and notes how psychiatry gained professional ground during the late nineteenth century.)

Many asylum attendee in this period were women. Pay and conditions were poor and the Select Committee of 1859 noted that the 'tendency of women's nature is to nurse'. The need for a 'school for students of lunacy' was also established as only St Luke's in London prepared medical students to work with lunatics.[7]

It has been suggested by some commentators that in the nineteenth century madness became synonymous with femininity whilst at the same time women were excluded from the ranks of psychiatry.[8] By the 1890s women had come to predominate as patients in all types of asylum except those for the criminally insane and 'idiot schools'.[9] It has also been noted that asylum design then incorporated the assumption that women patients would be in the majority in the layout and design of new buildings. The availability of space encouraged institutionalisation of marginal cases.[10] Elaine Showalter argues that a deterministic psychiatry, strongly influenced by evolutionary theories, dominated England from around 1870 up to the Second World War.[11]

Also of importance was the nineteenth-century belief that madness had an underlying physical aetiology. This belief was fundamental to psychiatrists' claim to be the supreme authority in the field.[12] Andrew Scull's point

that 'insanity was such an amorphous, all embracing concept, that the range of behaviour it could be stretched to encompass was almost infinite' is agreed by other prominent theorists in the field.[13]

Of significance to mental health services was the Royal Commission on the Poor Laws of 1905 which published its minority and majority reports in 1909. The minority report is argued by Professor Jones to contain the seeds of the 1946 National Health Service Act.[14] It represents a view which saw poverty and social 'deterioration' as the individual's fault (thus requiring a minimum of public intervention) whereas the minority report drafted by Beatrice and Sydney Webb believed that social services should ensure optimum conditions of life for all citizens. The failure of the individual was therefore seen as the failure of society to provide adequate conditions.[15]

In 1910 diplomas in psychiatry were instituted in England, and in 1912 in Scotland at Edinburgh.[16] The first chair of psychiatry within a British university was appointed in 1918 at the University of Leeds. In Scotland the first chair was at the University of Edinburgh in 1920.

In 1940 in Scotland the Faculty of Medicine of Edinburgh decided that each student should pass a professional exam in psychiatry as part of final examinations in medicine. This was as the result of student pressure. The student body pressed for psychiatry to be taught on an equal footing with other clinical subjects.[17]

Psychiatry and art: The clinical descriptive approach

The work of Guttmann, Maclay, Mayer-Gross and Reitman

In her short chapter on psychiatry and art therapy, Diane Waller (1991) focuses on the work of Erich Guttmann and Walter Maclay who were working at the Maudsley Hospital during the 1930s. Guttmann and another colleague, Walter Mayer-Gross, had emigrated to Britain from Europe along with many other intellectuals in a migration which Waller claims was crucially important to the development of medicine and psychoanalysis in Britain and the USA. (Mayer-Gross had worked at the Heidelberg Clinic where Prinzhorn had been based.)[18] Guttmann came to Britain with the aid of a research grant from the Rockefeller Foundation to work under the direction of Mapother, Professor of Psychiatry. Guttmann and Mayer-Gross joined the staff of the Department of Clinical Research at the Maudsley where they worked until the late 1930s joining Scottish psychiatrist Walter Maclay.

Guttmann and Maclay identify some general approaches within psychiatry to the study of visual images as follows: they divide the study of insane art into three categories: (1) the clinical, (2) the psychological and (3) the artistic. In the first, the 'clinical descriptive' approach to psychiatry, drawings and paintings are regarded as symptoms or to evince in their content 'fundamental disturbances'. This is also the approach taken by the authors.[19]

The psychological approach, they argued, is that of those interested in the genesis of art works; for example, Hans Prinzhorn (1886–1933) who saw art work as an expression of the psyche.[20] Dr Fritz Mohr (1874–1966) was cited as the first psychiatrist to have asked patients to copy simple figures in a systematic way in order to furnish psychological insights into the present condition of the patient.[21] Guttmann and Maclay also recorded that the idea of 'spontaneous artistic production' occurred in some studies.[22]

Guttmann and Maclay were interested in the artistic work of schizophrenic patients and also collaborated on several projects in the area of neuro-psychiatry. They published their clinical observations on schizophrenic drawings in 1937 in the *British Journal of Medical Psychology*. In this article they distinguished their work from that of psychiatrists such as Otto Pfister, whom they regarded as practising a 'psycho-analytical' or 'psychotherapeutic' approach to the image.

In 1938 Guttmann and Maclay were joined by Francis Reitman from Hungary. Reitman was also familiar with the work of Hans Prinzhorn in Heidelberg, who was then regarded as a leading authority in psychiatric art. Though the Prinzhorn collection was perhaps the most impressive and widely known volume of the art of the insane in this period, it is worth reiterating that such interest from medical men was not entirely new; medical superintendents of asylums made collections of 'psychiatric art' much earlier than this date. Most of the medics who ran asylums would have been familiar with some material on this subject.[23]

Reitman continued his interests in perception and creativity in later work with pre-frontal leucotomy patients and schizophrenics. In 1945 Reitman was appointed head of clinical research at Netherne Hospital, Surrey, where one of the first art therapy posts was created in 1946 by Dr E. Cunningham Dax. Cunningham Dax had become interested in 'psychiatric art' in the context of work with servicemen who had developed severe neuroses.

Guttmann and Maclay described their 'clinical' approach as focused on how schizophrenic patients perceive and express change in themselves pictorially during the course of their illness. They saw this inner change and the

awareness of it as the central symptom of schizophrenia; they were therefore interested in the visual image as a representation of pathology.[24]

Moreover, Guttmann and Maclay remarked that many schizophrenic artists used neologisms (new words) as well as prose or poetry, leading them to conclude that 'these patients feel driven to express their morbid experiences, their inner change, or whatever it is, and therefore to use every means available.'[25]

Furthermore, the authors noted that many patients experienced 'pictures' in their minds which changed at a rapid pace. Alternatively patients experienced a distortion of shapes and colours. The patients' wish to make art was seen as a 'desire to explain themselves'. However, they recorded that only a minority of patients had the capacity to translate the hallucination into a pictorial form and this inability was particularly evident during the acute phase of their psychosis. They noted that most psychotic patients painted after the acute phase of their illness. Making reference to case histories presented by Prinzhorn, the authors gave an example of one patient who illustrated his initial hallucination four years after the experience in many pictures. In this case the patient claimed that 'details became conscious only later during drawing'.[26] Guttmann and Maclay noted a tendency towards retrospective depictions of the acute psychotic phase. These illustrations, created after the psychotic phase, were seen as being more preoccupied with figurative content. During the psychotic phase, the authors noted that psychological interest was concerned with the mode of representation: in other words, with style.[27]

In 1938 the *Evening Standard* mounted a competition for the most 'outstanding doodle' and also advertised the services of an 'expert psychologist' to inform readers about the personality of the doodler.[28] Guttmann and Maclay acquired these doodles (over 9000 examples labelled with profession, sex, and what the doodler was actually doing at the time of making the doodle). The doodles were described by Maclay, Guttmann and Mayer-Gross as mental products to which no conventional standards might apply; the images were considered independent of traditional fashion and educational norms. Some problems with the sample were noted by the authors; for instance, because the doodles were produced for a competition they might have been contrived to look impressive. The sample was also considered as possibly unrepresentative because sexually explicit and pornographic work was excluded.

The authors noted that drawings in general had been looked at as material for studying the individual by the 'psychotherapeutic school' (as they had dubbed it in their 1934 paper). They stated that in such an approach the image is regarded 'as like free association or dreams' or as 'the unravelling of the unconscious'; images are viewed as expressive of personal qualities. Such representations were viewed as 'drawn involuntarily, regardless of their effect on outside observers'.

The authors also pointed out that such a 'psychotherapeutic' approach to the work 'naturally depends on its verification on a study of the individual' who produced it. This is a study they were unable to perform because they only had access to the images and not to the people who had produced them. This was also partly the case in their first study of schizophrenic art, since they became interested in an existing collection of art work at the Maudsley Hospital. Their aim in this 1937 paper on these spontaneous drawings is therefore clarified as an attempt to illustrate some problems of psychopathology in general terms.

Maclay, Guttmann and Mayer-Gross noted a number of 'superficial qualities' common to both schizophrenic art and to doodles, which are produced by ordinary people in 'a state of divided or diminished attention'. These qualities were described as evincing 'stereotype over elaboration or symbolism'. The authors concluded by noting that doodling was characterised by a lowering of conscious awareness, and that this state or process is 'primitive'. Of the scribble category, the authors said that it represented the lowest level of spontaneous drawing as seen in the earliest efforts of children and 'primitive peoples'.[29] They went on to note that the majority of pictures contained depictions of the human face; they claimed that this fact gave support for their argument because children draw the human figure in preference to any other subject. The authors seemed to equate the conscious state of the doodler with an earlier developmental period.[30]

As noted, Francis Reitman (1905–1955) arrived at the Maudsley from Hungary in 1938. He too was familiar with the work of Prinzhorn in Heidelberg and with Prinzhorn's collection of psychiatric art. Prinzhorn's book *Artistry of the Mentally Ill* had been published in 1922 in German as *Bildnerei der Geisteskranken*. According to Waller, the volume exerted considerable influence on Jean Dubuffet, amongst others, who built up a considerable collection of the work of the insane which he called 'art brut'.

Guttmann had begun to conduct experiments using mescaline-induced hallucinations. He had used the drug on himself to study the effects of the

drug at first hand.[31] Professional artists were invited to participate in the experiments. Lionel Penrose, Professor of Psychology at University College, London, the psychologist the *Evening Standard* had employed for their doodle competition, had a brother, Roland, who was a writer, painter, and critic of the Surrealist movement.[32] The involvement of Surrealist artists in such experiments was unprecedented.[33]

Guttmann saw Surrealist artists as sharing his own interests in Freud's work and in the unconscious and the irrational. In the catalogue notes of an exhibition entitled 'Realism and Surrealism' in May 1938 at the Guildhall, London, it is stated that Roland Penrose, Julian Cant, and Julian Trevelyan had all been engaged in research into the effects of mescaline on vision at the Maudsley Hospital.[34]

A paper describing the research was published by Guttmann and Maclay in 1941. In this publication they noted some of the common forms which appear in mescaline hallucinations or 'experimental psychosis'. The authors explained that because the effects of mescaline are primarily visual in nature, a visual rather than a verbal description would prove to be more accurate in describing the experience.[35] In their earlier paper on the drawings of schizophrenics they had noted that their patients were hindered in self-expression by their inability to draw. It was this belief that led them to invite professional artists to participate in their mescaline research.[36] In their conclusion to the research the authors stated that whilst the formal characteristics of the hallucinations (for example, the appearance and repetition of certain shapes or forms) are caused physiologically, it is the individual's psychology that determines what is actually seen in these general forms, the same principle as in inkblot tests.

The evacuation of the Maudsley Hospital and the dispersal of those involved in its clinical research meant an end to the research on schizophrenic symptomatology and mescaline and vision experiments. Walter Maclay was assigned as medical officer to Mill Hill Hospital and Guttmann worked with him briefly after his release from internment. As a Hungarian, Reitman was able to take up a position as an emergency war worker, and was assigned as medical officer to the Lady Chichester Hospital near Brighton. He remained interested in the subject of personality change. Moreover, Reitman had broad intellectual interests and between 1940–1945 he engaged in making his own spontaneous drawings. He also redesigned a test developed at the Maudsley in 1939 which aimed to detect disturbances in abstract thinking, as well as producing a 'pathographic' study of the works of

author Edward Lear. He was also to critique 'pathographic' accounts of Goya's life and work.

The establishment of an art therapy post at Netherne Hospital

Dr Mayer-Gross was appointed Clinical Research Director of the Crichton Royal Hospital (1 June 1939), a progressive Scottish institution with a long history of using the arts with patients. In 1945 Reitman was recruited to head clinical research at Netherne Hospital by Dr E. Cunningham Dax (Clinical Superintendent). Apparently Reitman had a fair amount of autonomy and instigated his research without Dax's direction.[37] At Netherne he conducted research into the effects of lobotomy. Reitman's arrival, which took place in 1946, coincided with the development of a 'therapeutic community' at the Northfield Military Hospital in Birmingham.[38]

Cunningham Dax was an enthusiastic proponent of art therapy. He included in the term 'art therapy' the Red Cross Picture Library Scheme which was inaugurated at Netherne and which included the loan of reproductions of well-known pictures (old and new 'masters') to mental hospitals.[39] As well as the picture loans, the scheme included lecturers visiting the hospital to talk about the art works and show slides on a weekly basis. Art books were also available for loan through the Red Cross libraries scheme. Edward Adamson, an artist, attended the hospital four times per week to supervise the art groups initially. (This was the position in 1948 before his appointment on a full-time basis.) Dax felt that the studio artist and the person giving the art-appreciation talks should not be the same person. He felt that giving tuition or talks was incompatible with the 'free and independent production [of art work] for emotional release'.[40]

Dax was bolder in his claims than Reitman about what he perceived to be the benefits of the art groups. In 1948 be described painting as 'prescribed as a form of treatment', the results of which were very psychotherapeutically 'promising'. The patients were aware that their work would be examined and in some cases discussed with the doctor as part of their psychotherapeutic treatment. He described the use of images as an adjunct to verbal psychotherapy as extremely useful, often saving weeks of the doctor's time because 'the patient subconsciously portraying his troubles in the most definite way on paper' gave crucial information to the physician.[41]

Moreover, the art works were seen as having a dual function for emotional expression and psychological investigation. For the artist to be successful in obtaining therapeutic effects he felt that they must 'assume a passive role'.[42]

Dax noted that in some instances 'a patient is able to express himself freely in his paintings and throw much light on the interpretation of the symbolic matter he produces with a minimum amount of assistance from the analyst. The method then becomes a definite variety of psychotherapeutic treatment in its own right'.[43] Here then in this statement is an identification of art therapy emerging as a distinct practice.

Although Reitman's 1950 book is primarily concerned with the formal elements of psychotic art, he does make reference to art as therapy, which he notes as much under discussion within psychiatry.[44] Art therapy he saw as distinct from his own research interests. He also saw it as quite distinct from the 'psychopathological schools' (psychoanalysis and analytical psychology), which he defined as drawing on the work of Freud and viewing pictorial symbols as disguised expression of thoughts which had to be interpreted.[45] Art therapy, in contrast, he describes as a form of treatment. He noted that this *occupational therapy at the higher level* had been introduced into psychiatric hospitals through the efforts of the British Red Cross and that it had taken two main forms. These were lectures about art and subsequent discussions of the art works and art classes in which patients could paint as they wished. These classes were supported by an encouraging individual who did not teach techniques.[46] Indeed, Reitman thought that such classes were only 'therapeutic' if 'craftsmanship' was not taught. The effect of this, he found, led to the production of art works which were not homogeneous in their nature. Although he didn't feel that group dynamics were significantly at play in the situation, he did think that the richness of the work produced was superior in a group context to that individually produced. Therefore he acknowledged that the experience of being in the group had some function in 'reinforcing the drive for spontaneous individual self-expression in painting'.[47] Reitman speculated that group activities (such as painting a mural) could be 'integrative' or at least an indication of 'group integration'. However, he doubted its curative value as a treatment method *per se*, concluding that whether a patient 'acts out his "autistic phantasies" in artistic creation, and gets better by means of this, is highly questionable'. He concluded that there was little justification for organising art therapy more universally.[48] Reitman's book is also significant for its cogent critique of symbol formation in psychoanalysis and the idea of the collective unconscious in analytical psychology.

Edward Adamson: A non-interventionist approach

Edward Adamson (1911–1996) studied at Beckenham and Bromley Art School (now Ravensbourne). He then completed classes in physiotherapy and also worked in his father's factory. He served in the Royal Medical Corps during World War II as a non-combatant, and on demobilisation he offered to work voluntarily for the British Red Cross (Timlin 1996: 'Art as a panacea', obituary notice for Edward Adamson, *The Guardian* 12.02.96). He had met Cunningham Dax, medical superintendent of Netherne Hospital, Surrey, while employed in 1946 by Millicent Buller MBE, head of the British Red Cross Society (BRCS) Picture Library, while it was touring hospitals to discuss pictures owned by the library.[49]

The BRCS Library art advisor, Mary Campion, had started bringing art works to Netherne Hospital in 1944. These works were discussed and examined by a group of newly admitted patients. Cunningham Dax (1953) noted that there was sufficient enthusiasm about this exercise for Mary Campion to be questioned for over two hours about the art works; their composition, techniques used and actual content all came under scrutiny. Another visit was made the next week by Campion and arrangements were made with Millicent Buller to borrow the art works, which were also exchanged between different wards. Shortly afterwards a visiting lecture series (based on the borrowed works) began on a weekly basis. These lectures concentrated on impressionism and modern art, and Edward Adamson was one of the lecturers invited.[50]

Adamson described his first visit to Netherne Hospital as intimidating. He remembered being ushered along 'long corridors, many locked and unlocked doors', before reaching his destination. He noted that many among his audience had undergone major brain operations and 'consequently many who had come to listen to me were shaven headed. Others were swathed in bandages and were disfigured by post-operative bruising'.[51]

After the lecture series had got underway a number of patients expressed their desire to paint their own pictures. However, before this was arranged, Dax and others visited Northfield Military Hospital, Birmingham, where 'free painting' was already being used with patients.[52] Discussions also took place with hospital staff, Sybil Yates, a Freudian analyst from the Tavistock Institute, and Susan Bach, a 'Jungian' art therapy pioneer, who is recorded as having given many valuable suggestions about setting up an art therapy post.[53] The visit to Northfield Military Hospital was to the unit that had been established by Foulkes and Tom Main for group therapy. On his return, Dax

described Netherne staff as enthusiastic: 'Dr Freudenberg, with many cultural interests, Dalberg, with a wide European experience, and Reitman, who had been at the Maudsley before the war with Guttmann and Maclay, all supported the project'.[54]

An invitation was issued to Adamson to take up the appointment of 'art master' because he had some experience of such work. He had worked as an art therapist in a TB sanatorium with Adrian Hill. He said of this work: 'Our role had been to lend our professional skills to those invalids who needed an occupation or diversion during their long months of recuperation. In some ways, we practised a form of occupational therapy through art'.[55] Dax, who created the appointment, described Adamson as having experience of lecturing in both sanatoria and mental hospitals. He noted that Adamson had not been 'analysed' and that he did not have any special knowledge of psychology, but that he was particularly interested in the evolution of artistic work. Dax (1953) felt that it was important that the appointee be a professional artist and not an amateur, who may therefore speak with 'knowledge' and 'authority'.[56] Adamson's background was in commercial art though he was a practising artist himself, producing abstract works.

When Adamson first arrived at Netherne to take up his appointment as 'art master' on 23 April 1946, there were few leisure activities and no art activities.[57] Initially Adamson worked inside the hospital in a committee room with up to forty patients at once, conducting two sessions per week. Soon after, this had risen to four sessions per week and it then became a part-time appointment.[58] Later, in December 1948, he was appointed to a full-time contract.[59] Adamson referred to himself as 'the artist'.[60] However, Dax felt that a number of terms might be applicable to him including 'art teacher', 'art instructor', 'art occupationalist', 'art therapist' or 'art analyst', depending on the role the worker was expected to adopt. However, 'the artist' was Dax's favoured term.[61]

The accommodation being unsatisfactory, Adamson was (in 1948) able to have a studio built in the hospital grounds for his own use. (Musical practice took place in the studio once per week but otherwise it was for art work only and therefore paintings could be left on their easels when unfinished.) This building was a converted army hut, 48 feet by 16 feet square, which Dax notes was able to accommodate twenty patients with comfort. The studio had a sink, storage units, central heating and roof-light windows. The roof was of cedar shingles and the floor covered in oil cloth. The chairs were painted green, other furniture cream, and the walls primrose.[62] (No rationale is given

for this particular colour scheme.) Later Adamson was to acquire more buildings in the grounds.

Each morning at 8.30 a.m. Adamson found a group of patients outside his studio waiting to come in. Generally he worked with 25 to 30 patients who had been referred by their individual psychiatrists. Adamson was not involved with the referral process, simply working with whoever came. Even if a patient seemed unresponsive, Adamson explained that he would never turn someone away because he thought 'even the walk to the studio across the hospital grounds' was of therapeutic benefit. Although some patients were reticent at first they all painted after a time.[63]

Figure 7.1 Edward Adamson c. 1948

After his appointment was put on a full-time basis, Adamson saw from 10 a.m. to mid-day a group of chronically ill (mainly schizophrenic) women patients in a ward of the main hospital. This group was established for research purposes. Dax notes that these patients painted for their own pleasure. They had not received the same information about the purpose of engaging in art work as the studio group. The women, he observed, were 'not united by a common bond of working to get better, nor with a label of treatment attached to their activities'. Although Dax does not elaborate on these research findings, they seem to indicate that the information given to patients about 'art therapy' or 'free painting' greatly influenced their reaction to the activity. Dax also noted that this group of psychotic women patients on the ward were much freer in their behaviour than those in the studio group, and that Adamson was subject to 'uninhibited transference' from them.[64]

Patients referred to the studio tended to be those who had difficulty expressing their feelings rather than people who were exhibiting particularly difficult behaviours.[65] Dax defined his referrals to the studio group as 'mainly young people expected to recover from their illness' and of 'normal intelligence'. Individual psychiatrists were responsible for making referrals. However, Dax described the broad categories of classification used for referral processes. These categories were as follows: those undergoing psychotherapy for psychoneurotic disorders; those diagnosed as needing psychotherapy but regarded as inhibited; those receiving insulin coma treatment or 'convulsion therapy' (ECT) who were later intended to receive psychotherapy; those whose art work Dax wished to examine in relation to specific diagnostic categories as part of his research programme; those cases where self-expression might be aided by the use of art; and patients who were artists prior to their admission to hospital.[66]

Each patient had their own easel and Adamson described this provision as essential in furnishing each person with their own area in which to work, a place where they could feel secure. Each patient was provided with a colour range of eleven poster paints, two brushes (size one and twelve) along with a small enamelled cake-tin with six divisions to serve as a palette, and pieces of paper of a standard size.[67] All the drawings and paintings were kept at the end of each session and were filed away by Adamson under the name of each patient. Doctors had access to the art work which provided a visual record of what had been expressed.[68] It was explained to patients before they started work in the studio that their pictures would be kept as 'case notes' and would not be returned to their possession, but be handed on to the psychiatrist.

Likewise patients were informed that their work would not be displayed or shown to relatives. Nor were patients allowed to sell or give away their art work, which remained the property of the hospital. Dax explained that some of these restrictions were imposed to avert the possibility of patients' work being subject to 'praise' which might influence them in a certain direction.[69] Although on the face of it these restrictions might seem reasonable, it was not always possible for patients in a confused state of mind to be aware that they would not be given their art work back. (A patient interviewed by Rumney (1980) was not happy about the loss of art work.) Psychiatrists had the opportunity to see paintings in the middle of each week prior to the work being filed away. Alternatively, they could arrange to have art work passed on to them by Adamson.[70]

There was relatively little interaction between patients in the studio because they were so 'wrapped up' in their own art work. Adamson didn't put art work on the walls because he didn't want the patients to be unduly influenced by each other. He was also opposed to the use of themes. Adamson described the atmosphere in the studios as quite magical and as 'sacrosanct'. He explained that he would never allow visitors into the studio while the patients were painting – 'You could feel them working,' he recounted to me in interview. The atmosphere of the studio was described by a former patient:

> It was quiet and peaceful and one could get on with what one wanted. I needed peace. I couldn't possibly work without it. He [Adamson] did keep the place quiet so there was only occasional conversation... It was very congenial. He had a calm of mind himself which communicated itself.[71]

Occupational therapists were introduced into the hospital shortly after Adamson's arrival and they showed an interest in what he was doing, but they had to be turned away because their presence in the studio would have 'broken the atmosphere'. He felt that the studio being separate from the rest of the hospital was very important. The studio provided a place where patients 'could be themselves without any fear of criticism'.[72] However, there were regular visits made to the studio by doctors and the medical superintendent. Dax described the studio as providing 'ordered freedom'.[73] The atmosphere was described by a former patient as 'serene and deep. Everyone who came there found themselves expressing a new world of ideas that were suppressed in them.'[74] A different patient described Adamson as a 'very quiet'

man: 'He would just sit down next to someone and ask them if they would like to paint'.[75]

Adamson said that it was the making of the art works which was healing, not the talking about it. He was excited to see what would be produced by patients and found this work of more interest than the modern art of the period.[76] This was not the attitude of his medical colleagues, who had differing opinions as to the value of art therapy.

One of his former patients said of Adamson that

> he was very encouraging – always saying nice things about our painting. He didn't look at it from the point of view of art, more self-expression. I used to think what I wanted to say to the doctors and paint it and she [the doctor] used to analyse it and find all sorts of things about my sub-conscious which I [had] painted without knowing it.[77]

However, the same patient was later to see another doctor with quite a different attitude: 'When I asked my doctor "Can you analyse paintings?" he said, "It wouldn't help you to have your paintings analysed".'

Art therapy was not regarded as an easy option by patients, but as part of their treatment.[78] Indeed, since some occupational therapy work was paid work, those who frequented Adamson's sessions were willing to forego this income, since art therapy attendance was not paid. Adamson noted that patients related to him as an artist rather than as a member of the medical staff. Consequently they were able to confide things in him that they would not tell their doctor, and he kept these confidences.[79]

Dax was very clear about the encouraging role he expected Adamson to perform. Adamson was instructed not to interpret paintings, nor elicit the patients' description of their symptoms (though Adamson could perform a useful role in noting such information for the attention of the psychiatrists). Adamson was instructed never to make suggestions about patients' art work and to remain in an 'essentially passive' role, giving technical advice if required, using a separate piece of paper.[80] Adamson was given instructions not to interfere nor make suggestions regarding colour, form or subject matter.[81]

Adamson was involved in the life of the hospital as hospital artist. He designed costumes for theatrical performances. He didn't involve the patients in assisting him with such projects because he wanted them to concentrate on their own self-expression. However, he did take groups of patients out to museums, exhibitions, theatre and the opera.

Adamson described himself as working very closely with the psychiatric staff. The pictures were seen by doctors at the end of sessions and an analysis of the pictures took place in the doctors' consulting room. In turn patients talked to Adamson about their sessions with the doctors.[82]

The conduct of patients was described by Dax as 'self regulated'. The studio group (unlike the women's group in the hospital) was bound, he felt, by the common aim of recovery. He explained, 'Thus, even though the work is enjoyable, it is nevertheless serious, which modifies the interrelationships of the patients, engenders a mutual respect for their [artistic] productions and breeds tolerance for those who wish to be left in silence and isolation'.[83] This statement makes evident Dax's understanding that patients' acceptance of their art work in the studio being a treatment had a pronounced effect upon their behaviour.

Sometimes patients' behaviour was extremely challenging. Adamson recalled being abused verbally and also assaulted. He described one incident in which a woman patient put her hands round his throat as if to strangle him. Calmly looking her in the eyes he said 'carry on' and she slowly released her grip and took her hands away.[84] (This description is very reminiscent of incidents recounted by the educationalist A.S. Neill in his book *Summerhill*, in which he described calmly challenging violent or potentially destructive behaviour.)

It is clear from Adamson's writing that a sharp contrast existed in conditions between his studio and the rest of the hospital:

> Those in the locked wards were all obliged to wear hospital clothes. In the stark dormitories, the long rows of iron beds offered no seclusion, as they were not curtained off from each other. The practice of taking communal showers offered no personal dignity, neither was there any privacy in the bathrooms.[85]

A paper written in collaboration with Adamson about his work described the presence of the artist in the hospital as 'in itself therapeutic: an antidote to the prevailing atmosphere of white-coated doctors, depersonalised treatment, regimentation, and lack of recognition of the individual'.[86]

Adamson expressed a similar view to that of Dr Reitman on the matter of interpretation of images. Adamson thought that patients had a desire to please their therapists and that encouragement by psychotherapists to produce art work would result 'in Freudian phallic symbols or Jungian signs' depending on the theoretical orientation of the therapist.[87] Reitman had been critical of both Freudian and Jungian models of analysis but in an article

written shortly before his death in 1955 he singled out H.G. Baynes'
Mythology of the Soul for particular criticism. He wrote that 'to my mind, the
abundant paintings of the Jungian patients are more characteristic of the
therapist than of anyone else'.[88]

Adamson felt strongly that only the patient should furnish an interpreta-
tion of art work, and that the art therapist should not. He never interpreted
his patients' art work but waited for them to talk about it, if they wished to do
so. Even the use of particular conceptual models, which might not be
explained to the patient (such as psychodynamic theory), he felt would
unconsciously affect the art therapy process, preventing the 'true person'
emerging. He described any attempt to use such theory as 'useless'. 'Ba-
sically,' he explained, 'you are putting your ideas in their head and I don't
think that's a healthy thing to do'.[89] Adamson felt very strongly that only
artists should facilitate art therapy and was disappointed at a movement
within the profession towards producing art therapists who are 'amateur psy-
chiatrists or amateur psychotherapists'.[90]

Cunningham Dax's view was slightly different to that of Adamson as his
primary focus was on getting paintings for psychiatrists that were not con-
taminated by an interfering artist. He described the pitfalls of having the
artist analyse the work as twofold: first, the patient may be 'taught' the
'meaning of so many symbols that he is frightened to lay brush to paper for
fear of its meaning'. Conversely, the patient might submit themselves 'to an
orgy of symbolic representation of a variety which will satisfy all the needs of
their inquiring therapist'; consequently Dax was not keen on proposals made
that art therapists 'should be recruited from artists with teaching experience,
who have had analysis'.[91] John Timlin, an urbane and intellectual associate
and long-time intimate friend and companion of Adamson, was very forth-
right on this point. Timlin had had analysis with Anthony Stevens and knew
Dr Irene Champernowne in Stanton, where she and some of the Withymead
staff moved after Withymead's demise with the intention of continuing with
their work. Timlin had also attended early art therapy meetings at Netherne
Hospital. Timlin felt that 'art psychotherapists' were projecting their
problems onto the patients' art work (using a part of their 'shadow' and pro-
jecting it onto the people they are with) and then defending this procedure
through an intellectualisation of the process.[92] Timlin explained his view that
the artist is capable of entering into the creative fantasy of their patients'
work; it is this approach that he considered to be healing.[93] (I interviewed

Timlin in Adamson's presence and he appeared to be completely in agreement with Timlin's views.) He wrote that as the artist

> is not a psychotherapist, his patient is not tempted to produce work which reflects his psychological orientation. Because the client is in a dependency situation, he is often anxious to please and even at the unconscious level he can pick up cues from his therapist to produce 're-warding' results.[94]

The tendency towards using reductive theory (particularly psychoanalytic theory), in Timlin's view, was the result of the professionalisation of art therapy. He explained that 'there was a small caucus of political people who really wanted to push their politics rather than the arts'.[95] This situation was later exacerbated, he felt, by the development of professional training in art therapy, training courses validated 'by people who hadn't got the slightest idea about the artistic framework' and who therefore developed course structures based on 'their own anally retentive structured way of looking at the curriculum' which did not suit the artist. He felt that the type of work done by Irene Champernowne and Edward Adamson, which relied on qualitative skills, was hard to duplicate and teach.[96] He elaborated his view that fitting artists into an academic paradigm 'is very constraining' given that an artist's 'whole life has been such that they use their intuition and their feeling'.[97] (Obviously Timlin's definition of the artist is as a person in touch with their creative unconscious impulses. This definition excludes the conceptual artist who is relying primarily on their intellectual resources.)

Adamson saw art therapy as being distinct from occupational or diversional therapy. He wrote: 'Harmony is the necessary language through which art finds its own expression. In coming to terms and having to deal with this, the mental patient is thus *exposed* to the beneficial *radiation* of harmony itself'.[98] Such an interesting use of metaphor indicated that Adamson felt that there was something both intrinsically penetrative and curative about the creative process. His view was questioned by a psychiatrist, Dr Tredgold (editor of the journal of the National Association for Mental Health), in his preface to Adamson's article. Tredgold argued that occupational therapy and art therapy had much in common because an activity in OT might begin as a distraction and end up as a form of self-expression. Clearly, Tredgold did not see a clear-cut distinction between OT and AT and encouraged art therapists and occupational therapists to work closely together.[99]

It is clear from Adamson's writings that he saw his art sessions performing a function beyond that anticipated by artists in their studios. He described art as a means of 'reassembling the fragments of a disintegrated personality' and useful for patients 'owning and exploring parts of their personality'. Adamson also recognised the cathartic value of art-making: he called this a 'cri de coeur'. He also noted that one can achieve in fantasy what one cannot achieve in 'reality'. He described the patients as wanting to express their feelings and as 'pouring out their very souls on paper'. Patients, he believed, needed encouragement without interference.[100] This was also the instruction given to him by Cunningham Dax who, as noted, was wary of the art therapist's influence on the content of art work.

Timlin (1991) explained the value of an artist rather than a psychotherapist performing this work:

> Because of the artist's divergent personality he [sic] can accept unconventional and unexpected modes of expression. He incorporates them in his own work, often welding them into a constructive outcome... The artist is no stranger to his unconscious; he is in a constant dialogue with it. Here he has a bond of sympathy with his patient, the difference being that while the artist can select and consciously modify his work, his patients cannot... Now these are just some of the advantages of the presence of the artist in a therapeutic setting. A vastly differing role to that of the OT.[101]

Adamson saw art as a form of communication particularly for those whose treatment had hindered their ability to communicate. In his book *Art as Healing* (1990), he identified art work as useful for providing information about the patient and for diagnosis. He wrote that paintings have a 'unique merit' in revealing the patient's state of mind at a moment in time or in providing a record before, during and after an experimental situation or a new course of treatment. He also noted that a painting might warn of an imminent crisis. However, he was cautious about the use of images for diagnostic purposes. He felt that such diagnoses might reveal more about the mind of the spectator who is analysing the work than that of the artist who made it.[102]

Adamson was well aware of the multifarious ways in which an art work might be 'read'. He wrote:

> Paintings can become a window through which we can see a person's submerged thoughts and feelings... There is a superficial 'manifest'

level, where one accepts the literal meaning of the illustration, then there is the deeper level of symbolism, where the selection of the subject, the objects chosen to be represented, the colour choice, the placing on the paper – everything, in fact, where the choice has been exercised, has a much deeper significance.[103]

Diane Waller (1991) points to a close link between Adamson's passive role and that adopted by progressive educators such as John Dewey and Herbert Read.[104] She argues that in a context other than a hospital this approach could be seen as a form of progressive art teaching rather than art therapy. Waller's analysis points to the fact that location was important in creating a definition of art therapy. However, it is clear that Adamson's non-interventionist presence was considered more than simply that of an artist in their studio. For example, Stevens says of Adamson's work: 'Intuitively he knew there to be a connection between creativity and healing, and he understood the importance of providing a sanctuary – a space, a *teminos* – in which this connection could be made. His genius lies in his ability to create an enabling space'.[105]

Adamson felt that his unconditional acceptance of the art work distinguished his approach from both occupational therapy and art teaching. He also felt that producing art was intrinsically healing; this is stated quite explicitly in his writing. Although understated in his writings, there is also an underlying spiritual dimension to Adamson's approach.

The close contact of doctors with the art works is also of significance. Adamson attended the clinical meetings which took place once or twice a week, at which the pictures were discussed by the doctors. The pictures were considered to be important, and some discussions at these meetings were entirely devoted to analysis of the art works. Through his attendance at this meeting, and his daily contact with doctors, Adamson was aware of the role that the images played in his patients' psychotherapy.[106]

As well as having a diagnostic significance, Dax concluded his principal text on the subject by saying that he thought art could be a useful aid to psychotherapy in psychoneurosis. Paintings could, he argued, be treated as dreams and interpreted by the person who had made the image. Such a method Dax regarded as a form of psychotherapeutic treatment in its own right and 'capable of far greater use than has so far been realised'.[107] It is on this point that there is definite agreement between Dax and Adamson.

Clearly there was a tension between Dax's attempts to create standard research conditions, which now seem quite naive, and Adamson's views about the curative potential of art therapy. Adamson's appointment was

highly regulated, as I have illustrated. Nevertheless his non-interventionist way of working was to influence many art therapists.

Adamson was a significant pioneer of art therapy. He organised many exhibitions of patients' art work in Britain and abroad and gave lectures about the art works. He wrote numerous articles about art therapy. One in particular reached a wide audience in 1962 and helped to raise the profile of the profession, as did exhibitions of patients' art work held at the Institute of Contemporary Art in London.[108] The Adamson Collection of art works was started in the 1940s and now comprises over 60,000 examples of psychiatric patients' art work.[109] Adamson died in 1996 aged 84.

Conclusion

In this chapter I have explored how developments in art therapy arose in the context of medical interest in neuroscience and visual perception. I have presented a detailed account of the work of Edward Adamson. Although Dax was perceptive in recognising that art therapy could provide a 'definite variety of psychotherapeutic treatment in its own right', he placed a number of restrictions upon Adamson's role. Adamson, unlike Adrian Hill, was forced into a passive position with his patients, because of the terms and conditions of his initial contract. However, he found that patients 'poured out' their very 'souls' on paper without much prompting. He clearly became attached to this way of working because even after Dax had left the hospital, and Adamson had much more autonomy in how he worked in the studio, he maintained what I have called a 'non-interventionist approach'.[110]

Adamson's approach relied on the creation of an atmosphere in which people could be creative. An important aspect of this was the notion of freedom, particularly freedom from the constraints of the hospital routines, which Adamson felt were deeply inhumane. Adamson was prepared to keep his patients' confidences; he did not feel obliged to relay every piece of information entrusted to him by clients straight to their psychiatrists. Patients must have realised this after a time, and trusted him with secrets that they felt they could tell no one else.

Adamson's sense of being different was emphasised by the location of the first studio, and later studios, in the grounds of the hospital, which Adamson felt was crucially important in distinguishing what he was doing from other sorts of staff in the institution. Adamson felt that artists had a bond of sympathy with those suffering from mental distress and illness.

Although the department was established in the context of research being completed into visual perception, he managed to co-exist with this different ethos, forming good working relationships with the psychiatric staff. However, he was strident in his view that art therapists should not interpret their patients' art work, and that those art therapists who worked in this way were damaging their patients, or at least displaying more about themselves than they were elucidating about their patients' psyches.

Dax's research methodology now seems crude. However, it was important in determining Adamson's role and the restraints upon him. Adamson, though kept informed, did not play an active part in determining referrals or research structures and objectives. He did add important information to the research by providing psychiatrists with information about the manner in which art works were made.

Notes

1 Reitman 1950, p.168.

2 Adamson's appointment in 1946, and the establishment of an art therapy department, was the first appointment of its kind. It is significant as a permanent hospital appointment, rather than a sessional appointment made under the auspices of organisations promoting art therapy. However, he started on a part-time basis and was not appointed full-time until 1948, by which time another art therapy appointment had been made (discussed in the chapter on Withymead) on a full-time basis in 1947. Adamson's was not, therefore, the first full-time appointment in Britain, though his work was particularly influential.

3 Jones 1972, p.153.

4 The Medical Registration Act of 1858 established a register and a system of examinations.

5 Gay 1977, p.3. James Hansard in 1845 formed a society called the 'Alleged Lunatics' Friends Society' which campaigned for better conditions. An Association of Medical Officers of Asylums and Hospitals for the Insane formed in 1841 and acted as a pressure group producing its own journal 'Asylum Journal of Medical Science'.

6 A select committee established in 1859 (which did not apply to Scotland) which led to the Medical Registration Act of 1858 and later in 1874 to a grant-in-aid scheme for pauper lunatics. This provided a financial incentive to the boards of governors of workhouses to move their mad paupers into centres for treatment. The findings of the 1877 select committee are seen by Professor Jones as the beginnings which led to the provisions for voluntary status under the Mental Treatment Act of 1930. Significant legislation was introduced in 1890. The Lunacy Acts Amendment Bill (1890) introduced new procedures for detainment which included the introduction of a judicial authority for the detention of a person as a lunatic; a time limit on orders of detention; protection of medics who were getting worried about being sued (see Weldon versus Windslow in Jones 1972); restrictions on the opening of new asylums. In addition to this the Lunacy Commissioners were to have increased rights of report and visitation to ensure that conditions in asylums were humane. The effects of divine service upon the congregation and the use of mechanical restraints were two areas of interest as well as diet and physical condition of pauper patients.

 The effect of this legislation was that it was now harder to deprive a person of their freedom. A possible disadvantage, though a dubious one, is that early diagnosis and treatment were made more difficult as the person could not be certificated until their illness had become apparent to a lay person – the justice of the peace. Because the early diagnosis and treatment of patients was out of the hands of the asylums their role became a mainly custodial one. (Jones 1972, p.250)

7 Showalter argues that the 1845 Lunatics Act was significant in creating a shift towards asylums being run by men rather than women. In 1859 the Commissioners in Lunacy reported that they considered granting new licences for asylums only to medical men. Women applicants were discouraged though

not always refused (Showalter 1987, p.53). This tendency toward limiting women's role in the provision of care to lunatics has been argued by many theorists (e.g. Stocking 1987, p.198) to be part of a general trend in the nineteenth century restricting women's economic activities accompanied by the withdrawal of women (at least those who had some money) into the domestic sphere. Nineteenth-century women had less freedom than their eighteenth-century counterparts. The middle-class family home became in Ruskin's words 'the place of peace' and in that home it was on women that 'fell the burden of stemming the immoral and irreligious drift of modern society'. Taking into account this general tendency within nineteenth-century society invalidates those theorists (e.g. Ussher 1991) who discuss the male domination of psychiatry specifically as an instrument of male control over women. Psychiatry should be seen as representative of a general resurgence of patriarchal authority in the century. See also Jones (1972, p.158).

8 Ussher 1991, p.66.

9 This is the period that Showalter (1987, p.55) identifies as that which links insanity with women's biology. The link between poverty and insanity was discussed with 'lactational insanity' being identified as caused by malnourished mothers breast feeding in order to prevent conception and in order to save money. However, generally there is a move away from an examination of social factors in psychiatric discourse.

10 Scull cited in Showalter 1987, p.55

11 Legislation introduced towards the end of the nineteenth century did not distinguish between 'mental defectives' or 'idiots' as they were then called even though some discrete housing for idiots already existed. The Lunacy Act of 1890 (section 34) defined a 'lunatic' as an 'idiot or a person of unsound mind'. Accommodation for idiots included Park House in Highgate, founded in 1846. Terms used in the nineteenth century for 'idiots' included 'mental defective' and 'feeble minded' used interchangeably.

12 Renvoize 1991, p.70.

13 Showalter (1987) and Renvoize (1991) agree on this point. Showalter points to the model of 'moral insanity' as a deviance from socially accepted behaviour. Therefore the term 'insanity' could be applied to almost any kind of behaviour disruptive to community standards (Showalter 1987, p.29). Showalter's excellent analysis of the writings of nineteeth century psychiatrists illustrates that 'the insane temperament' (as Maudsley called it) was becoming more subtle in its appearance as psychiatrists turned their attention towards 'incipient lunatics' or those with 'latent' brain disorders. Only the trained specialist was able 'to patrol this mental and sexual frontier...saving society from their dangerous infiltration' (Showalter 1985, p.105).

14 Jones 1991, p.94.

15 Jones 1972, p.195.

16 Henderson 1964, p.269.

17 Henderson 1964, p.263. In 1942 the Royal College of Physicians in London appointed a committee to consider the future development of psychological medicine. In 1943 the committee recommended that a course of normal psychology should form part of the undergraduate medical curriculum and that the final examination for a degree in medicine should include a separate examination in psychiatry (Henderson 1964, p.263–264).

18 Waller 1991, p.27.

19 Berrios (1991) argues that Walter Mayer-Gross and Erich Guttmann and others had been influenced by phenomenology in Europe. These émigrés brought with them the notion of 'theory free description' of symptoms (Berrios 1991, p.236).

20 Hans Prinzhorn obtained a doctorate in 1908, having studied art history and aesthetics at the University of Vienna. He later studied medicine and psychiatry. In 1919 he joined the staff of the Heidelberg Psychiatric Clinic where he extended an already existing collection of psychotic art into the largest in Europe. The publication of a book featuring large illustrations of some of the collection in 1922 'made him famous overnight' (MacGregor 1989, p.194). The text was to become hugely influential – though non-German speakers were excited about the pictures rather than Prinzhorn's theories. The illustrations are varied, bizarre and hugely interesting. Many of them are also very beautiful. Prinzhorn believed that underlying all forms of picture-making was the same process: 'That basic process would be essentially the same in the most sovereign drawing by Rembrandt as the most miserable daubing by a paralytic: both would be expressions of the psyche' (Prinzhorn 1922, p.xviii cited in MacGregor 1989, p.196).

21 Fritz Mohr developed an experimental approach using visual tests to identify specific areas of impairment in perceptual and motor skills used in drawing. His work was based on Emil Kraepelin's (1856–1926) interest in disorders of thought and perception and orientated very much towards diagnosis. Mohr was not particularly interested in spontaneous image-making and his work is

significant because it marks a shift within psychiatry away from a discursive approach to patients' art work. MacGregor (1989, p.192) argues that it was Mohr who initiated a tendency that was to dominate the psychiatric and psychological approach to patient art work in the twentieth century. He says: 'The complex spontaneous productions of patients were increasingly to be seen as too unsettling and confusing for the psychiatric researcher' (MacGregor 1989, p.192).

22 Guttmann and Maclay 1937, p.184.

23 The Physician Superintendent at the Crichton Royal Hospital in Scotland, W.A.F. Browne, in 1880 mentions 'three gigantic volumes containing specimens of pseudo-art of the derangement' which were drawn from an asylum population 'exclusively belonging to the educated classes'. Browne was also aware of the work of Sir A. Morrison who published illustrations of mental diseases. Indeed he felt that his own volumes surpassed the illustrations produced by Morrison (Browne 1880, pp.33–34). Unfortunately the work to which Browne refers has been mostly lost.

24 They placed the work of psychiatrist Walter Morganthaler (1882–1965) in this 'clinical' category also. Morganthaler had written about characteristics of a patient's art work, that of Adolf Wölfli (1864–1930), and had published a book on Wölfli a year before the first edition of Prinzhorn's influential text. Morganthaler had noted a tendency of schizophrenics to develop often ornate writing from drawing. Guttmann and Maclay noted that Morganthaler interpreted this tendency as a regression of expression (Guttmann and Maclay 1937, p.185). The authors therefore seem to believe that Morganthaler viewed the image to be a superior form of expression, and that the patient produced writing as the psychopathology worsened.

25 Guttmann and Maclay 1937, p.185.

26 Guttmann and Maclay 1937, p.191.

27 Guttmann and Maclay noted in their work some characteristics of schizophrenic art: 'Rather unusual and abnormal are fragments of living beings – limbs, heads, eyes etc which are quite frequently found in schizophrenic art. More suspect of pathological origin are mixtures of letters, figures and odd lines… These single features, however, become strange when they accumulate and are then more suggestive of schizophrenia' (Guttmann and Maclay 1937, p.193). The authors also noted that much schizophrenic art is characterised by a lack of vividness and pedantic repetition of motifs as well as indulgence in detail and meticulous elaboration. They argued that other features are found in the construction of the entire picture which correspond with clinical symptoms, a typical example of this is a picture in which there is a number of superficial associations of ideas between elements but none of which is dominant and with no controlling idea. In other words, the imagery was fragmented in its nature. The authors thought that schizophrenic artists tended to add inscriptions to their art work which attempted to explain the contents. This tendency of schizophrenic artists, they felt, was in complete contrast to that of manic patients, who were unable to concentrate. With reference again to Prinzhorn's collection, the authors noted that very few of the images reproduced depicted concrete objects in a realistic manner (Guttmann and Maclay 1937, p.193). When objects were depicted they were frequently imbued with deep symbolic significance and religious topics were noted as being extremely frequent (Guttmann and Maclay 1937, p.194). They noticed that pictures are often overloaded with symbols and are full of mystical allusions. The authors speculated that it would be interesting to corroborate their observations with a study of schizophrenic style in artists; they noted the rarity of such material. Discussion by psychiatrists on the change of style in artists who have developed psychosis had concentrated on the life and work of Vincent Van Gogh (Guttmann and Maclay 1937, p.194). One of the case studies they presented was a woman who was also a trained artist. In illness she is seen as giving up her strict academic style to 'produce and form her own ideas'.

Guttmann and Maclay then moved on to examine the question of artistic talent and illness. They examined Lombroso's claim that it is common for people who never before thought of making art to 'pick up the painter's brush'. The authors did not believe that a higher standard of artistic ability is achieved in a psychotic state. Guttmann and Maclay did see artistic training as relevant: 'If one looks through the work of patients who have had no training at all, the surprising fact is revealed that they all remain in the province of playful ornamental drawings. Such drawings may be brought to a high degree of perfection, but no one without training seems to go further than that. Only those who have technique can do so on account of their ability to illustrate and express' (Guttmann and Maclay 1937, p.201). It is clear that Guttmann and Maclay believe that artistic training contributes to the ability of patients to express themselves in pictorial form. Indeed, they noted that in Prinzhorn's collection the two patients who contributed the most impressive paintings were an architect and an art teacher, and that two others had been drawing as amateurs (Guttmann and Maclay 1937, p.201). The authors pointed out that in much of the literature this point has hardly been considered. They also remarked that two of Prinzhorn's 'best' cases (one can assume that they mean most technically competent) had fathers in the artistic professions. On the topic of influence of disease on artistic productivity, they argued the opposite of what was commonly thought to be the case, that there is a deterioration,

rather than an increase in artistic productivity. However, they noted that it was the primary hallucinatory material which often furnished the content for work produced at later stages. They also noted that states of excitement experienced later on in schizophrenia could lead to an increase in artistic production and Blake and Van Gogh are cited as examples of this tendency.

28 Waller 1991, p.28.

29 Maclay, Guttmann and Mayer-Gross 1938, p.54.

30 Maclay, Guttmann and Mayer-Gross concluded by noting surprise at the amount of uniformity in their collection of doodles, and cited Jung's idea of the collective unconscious as perhaps being relevant to their findings. They also noted that Jung's school made use of drawings, including spontaneously produced drawings of a 'doodle-like nature'. Their final conclusion was that they suffered from a 'lack of descriptive terms or adequate comparisons for characterising the material. In spite of our reluctance we were easily led to use terms from pathology, and to interpret by analogies, the restricted value of which seems obvious' (Maclay *et al.* 1938, p.63).

31 Waller 1991, p.28.

32 Roland Penrose was to work as Director of the Institute of Contemporary Art which staged exhibitions of art therapy work discussed elsewhere.

33 Roman 1986, p.18.

34 Waller 1991, p.29. On the same day that war was declared the Rockefeller Foundation withdrew its funds, leaving Reitman, Guttmann and others without backing. Erich Guttmann as a German refugee was interned and not permitted to work again until 1941, when he rejoined Maclay briefly before being posted to the Radcliffe Infirmary at Oxford, where he remained to the end of the war.

35 Maclay and Guttmann 1941, p.130.

36 This is incidentally a view shared by Arthur Segal, who founded a painting school where art students and those with mental illnesses painted alongside each other.

37 Letter from Dax cited in Roman 1986, p.32.

38 Waller 1991, p.30 citing letter written by Dax to Roman.

39 NAPT leaflet c. 1946.

40 Report on Dax's speech in *Rehabilitation* 1949, p.11.

41 Dax 1948, pp.592–594.

42 Report on Dax's speech in *Rehabilitation* 1949, p.11.

43 Dax 1953, p.93.

44 Reitman 1950, p.21.

45 Reitman 1950, p.163.

46 Reitman 1950, p.163. Italics added for emphasis.

47 Reitman 1950, p.165.

48 Reitman 1950, p.166.

49 Adamson 1970, p.149 cited in Waller 1991, p.53.

50 Dax 1953, pp.18–19.

51 Adamson 1990, p.1.

52 Dax in correspondence with Roman (Jan. 1986), cited in Waller 1991, p.53. Waller's account states that this group was organised by an army sergeant, which is incorrect.

53 Dax 1953, p.19.

54 Dax in correspondence with Roman (Jan. 1986), cited in Waller 1991, p.53.

55 Adamson 1990, p.2.

56 Dax 1953, p.21.

57 Adamson 1990, p.9.

58 Dax 1953, p.19 and Dax 1948, p.592.

59 The Physician Superintendent reported that the pursuit of art therapy was becoming increasingly important in the work of mental hospitals. Adamson had been employed for fifteen hours per week at ten shillings per hour. The salary offered to Adamson of £700 compared favourably with that of secretarial staff. In the same year an educational psychologist was appointed at a salary of £800. Adamson's salary was suggested by the Director of Croydon Art School who was consulted about the matter (Netherne Hospital Management Committee, Establishment Report sub-committee 3 Dec 1948).

60 Susan Hogan: interview with Adamson, 1994.

61 Dax 1953, p.21. In 1949 Dax was hostile to the term 'art therapy'. He noted disparagingly that 'there are as many therapies in psychiatric nomenclature as there were "phobias", and it bought only disrepute on their experimental methods' (Dax, E.C. 1949, Psychiatry and Art. Netherne Hospital Exhibition, BMA report July 3rd p.228).

62 Dax 1953, p.22.
63 Susan Hogan: interview with Adamson, 1994.
64 Dax 1953, p.23
65 Susan Hogan: interview with Adamson, 1994.
66 Dax 1953, p.25.
67 Dax 1953, p.22.
68 Unnamed former patient (No 2) in Rumney 1980, p.49.
69 Dax 1953, p.20.
70 Dax 1953, p.25.
71 Unnamed patient, No.5, cited in Rumney 1980, p.57.
72 Susan Hogan: interview with Adamson, 1994.
73 Rumney 1980, p.4.
74 Unnamed patient, No.2, cited in Rumney 1980, p.49.
75 Unnamed patient, No.1, cited in Rumney 1980, p.47.
76 Susan Hogan: interview with Adamson, 1994.
77 Unnamed patient, No.1, cited in Rumney 1980, p.47.
78 Susan Hogan: interview with Adamson, also Dax 1953, p.20.
79 Susan Hogan: interview with Adamson, 1994.
80 Dax 1953, p.21.
81 Dax 1953, p.20.
82 Susan Hogan: interview with Adamson, 1994.
83 Dax 1953, p.23.
84 Susan Hogan: interview with Adamson, 1994.
85 Adamson 1990, p.2.
86 Timlin 1991, p.2.
87 Adamson 1970, p.152.
88 Reitman 1955 cited in Roman 1986, p.37.
89 Susan Hogan: interview with Adamson, 1994.
90 Adamson's attitude mirrors to a certain extent that of Dax who distinguished between 'genuine' and 'conscious' pictures.
91 Dax 1953, p.27.
92 Susan Hogan: interview with John Timlin, 1994.
93 Susan Hogan: interview with John Timlin, 1995.
94 Timlin 1991, p.2.
95 Susan Hogan: interview with John Timlin, 1994.
96 Susan Hogan: interview with John Timlin, 1995.
97 Susan Hogan: interview with John Timlin, 1995.
98 Adamson 1963, p.53. Italics added for emphasis.
99 Tredgold: preface to Adamson's article, 1963, p.50.
100 Susan Hogan: interview with Adamson, 1994.
101 Timlin 1991, pp.2–3.
102 Adamson 1970, p.156.
103 Adamson 1990, p.3.
104 Waller 1984, p.7.
105 Foreword to Adamson 1990.
106 Dax 1953, p.25.
107 Dax 1953, p.93.
108 'Darkness into light'. *The Observer* 1962.
109 Timlin 1991, p.1.
110 Indeed, those that determined the limitations of his role left the hospital before Adamson did. Cunningham Dax resigned in 1951 to take up a post in Australia and Francis Reitman, the then Director of Clinical Research, was made redundant in 1953 and left the hospital in March 1954 (Netherne Hospital Management Committee Minutes, Establishment Committee, 5 Feb. 1954, p.2).

Pioneers of Art Therapy
The Development of Art Therapy within Psychiatry and Related Settings (c.1935–1965)

This chapter will illustrate how art therapy developed in psychiatric environments with particular reference to the period in which the first art therapy posts were established. Since I do not wish to duplicate the work that Diane Waller (1991) has already done, I will not be focusing on the development of the professional association in detail, as she does this adequately in her book. However, Waller makes only cursory mention of the development of art therapy within psychiatry in this period and her account is lacking in intellectual context.[1]

Rather than being a distinct discipline, with clearly identifiable features, 'art therapy' represented a variety of practices developing in specific contexts. I shall illustrate, through an examination of secondary texts, that there was no clear consensus as to what constituted art therapy. Significant to the period under discussion here are issues of control and self-identity; debate began about *what* art therapy should be, *who* should be defined as art therapists and *how* they should be trained for their role.

is there a conscusus now?

Just the development of proff. body

An important factor regarding the development of art therapy within psychiatric environments was the development of a 'social psychiatry' movement. Whilst in some respects this was a continuation of 'moral treatment', it also employed ideas which were developing in psychoanalysis. I shall examine art therapy work carried out in this context and note its distinctive features.

Early art therapy pioneers within psychiatric environments

It is interesting to note that at the beginning of the twentieth century in Scotland, Dr Weir Mitchell's 'rest cure' was still the standard treatment for

neurotic patients. Indeed this treatment was used with patients 'irrespective of their particular diagnosis'.[2] Henderson, a psychiatrist, wrote that the 'aetiology, symptomatology and treatment of neurosis was seldom referred to.[3] Clouston's lectures were confined to psychosis.' Henderson described the rest treatment that neurotics received:

> They were confined to bed, screens isolated them from other ward patients, they were given a liberal milk diet, visitors were prohibited, and their *psychotherapeutic treatment was based on suggestion, explanation, encouragement, and sympathetic understanding.* Medicinal treatment consisted mainly of tonics, bromides… The suggestive effects of treatment were heightened by high-frequency electricity and ultra-violet rays which were credited with a virtue which they did not really possess.[4]

This is important to note because some of the first art therapy posts established in Britain were created by psychiatrists who were not necessarily interested in or sympathetic towards psychoanalysis.[5] They were primarily influenced by the history of 'moral treatment', of which the rest cure may be seen as a continuation with its emphasis on admonishment and counselling or suggestion.

The 1930s in Britain were characterised by mass poverty, unemployment, struggles and hardship. George Orwell estimated that nearly ten million people in Britain lived on the edge of destitution.[6] Areas with particularly high unemployment rates were identified (such as Glasgow, Jarrow and South Wales). The depressing effect of unemployment on the economy as a whole was identified as the 'downward spiral' by Maynard Keynes in 1936. Keynes argued for higher taxation at times of affluence and public investment in times of depression.[7] It was sadly rearmament which provided public investment in the late 1930s. Marwick identifies the 1930s as being characterised by a particular interest in the idea of political and economic planning.[8] The period is also marked by extremist politics and an unstable global situation.[9]

It is worth paying some detailed attention to the 1930 Mental Treatment Act[10] since it is the legislation of most significance to the period in which art therapy became established as a recognised discipline. If the Lunacy Act of 1890 had had the effect of forcing asylums into a mainly custodial role, then the 1930 legislation sought to reverse this trend by making it easier for people to gain treatment in asylums by making provision for voluntary and outpatient treatment.[11] Authority was given to county borough and county councils to provide outpatient and observation wards in asylums and in

Where is this footnote?
? ×11

general hospitals.[12] These changes represented a significant shift in attitude away from the idea of institutionalisation as the only means of treatment apart from the Poor Law and charity. (It was not until 1948 that a range of forms of care became available including sheltered workshops and night hospitals).[13] The legislation also reorganised the Board of Control (responsible for visiting institutions) in a way that professionalised the role of the commissioners, who now became salaried.[14]

Whilst the new legislation left some uncertainties (at what point a voluntary patient may be considered to have recovered volition, for example) it seems also to have sparked off a debate about aftercare and who should be responsible for it. In terms of the structure of the mental hospital, as it was by now called, it had become increasingly staffed by men. Between 1929 and 1931 the official unemployment rate had almost doubled and benefits had been cut. The rise in unemployment solved the acute staff shortages in mental hospitals by providing new staff, particularly men.[15]

The change in legislation had an effect on art therapy in hospitals which is perhaps best described by pioneer art therapist Edward Adamson. He recounted that the 'open door' movement expanded during the early 1940s and that this allowed patients greater freedom of expression. He wrote:

> Patients expressed their concern about the conditions in which they lived, the hospital restrictions and the iron railings around the ward gardens. They also expressed their great fear, their panic and despondency about life in the institution, their experience of the discipline exercised by the nurses and their awe and reverence for the omnipotent medical doctor.[16]

In other words art therapy gave patients a voice and allowed for a critique of the institution.

The reconstituted board of control was concerned about improving conditions within mental hospitals and Dame Ellen Pinset, who was a senior commissioner of the board, advanced concern about the grooming and dress of women patients. There was a recognition of, or rather a re-emphasis on, the therapeutic value of clothes and hair dressing. Familiar food for patients was also an issue of concern. Links between diet and mental health had been established by anthropological studies of the time, and many of the patients entering hospital during the period of economic depression were suffering from malnutrition.[17]

[handwritten margin note, left top: "This doesn't make sense with footnote."]

[handwritten margin note, left: "Footnotes don't correspond w/ h text"]

[handwritten margin note, left: "needs to expand on this illness vs institution"]

[handwritten note, bottom: "More O.T concern than Art Therapy"]

Whether aftercare was part of psychiatry or should be performed by social workers was also a question of discussion. Evelyn Fox (Secretary of the Central Association of Social Welfare) stressed the importance of having trained social workers who could work under the instruction of psychiatrists in offering support and adjusting the domestic situation.[18] Training in psychiatry remained the same from this period until 1971 with completion of a two-year diploma for medical practitioners in addition to clinical work being the norm.[19] The General Nursing Council (GNC) introduced three-year training. A State Registered Nurse could then complete another course and gain the Mental Nursing Certificate.[20] The first occupational therapy training had been introduced in 1930, and the Association of Occupational Therapists established in 1936. In Scotland in 1924 the Scottish division of the Royal Medico-Psychological Association discussed the value of establishing a training school for occupational therapists. This was set up at the Astley Ainslie Hospital in Edinburgh with the help of Canadian occupational therapists. (Unfortunately the start of the Second World War caused the school to close. The Scottish Association of Occupational Therapy (SAOT), established in 1932, also disbanded.)

In 1934 the Board of Control undertook a survey of recreational activities provided by hospitals: these included sports (cricket, football, hockey) at most hospitals and also cinema shows. Mixed-gender dances were also organised in some hospitals and this would probably have been the only time male and female patients met if they were on locked wards – and most wards were locked.[21] The introduction of voluntary patients in 1930 caused the procedure of locking wards to be examined. Prior to the legislation 'working out' and 'convalescent' wards were the only wards to be routinely unlocked.[22] Wards were also segregated on gender lines with a male nurse supervising the male ward and a male staff team. The women's wards were headed by a matron supervising women nurses. (The jangling bunch of keys were a regular feature of mental hospital life. The swiftest road to dismissal was for nurses to lose their keys).[23] A recent publication from MIND (the National Association for Mental Health) called for the reintroduction of gender-segregated wards to prevent cases of sexual harassment and rape of women patients. However, the move towards mixed-gender wards and increased interaction of women and men patients was considered to be enlightened at the time.[24]

Although only two new mental hospitals were built between the First and Second World Wars, they embodied new ideas about the treatment of mental

patients. Both hospitals were designed to accommodate small social groups and both were set in extensive grounds: Bethlem and Runwell Hospitals rejected the Victorian barrack pattern commonly used.[25] However, according to a medical colleague of Edward Adamson at Netherne Hospital, most institutions of this period 'gave high priority to such considerations as the cost effectiveness of custodial care, the mass application of standardised treatments to large populations, and to the removal of symptoms through drugs, electric shocks, behavioural manipulations and mutilating operations of the brain'.[26] *This move O.T where is A.T .*

The Second World War[27]

Professor Jones suggests that the war had the effect of unifying services which had previously been incoherent, *ad hoc*, uneven and complex.[28] Three of the four largest mental health voluntary agencies were amalgamated to form the Provisional National Council for Mental Health.[29] The outbreak of World War II in September 1939 led to an increase of interest in mental health work, particularly as it pertained to public morale.[30] Professor Jones asserts that 'the comforting picture of an England united in community spirit, class barriers swept aside, preparing for a brave new world, may owe more to the efforts of the Ministry of Information than to reality'.[31] However, it was the case that former barriers were removed and Harley Street specialists were to be found working side by side with colleagues from the Public Assistance Service or consultants with GPs.[32] The war also galvanised social scientists and psychiatric and psychological services as part of the war effort. (This process is described in detail by Rose 1990, pp.27–41.) Furthermore, people accepted an unprecedented amount of public interference in their lives.[33] Conscription from 1941 for women as well as men, controls on labour, the compulsory takeover of land and property, having children or troops billeted in one's home, and excess profits tax.[34]

In psychiatric circles the thought prevailed that in the period immediately following the outbreak of war there would be a large number of nervous breakdowns. In October 1938 a committee of psychiatrists from London teaching hospitals met to discuss what services should be put into place to cope with the anticipated mass panic.[35] The committee anticipated some three to four million acute cases within six months of the outbreak of hostilities.[36] Local treatment centres, mobile psychiatric teams and special neurosis hospitals were thought necessary.[37] However, by 1940 it became apparent that these predictions had been largely wrong and that, ironically, the morale

noThing to do with note.

of the civilian population rose during the blitz.[38] Indeed, the preparations for war were found to relieve tension; the issuing of gas masks, digging of trenches in public parks and construction of air raid shelters eased public apprehension.[39] The Provisional National Council for Mental Health (formally the Mental Health Emergency Committee) found that some problems were caused by evacuation of urban populations and also established services (from 1944) to care for service personnel discharged on psychiatric grounds: each of the thirteen civil defence regions had an office staffed by three workers including a psychiatric social worker.

The beginning of the professionalisation of art therapy is usually traced to this period. Undoubtedly, 'art therapy' benefited from the wartime interest in psychology as a factor in the management of both patients in hospital and the population in general. While the psychological condition of the population proved to be more robust than had been foreseen, there were considerable numbers of traumatised and maimed civilians and military personnel to be treated.

Even during the course of the war, post-war plans for reconstruction were discussed.[40] A Ministry of Town and Country Planning was established in 1943 and made permanent in 1947. The Beveridge Report on Social Insurance and Allied Services (published in December 1942) formed the basis of later legislation (in 1946 to 1948) which was to form the welfare state.[41] The report was recognised as providing the basis for a more egalitarian Britain and the popular press came up with the slogan of social security 'from the cradle to the grave'.[42]

In general social services had been extended because of wartime conditions.[43] The 1945 report 'The Future Organisation of Psychiatric Services' argued that psychiatry should be treated like all other branches of medicine.[44] However, apart from combining the treatment of neurosis and psychosis, continuity of care remained a problem with the new proposals.[45]

The National Health Service Act of 1946 proposed structural changes.[46] These included the setting up of thirteen Regional Hospital Boards in England (using the thirteen civil defence areas) to take over the running of county mental hospitals.[47] Whilst the Board of Control continued its regulatory functions with the use of commissioners, the Minister for Health assumed responsibility for mental health, including the administration of hospitals and the licensing of homes and hospitals for the insane and control of local authority work.[48]

The act proposed a national health service in the following terms:

It shall be the duty of the Minister of Health...to promote the establish-
ment...of a comprehensive Health Service designed to secure improve-
ment in the physical and mental health of the people...and the preven-
tion, diagnosis and treatment of illness...the services so provided shall
be free of charge, except where any provision of this Act expressly
provides for the making and recovery of charges.[49]

The National Health Service Act was passed on 5 July 1948. Professor Jones
wrote of its reception:

The National Health Service Act meant many things to many people: to
general practitioners, a period of serious overwork; to former voluntary
hospitals, frustration, and chafing under unfamiliar controls; to local
authorities, new responsibilities and opportunities in an expanding field;
to members of Regional Hospital Boards and Hospital Management
Committees, new powers; to medical specialists, new possibilities of
knowledge and professional advancement; but the most important single
factor was its effect on the patient. By dissociating medical care and
treatment from the ability to pay for it, by making free treatment available
as a right and not as charity, the Act bought freedom from fear for many
who had never been able to afford adequate medical treatment.[50]

Adequate medical treatment for the mentally ill frequently meant incarcera-
tion. One medic described the hospital he worked in thus:

...a huge impersonal fortress standing in an isolated location, and sur-
rounded by high, iron spiked walls. The intention behind such a reposi-
tory for human misery was far from therapeutic: it was a concentration
camp for the imprisonment of unfortunates.[51]

A very different picture is presented by a journalist, Richie Calder, who
visited Netherne Hospital in 1949, nineteen years after the implementation
of the Mental Treatment Act. Calder emphasised that at Netherne eighty per
cent of patients were there on a voluntary basis. He wrote that patients

have their own cafeteria where they serve themselves without supervi-
sion. The women have regular 'perms' and beauty treatment at a salon
which would be an ornament to Mayfair. They have their club-rooms,
where in lively and colourful surroundings, they live a pleasant social life
and entertain their friends. Notice boards display the social activities
organised and run by patients...[52]

Clearly the new legislation, with the resultant rapidly increasing numbers of voluntary patients, was having a transformative effect on hospital environments.

Pioneers of art therapy

I shall now mention the work of several pioneers of art therapy who were practising in the period between 1940 and 1965. In this period a number of sessional and permanent appointments of art therapists to mental hospitals were made. Tatiana Manuilow's work is not well known in Britain because she moved to France, where she remained. However, she saw art therapy as a form of psychotherapy which enabled pictures to be analysed and interpreted in the same way as dreams. She actively encouraged her patients to talk about their art work and to take their pictures to their psychotherapists if they were receiving psychotherapy. If a patient seemed to become emotionally disengaged from their work she would suggest a change of medium or that they doodle, finger-paint, or experiment with the art materials. Thus she hoped to enable them to work in a meaningful way or to experience relief. She also experienced difficult transference situations with patients and communicated closely with doctors so that they could make use of information coming to light in the art therapy situation (Manuilow 1964).

Another important pioneer of art therapy in psychiatric hospitals was Jan Glass. She worked at Warlingham Park Hospital in Surrey in the late 1950s and 1960s. Glass was a graduate of Chelsea School of Art, and like many art therapy pioneers she had started her career working for the Red Cross picture library scheme.[53] She was joined at Warlingham in 1959 by a young Australian artist, John Henzell, who wanted to learn more about art therapy. (Henzell had arrived in Britain from Australia, where he had studied painting and sculpture in Perth. Henzell worked with Glass until 1960 as assistant art therapist. He then went on to work at Napsbury Hospital, Hertfordshire, as an art therapist until 1966.) He wrote of this experience:

> From her I learnt how to accept the patient's form of expression as something to be valued and enjoyed in its own right, that this was the importance of what the patients painted, drew and modelled, as well as the conversations that grew from them, rather than as a form of psychiatric assessment or diagnosis. I was also hugely impressed by the striking power and beauty of many of the patients' images – they had a fascination often lacking from images of the official art world… I tried to reach

behind the extraordinary behaviour, expressions and utterances I encountered towards the experiences from which these derive without my sense of this being blunted by overly clinical preconceptions.[54]

Jan Glass felt that the personality of the artist was significant and that an arts training was important for art therapists. Artists, she felt, were able to readily accept conflicting thoughts and feelings and help their 'integration into acceptable forms'.[55] Making images also had the benefit of helping individuals to clarify their relationships with other people and to society in general. She saw art-making as a means of enabling people to regain their sense of identity through the reflection of their moods and problems depicted in the art object.[56] Glass said of her work at the hospital: 'Many people at Warlingham, both patients and staff, find the art department a place in which they may move with a greater freedom than they have ever known before, discovering aspects of themselves previously denied or rejected'.[57]

Referrals to Glass's department were often made because the patient was felt to be out of touch with their feelings or unable to talk about problems.[58] Although Glass acknowledged the use of art therapy products as an aid to diagnosis she was much more interested in the therapeutic potential of the art-making itself.[59]

Glass was suspicious of over-analysis of images, saying that 'to stress the content of a work in verbal terms may be beside the point and actually destroy the value of a creative experience'.[60] Her approach was therefore in sharp contrast with that of Tatiana Manuilow. Problems of personality, she felt, could be both challenged and explored through art-making. Glass did, however, encourage patients to talk about their 'present experience' of making the art works.

Her emphasis on allowing patients 'greater freedom' to discover aspects of themselves previously denied or rejected has libertarian overtones. The process relied on the personal volition of the patient rather than expert intervention, or the authority of the specialist's interpretations. It is a model which emphasised individual empowerment through the discovery of personal identity.

Jan Glass went on to become the first membership secretary of BAAT, and she was active in subsequent professional developments whilst also maintaining her own professional practice.

Another pioneer of art therapy who worked in the field of mental illness was Alexander Weatherson, who worked at Springfield Hospital in Upper Tooting, London. (He was described by Mike Pope as fastidious, nattily

dressed, probably homosexual and as having a keen sharp mind.)[61] Weatherson was influential while he remained involved in art therapy but in the late 1960s he left BAAT and went to lecture at Leeds Polytechnic. However, he held the chair of BAAT from 1967 until his departure from art therapy.[62] His article 'Seeing Insanity through Art' (1962) certainly made some converts to art therapy. (For example, art therapist Rupert Cracknell recalled in interview that it was on reading this article that he decided to pursue a career in therapy.) Weatherson noted in this article that the definition of art therapy covered a broad range of approaches from an 'old gentleman visiting the hospital once a week to encourage a little group of flower painters to greater efforts' (possibly a reference to one of the British Red Cross Society or NAPT workers), to a 'formidable lady holding a diploma in psychology (German) investing cathartic procedures with some of the characteristics of a purge'! He noted that the exact functions of art therapy departments depended upon the extent of knowledge of the subject by medical staff. He rather simplistically divided art therapists into two categories, the first category being those who were primarily interested in 'occupational' and 'diversional' aspects, the second those who were interested in gaining access to the 'continually changing mental state of the patient'.[63] He was also critical of analysts' uses of pictures because they tended to look at finished products, whereas Weatherson stressed that the way in which a picture is produced is often as revealing as its actual content. He felt that tensions between art therapists and psychiatrists were created by this difference in attitude. He felt that analysis of finished images was also complicated by the fact that patients might not have the technical skills to fulfil their intentions. Their artistic products were subject to 'the vagaries of paint' or the physical effects of their illness or medication. He wrote: 'A shaky hand has probably contributed quite a lot of symbolic images.' Such a statement indicated a scepticism of the psychoanalytic interpretations furnished by psychiatrists or psychologists such as Pickford.

Weatherson was critical of the psychiatric profession's reluctance to accept the findings of individuals outside the medical profession, a reluctance noted to include the services of clinical psychologists. As a result of such attitudes, he argued that a valuable source of information to the psychotherapist about the patient was lost. Though critical of psychiatry it is clear that Weatherson was appealing to the psychiatric profession when he went on to stress the use of art products to assess patients' state of mind and prospects of recovery.[64]

Weatherson also saw art work as an alternative means of combating institutionalisation. In psychiatric hospitals he noted a gap between volition and action. The immediacy of art work he felt appropriate for use with 'chronic patients' who, he asserted, represented a conspicuous problem in psychiatric hospitals and were less amenable to occupational therapy than their less disturbed counterparts. For some chronic patients Weatherson argued that art therapy was the only means of communication left to them. He described such work: 'The problems of picking up a brush, finding the water pot, choosing a colour become paramount, and the act of painting to one of contact with life. As control and familiarity with the medium increases, the possibility of abreaction becomes greater'.[65]

Although Weatherson was aware that art therapy might become regarded as a 'queer', 'fringe' activity he encouraged his readers to look at the images themselves as expressing the fears and the struggles of patients. He felt that engaging in art was very helpful for patients finding a balance between 'fantasy' and 'reality'. He concluded by emphasising that images served an important function as 'appeals' for 'help and understanding' and could therefore generate sympathy for the plight of the mental patient.[66]

The tension between Weatherson's approach and that of psychiatrists, to which he refers, is immediately evident in his writing, and he was clearly dismissive of their attempts to interpret completed art works. His emphasis on giving the patients a voice and on encouraging greater autonomy is similar in spirit to that of Jan Glass.

Two other pioneers of art therapy, who have been overlooked in writing on art therapy, were Hubert Parkin and Besley Naylor. Parkin was born in Exmouth in June 1904. As a child he had suffered from epilepsy and his schooling had been disrupted. In 1924 his family moved to Bournemouth and, having a talent for drawing, he attended colleges in Bournemouth, and then in London, specialising in portraiture.

Parkin was considered unfit for military service and during the war years he taught art at a boys' school. After the war he met Ena, a cellist and school music teacher, who became his wife. It was around the time of his marriage to Ena that a close friend of his suffered a nervous breakdown. He came across a book on art therapy, which was almost certainly Adrian Hill's *Art Versus Illness* (1945). These two events fired his enthusiasm to become an art therapist. He obtained an interview with Dr Sinclair who was the medical superintendent of Herrison Hospital near Dorchester. The result of this meeting was that Parkin was appointed art therapist to the hospital in 1948. He was given a

room to work in, equipment, and until his retirement in 1974 he would take the train to Dorchester and then a bus to the hospital (as he did not drive) every Tuesday and Thursday.[67]

is this necessary?

Parkin saw a mixture of patients, including acute admissions and long-term patients. While he hoped to receive referrals from doctors this hardly ever happened. Nor did doctors discuss their patients' work with him. His referrals came from the occupational therapy department, to which he felt an appendage.

Mornings were spent doing art therapy. Parkin also did music and drama with patients in the afternoons, including play readings. He continued his work as an art teacher on the other three days of the week and this influenced his approach; he taught techniques and the use of perspective to his patients. His approach was therefore similar to that employed by Adrian Hill.

Parkin was involved in putting on theatrical productions from time to time for the entertainment of patients and staff. On these occasions he was at the mercy of the unexpected – once, five minutes before the curtain went up, he discovered that his leading lady had been discharged that morning! There was nothing for it but for him to take her part himself, holding the book, as well as fulfilling the roles of producer, director, and stage manager!

Parkin joined BAAT on one occasion, but he did not feel comfortable at meetings, blaming his lack of formal education for his inability to understand what was being discussed. He therefore never played a role in the professional development of art as therapy. He was not a pioneer in this sense, but deserves mention because his was one of the first art therapy appointments in Britain.

Think Unfair

Besley Naylor was born in December 1919. He was the son of a foreman at a belt-manufacturing company. His mother was a singer of some repute. He was educated at Beaumont School until he was thirteen, when he gained employment as an office boy at a local iron and steel manufacturers. He continued his formal education at night classes, reading widely, as he was to continue to do throughout his life.

Naylor was athletic, taking part in boxing, running and walking competitions. During the Second World War he volunteered for the RAF medical corps (from November 1939 to May 1945). During this time he completed nursing training to SRN level, having been sent on an intensive nursing course which included tropical medicine. He was then sent to an RAF hospital in Yatesbury where he worked on medical, surgical, skin disease, and isolation wards. Most of the time he spent on the isolation ward where there

were TB, meningitis and yellow fever patients. During this service Besley had
to work two months of night shift at a time, in sole charge of a ward. (While
working nights, during the day Naylor notched up 20 hours as a passenger
(for ballast) in De Havilland Rapide aircraft, and was reprimanded by the
matron for not getting enough sleep!)[68] He then worked in the laboratories
before moving on to work in the operating theatre, where he assisted with
amputations.

During his national service in 1942 he met and married his wife, a WAAF.
Naylor then volunteered to become a pilot, was accepted, but failed his
medical due to having a burst eardrum which he had acquired whilst boxing.
It was also during this period that he formed a close friendship with Dr David
Mead, an artist and pianist who had trained at the Slade School of Art. Mead
had a lively interest in all of the arts and took Naylor to exhibitions in
London and talked about the art works with him.[69] Naylor then started
attending classes in life drawing at Warrington arts school, becoming an
accomplished artist.

After being injured by a bomb blast he took advantage of a government
training scheme in painting and decorating. (Besley was actually blown up
three times by German bombs. The first incident in 1940 hospitalised him
for three months and killed the person he was standing next to when the
bomb exploded. On this occasion he was buried by rubble. He was blown up
twice in 1941, once when the building he was in was struck by a bomb and
once when he was alone in the early hours of the morning in Whitechapel,
having been out dancing at the Royal Opera House at Covent Garden.) He
had thought of starting his own business, but in 1947 he took up an appoint-
ment as a painter and decorator at Winwick Hospital, a large psychiatric
hospital which was virtually self-sufficient in this period, situated in the
village of Winwick about two miles north of Warrington.

Shortly after his appointment to Winwick, he began to get involved in the
stage work for hospital plays. Naylor continued with his own artistic work
and helped design and build stage sets and props. He also painted backcloths
on canvas of about thirty feet by eighteen feet. He also produced decorations
for balls and dances. In the late 1940s he became head of one of the stage
teams. Naylor was also prepared to step in as Master of Ceremonies, as this
paid £3.00, a useful addition to his wage as by then he had four children to
support.

It was a chance encounter with the medical superintendent of the hospital
some years after his initial appointment that secured Naylor a position as art

therapist.[70] Initially, in the late 1950s, he had worked with a nurse called Wilfred Wells, from whom he learned many crafts skills, including pottery.[71]

He started practising art therapy, carrying a box of materials to wards in the hospital. The ward sisters were responsible for selecting about a dozen patients, and they would be assembled on his arrival round the large dining table in each ward.[72]

An adjacent hospital (of about 250 beds) for short-term admissions was opened, near to Winwick, and Naylor worked there doing both art therapy and occupational therapy. He was also able to secure an OT helper position for his wife at Delph Hospital. He was eventually appointed with the title 'art therapist' in July 1962, though he had been working in this capacity for some time before his change of job title.[73] Naylor felt that art therapy had rehabilitative effects, giving patients 'visual evidence' of their own progress along with an increasing sense of achievement. This resulted, he believed, in an enhanced sense of self-worth.[74] His emphasis was on the self-expression of the patient, rather than seeing the art works as evidence of psychopathology.

In contrast to Parkin's experience of being isolated from medical staff, Besley Naylor was able to interest doctors in his art therapy work. Medical staff often visited his art room. On occasions he would take a piece of art work to a consultant psychiatrist if he thought that it was of particular interest. If referrals were made by a consultant he would be briefed about the psychiatric history of the patient. Naylor continued to work as an art therapist until his retirement. He was also a founding member of BAAT.

The work of these pioneers influenced the next generation of art therapists. Michael Pope, for example, who became a prominent member of BAAT, finished his art school training in the early 1960s. He described going on 'pilgrimages to the art departments of many of the pioneers including Adamson, Weatherson, Glass and Lydiatt'.[75] He explained that as an impressionable young man

> these figures assumed legendary status and there seemed to be something quite magical about the atmosphere and creativity in their art rooms. Tucked away somewhere in the maze-like geography of the old psychiatric hospitals, their studios were congenial, cluttered and colourful havens in a world of clinical routines and barren wards.[76]

Mike Pope had shared a flat with the artist Ken Kiff, whose expressionistic art works had also influenced him. Ken Kiff went to see a psychologist himself, taking small drawings and paintings to discuss with him. However,

Kiff did not regard these pieces as art works. He asserted 'I thought, and think still, that there is a vital difference between these "psychological" works and the works that I exhibit. Not that the "psychological" works are too personal, but that they are too narrow.'[77]

Figure 8.1 Work by Ken Kiff. The Sequence No.113. *(Mike Pope's flat mate), undated*

By the mid-1960s there were a number of art therapists established in psychiatric hospitals and day centres. These included Mrs A. Arnold at the Burgh Health Centre in Epsom, Surrey, Mr R. Robinson at Horton Hospital and John Henzell who had by that time secured an appointment at Napsbury Hospital in St Albans. By the first annual general meeting of BAAT in 1966, there were as many as eighty-four full and associate members of the association.[78] *Don't talk much about John Henzell*

The aims of art therapy

In 1966 the criteria for acceptance to full professional membership of BAAT was whether or not the applicant was practising art therapy or remedial art teaching (as distinguished from related activities such as occupational therapy, recreational instruction or art teaching).[79] Those applying to BAAT

were asked to fill in a questionnaire defining their aims, and giving other details of their employment situation. These documents therefore represent an excellent opportunity to analyse how art therapists conceived their role. Most frequently emphasised in these questionnaire answers is the cathartic potential of art therapy. This is seen as allowing the release of mental and emotional tension which in turn can relax or relieve the patients' anxieties. Most of the questionnaires also reflect the belief that engaging in art therapy could help the patient to discover previously unrecognised potentialities leading to improved feelings of self-worth or to a greater feeling of wholeness. Art therapists also clearly placed great emphasis on communication, self-expression, and giving the patient a voice. As Edward Adamson explained, prior to the 1940s

> most of the wards were closed, and patients detained under compulsory orders. There was little freedom, and communication between patients and staff was very restricted. In those days, if patients expressed themselves pictorially they were obliged to draw on any material they could get hold of, and their work was usually very formal and conventional in manner.[80]

Clearly Adamson believed that the new 'open door' legislation was instrumental in creating a climate in which patients could begin to question their lot. He wrote that with the change of institutional practices came the opportunity to make art works 'which reflect, both in style and content, the new freedom.'[81]

Social psychiatry and art therapy

In contrast to the large mental hospital was the therapeutic community, whose concept developed from the theories of two military psychiatrists: Tom Maine and Maxwell Jones. It was at about the same time that S.H. Foukles and W.R. Bion were attempting to use group methods with psychoanalytic theory. It was this work that set the ground rules for social psychiatry in this period. A number of therapeutic communities were established. The first of these (Withymead near Exeter) had an arts therapies emphasis. Several years later a therapeutic community was established at the Cassel Hospital, Richmond, in 1946. Soon afterwards, at the Bellmont Hospital (which subsequently changed its name to the Henderson Hospital, Sutton), another therapeutic community was set up in 1947 by Dr Jones. The first attempt to

extend therapeutic community practice to a whole civilian hospital was undertaken by Dennis Martin at Clayberry some years later.[82]

Indeed, the emphasis of psychology during the Second World War and post-war period turned towards the use of group methods: 'The concept of the group was to become the organizing principle of psychological and psychiatric thought concerning the conduct of the individual. From the wartime years onward, social and institutional life was increasingly to be conceived as intersubjective emotional relations...'[83] for communities ?

The idea of therapeutic social clubs was born in 1938 and were first used for acute neurotic and psychotic in-patients.[84] St Bernard's Hospital used two rooms under the wards. Other clubs such as the 'Goodfellows Club' in Holland Park or the 'Phoenix Club' (the first of these experiments) at Kingsway, London, chose sites away from the psychiatric hospital environment.

The Social Psychotherapy Centre (the first day hospital in Britain) opened in Hampstead, London, in 1946, and relocated in 1954, changing its name to the Marlborough Day Hospital. Methods of treatment on offer included group psychotherapy, occupational and recreational therapy, social club therapy, group therapy and group discussions, psychodrama and arts therapies (painting, music, and drama) as well as physical treatments.[85]

These ventures are described as self governing and democratic.[86] Joshua Bierer, a founder of social psychiatry, described its aim to 'mobilise the hidden and scarcely tapped resources within the patient, to make him a partner in his own treatment and that of his fellow sufferers'.[87] The social clubs idea was founded on the belief that engaging in active social relationships and taking responsibility for the running of the clubs led to both the disappearance of symptoms and to a fundamental change in patients.[88] This was an empowerment model which aimed at treating patients as though they were normal, giving them 'an incentive to think, to plan and create'.[89] Another proponent of social therapy notes that these ideas were taken up with enthusiasm in occupational therapy departments. However, a difference between psychotherapy and social therapy was noted. Social therapy, unlike psychotherapy, was seen as concerned with 'influencing the patient in a dynamic and social background instead of the static and confidential atmosphere of the consulting room'.[90] Transference was not viewed as a significant factor in the curative effects of the social clubs. Blair, a psychiatrist following this approach, wrote: '...enthusiastic psychoanalysts have sought to explain the success of the club by the fact that a transference (in the psy-

choanalytic sense) occurs between the patient and the psychiatrist... I consider this is stretching the conception of transference to an unjustifiable extreme'.[91] Bierer himself was critical of psychotherapy. He felt that the schools of psychotherapy were 'much too narrow and dogmatic'. He asked: 'How can we approach each different patient with the same fixed method, the same fixed treatment?'

It is the psychiatric social club movement which was instrumental in the development of some art therapy posts. In 1946 Edward Adamson, who held the first art therapy post at Netherne Hospital, was invited to talk to a social club about some reproductions. He wrote: 'It was suggested that I might help the patients to paint for themselves. I was dubious but I resolved to try, and it was out of that chance visit that my present work developed'.[92] Richie Calder wrote in the *New Statesman* of his subsequent visit to the Netherne studio that art is 'one of the most useful ways of releasing tormented people from their neurosis' and that 'at Netherne and other hospitals, painting is now an accepted form of treatment'.[93]

Rita Simon was privately educated and then attended Richmond Art School in Surrey. She then specialised in book production at the Central School of Art and Design in London. Simon was only in her 20s when she met Joshua Bierer. Bierer had developed his interest in art therapy through his wife's involvement with the British Red Cross Society Picture Library Scheme. It was through this that he had learnt of the work of Adrian Hill.[94]

Rita Simon's first experience of art therapy was that of setting up an art group in her home in 1942, with Joshua Bierer's encouragement, which took place on a weekly basis. She wrote of this experience:

> I was immediately impressed by their commitment to drawing and painting, by comparison with the often jaded atmosphere of the conventional art class. Although I was prepared to lend studio space to the patients, I was not at all interested in teaching them and was relieved to find that they were not interested in being taught.[95]

The length of attendance by group members varied from a few months to one or even two years. The class met initially every Sunday afternoon, and was of three hours' duration. A variety of art materials were made available to those that attended, including oil paints. One of the members of Simon's group went on to study at the Central School in London. However, teaching skills was not part of her remit, and most of her patients ceased to paint at the end of their treatment. Thus there was no sense of competition between patients with regard to their level of technical accomplishment. Simon also felt that

Figure 8.2 Rita Simon at a psychiatric social club (dancing, far right). Modified image.

therapeutic drawing and painting should only be carried out in conjunction with parallel analytic treatments.[96]

Developing from the Kingsway Social Club, an art group was formed in February 1944.[97] With the opening of the Social Psychotherapy Centre (as it was then called) in 1946, Simon was offered a part-time appointment and a room to work from. There she had an opportunity to meet doctors at weekly case meetings as well as psychiatrists interested in social psychiatry. She now came into contact with a range of psychotherapeutic theory (Bierer was an Adlerian). However, at this time she could not embrace such theory. She wrote:

> At first I tried to be helpful by looking at the ideas behind the subject of a patient's art work in terms of Freudian or Jungian symbolism, but I put these theories aside as I soon found myself out of my depth...at that time I did not have the experience to cope with them and I had to accept that the type of patient who needed a 'therapeutic talk' would give up art work if he could not find satisfaction in the use of non-verbal expression alone.[98]

Although she wanted very much to understand what was going on when people made images, she 'felt averse to reading psychology or psychotherapy, clinging to the feeling that only the actual experience of seeing the art work and watching the way it came about could properly teach me'.[99] This was a view which she held throughout her career. (In 1992 she wrote: 'I am still not happy to go far from the work process in the search for the meaning of art as therapy. I feel that I understand best when I watch an image unfold in all its unexpectedness – showing the life of the inner person I do not meet in any other way.')[100]

The emphasis was on self-expression and each class ended with a group painting to which patients contributed in turn. Simon felt that this structured ending to the group was useful in several different ways: patients became so engrossed in their work during the art therapy session that they found it difficult to stop, and initially Simon had difficulty in closing the group. Second, the structured ending enabled a contained emotional release or catharsis to take place. In addition to this, the ending exercise allowed 'group dynamics' some acknowledgement.[101]

Simon described herself and other art therapists working in this period as very much 'groping in the dark'. The patients she saw were mainly self-referring and therefore largely well motivated.[102] She did not have regular meetings with psychiatrists. Many psychiatrists felt that she didn't need to know a great deal about the patients she was working with, and frequently she would work with people without having been briefed about their condition.[103] Getting to talk to busy psychiatrists was very much a matter of catching one as they 'flew by' in a corridor.[104] Though busy, Bierer was not aloof and he and Simon had a firm friendship. She always called him 'Josh'.

Simon came to believe that art therapy could have particular value in conjunction with analysis. She described the benefits to be gained by participation in 'the art circle' thus: that feelings (both conscious and unconscious) usually withheld could be expressed, giving pleasure and relief to patients. The social aspects of the work were noted by her as useful. They presented an opportunity for the development of a more objective attitude, or, in contrast, the depiction of fantasy which can then be communicated to others. She also felt that engaging in art could help to form 'a co-operative link' between the patients and their doctor. The images illustrated what had been felt by the patient between interviews.[105]

Based at the day hospital, Simon began to visit general hospitals and sanatoria. She also established a group for long-stay schizophrenics of which she wrote, 'It seemed rather miraculous that patients who had been institutionalised for up to fourteen years, and were normally quite withdrawn, could make such a social commitment'.[106]

Towards the end of the 1940s she met art therapy pioneer Adrian Hill (who was partly disabled from the effects of pulmonary tuberculosis) at a meeting convened by the newly formed National Association of Mental Health. This meeting was to widen her idea of the therapeutic value of art in cases where otherwise healthy people were mentally upset by a physical condition.[107]

Around this time she met a Jungian analyst and psychiatrist, Eric Strauss, who was based in the newly established department of psychological medicine at St Bartholomew's Hospital (where Foulkes was employed from 1946 after his stint at Northfield). She took some of her patients' art with her and Eric Strauss suggested that she further explore the psychodynamics of art by going into a personal analysis with a Freudian psychiatrist, J. F. Lovel Barnes. She wrote:

> I made very few drawings and paintings as a direct contribution to my analytic work, and although I did a great deal of poetry and spontaneous writing that was helpful to me, I did not think of it as therapy.[108]

This experience of undergoing analysis led Simon to understand the relevance of 'transcribing sensuous, emotional and intuitive experiences into conscious thoughts', but also led her to appreciate the 'difficulties' and 'limitations of words for communicating these thoughts to others'.[109]

Simon described a turning point in her thinking about art therapy as occurring when she read Marion Milner's book, *On Not Being Able to Paint* (1950). She described the book as illustrating 'our capacity to create visible symbols of things we comprehend unconsciously'.[110] Simon was immediately struck by the similarity between Milner's descriptions of scribbling and doodling as a means of liberating the imagination and her own experience of facilitating art therapy groups. She wrote:

> Milner was able to detect underlying emotions in her free scribbles, and she interpreted them psychoanalytically as a resurgence of infantile terror, rage and despair. She came to the conclusion that blocks in creativity are caused by the fear of experiencing once again these primitive feelings.[111]

These ideas led her, later in her career, to become interested in both object relations theory and the work of Klein. (Kleinian theory has subsequently been applied to art therapy practice, viewing the art object as a means for the subject to make reparation to objects destroyed in 'phantasy'.) However, Simon remained, at least in the early stages of her career, more influenced by the psychiatric social club ethos than by these ideas. She explained her approach some years later thus:

> The socially orientated art therapist seeks to strengthen group relation-ships and to establish with the patient a sense of belonging to the wider group of the cultural community through mutual support. Their common interest in the patient's work is a way through the loneliness and isolation of mental disturbance and the usual communication afforded by the patient's work increases the therapist's understanding.[112]

Thus in a social art therapy approach the focus is on the redefinition of patients' relations to themselves and society. Art therapy, she felt, could also mitigate the stress experienced during mental illness.[113]

Simon retained her concerns about the interpretation of art work. She worried that interpretations emphasise what can be said, and that which cannot be easily translated into words might be denied. During the early art therapy meetings, Simon came across art therapists who described abstract art works made by patients as 'no paintings' because 'they couldn't be inter-preted'. Simon said of this approach that it made her 'very angry'. She felt that some art therapists were getting patients to paint in order to interpret the work. She recounted that she felt 'very antagonistic to this, particularly in the hands of people who hadn't had psychotherapy in depth. This seemed like a very destructive way of using art'.[114] She felt that what was useful in art therapy was the opportunity for the patient to enter into a state of 'reverie'. This state of consciousness she felt was 'tremendously important if the client is going to get beyond what they already know, beyond their conscious knowledge'.[115] This is a view she held throughout her professional career. Many years later she was to agree with Winnicott who had written: 'Psycho-therapy is not making clever and apt interpretations: by and large it is long term giving the patient back what the patient brings...if I do this well enough the patient will find his or her own self and will be able to exist and feel real'.[116]

Simon's approach to art therapy was essentially radical, as she perceived mental illness as something generated in the interaction between people and society. She was fairly central to art therapy developments during this period.

She had met Adrian Hill and Frank Brakewell through a friend, an occupational therapist, Beryl Harris, who was interested in the work of the NAPT. She became a very close friend of both Hill and his wife Dorothy.[117] She was aware of the work of Cunningham Dax and Edward Adamson through her work at the Social Psychotherapy Centre, where she had heard Dax lecture. She was aware of Irene Champernowne's work at Withymead and that conducted at Hill End Hospital in St Albans. She knew Lydiatt well and also Manuilow who worked as an art therapist at St Bernards Hospital, Southall, Middlesex, and who had undergone Freudian analysis. Manuilow she described as having a tremendous ability to empathise with patients, one which she shared with Lydiatt, which drew Simon to both women. Neither Manuilow nor 'Liddy' allowed their theoretical persuasions to take priority over their personal human relationships with their clients. Simon described this attitude as 'there but for the grace of God go I!'.

Rita Simon moved to Ireland in the 1950s, where she started a painting group at the Purdysburn Psychiatric Hospital in 1952.[118] Her departure to Ireland meant that she did not take up a central role when the British Association of Art Therapists was formed, as undoubtedly she would have, had she stayed in England.

Simon was later to become fascinated with pictorial styles and what they might indicate about the personality of the person using a particular style. She was influenced by Jungian theory on the four function types in her thinking on this subject. Eventually she produced a book entitled *The Symbolism of Style* and other works exploring the same subject.[119]

Sigmund Henrich Foulkes

Another significant art therapy development was instigated by Sigmund Henrich Foulkes (1898–1976) at Northfield Military Hospital. Foulkes had completed medical training in Germany before training as a psychoanalyst in Vienna with Helene Deutsch. In 1933 he visited England and met Ernest Jones and James Strachey (who was responsible for the translation of many of Freud's works into English).[120] He then moved to Britain, qualifying as a British MD in 1936, the same year in which he met Sigmund Freud. In 1938 he became a British subject and changed his name to Foulkes.[121]

Between 1940 and 1942 Foulkes maintained a private practice in Exeter, and it is highly likely that he became acquainted with the work of Withymead during that period. He would almost certainly have met Irene Champernowne and other Withymead analysts who maintained private

practices in Exeter. Foulkes also worked for the Exeter Child Guidance Clinic where some of the Withymead staff also practised.[122]

In 1942 he joined the Royal Army Medical Corps and was appointed Major and specialist psychiatrist to Northfield, a large military hospital in Birmingham. The institution comprised a military neurosis centre as well as a psychiatric training centre. The 'first Northfield experiment' had been undertaken by two psychiatrists, Bion and Rickman, who had established a group method in one of the wards of the hospital. Foulkes was given the brief to develop group techniques, including psychodrama and art therapy, which started in October 1945. He was instrumental in the 'second Northfield experiment', in which the entire hospital, including all of the staff, became a 'therapeutic community'.[123] Similar work was also being conducted at Mill Hill Hospital by 1945 where Maxwell Jones was by then employed.[124]

The type of men referred to Northfield is revealed by the confidential psychiatric reports. Diagnoses listed were different types of 'hysteria' and anxiety states. Recorded symptoms included lack of confidence, depression, disturbed sleep, tremors, giddiness, morbid feelings and attacks of weeping, headaches, weakness. Many of the men had been shaken by specific incidents, usually a wounding or accident of some kind; prior to this they may have had no history of psychological problems.[125]

A pilot 'art class' with 'group discussion' was started on 19 October 1945, facilitated by Foulkes himself with other members of staff depending on their availability; these included Sergeant Bradbury (who was the only person to attend all sessions, with the exception of Foulkes himself).

The art group took the form of free painting sessions followed by a group discussion of some of the work produced. Attendance varied from between six and fourteen patients with between two and four members of staff joining the group discussion. At this meeting patients were encouraged to speak freely about their reactions to the art works as well as issues arising from them. The clinical notes of the first meeting observe that drawings by one particular patient were interpreted quite differently by different patients.[126] To give a flavour of the art group here is an extract from the notes on the second group:

> The group…were [sic] slow to respond to the drawings, and the paintings which Michael showed to the group caused little excitement. Even the most depressed of Michael's works were accepted with little interest, though everyone agreed upon the drabness of the colouring in each case and no-one suggested that the pictures could be [seen as] cheerful,

despite the cheerful element in each. Peter, realistic and usually reserved, made a long, cynical, and determined statement on the unresurrected dead – which appeared in one of Michael's drawings. None of the group opposed or seconded Peter's opinions, but though he appeared to be serious enough himself, the group was inclined to be amused. Drawings – 'doodle-type' – by Ben provoked an outspoken discussion on English women, their lack of loyalty in this war… [A number of the men were experiencing marital difficulties.] Simon, a direct sufferer in this respect, gave heated replies to one or two who defended the English women. Usually Simon is quiet and agreeable, but he was exceptionally bitter today. Practically everyone took part in the discussion, excepting Ben himself. The Group was not interrupted and ran on to tea time, i.e. 2 hours.[127]

Clearly, the discussion in this example, which is not untypical of those that took place, was not primarily focused on analysis of the images. Rather, the drawings and paintings acted as a catalyst for discussion of wider issues. Although Cunningham Dax and others visited this group, this is not the model they chose to adopt at Netherne Hospital. It is noteworthy that no record was made of the actual process of art-making which appears not to have been regarded as part of the psychotherapy procedure. Given that Foulkes was a trained psychoanalyst, this emphasis on the spoken word is hardly surprising.

Though both were working in 'community' settings with an emphasis on group methods there is a sharp difference in approach between Foulkes and Rita Simon.[128]

Early art therapy meetings

A number of developments were instigated in the 1940s by Adrian Hill including the British Red Cross Society (BRCS) Art Therapy Advisory Committee of 1944, the BRCS Sub-Committee of 1945, and Hill's 1949 chairmanship of the Art Therapy Committee of the South West Metropolitan Hospital Board. The BRCS advisory committee and sub-committee provided an important meeting place of influential opinion, the significance of which has been overlooked. The first discussions about training for art therapists took place at these meetings: for example, in 1948 the Arthur Segal School in London was noted as successful in its training of art teachers for specialist work in hospitals as art therapists (BRCS Report on the Picture Library Scheme, 1948). However, in addition to these more formal meetings art ther-

apists began coming together to discuss their experience in informal meetings.

Edward Adamson felt that the first informal meetings, which were held at Netherne Hospital in the 1940s, were very unified. They comprised mainly artists who were working in a similar way, who used it as an opportunity to talk about their patients' work and issues of support. They were primarily social occasions, as many art therapists felt isolated in their places of work. Adamson felt particularly sympathetic to the work of Lydiatt and Dr Irene Champernowne (both Jungians). However, he described the meetings as 'disintegrating' once non-artists started to attend and becoming 'too political'.[129] John Timlin, who also attended these early meetings at Netherne, felt that the meetings were supportive. They were not intellectual debates, he explained, but focused on the art works of patients which were often brought along. The primary function of the meetings was social.[130] These meetings were later to become more structured, formal and minuted.

In addition to knowing most of the art therapy community, Rita Simon attended early art therapy meetings, describing them as 'open' and 'informal'. She described these meetings as often comprising fourteen or fifteen people sitting around a large table, talking about the work they were doing. People present included Joshua Bierer, Susan Bach, Cunningham Dax, Richard Fritzsche, Frank Brakewell, Adrian Hill, Nancy Overend, and Elizabeth Wills. Simon noted that there was some disagreement even at those early meetings.[131] (She also attended the more formal meetings set up in the 1950s to discuss training issues.)[132] Mike Pope, who also attended these later meetings, described a shift, as he put it, from an 'idealistic' to a more pragmatic 'politically aware' group.[133]

Adrian Hill and his close associates were not adverse to seeing art therapy as a *specialised* form of occupational therapy. This may account for some of the tensions apparent in the 1960s at the time that the British Association of Art Therapists was formed. An unnamed interviewee said of their experience of the first BAAT meeting, '...it was fractious...I was met in the corridor by Adrian [Hill] and Frank [Brakewell] and they were troubled. They felt it was moving in a way they didn't like...there were troubled waters right from that first meeting'.[134] Indeed, it may be that Hill supported Maria Petrie's view, since he much admired her work, that training for therapists should be generic, encompassing industrial arts, physiotherapy as it relates to craft activity, occupational and diversional therapy, art appreciation and art

therapy. This generic approach she believed should constitute a three-year training.[135]

Hill wrote: 'It is my belief that sooner or later Art must come into line with occupational therapy. At present I have likened it to a young and healthy off-shoot from the parent growth which should now be regarded as a cutting to be grafted on to the main stem so as to become an integrated part of the whole'.[136] Interestingly, this was also the opinion of Dr Balme (Director of Welfare Services) of the BRCS with whom Hill was working in promoting art therapy.

Certainly, there were a variety of approaches evident at the early meetings, including Adamson's non-interventionist stance; the Withymead model of art therapy coupled with analysis; other Jungians; Segal-trained art therapists such as Elsie Davies; several occupational therapists as well as Adrian Hill and his supporters.

In the 1960s Rita Simon noted that art therapy became increasingly polarised into two camps: those who wished to concentrate on the 'social aspects' of art therapy and those who 'plunged bravely, or reluctantly, into the deeper waters of their patients' troubled minds'; however, art therapists interested in 'taking the plunge', as illustrated, had radically different ways of regarding and practising art therapy. Art therapists who plunged often got more than they had bargained for, according to Simon: 'He [sic] found himself drawn into the position of an untrained psychotherapist and his aesthetic values were often in conflict with the patients' psychic needs'.[137]

Simon noted that many different approaches were evident at early meetings, but that in the late 1960s the prevailing opinion among those regularly attending the meetings moved towards viewing an analytical approach as desirable for art therapists, leaving Hill increasingly isolated as he remained resistant to using concepts from psychoanalysis as a basis for art therapy work.[138]

It would appear (though this is largely conjecture, as there are no written statements as to the collective position) that activists within BAAT began to embrace psychodynamic theory in the mid-1960s precisely at the moment when such theory (and particularly object-relations theory) was becoming increasingly challenged by sociologists and historians.[139] Whilst the power struggle within the professional association attempted to create a homogeneity within art therapy, Nikolas Rose's description of psychology is relevant here; far from being homogeneous Rose describes it in this period as 'riven between incompatible explanatory models, tacitly or explicitly founded

Differences of Approaches — Coming together beginnings of Supervision though this not discussed

upon opposed philosophical bases', a description which could well be applied to art therapy in this period too.[140] As some art therapists began to align themselves with particular psychological theories an already disparate group was to become further divided.

Conclusion

In this chapter I have presented a picture of developments in psychiatry within which art therapy developed. I have presented a detailed account of the work of Rita Simon in particular (prior to her departure to Ireland). Both Rita and Edward Adamson started their art therapy careers in the art therapy schemes initiated by Adrian Hill and I have noted Hill's influence in early institutional developments.

I have argued that art therapy practice was shaped in its emergence by the diverse contexts in which it developed, and that it was heterogeneous during this period. The way that art therapists practised differed immensely, as did their roles within the hospitals and special units in which they worked. However, I have also noted a widespread repudiation of the practice of analysing imagery and furnishing dogmatic interpretations based on psychoanalytic theory amongst pioneer art therapists. Such work was carried out not by art therapists, but largely by other professionals such as analysts, psychoanalysts, psychologists, psychiatrists and psychotherapists. Psychiatrists during this period quite rightly distinguished between such work and 'art therapy'. However, towards the end of the 1960s the distinction between these approaches began to become slightly blurred.

This chapter and the previous chapter have illustrated how the working methods and philosophies of the main pioneers of this period differed. However, what many of these art therapists clearly had in common was a potentially subversive emphasis on giving the disempowered patient a voice. This work was done in the context of institutional reforms carried out in response to the 1930 Mental Treatment Act. Given this potentially subversive emphasis within art therapy, it is hardly surprising that the profession developed much more slowly than occupational therapy, and that institutional support for the work of the art therapist, most tangibly in the form of referrals, often came from nursing and occupational therapy staff rather than from psychiatrists.

Simon differed from both Hill and Adamson in her approach which, right from the start, was geared towards, and interested in, group approaches to art therapy. Her art therapy group at the Social Psychotherapy Centre in London

was very much a precursor of modern art therapy practice in which interactions between group members are emphasised.[141] However, she was ambivalent about the application of psychoanalytic theory to the process, an ambivalence not shared by all of the later generation of art therapists. Adamson, as I noted in the previous chapter, did not encourage his patients to communicate with each other, and the physical layout of the studio, comprising separate easels, helped to discourage much communication between individuals.

Simon, unlike Hill and Adamson, was not of independent means and she did not have access to those in power in the same way. (As already noted Hill entertained various royals and mixed with members of the aristocracy whilst promoting art therapy.) However, her influence was considerable through her personal contact with other art therapists and because of her publications on art therapy. She practised an approach which was not dissimilar from that which has become the dominant model of art therapy in Britain. Foulkes, in contrast, though working in a setting with a similar philosophy, was not a trained artist and worked with a greater emphasis on verbal analysis and group discussion in an approach orientated towards verbal psychotherapy.

In this chapter I have sought to illustrate how a variety of approaches were lumped together under the title 'art therapy'. It is hardly surprising that as professional developments got under way, with the formation of the British Association of Art Therapists, getting agreement on a wide range of issues would prove to be problematic.

Notes

1 Given that much sound research has already been carried out in the area of general psychiatric history by other writers, only a sketch of psychiatry will be necessary in order to contextualise the work of art therapy pioneers and to assist in the task of analysing the motivation for the establishment of art therapy posts. Nor is it my intention to write an alternative history of psychiatrists who have an interest in art, such as Prinzhorn, Kris or H.G. Baynes, as they have already been discussed elsewhere in considerable detail (MacGregor 1989). Their work is significant in that they formed part of the intellectual resources available to pioneer art therapists. The aim of mentioning some of these psychiatrists is to provide an intellectual context for the emergence of a nascent art therapy practice. Not all art therapy pioneers were unaware of literature written by psychiatrists. Most art therapy pioneers were, however, influenced by specific publications on art as therapy, particularly those that appeared in popular newspapers and journals, written by Adrian Hill and Edward Adamson in particular. Also significant were chance encounters with pioneer art therapists (particularly those connected with the Withymead Centre who were very active, giving lectures and workshops, during the 1940s and 50s). Many art therapists had an interest in modern art, and Surrealism in particular.

2 Henderson 1964, p.250.

3 Henderson notes that in Scotland the Royal Hospitals (known as 'the Royals') formed close teaching links with the universities of Aberdeen, Glasgow, Edinburgh and St Andrews. Indeed, the first proposal for a chair in psychiatry had been made as early as 1823 and had been 'scornfully rejected'. The professor of medicine would give some lectures on mental illness (Henderson 1964, p.258).

4 Henderson 1964, p.250. Italics added.

5 I have already noted that the psychiatrist Reitman, for example, clearly distinguished between 'psychopathological schools' of art (psychoanalysis and analytical psychology) and art therapy.

6 George Orwell cited by Jones 1991, p.109.

7 Jones 1991, p.114.

8 Marwick 1968, p.243.

9 In September 1931 Japan attacked Manchuria. In October 1933 Germany withdrew from the World Disarmament Conference. The Italian fascists invaded Abyssinia. In March 1936 German troops reoccupied the demilitarised Rhineland. In July 1936 Franco commenced hostilities against the Spanish Republican Government and shortly after, Hitler and Mussolini commenced open support for Franco. (Marwick 1968, p.238)

12 Asylums were not technically speaking hospitals until this legislation. 'The concept of mental illness was cautiously accepted' (Jones 1991b, p.23).

13 Three types of patient were created. These were 'voluntary', 'temporary' and 'certified', the latter using the legislation existing from 1890. A voluntary patient could be admitted by making an application in writing to the institution of their choice. Temporary patients were those defined as 'suffering from mental illness and likely to benefit by temporary treatment, but for the time being incapable of expressing as willing or unwilling to receive such treatment' (section 5). This required a petition from a near relative and two medical certificates. The order was for six months and could not exceed one year. If a patient recovered volition they could be discharged within 28 days or be admitted as a voluntary patient (Jones 1972, p.252). Changes in terminology occurred too and 'asylums' became called 'mental hospitals' and 'lunatic' was replaced with 'patient' (Jones 1972, p.252). Some concern was also expressed about the possibility of voluntary patients becoming an elite and receiving better treatment or causing a waste of resources by embarking upon a course of treatment without finishing it, but the overall response to the legislation was favourable.

14 Being able to attend an outpatient unit of a general hospital for mental health treatment helped with the stigma of mental illness. This point was made at the two-day conference which accompanied the new legislation at Westminster Central Hall by the then Minister for Health Arthur Greenwood (Jones 1972, p.252). However, by the outbreak of war, it was clear that many outpatient clinics were ill-equipped, understaffed and had inadequately trained personnel (Jones 1972, p.268).

13 Jones 1972, p.282.

14 Under the Mental Deficiency Act of 1913 unpaid commissioners had been used. The new Central Authority was to contain salaried commissioners. Two of the maximum number of five were to be medical commissioners and one had to be a woman (Jones 1972, p.250). No qualifications (legal or medical) were specified as necessary for the woman member.

15 Jones 1972, p.254. With unemployment rates so high some fear was expressed (at the conference accompanying the introduction of the 1930 legislation) that the hungry might check into mental hospitals to get free meals (Jones 1972, p.235).

16 Adamson 1968, p.12

17 Jones 1972, p.257.

18 Jones 1972, p.255. A specialist course in psychiatric social work existed by this time (founded in 1929) at the LSE and received funding from the Commonwealth Fund of America. Elizabeth Macadam (founder of a course in Liverpool) organised a national body called the Joint University Council for Social Services which made recommendations about the nature of the training, which was a mixture of practical and academic work, including social policy, social theory and practical work under supervision (Jones 1972, p.259).

19 The diploma in psychological medicine was offered by London and Manchester Universities (Jones 1972, p.259).

20 Registration training could also be completed in a GNC-affiliated school over four years. The Mental Nursing Certificate could be completed in a GNC-affiliated school over three years (Jones 1972, p.259).

21 Jones 1972, pp.257–258.

22 Four types of 'freedom' were extended to patients: 'hospital parole' giving freedom of movement within the building; 'ground parole' allowing access to the grounds of the hospital; 'outside parole' giving patients the opportunity to venture out alone or with another patient to visit the nearest town or relatives; 'weekend parole' tended to be granted shortly before discharge (Jones 1972, p.258).

23 Jones 1972, p.258.

24 Gorman 1992. Stress on Women: Out of the Shadows. MIND.

25 Jones 1972, p.261.
26 Dr Stevens described Netherne Hospital in 1946 as a 'nightmare world' (Stevens 1990 in the foreword to Adamson).
27 Neville Chamberlin became Prime Minister in October 1937 and the declaration of war on Germany was made on 3rd September 1939.
28 Jones 1972, p.247. Professor Marwick argues that the Ministry of Health had recognised the unifying effect of the war on hospital services when it in 1942 wrote that 'there can be no return to the pre-war position of unrelated hospital units pursuing independent and often wastefully competitive courses' (Marwick 1968, p.267).
29 In 1939 four voluntary services existed on a national level in the mental health field. These were the Mental After-Care Association (founded in 1879), the Central Association for Mental Welfare (founded in 1896 to care for mental defectives), the National Council for Mental Hygiene (founded in 1918 with an emphasis on educational and preventative work) and the Child Guidance Council (founded in 1927) (Jones 1972, p.268). Amalgamation had been one of the recommendations of the Feversham Report of 1939 and the latter three organisations were merged. All were finally amalgamated in 1946 in the National Health Service Act. However, in 1942 three of the four merged to form the Provisional National Committee for Mental Health (PNCMH), which was called the Mental Health Emergency Committee when first established until the name change in 1942. The Board of Control did not have control over services provided by local authorities, which varied tremendously. These services included social work, outpatient, occupational and industrial centres (Jones 1972, p.262).
30 Jones 1972, p.270.
31 Jones 1991, p.125.
32 Jones 1991, p.124.
33 Jones 1991, p.122.
34 Unlike Jones (1991) theorists such as Calder (1969), Pelling (1970) and Marwick (1974) have expressed scepticism as to whether the expansion of state machinery was the result of wartime events or rather a response to more fundamental processes of social development, namely the rise of Socialism in Britain during this period. However, Nikolas Rose (1990) has made a convincing argument that, as far as psychological services were concerned, they were shaped by their utilisation as part of the war effort to improve the deployment of human resources in the armed forces and in industrial contexts, as well as being concerned with the more obvious investigations into the national mood which influenced political calculations.
35 Titmuss 1950, p.20.
36 In 1940 the Conservative government led by Baldwin IV was replaced by a coalition government led by Churchill.
37 Jones 1972, p.271.
38 Jones 1972, p.270.
39 Jones 1972, p.270.
40 A Medical Planning Commission had been established as early as 1940 to consider the present and future needs of Britain's medical services. This included representatives from the BMA and two Royal Colleges.
41 The report was published only weeks after the battle of El Alamein, considered to be a turning point in North Africa. A victorious mood prevailed, church bells not rung since the onset of war were heard, and the war was considered to be almost over (Jones 1991, p.130). Report of the Inter-Departmental Committee on Social Insurance and Allied Services (the Beveridge Report), HMSO, 1942.
42 Pensions were suggested for both men and women. However, social insurance did not cover full-time home makers (usually women) for disability, as this was not defined as work. Most of the benefits available to women were connected to their role as wife and mother and payable to the man. For example, suggestions in the report included a grant to be made available on marriage, a grant on the birth of a child, and 13 weeks of maternity leave allowance which the woman could claim for in her own right. In 1942 an estimated 1.4 million women were in paid employment and it should be remembered that this was at a time when many professions (teaching and the civil service) sacked women when they married. Beveridge also suggested cutting the widow's pension to 13 weeks and providing training benefits for women so that they could acquire new skills and join the paid work force (Jones 1991, p.128). Although all political parties made encouraging noises in response to the report, when Labour moved an amendment in parliament for its implementation in 1943 it was

defeated. Certainly Winston Churchill's initial responses to the report were decidedly cool. The 'five giants' that Beveridge identifies were to be systematically tackled with legislation between 1944–1949. These 'giants' were want, disease, idleness, ignorance and squalor.

43 Increases in social services, including provision of school meals and milk to all children. There was a massive increase in child care provision so that mothers could work in factories and on the land. This policy was unfortunately not to last after servicemen returned at the close of hostilities. Women were made redundant and then did not appear on the unemployment register if they were wives (Jones 1991, p.124 and 144). The main year of demobilisation was 1947 and the two million unemployed men were quickly absorbed back into the work force but at the expense of the women.

44 The report was compiled by the Royal Medico-Psychological Association, the psychological medicine section of the BMA and the Royal College of Physicians. Jones (1972, p.275) suggests that its implementation would have the effect of bringing together the treatment of neurosis and psychosis which had been quite separate up to this point. Neurosis was treated at out-patient clinics, in private practice or at voluntary hospitals associated with the teaching of psychiatry. Psychosis was treated mainly in country mental hospitals which, as we have already noted, erred towards containment rather than treatment. It may be argued that the divide was that neurosis was treated and psychosis contained. The White Paper of 1944 also included mental health services and stressed the connection between the body and the mind. Reference to the Macmillan Report of 1924–26 is made in emphasising the mind/body connection.

45 Local authorities were to be given more powers to provide community care but the control of hospitals was to be handed over to Regional Hospital Boards (called 'joint boards' prior to the 1946 legislation). GPs were to be administered by Executive Councils (Jones 1972, p.275). Structural liaison built into the 1946 National Health Service Act included the requirement that Regional Hospital Boards include persons nominated from the local health authority, from the university and from the medical profession. Hospital Management Committees were to contain nominees of the Executive Council and local authority area. Boards of governors of teaching hospitals were to contain nominees from the local health authority and the Regional Hospital Board. Executive Councils were to have eight of their twenty-five membership appointed by the local health authority. All other liaison was on an ad-hoc basis.

46 The Churchill-led coalition government was voted out in the 1945 general election (called the 'Khaki election' because the vote of the armed forces was thought to be significant in the result) and a Labour government voted in with a large majority, with Clement Attlee as Prime Minister. The coalition government had already passed some social welfare legislation. This legislation included the 1944 Education Act, the Disabled Persons Employment Act and the Family Allowances Act of 1945.

47 The introduction of the National Service Act is complex, not only because the act became law in 1946 but did not come into effect until July 1948, but also because it was the result of a huge process of negotiation. Discussions with relevant groups had started in 1943. After the 1945 election Aneurin Bevan became Minister for Health.

48 Local authorities lost control of their hospitals when the act came into force but were given powers to create health centres to provide a range of services including health visitors, district nursing, vaccination, ambulance services, midwifery, maternity and child welfare and home helps. The National Medical Practices Committee was responsible for providing medical practices and there was widespread opposition of GPs to the idea of health centres run by local authorities (Jones 1991, p.142). The division of local authorities, general practitioners and hospital services introduced with the legislation caused problems of liaison between these areas. Co-ordination of services only existed at a national level in the Ministry of Health. Professor Jones points out that below the Ministry the three branches functioned quite separately and that 'even within each branch there was no uniform or unitary structure' (Jones 1972, p.284).

49 Section One of the National Health Service Act cited in Jones 1991, p.140.

50 Jones 1972, p.279.

51 Dr A. Stevens describing Netherne in 1946 in the foreword to Adamson 1990.

52 Calder 1949, p.550.

53 Waller 1991, p.80.

54 Henzell 1997, pp.116–118. Cited in Killick and Schaverien.

55 Glass 1963, p.57.

56 Glass 1964.

57 Glass 1964.

58 Glass 1963, pp.57–58.
59 Glass 1963, p.57.
60 Glass 1964.
61 Mike Pope 1999 interview.
62 Waller 1991, pp.107–108.
63 Weatherson 1962, p.18.
64 Weatherson 1962, p.18.
65 Weatherson 1964.
66 Weatherson 1962, p.19.
67 Dr Marianne Harling: personal correspondence to Susan Hogan 29.02.96.
68 Naylor: personal correspondence to Susan Hogan, Jan. 1996.
69 Naylor: personal correspondence to Susan Hogan, Dec. 1995.
70 Naylor: personal correspondence to Susan Hogan, Dec. 1995.
71 Naylor: personal correspondence to Susan Hogan, Jan. 1996.
72 Naylor: personal correspondence to Susan Hogan, Jan. 1996.
73 Letter from Consultant Psychiatrist W.P. Walsh (22 Feb. 1962) in support of Naylor's application for full professional membership of BAAT.
74 Naylor 1966: Questionnaire for Membership of BAAT 04.09.1966, cited with his permission.
75 Michael Pope: personal correspondence, 04.03.96.
76 Michael Pope: personal correspondence, 04.03.96.
77 Ken Kiff: personal correspondence January 2000.
78 Secretarial Report of the Annual General Meeting of 08.01.66.
79 Letter from BAAT to prospective applicant, 1966.
80 Adamson 1968, p.11.
81 Adamson 1968, p.11.
82 Dr Stevens: 1984 BBC broadcast.
83 Rose 1990, p.48.
84 Bierer 1949, p.158.
85 Report on Marlborough Day Hospital, 1961, p.198.
86 Bierer 1942, p.161.
87 Bierer 1966, p.14.
88 Bierer 1949, p.163.
89 Bierer 1949, p.164.
90 Blair 1949, p.172 in Bierer (ed.) 1949.
91 Blair 1949, p.174.
92 Adamson, *The Observer,* June 17 1962, p.31.
93 Calder 1949, p.550.
94 Simon 1986, p.6.
95 Simon 1992, p.1.
96 Simon 1949, p.62.
97 Simon 1949, p.61.
98 Simon 1992, p.3.
99 Simon 1992, p.2.
100 Simon 1992, p.2.
101 Simon 1988, p.48.
102 Rita Simon in interview with Susan Hogan, 13.08.94.
103 Rita Simon in interview with Susan Hogan, 13.08.94.
104 Rita Simon in interview with Susan Hogan, 13.08.94.
105 Simon 1949, pp.61–62.
106 Simon 1992, p.3.
107 Simon 1992, p.2.
108 Simon 1992, p.4.
109 Simon 1992, p.4.
110 Simon 1988, p.51.

111 Simon 1988, p.49.
112 Simon 1964, p.13.
113 Simon 1972, p.1.
114 Rita Simon in interview with Susan Hogan, 13.08.94.
115 Rita Simon in interview with Susan Hogan, 13.08.94.
116 Winnicott 1971, p.117 cited in Simon 1992, p.199.
117 Rita Simon in interview with Susan Hogan, 13.08.94.
118 Simon 1971, p.1.
119 Similar ideas have also been explored in Gestalt psychology. According to Pickford, Fetchner's 'Vorschule der Aesthetic' (1876) had become popular amongst experimental psychologists by the 1930s.
120 Strachey also became one of the selectors for the Left Wing Book Club (Symons 1960, p.101).
121 Smith 1994, pp.2–6.
122 In 1944 Foulkes co-authored a paper with Eve Lewis, a Jungian analyst who worked at Withymead.
123 Smith 1994, p.15.
124 The Foulkes Papers: Discussion on Group Therapy, 24.05.45.
125 The Foulkes Papers: Confidential Psychiatric Reports on Patients, Feb. 1945.
126 The Foulkes Papers: Clinical Notes from Oct. 1944.
127 The Foulkes Papers: Clinical Notes from Oct. 1944. To maintain conditions of confidentiality all patients' names in original reports have been replaced with pseudonyms.
128 Foulkes was released from army service in 1946 and returned to London.
129 Adamson: 1994 interview.
130 Timlin: 1994 interview.
131 In addition to those already mentioned occupational therapists were represented at the later, more formal meetings. Dr Culver Barker (a Jungian analyst associated with both Withymead and Dartington Hall) attended along with Millicent Buller (Red Cross Picture Lending Scheme), Dr Irene Champernowne (Jungian analyst and Clinical Director of Withymead), Elsie Davies (Birmingham Sanatorium and former pupil of Arthur Segal), Mary Webb (art therapist) and Dr J.A. Hadfield (psychiatrist).
132 These early meetings are carefully documented by Diane Waller (1991, pp.101–111). She lists Michael Edwards as present on the meeting of Tuesday 6 February 1951 (the first working party to discuss the training and selection of art therapists) when he is not listed on the minutes. However, Edwards was present at later meetings.
133 Mike Pope in interview with Susan Hogan, 1999.
134 Cited in Waller 1991, p.109.
135 Petrie 1946b, pp.139–140.
136 Hill 1948, p.101.
137 Simon 1964, p.5.
138 Simon 1986, p.6.
139 As Rose points out, psychoanalysis was to become popularised in the post-war period as a theory of development, and in particular a theory of the role of the mother in the development of the adjusted or maladjusted child's ego (Rose 1990, p.164). However, by the mid-1960s the 'naturalness' of the mother–infant bond, illustrating aspects of the purportedly unchanging nature of the human condition, was rejected and the increasing regulation of motherhood challenged particularly by feminist theorists (Rose 1990, p.175).
140 Rose 1990, p.9.
141 The 'group interactive art therapy model', described in Diane Waller's text (1993), is probably the dominant model of art therapy practice used today.

Withymead

Britain's First Therapeutic Community
Dedicated to Art Therapy

In the last chapter I presented an account of art therapists working in psychi-
atric environments. The styles employed by pioneer art therapists varied
according to their location and brief. However, I argued that, although heter-
ogeneous in its nature, there were overriding features evident in most art
therapy of the period, notably an emphasis on communication and giving the
otherwise disenfranchised and 'institutionalised' patient an opportunity to
express their thoughts and feelings through the art-making process. In other
words, there was a discernible interest in giving the patient a voice. This, I
argued, was potentially subversive in relation to psychiatric control and at
odds with art therapy as an adjunct to psychoanalysis. The latter approach, as
I have illustrated, overrode the personal expression of the individual
involved; it resulted in therapists furnishing interpretations of art work based
on psychological paradigms and conceptualising both the content of the art
work and their patients' behaviour according to the particular psychological
schema being employed. These different approaches to art therapy represent
fundamentally different philosophical attitudes. The latter approach encour-
aged dependence upon the therapist; this process has been neatly described
by David Ingelby (1985) as involving 'a tendency to appropriate skills to
itself [the profession] – acting to "disable" the lay population...by withhold-
ing information (or formulating an esoteric dialect), and by discrediting the
ordinary person's competence'.[1] However, it is important to distinguish
between psychoanalysis and analytic psychology as each had quite distinc-
tive attitudes towards the possibility of art as therapy.

Drawing on interviews and hitherto unpublished material, this chapter
aims to present the art therapy work undertaken at Withymead, with particu-
lar reference to the 1940s and 1950s. I have not gone into minute detail

about the theoretical differences between psychoanalysis and analytical psychology. These are touched upon in more detail elsewhere. Nevertheless, some background information on how analytical psychology was understood by the staff at Withymead is necessary to provide the context in which this innovative art therapy work occurred. As Withymead was a therapeutic community, how was the art therapy practice integrated into community procedures as an integral element of treatment?

Withymead is an interesting development since it exhibits several discrete discourses, notably analytical psychology, and the successor of the 'moral treatment' method, described by Elinor Ulman as 'rehabilitation through work' – there is, she wrote, 'scope for all residents to take part not only in gardening and routine maintenance, but in new projects which help shape the development of the centre'.[2] Art therapists were engaged in a wide range of activities within the community as well as their work in the studios.[3] Another 'remedial' factor was noted as 'community living'. The notion of communality being curative was based more on the idea of re-creating a 'family' structure than on radical social experiments with socialist intent.[4] However, there are enough similarities between practices at Withymead and later 'therapeutic community' developments to justify a re-evaluation of Withymead as the first therapeutic community in Britain. Certainly, the claims that Withymead made about itself should be considered as relevant. Withymead regarded itself as a 'therapeutic community' and applied this term to itself.[5]

My account will not dwell on the death-throes of Withymead, as I wish to examine it as a working community.[6] I hope to present a fuller picture of how art therapy functioned there than has previously been published. My intention is to elucidate art therapy practice rather than to write an alternative history of Withymead. Although I make mention of music therapy with Molly Kemp, or Laban movement therapy with Carol Paul-Jones, Dennis Hill, or Veronica Sherborne, I am primarily interested in painting and clay work – what today is called art therapy. Therefore there may be key figures in the community as a whole who do not receive much attention in the following text because they were peripheral to art therapy activities.

A brief history of Withymead and its founders

Irene Broomhall (1901–1976) was born in Islington. She was the eldest daughter of a missionary and educated at the City of London Girls' School during World War I (1914–1918). Despite lack of encouragement from her

school, and evincing a certain force of personality in the face of such a lack of support, she entered Birkbeck College to study science subjects to enable her entry into medical school.[7] After what might have been described as a 'nervous breakdown' in 1926 she embarked on personal analysis at the Tavistock Clinic with a Freudian analyst (Leonard Brown) for three years (1926–1929).

Irene Broomhall became interested in the work of a number of prominent theorists, including Adler, whom she visited in Vienna in 1930, and Leonhard Seif, whom she met in Munich.[8] In 1935 she enrolled at University College, London, for a B.Sc. in psychology. It was around this time she met Godwin Baynes who was later to have a strong influence on her and become a colleague in a London analytic practice. However, it was Seif who introduced her to the work of C.G. Jung, whom she visited in Ascona in 1936. Some years later in 1950 Irene attempted to enlist Jung's support for Withymead but by this time he was in semi-retirement following a serious illness. From 1951 to 1961 Jung did little work with patients.[9] He declined to become involved with Withymead.[10]

In 1937 Irene Broomhall met Gilbert Champernowne (1884–1959) who was the ninth son of Arthur Champernowne, Squire of Dartington and resident at Dartington Hall until 1925 when Leonard and Dorothy Elmhirst bought the estate. Gilbert had studied theology at Christchurch College, Oxford, as part of a general arts degree (his mother had wanted him to enter the church). Armed with a private income, he was able to devote himself to good works, including activity on behalf of Oxford House Settlement in Bethnal Green, which had strong church connections at that time. He had also come into contact with pioneer art therapist Adrian Hill.

Gilbert Champernowne was fifty-three years old when he met Irene. Described as 'thin and frail' he was quite an elderly figure by the time Withymead was set up.[11] After their marriage which took place on 9 April 1938, Irene and Gilbert Champernowne played host to the Analytical Psychology Club in their large drawing-room at Bedford Square, London. Guest speakers to the club, such as Emma Jung, stayed with them as their guests.[12] In 1941 Irene and Gilbert Champernowne moved to Countess Wear, outside Exeter (near to where Gilbert had grown up as a boy), because of bomb damage to their London house, and established Withymead as a residential community. They moved into the house on 1 January 1942.

The context in which Withymead developed is of crucial importance; Irene felt that 'the darkness of the war' had seeped into 'her soul' and that the

suffering being experienced collectively at that time provided an important motivation for her work of alleviating the anguish of those experiencing mental distress.[13] (It is worth noting that some of the patients at Withymead were suffering from the effects of the war. For example, there were women whose husbands had been killed in active combat or in the bombing raids.)[14] Interestingly Jung (referring to World War I) had used the mass destruction of that war as an argument for the importance of analytical psychology. He declared: 'The present day shows with appalling clarity how little able people are to let the other man's argument count...he denies the "other" within himself the right to exist – and vice versa. The capacity for inner dialogue is a touchstone for outer objectivity.'[15]

During 1941 and early 1942 Irene built up a private practice as an analyst in Exeter. On 3 May 1942 Exeter was devastated by bombing during the 'Blitz'. The following day patients of Dr Joyce Partridge and Irene came to

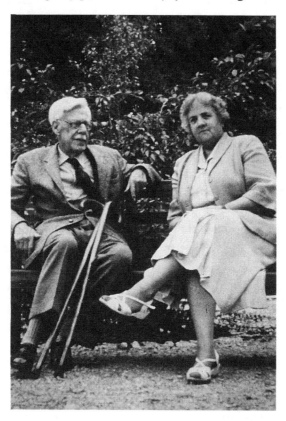

Figure 9.1 Gilbert and Irene Champernowne

the house because they had nowhere else to go. Public transport had been disrupted. Exeter had been devastated, but Irene felt that 'the work of healing could go on'. So they opened the house to those who arrived, even though they were ill-prepared. Fifteen people moved in that day and the house was never empty again.[16] Withymead was very much a 'home' in this early period of its development. For example, Irene used to come round in the morning with large mugs of tea for everyone in the house, and until 1952 the community was small enough to eat around one large table.[17] Simple household tasks, such as washing up, were shared by community members. Former resident and art therapist Norah Godfrey described what Withymead was like in 1945:

> Withymead was a small family, Gilbert and Irene's home, with a household of six or seven people all of whom were in need of some kind... Despite the temperamental differences there was a strong sense of unity and fellowship, for all were searching out the way in lives which had become blocked or muddled. Almost all were having psychological interviews with Irene, and her strength and energy carried along those temporarily unable to manage alone. This close contact, an ever-present sense of her presence, was enough to hold safely even the very depressed so that they were free in their ordering of their day.[18]

Withymead eventually accommodated about forty residents including twelve to fourteen professional staff. In addition to this were numbers of day patients and visitors.[19]

Withymead itself was a large, fourteen-roomed Georgian house near to water meadows, with a mill stream beside it that ran into the river Exe. It had been chosen for its grounds and outbuildings, as much as for the main house itself, which Irene and Gilbert immediately saw would make good studio spaces.[20] Art therapy (also called remedial art) was foreseen from the beginning. Irene pointed out the centrality of art therapy to the project when she wrote, 'The life of the community has grown around these creative activities, and the psychotherapeutic work is geared into artistic expression in the studios'.[21]

As noted, Withymead started on a very small scale.[22] After a period of gradual expansion there were on occasions upwards of forty residents (including residential staff). These people were fee-paying patients and tended to be drawn from the professions or were wives of professional men. Residents were described as 'people of good cultural background, ready verbal faculty, and above-average intelligence', who were thought at the time

Figure 9.2 Withymead: View of house

to be particularly amenable to analytic treatment.[23] Irene, however, also took on patients who could not afford the fees. Such people might work for Withymead in return for residency, performing a wide range of tasks, from building to secretarial work.[24] Referrals came from London-based GPs including Michael Fordham and D.W. Winnicott.

From the beginning Withymead was unable to be self-financing and had to rely on charitable donations. The most important of these, from 1950, was from the Elmhirsts of Dartington Hall. The Elmhirsts withdrew their support shortly after Gilbert's death. Michael Young's account indicates a conflict between Irene and Leonard Elmhirst:

> Withymead came to grief, literally and figuratively, after Gilbert died in 1959. His had been the unobtrusive hand which kept the finances and Irene within bounds. When he was gone the place fell apart. Irene became suspicious and temperamental. She could generate a terrifically charged atmosphere. As the Chairman of the Withymead Trust Leonard

bore the brunt of it, Irene was so overpowering that Leonard developed a peptic ulcer… Irene also tried to divide Dorothy and Leonard as many others tried to do, before and after; she failed too.[25]

Trusteeship of Withymead was placed in the hands of Irene's solicitors Crosse and Loup. These solicitors noted at the time that 'for an average number of residents of 16 and an absolute maximum of 20, it seems almost incredible that there are 16 professional staff'.[26] Reforms of Withymead's practices were in the offing. Non-Jungian staff were introduced.[27] Analysts Irene Champernowne, Florida Scott-Maxwell, Inge Allenby, Joan Mackworth and later Doris Layard and Eve Lewis were all Jungians.[28] Art therapists Mary Egerton (née Howse), Winifred Gaussen, Norah Godfrey, Jo Sawyer (née Guy), Winifred Baker, Ben Belton, Richard Fritzsche, Elizabeth Wills (née Colyer), Peter Lyle, Michael Edwards, Euanie Tippett, Rupert Cracknell, and others were all trained on-site and were therefore also Jungian. In response to the Mental Health Act of 1959 Crosse and Loup insisted that Withymead should be placed under the direction of a medically qualified consultant psychiatrist.[29] There was a succession of appointments

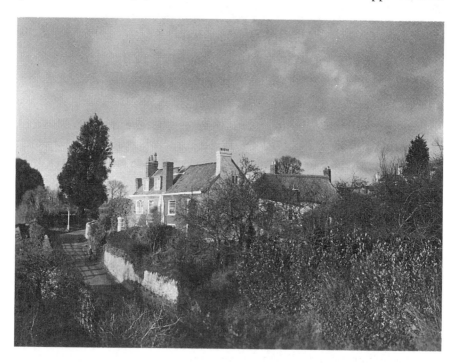

Figure 9.3 View of Withymead across the water meadows

made and these consultants were not trained Jungian analysts. It is the introduction of non-Jungian staff which several of my interviewees felt was responsible for Withymead's eventual demise.

In 1967 Irene was forced to leave Withymead purportedly because she was, quite unreasonably, unwilling to concede to the demands of the Board of Trustees who wished to hand over the management of the community to a medically qualified director who would have total control.[30] The alternative account is that Irene wished to preserve Withymead as a therapeutic community outwith the NHS, with power not exclusively held in the hands of a medical director, and for this she had the full support of the other therapists.[31] In 1974 she was diagnosed as having cancer. She died aged seventy-five working until the very end of her life.

Writing on Withymead

There is very little literature on Withymead. Diane Waller in *Becoming a Profession* (1991) devotes thirteen pages to a useful account of Withymead. The main problem with her description lies in its brevity. Waller quite rightly describes Withymead as having had a 'considerable influence on the development of art therapy in Britain'.[32] She correctly notes that many people associated with it later became prominent art therapists and/or founders of the British Association of Art Therapists. Withymead's founder, Dr Irene Champernowne, was herself involved in early moves towards the professionalisation of art therapy and attended some of the National Association of Mental Health (NAMH) working parties.[33] Indeed, it would have been difficult to have maintained a serious interest in art therapy in Britain in the late 1940s and 1950s without being aware of Withymead's activities. It was undoubtedly the single most important institution in the development of art therapy during this period.

Diane Waller's account rightly challenges Anthony Stevens' narration by pointing out that group work and shared activities were of great importance to Withymead's structure.[34] However, Waller's account of a clear dichotomy between the art therapist who is responsible for the *production* of the work, and the analyst who would enter with the patient into the deeper *meaning* of the work, is too simple and does not do justice to actual practices at Withymead.[35]

Irene Champernowne's book, *A Memoir of Toni Wolff* (1980), confirms her engagement in art therapy for her own therapeutic benefit. However, it is an intensely personal account of her relationship with her analyst and does

not reveal very much about the day-to-day history or functioning of Withymead as a community.

Michael Young's fascinating and well-researched book, *The Elmhirsts of Dartington Hall: The Creation of an Utopian Community* (1982), makes a few cursory but useful references to Withymead in the context of describing Dorothy and Leonard Elmhirst's range of interests and charitable patronage.[36]

The only full-length text that exists on Withymead is a highly readable anecdotal account which is rich in detail, entitled *The Withymead Centre: A Jungian Community for the Healing Arts* (1986), written by Dr Anthony Stevens, a psychiatrist and Jungian analyst who entered into analysis with Irene at Withymead while he was a young medical student. Although he visited the community over a number of years he did not become a resident.

Stevens' history places the Champernownes in the tradition of moral treatment. He describes them as 'reformers' and argues that what they regarded as important was the attitude one adopted towards the mentally ill.[37] Stevens is at his best as a writer when railing against the injustices of mental health treatment as practised in large asylums, which he describes as 'concentration camps ruled by apathetic regimentalised custodians'.[38]

His account was attacked by David McLaughlin, who argues in a review of his book that Stevens is guilty of making assumptions about the reasons for the dissolution of the community which are based on *a priori* convictions:

> Dr Stevens' hypothesis requires logic and machismo in the men, and intuitive intransigence in the women. If only those gifted, foolish women had accepted the guidance of the strong, wise men (i.e. those with structural authority) Withymead might have been saved. This is nonsense. What Withymead needed to survive was good management including administrative *support* for the therapeutic team.[39]

Clearly McLaughlin does not feel that this support was forthcoming. His account is close to that of Irene Champernowne herself, who charged the last medical director of Withymead (Dr Sime) with high-handedness and complained about lack of consultation. Irene's view of the matter seems to have been that Dr David Sime did not understand 'the true nature of the therapeutic community'.[40] McLaughlin puts the matter thus:

> The conflict that destroyed Withymead had its origins…in the historical inability of 'strong' men to honour the strength and authority of women.

When it came to the crunch the men had the executive power and they used it ruthlessly.[41]

It is clear from Stevens' version of events that he regarded Irene as directly responsible for the collapse of the project and as a malign influence. One of his most extraordinary bits of text starts with a quotation of Jung's that Irene often repeated: 'In God's name make a vessel to contain your evil.' Stevens wrote:

> ...believing that at Withymead such a vessel existed in the analytic situation, in the staff meeting, and in the studios. The trouble was that when thwarted she was, in her own case, prepared to smash the vessel. And the *daemonic energy released* was in need of greater constraint than could be provided by a wise and conciliatory chairman.[42]

This is strong stuff indeed, with destructive, irrational, feminine evil (or attendant spirit) triumphing over masculine consoling wisdom! Stevens' misogyny is not far beneath the surface in the rest of his account. He describes Irene as 'belligerent' and 'pig-headed' in her dealings with the management committee.[43] He strongly hints that she suffered a period of instability following Gilbert's death which 'affected her judgment' and also that the loss of the Elmhirsts' important funding was due to the loss of Gilbert's provision of rational, masculine leadership to the community and to Irene herself.[44]

Stevens also treats his readership to diatribes about the different social and emotional roles for which men and women are 'constitutionally geared'. Not surprisingly these 'natural' roles reflect the dominant ideology of the period, i.e. woman as 'homemaker' and man as 'provider'.[45] This endemic sexism in the text posing as a universal truth is irksome. It is clear from his writing that Stevens regarded Irene's forcefulness, and her attempts to prevent a takeover of clinical work at Withymead, as deviant. (Irene was herself ambivalent about this as I shall later explore.) However, the main weakness of his text is that he does not emphasise the centrality of art therapy in Withymead's structure. Rather, he views it as an adjunct to analysis.[46] He devotes only 26 of his 254 pages to art therapy and he does not give an understanding of how transference was viewed in relation to the work of the art therapists. Another weakness is that he does not sufficiently emphasise the spiritual accent of Irene Champernowne's approach. This chapter, therefore, will illustrate the central role that art therapy played at Withymead.

I will also illustrate the importance of a spiritual dimension to the life of the community, which has been overlooked in previously published accounts.

The foundation and theoretical basis of Withymead

Withymead may be regarded as the first therapeutic community founded in Britain and it was committed to the use of art as therapy from its inception. Art therapy was a central, rather than a peripheral, treatment method. Dr Irene Champernowne (sometimes described as a 'charismatic leader') regarded herself as 'an intuitive feeling type' rather than as an intellectual.[47]

After receiving her BSc in June 1937 Irene Champernowne went to Zurich where she entered into analysis with Jung. She started work on her PhD which she completed shortly before the outbreak of the Second World War. She also started to have analysis with Antonia 'Toni' Wolff (1883–1953) (Jung's closest colleague) in addition to her sessions with Jung.[48] During that period there were no formal professional structures within analytic psychology, so would-be analysts would go to Zurich to see Jung and/or Wolff. If the analysis was successful the analysands were permitted to attend Jung's more advanced lectures.[49] Others were invited to attend the psychology club. Jung also gave public lectures which were attended by some of the Withymead residents. Therefore, Irene's introduction to analytic psychology was quite usual for the period. Indeed, until the 1940s the idea that analysis should become a profession in its own right had not taken root. This change in attitude was marked by changes in institutional structure, notably the formation of a Society for Analytic Psychology in London.[50]

It is important for the reader to get a sense of Irene's approach as Withymead was very much her creation. She was a forceful personality and intensely religious. She was described by Dorothy Elmhirst, who became one of her closest friends, as 'one of the two or three most remarkable women I've ever known – with extraordinary intuitive powers combined with profound knowledge of human beings'.[51] In a letter to Irene she wrote: 'I think I have never known in anyone such love and power combined... And Easter will be for me a day of infinite gratitude for knowing you, and for being able, here and there through my contact with you, to glimpse something of the Holy Spirit'.[52]

Irene was by all accounts a strong mother figure in the community who was 'adored' by many of the staff and patients.[53] She worked using ideas from Adler, Jung and H.G. Baynes whose *Mythology of the Soul* she described as a

'bible' to her.[54] Jung's ideas in particular dominated the community because of Irene's enthusiasm for his work, and all therapy staff had to undergo in-depth 'Jungian' analysis as a condition of employment.[55] It was possible, and not unusual, for an individual to arrive at Withymead seeking help and end up, after having had sufficient analysis, as a member of the staff team helping others.[56] In addition to this there were a number of professional people and artists who came to Withymead seeking 'analytical help for a deeper and more creative insight into their work'.[57] Indeed, Irene is quite explicit on this point saying, 'no one who has not experienced something of the power of healing within these modes of expression is really fit to be a healing teacher or art therapist'.[58]

In addition to the long-term patients who stayed from one to three years (and occasionally longer) there was also a steady stream of short-term visitors and patients. Various events served to attract professional people who wished to engage in psychological study. These events were also attended by the majority of residential patients at Withymead.[59] Some of the professional people who came to study at Withymead discovered at the centre 'a potential answer to their emotional needs' and returned for short-term residence when their work permitted. Former patients also returned to engage in brief periods of study.[60] Norah Godfrey described people turning up very 'synchronistically' at Withymead.[61] Few, if any, of the staff team had been attracted to the centre through formal advertisements; she recounted 'they were all there from their own need, and because they wanted to be'. Norah explained that the residents of Withymead felt 'deeply inspired by the whole idea of building a place where people could try and discover their individual truth... I was going to devote my whole life to it. You see, I was completely enthralled'.[62] Norah Godfrey herself joined Withymead in 1945 as a residential patient. She then became an art therapist and stayed until 1955. She taught in special education for a number of years and rejoined the community as art therapist on a part-time non-residential basis between 1967 and 1968.[63]

The lack of a tidy boundary between patients and therapists (all called 'residents', except for those who were non-resident) was also in evidence in the analytical psychology establishment, and therefore Withymead may be seen as a reflection of this. For example, analysands were able to attend the meetings of the Zurich Psychological Club (1913–1948). It was the Zurich Club which became the model for further 'Jungian' developments. Andrew Samuels, an analyst, points out that not every patient would join the local

Figure 9.4 Example of slide used in Withymead lectures

Figure 9.5 Example of slide used in Withymead lectures

club, but many would, and it became *de rigueur* as a first step if the patient wanted to transform him or herself into an analyst. Their acceptance into the clubs was based on their human attributes rather than their status as a trained or untrained person. The basic requirement for membership of the clubs was a reference from one's analyst.[64] Therefore personal characteristics such as the individual's 'capacity to attend to the unconscious' or their interest in and 'displayed capacity for human relationship' [sic] became crucial determining factors as to whether the person would be allowed to attend.[65] Later staff and patients of Withymead were to visit the Analytical Psychology Club (APC) in London.[66] There was close contact between Withymead and the APC. Many members of the APC visited Withymead.[67] Another institutional link was between Withymead and the Guild of Pastoral Psychology[68] in London, at which members of Withymead staff, such as Inge Allenby, Barbara Hannah and Irene Champernowne, gave papers.

Part of the inspiration for Withymead came from Gilbert Champernowne's contact with pioneer art therapist Adrian Hill. Gilbert had subsequently taught pottery and woodwork at the Mill Hill Military Hospital where Walter Maclay was Medical Officer. Prior to taking up the post Gilbert had served as Secretary to the Royal Society for the Assistance of Discharged Prisoners. During the war he served under the National Council for Mental Health as an aftercare officer for the county of Devon where he had the job of visiting ex-servicemen discharged from psychiatric hospitals. Gilbert had been involved in starting the pottery studio at Withymead which was developed by Jo Guy prior to the appointment of Ben Belton in 1952.[69]

Dr Hardy Gaussen and his wife Winifred were involved in the project at an early stage. Hardy had been working at the Tavistock Clinic where he had seen a notice about the project. Many Withymead meetings took place in the Gaussens' house in Elm Grove Road, Exeter. This house became an annex to Withymead, housing many of Dr Joyce Partridge's patients as well as offering studio space in the roof. Winifred was an artist who was untrained except for a stint with Arthur Segal in London.[70]

In Dr Anthony Stevens' charming account of Withymead he describes the house and grounds:

> ...one approached it [from the South] down a leafy Devon lane whose hedges were a mass of wild flowers. The house itself was surrounded by well stocked gardens and orchards... Behind the house a group of stone stable buildings, converted into pottery and painting studios, clustered around a busy courtyard and through open windows I heard the sounds

of talk and laughter mingled with a young woman singing Mozart to a piano accompaniment.[71]

Figure 9.6 Painting of studio by Norah Godfrey

A similar first impression is recounted by Norah Godfrey who told me of a visitor who, after being shown around Withymead, turned and asked Irene 'But where are the patients?' only to be answered 'we are!'.[72] Michael Edwards, who worked at Withymead as an art therapist at the time of Dr Stevens' first visit (he left in 1960), confirmed this was also his initial impression. 'At Withymead,' he said, 'you were never quite sure who was staff and who was a patient. It was very ambiguous.' However, he asserted that it was by no means a 'cozy, middle-class nursing home' but full of very disturbed people.[73] These were generally people who could no longer manage their lives in the outside world.[74] However, Withymead, Michael Edwards felt, had a particular atmosphere which was 'unconditional and very loving and very warm'.[75]

Withymead is of significance in providing a therapeutic community setting which emphasised the importance of tapping the unconscious aspects

of clients through their participation in the arts. Indeed the 'unconscious' was central to the economy of the community. It was an unusual idea in this period that analysts and patients should live in the same house and spend much of their time together.[76] However, it is important to recognise that this innovation came about quite by chance rather than from forward planning. Withymead is in this sense a precursor to the modern 'therapeutic community movement' which emerged out of specific historical and political conditions but which shares some of the fundamental characteristics of Withymead.

In some ways Withymead was slightly less 'democratic' than subsequent 'therapeutic community' developments (which of course varied in scope and ambition). For example, its management was not something patients were actively engaged in.[77] Irene and Gilbert Champernowne saw themselves as 'parent' figures.[78] Furthermore, it is clear that the fully qualified Jungian analysts were held in particular esteem. This is hardly surprising since in

Figure 9.7 Norah Godfrey sketching in the garden c. 1946

1939 the Jungian community world-wide was small, probably not exceeding 200 people.[79] McLaughlin, a former member of staff at Withymead, claims that the art therapy staff had a lowly status within Withymead.[80] This remark is contradicted by the practice of often having art therapists and psychotherapists make the first contribution at the community staff meeting, later called the clinical staff committee meeting, in which those 'most immediately concerned with the patient' spoke first.[81] The analysts had their own meeting at which more in-depth discussions of patients took place. These meetings were not open to other members of staff as a rule though an art therapist might be invited to attend one in particular circumstances, such as if they had formed a close rapport with a patient.[82] This 'small inner group' dealt with matters which were considered 'too intimate or too difficult to be put before the entire meeting'.[83] The analysts' meeting was also a concrete embodiment of the hierarchy of knowledge about the mechanisms of the unconscious. Although with enough analysis a patient might graduate to staff member, it was to a non-analytic position. Some exceptional individuals, such as Joanna Hogg, were considered by Irene to be 'natural psychotherapists' and employed in this manner. However, when Joanna came to be seriously considered for the post of torchbearer (Irene's possible replacement) she was sent to Zurich for full Jungian analytic training.

Central to the effective functioning of Withymead was the community staff meeting which took place each week, at which every patient was discussed. This meeting consisted of art therapists and other trained professional staff such as doctors, psychotherapists, psychologists, the psychiatric social worker and nurses. Close communication between staff was of crucial importance for the success of therapeutic work, as I shall explore in further detail.

It was at this meeting that new patients and their background were discussed, so that 'the depth of crisis or problem' could be understood by all the staff, who could then be sensitive to it.[84] There was a 'close-knit sharing of information between analysts and other members of staff'. The dynamics of community life were identified and analysed at these meetings so that all staff were aware, not only of how patients were feeling, but with whom they were building particular sorts of relationships. Irene describes this process thus: '...the psychodynamics of the clinical staff committee in its group deliberations are of the deepest importance to the healing process. Free discussion among the members resolves personal difficulties which, if unrecog-

nised, might adversely affect the patients'.[86] She goes on to explain this further:

> It is when discussion of all the material offered about an individual patient begins that one sees the psychotherapeutic value of the interchange between members of staff – not only for the patient, but also for the members themselves... Sometimes the staff discussions may be infinitely more than the reactions between two members of staff, who are only superficially at odds. Then a long period of wrestling takes place, in which the intimate emotions and personal conflicts of the members are recognised as being involved.[87]

Peter Lyle, patient (1955–1959) and later an art therapist until May 1963, described how some art therapy material was discussed at this meeting (though he seldom brought actual art works to the meeting – these would be looked at by the art therapist and analysts involved with a particular patient); he said:

> We would share at those very important meetings things that were happening in the art therapy.[88] Some of the things we shared with everyone, some of the things were only between you and the analyst, but that very, very strong link amongst all the staff and with the analyst and the art therapist was of paramount importance. It was a therapeutic community situation.[89]

Irene described what took place at the staff meeting as a 'full exchange of experience, opinion' and 'self examination' which she felt was not only of psychotherapeutic benefit to the members of staff but also of 'the most vital importance to the patients', each of whom was considered at this meeting.[90]

The benefits of such group discussion included getting a fuller picture of the individual. For the analyst this avoided their developing an unbalanced or 'lopsided' judgement of an individual. Irene felt that the contributions of the studio staff were particularly valuable in this respect.[91] She emphasised this still further when she wrote that 'this apparently heterogeneous collection of individuals is in fact an organism. It functions as a person in itself and, like any living body, has to integrate, modify, and generally care for itself to remain positive and healthy. The heart and mind of the organism is the clinical staff committee'.[92]

As noted, it was possible for a patient to be in therapy with more than one analyst and more than one art therapist. In addition to this they might form strong bonds with other members of staff and all of this was noted and talked

about. (I will discuss transference issues later on.) Elinor Ulman, a prominent American art therapist, said of the community staff meeting that characteristically there was 'no formal division between discussion of patients and such talk as may help to keep clear the emotional atmosphere between the people who work with patients'. Staff members, she pointed out, have been in analysis. This results in a community in which 'there is no sharp dividing line between patients and staff'. Ulman felt that this was a particular strength of Withymead. She wrote, 'All are patients in that they have to suffer and understand their own problems... It is this accepting of the sick in each one, while constantly making demands on the healthy in each one, which gives the life at the centre its unique and pioneering quality'.[93]

The inspiration for the emphasis on the arts came directly from C.G. Jung, who said of psychotherapy that it was 'less a question of treatment than of developing the creative possibilities latent within the patient'. The studios at Withymead were therefore considered to be a 'gymnasium of the soul' where one can develop aspects of the self. Outhouses were converted into studios and clients were encouraged 'to experiment with one's own nature' and to 'enter into entirely new modes of experience'.[94] Jung saw engagement in art as able 'to bring about a psychic state in which the patient begins to experiment with his own nature, a state of fluidity, change and growth where nothing is externally fixed and hopelessly petrified'.[95]

Irene believed that art had a useful diversional and empowering effect, allowing the patient to 'make his mark on life'. She wrote that through work in the studios 'the patient has found himself as a person...his neurosis has disappeared; he has learned self-respect and self-reliance'.[96]

More important to Irene was her belief that the unconscious could 'speak' through art. She felt that a 'non-verbal' method avoided the over-intellectualisation of verbal therapy and put the ego in direct 'contact with the voice of the unconscious'.[97] This is a view also held by Jung who felt that it was possible for the individual's ego to assimilate the content of a picture rich in unconscious symbolism *without every detail of it becoming conscious*. He wrote:

> Very often a total reaction [of the ego to the content of the art work] does not have at its disposal those theoretical assumptions, views, and concepts which would make clear apprehension possible. In such cases one must be content with the wordless but suggestive feelings which appear in their stead and are more valuable than clever talk.[98]

Irene also felt that the use of symbolism created more potential for personal change to occur. Symbols, she felt, arose from the unconscious mind and could hold ambiguities and nuances that words (except in poetry) cannot. She realised the value of encouraging patients (and staff) to use the arts for 'subjective purposes'. Such work she did not necessarily define as 'art' as they could be 'any self-expression...doodles or externalisations'.[99] She felt that this could be very empowering for the individual, regardless of whether or not the work became regarded as aesthetically successful.[100] The content of such art work could originate in dreams. Sometimes in a psychotherapeutic session Irene would say to a client 'go and paint as much of that as you can' or 'enlarge it by [making] a picture' or she'd suggest: 'Take parts of it and dream the dream onwards on paper in paint, in poetry, in dance, in mime, in models, in music'.[101]

Irene encouraged patients and staff at Withymead to express themselves in creative media which she saw as analogous to dreams in which 'people and happenings are symbols of their life but very often the underside of life – the hidden unconscious aspects of the individual – the compensating, complementary aspects'.[102] This could be done in painting, drawing, mime, dance and free expression in drama (rather than learned plays).

This idea of the compensatory function of the unconscious mind is a very important aspect of 'Jungian' thinking. Constance Long, an important proponent of Jung's early work, explained his understanding of the unconscious:

> He regards it as being the creative mind, and as having a balancing tendency also.[103] Thus repression is not referred to sexuality and the primitive instincts alone, but to all the neglected and under-valued material belonging to the various psychological functions of thinking, sensation, and intuition.[104]

This is an important difference between psychoanalytic thinking and Jung's analytic psychology because this attitude towards unconscious material allows its emergence in art works to be viewed positively as life enhancing, rather than negatively as evidence of psychopathology, wish fulfilment or unresolved sexual fantasies, as in the Freudian system of thought.[105] The attitude of analytical psychology is therefore much more sympathetic to the production of art work than the Freudian theoretical framework.[106]

Jung felt that health was best achieved by giving voice to the unconscious aspects of the self (which can have a regulatory influence upon consciousness if not repressed).[107] He saw symbols as 'the best possible expression for a

complex fact not yet clearly apprehended by consciousness'.[108] Constance Long asserted that in analytic psychology the unconscious is not seen as merely representing repressed aspects of the psyche but as a creative entity which is prone to 'expressing itself in symbols and symptomatic acts because it can only express itself in a non-rational manner'.[109]

Irene's idea of 'dreaming the dream onwards on paper' is very close to that described by Jung – indeed, she attributes the phrase to him.[110] Jung wrote of the value of painting dreams thus:

> Often it is necessary to clarify a vague content by giving it a visible form. This can be done by drawing, painting, or modelling. Often the hands know how to solve a riddle with which the intellect has wrestled in vain. By shaping it, one goes on dreaming the dream in greater detail in the waking state, and the initially incomprehensible, isolated event is *integrated into the sphere of the total personality, even though it remains at first unconscious to the subject.* Aesthetic formulation leaves it at that and gives up on any idea of discovering meaning.[111]

Such a statement indicates that art-making was regarded as potentially therapeutic even when not accompanied by a verbal analysis of the art work. Jung felt that giving a disturbance 'visible shape' had a 'vitalising influence' because it reproduced the content of the disturbance in some way either concretely or symbolically.[112] He wrote that:

> Patients who possess some talent for drawing and painting can give expression to their mood by means of a picture. It is not important for the picture to be technically or aesthetically satisfying, but merely for the whole thing to be done as well as possible…a product is created which is influenced by both conscious and unconscious, embodying the striving of the unconscious for light and the striving of the conscious for substance.[113]

The term 'active imagination' was used by Jung in 1935 for a process of dreaming with the eyes open. The patient concentrates on a specific mood, picture or event and follows a succession of associated fantasies. The content can be painted or written down.[114] Irene expressed her understanding of 'active imagination' as a process of 'meditation on dream images – dreaming the dream onwards'.[115]

Sometime later Jung was to state his view thus:

> Behind consciousness there lies not the absolute void but the unconscious psyche, which effects consciousness from behind and from

inside... As this 'inside' is invisible and cannot be imagined, even though
it can effect consciousness in the most pronounced manner, I induce
those of my patients who suffer mainly from the effects of the 'inside' to
set them down in pictorial form as best they can. The aim of this method
of expression is to make the unconscious contents accessible and to bring
them closer to the patient's understanding.[116]

Interpretation of art work

I have presented an account of the theoretical basis of Withymead and I shall
now move on to an examination of views about interpretation of art work. It
is important to distinguish between analytical psychology and psychoanaly-
sis as these theoretical models incorporate quite different perspectives on the
matter of interpretation.

The precept that interpretations of art work should not be carried out
according to a priori ideas is firmly stated by Constance Long, who writes,
'For the Swiss School, the meaning of the dream symbols is individual and
manifold. There are no symbols with absolutely fixed meanings, though
there are many typical ones, which appear everywhere'.[117] These 'typical'
symbols are the 'archetypes'.[118]

Without getting bogged down in a mass of definition and theory it is easy
to see a possible tension between the idea that all dream symbolism is 'indi-
vidual' but may also be 'archetypal' and 'collective'. To acknowledge that
symbols have culturally derived meanings is, on the face of it, a reasonable
thing to do. However, H.G. Baynes, probably the leading exponent of Jung's
work during this period up to his death in 1943, explores the ways in which
images can represent psychic states in categories such as 'heroic combat' or
the 'maternal aspect', which he argues are archetypal. Such generalisations
provoked the psychiatrist Ernst Kris to accuse Jung of working within a 'vul-
garised conceptual framework'.[119]

The interpretation of images by Baynes is done in an exuberant fashion; it
is essentially a metaphysical approach. First Baynes establishes an argument
for collective psychology. Once this is done the categories with which he
describes the images are introduced in a dogmatic a priori manner. The
meaning of the work is derived from these already invented categories rather
than from discussion with the patient. In a couple of examples from his
Mythology of the Soul, the snake is the archetypal symbol of sexuality and a
gun an affirmation of social power.[120] Sonu Shamdasani, an historian of ana-
lytical psychology, explained the technique thus: 'In Jung's understanding of

the constructive method and amplification, symbolic parallels have to be introduced by the analyst, as the material does not stem from the personal unconscious, and hence from the patient's history'.[121] However, it must be remembered that Irene was not an orthodox Jungian in this respect. She did not regard the material as evincing just archetypal significance but 'continually sought to find literal, personal meanings in her images'.[122] It is therefore not insignificant that she 'finally succeeded in convincing' both Jung and Toni Wolff that her painting had particular significance in pointing to unconscious aspects of her relationship with Wolff.[123] If this is true then it indicates that both Jung and Wolff were willing to concede that art therapy work could provide information which is both literal and personal. In other words, Jung was willing to rethink the notion of amplification. However, this view seems not to have been accepted by the Jungian Institutes established around the time, with which Jung had little contact in the final decade of his life.[124]

The Freudian school has no qualms at all about attributing *a priori* meanings to dream content. Freud gives some examples of symbols in dreams in *The Interpretation of Dreams*. The erect male organ [1909], for example, may be represented by a tree-trunk, umbrella, knife, dagger or pike.[125] Similarly the uterus may be represented by boxes, cases, chests, cupboards and ovens.[126] He also makes some seemingly absurd suggestions – for example, that 'rooms in dreams are usually women'[127] – and it is at this level of generalisation that perhaps Freud's work on symbols is most open to question. Certainly Jung was very critical of him in this respect. To give some more examples from *The Interpretation of Dreams*:

> ...a dream of going through a suite of rooms is a brothel or a harem dream...steps, ladders or staircases, or, as the case may be, walking up and down them, are representations of the sexual act. Smooth walls over which the dreamer climbs, the facades of houses, down which he lowers himself – often in great anxiety – correspond to erect human bodies, and are probably repeating in the dream recollections of a baby's climbing up his parents or nurse. The 'smooth' walls are men...tables, tables laid for a meal, and boards also stand for women...a women's hat can often be interpreted with certainty as a genital organ. In men's dreams a neck tie often appears as a symbol for the penis.[128]

Similarly, Freud asserts that castration is depicted symbolically in a variety of ways which include hair cutting, decapitation and the falling out of teeth.

Clearly there is a huge difference in approach to unconscious imagery between Long's assertion that there are no fixed meanings to symbols and Freud's dogmatic interpretations.

Religious sentiment and Withymead

The connection between 'psyche' (from the Greek for 'breath, soul, life') and 'spirituality' should not be overlooked. Irene Champernowne's deep personal sense of spirituality was an important aspect of her attitude to therapy. Irene felt that she was exploring the deep layers of the soul (through her work with archetypes) and she was increasingly aware, she said, of the 'immanence of God'. H.G. Baynes, whom she much admired, saw a vital religious belief as a prerequisite of cure for many categories of mental illness. However, in terms of the institutional development of the profession H.G. Baynes ('the Jungian Ernest Jones') had warned in 1934 that the Analytical Psychology Club of London (1922–1957) was becoming a 'quasi-religious' group 'with its accent on moral and spiritual uplift'.[129] This view may not have been exaggerated, as the main criterion for membership was experience of undergoing or having undergone analysis. A member of the club wrote in 1945 that 'we seek our religion and way of life in the Jungian and not the orthodox way'.[130]

C.G. Jung believed that many forms of neurotic illness stemmed from a disregard of the fundamentally 'religious' nature of the psyche, especially in the second half of life.[131] Indeed, Jung regarded 'God' as a synonym for the unconscious. In his essay *The Spiritual Problem of Modern Man* (1933) Jung equated the 'soul' with the 'psyche' and compared it with a 'stream' that can become 'dammed up' causing us to be 'at war with ourselves'. However, in the resultant distress he believed that the individual can discover the psyche 'or more precisely, we come across something which thwarts our will, and is strange and even hostile to us...'[132] In another essay, *Psychotherapists or the Clergy* (1933), Jung postulated that in mental illness destructive powers could be converted into healing forces, or, 'As the religious-minded person would say: guidance has come from God'.[133] The 'living spirit' could be evoked by the experience of mental distress which Jung saw very much in terms of an opportunity for spiritual renewal. This is a very positive way of viewing mental illness, one which is characteristic of the Jungian school and also indicative of attitudes at Withymead (as will become increasingly apparent to the reader).

In Jung's view one method of contacting the 'spontaneous life', 'psyche' or 'God' was through art-making. He described engagement in 'active fantasy' as 'one of the highest forms of psychic activity. For here the conscious and unconscious personality flow together into a common product in which both are united. Such a fantasy can be the highest expression of the unity of man's individuality (q.v.), and it may even create that individuality by giving perfect expression to its unity'.[134] It is clear that art-making is viewed as an instrument able to unblock the soul, creating a channel to God's guidance.

It was Irene's own experience of deep depression and 'spiritual darkness' when she was just 25 years old (or the 'night journey of the soul' as she also referred to it) that led her towards 'God' and the idea of 'inner death and resurrection'. She describes this formative experience:

I don't want to live any longer. I can't sort it out. It's just too dark and perhaps God doesn't exist – perhaps there is no meaning – perhaps life is really like this – chaos. I went out and walked in this very wild night. A stormy beach I remember seeing the white foam as the waves broke otherwise it was pitch dark. Along the shore there were no buildings just wild coast and suddenly the woman appeared beside me and asked me 'could she walk with me'... she said 'Funny that I should meet you here, I was just going out to drown myself'. I was so absolutely flabbergasted because although I hadn't thought about it in quite those concrete terms I knew that I was walking out into my death – that I just couldn't cope any longer. So we talked as we walked in the howling wind shouting at each other. I don't know how long we walked or how long we talked, but eventually we turned round and walked back the way we'd come. When we got back into civilisation again she...thanked me very much and said 'I feel much better for having met you and talked to you' and then went away and I went back to my house... On the mantelpiece was a modern translation of the *New Testament*...and I knocked it off just by mistake and it fell onto the floor and opened and I picked it up and as I picked it up my eye lighted on the verse 'God who commanded light to shine in the darkness has shone into your heart'...and I thought that's it...[135]

Irene's profound religiosity influenced her attitude to art therapy, which she often describes in spiritual terms. She said of the art therapy process that 'the healing comes [to the individual] because he has touched the *mystery* of creative life'. Quoting Graham Greene, she added, 'there is always hope and a possibility that a *miracle* may happen'.[136] Michael Young described Irene thus:

'As an ardent follower of Jung, Irene was much concerned with religion and psychology, and with the arts also as a member of the same great trinity'.[137]

Art therapist Norah Godfrey expressed a similar sentiment when she said that the 'profound inner paintings…really expressed the spiritual search in the underworld… It was very spiritual, and it touched real religious depth…'[138] Norah went on to say that the art therapist can help the individual to get in touch with the 'spark of life within' through which 'healing and development can come'. She emphasised that through painting the 'individual can experience personally the *natural* balance and autonomy of the self-regulating power of the psyche' which can aid the search for 'spiritual meaning… The core of meaning in healing through artistic expression lies in experiencing spiritual values'.[139] Similar remarks were made by art therapist Richard Fritzsche. In his analysis of a visual image he saw it as representing '*the* religious experience'[140]. He explained that at Withymead religion in the conventional sense was not very apparent but that 'there was a profound sense of spiritual truth'.[141]

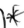

To have a full understanding of how art therapy functioned at Withymead it is vital to appreciate that art therapy was regarded as facilitating a '*natural*' healing process. Interpretation of images did not therefore play a large part of the work of the art therapists. Michael Edwards described this as a policy of 'non-interference'. The job of the art therapist was regarded as 'facilitating a process', and if necessary 'being at risk of missing things' by standing back, but working 'on the assumption that if you make somebody feel more secure today by not jumping in too completely, then it [whatever issue the patient was grappling with] would come up next week anyway probably and in a much safer way'.[142] Richard Fritzsche described that through work 'in the unconscious new spiritual meaning appeared guiding towards a new wholeness from the divine spark within'.[143]

This idea of healing through 'natural' processes can be seen as part of a cultural shift that has now become more dominant – that of holistic healing. Mary Douglas has pointed out: 'New religions depict a compassionate image of God. In quasi-religious mood, environmentalists try to make us sensitive to nature's needs. Alternative medicine invokes sensibilities on behalf of the body… It is alternative in the whole counter cultural sense, "spiritual" in contrast to "material"'.[144]

Power relations and the idea of transference and group psychodynamics at Withymead

Transference can be defined as the process by which a patient displaces on to their analyst ideas or reactions which derive from previous figures in their life. This is a problematic concept because it is sometimes hard to distinguish between the patient's transference to the therapist and the therapist's projection onto the client. Such difficulties may be minimised by a group approach.[145] The point I am making, in more simple language, is that emotional responses between the therapist and patient are sometimes hard to disentangle. The person with the most power can determine what constitutes 'reality' in any situation.

Such concepts are open to potential abuse, as Dorothy Rowe has pointed out. In dynamic psychotherapy there is a hierarchy:

> The psychotherapist is superior, the patient inferior. The psychotherapist, by virtue of his knowledge, training and special insight has access to truths above and beyond the capacity of the patients. The psychotherapist's truths have a higher truth value than the patient's truths. The psychotherapist interprets the patient's truths and tells him what they *really* mean... In the final analysis, power is the right to have your definition of reality prevail over all other people's definition of reality.'[146]

It may be far too simplistic to interpret an asymmetric power relation in terms of one-way subordination. However, to question how power relations operate is important. With these thoughts held firmly in mind I shall further explore how these ideas functioned in the community.

Withymead certainly seems to have been a benign environment (during its early history at least). I have already discussed the lack of hard-and-fast divide between patients and staff which had the effect of disrupting the hierarchy Dorothy Rowe describes.[147] However, there must be no doubt that a hierarchy did exist and also a hegemony, despite there being scope for flexibility and 'multiple transference' (which is a fairly unpopular idea in most psychotherapy environments).[148] Michael Edwards recounted that at Withymead there was not a lot of debate about theory: 'We used to have reading groups with the patients... They were just working through a text in a noncontroversial way, just trying to explain what the ideas might be. It wasn't a critical thing.' Criticism of Jung, he explained, 'would have been unimaginable at Withymead'; the question would have been asked, 'Is he still with us?'[149] Essentially an attitude of unquestioning faith and belief were

Figure 9.8 Withymead pottery with Peter Lyle seated

highly regarded. This impression is also supported by Stevens who described a 'striking homogeneity of attitudes' in the community. Whilst a certain amount of homogeneity is to be expected in any close-knit community (and we should remember that Stevens was a visitor not a resident), adherence to Jung's ideas and other norms of community life, he said, were '*idées reçues*' (received ideas). He recounted an incident which took place in the pottery studio during which he had been questioning Jung's idea of the collective unconscious: 'I was interrupted by Ben Belton in the middle of my first sentence: "I'm here to stop that kind of talk," he said firmly'.[150] Now perhaps Ben Belton was joking, and Stevens being young and earnest, lacking a sense of humour, but the impression one is left with is that deviance from the *idées reçues* was not to be tolerated.[151] Art therapist Rupert Cracknell described the attitude as being very much 'We have the truth here'.[152]

The importance of the community staff meeting has been emphasised but its functions should be further elaborated upon. One was to discuss the different types of relationships struck up between a client and different members of staff. An underlying assumption was that quite different parts of

the patient's personality could be manifested in their different relationships with various members of staff, that 'transference' might be exhibited. If we think of the Latin '*trans*' as a preposition for 'across' (in this case between people), and 'transact' meaning to manage and settle affairs, then we can see the community staff meeting as providing a place where the emotional affairs of the community were managed and settled. The development of 'transference' was encouraged as a way of allowing the patient to fully express their personality. It was regarded as positive so long as close communication between staff members allowed them to build up a total picture of the patient. Peter Lyle, art therapist, felt that he was often able to give the analyst information about patients because he was seeing a side of them that the analyst was not. He recounted one particular patient who had a good relationship with her brother. Lyle felt that he was like an elder brother to her and was therefore able to build a better rapport with her, in this instance, than the female analyst who was more like a mother figure to her. He said at Withymead there was

> amazing flexibility and insight that the community of analysts had. They were able to recognise the power of the benefits of a patient having more than one analyst... In other words somebody became a father figure, somebody became the mother figure, another person became a sister or brother figure... Different information about that patient's condition would be coming to each one. If it had been restricted to one analyst it might have been that [significant] information might not have been available... The analysis might have taken a lot longer. But the critical thing always was the liaison and harmony between the people who were in touch with the patient... Consequently the situation at Withymead was totally dynamic [with therapists and analysts] working very flexibly and very closely – it was tremendously Jungian![153]

The community staff meeting, as I have just mentioned, is where different perceptions of patients were thrashed out. It was also considered to be an opportunity for different staff members' counter-transference to the patients to be examined. Irene explained how this concept was understood at Withymead:

> The actual emotional content of a patient's sickness is often transferred to a member of staff who is most closely involved with him. The sick person may have 'got under the skin' of the [staff] member. Other members of staff might have different reactions to the patient. Thus, one person may sense a suicidal content in a patient's actions or words [or pictures], and

may have taken fright because of his or her own conflicts. Another is better tuned in to his life urge, will be able to meet the situation...decisions about any action to be taken can, at last, be distilled out of the differences.[154]

Conversely, patients could be affected by the psychodynamics of the staff group, which therefore needed careful monitoring. For example, discussion of an individual might function 'unconsciously' to 'uncover' some aspect of the staff group. In other instances, 'the change in the patient may have taken place entirely because the painful discussion in the committee had dealt with its own anxieties constellated by him. Consequently he has been left free to recover. It is as if the very living out in our own minds of some aspect of his life has given him relief, and enabled him to move into the next phase'.[155] Norah Godfrey described this process: 'Everybody pooled their experiences and observations, and that in a very extraordinary way worked on the healing of the people. Quite often they would change because of our consciousness'.[156] There is a parallel here to be drawn with faith healing. Transference is used as a quasi-religious concept.

The emphasis at Withymead, as noted, was to create an environment in which 'natural' healing processes could take place. Jung described such an environment as one where the patient can experience 'the universal feeling of childhood innocence, the sense of security, of protection, of reciprocated love, of trust, of faith...'[157]

Certainly if a 'regression' to a childlike state was felt to be useful it was allowed to occur. Irene describes a young schizophrenic woman who had been 'deprived of love' in her childhood. She was allowed to regress

> back and back until one day she told us that she was about to re-enter the womb and be born again. After this she lay for a month in bed, enacting the utter helplessness of an infant...when at the end of the month she asked for baby foods, these were provided... She knew that everyone, staff and patients alike, knew what was happening... It is our opinion that the other patients' acceptance of this situation was an important factor in her ultimate healing.[158]

The aforementioned staff meeting (or clinical staff committee as it was later called) I have illustrated as being a dynamic entity which functioned as a 'group ego'. Irene summed up the importance of group dynamics at Withymead. Some researchers, she said, 'point to the role of the group in maintaining contact with outer reality; others to its value in promoting unconscious activity'. However, at Withymead:

In our experience, the clinical staff committee, owing to its unique
nature, performs both these functions, and may in consequence be called
the group ego. It is the focal point of consciousness in the community as a
whole, being in constant relationship with the outer world of reality. But
at the same time it is always sensitively open to the dynamism of the
unconscious... Like the ego of the individual, it can differentiate and
grow. This, we suggest, is due to the healthy inter-relatedness of its indi-
vidual members...[159]

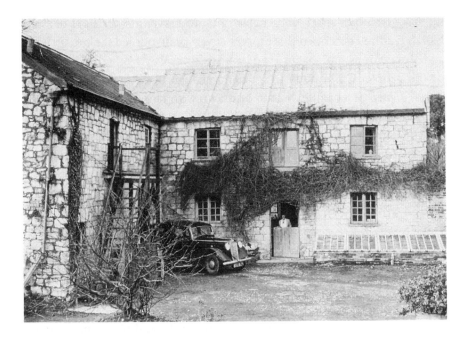

Figure 9.9 Withymead Studios

It was challenges to the structure of this group, the very heart of the
community, which were eventually responsible for the dissolution of
Withymead. Irene in a letter to the Chair of the Management Committee
defended the staff meeting thus:

> The community life rests on an inner authority vested in a weekly staff
> meeting at which *all* differences are *openly* discussed and a working com-
> promise arrived at. This method is probably too democratic for a man of

Dr Kimber's [the medical director's] standing but it is essential for the *inner-life* of the Centre which, by means of this strong team unity, makes possible the treatment of the difficult, despairing and sometimes destructive people who come.[160]

Stevens' male/female explanation (the sensible male management committee versus the emotive female therapist) for this conflict is an example of sexism in his text. This conflict was between incompatible types of cultural organisation which are mutually antagonistic.[161] In this case the conflict was between those who wished to impose a hierarchical framework, and those who wished to defend the existing model as described, which, as I have illustrated, was essentially egalitarian.

The art therapists

The art therapists at Withymead came from a variety of (mainly professional) backgrounds. Ben Belton, for example, had led a successful career as an architect prior to joining the community as a staff member in 1952. He had learnt about Withymead through his sister who was employed there before him as a social worker. Like all residential staff he entered into analysis, in his case with Irene, Culver Barker, Eddie Bennet and Barbara Hannah.[162]

The first art therapists at Withymead were Mary Howse (later Egerton), Norah Godfrey and Jo Guy. Mary Egerton joined Withymead as a non-residential teacher. She had trained at the Chelsea School of Art and the Froebel Institute. During the war she worked in war nurseries in Exeter. She attended Irene Champernowne's WEA class in psychology at Withymead and was asked to come and work on a part-time basis. Mary left Withymead after the close of the Second World War and pioneered painting with women prisoners at Holloway Prison. She maintained her contacts with Withymead and the Analytic Psychology Club; she was also briefly a member of the British Association of Art Therapists (BAAT).

Jo Guy

Jo Guy arrived as a resident in May 1947 to work in the pottery with children. Although she came to Withymead for personal reasons, she had maintained a successful career prior to a chance meeting on a train with an academic who, on listening to her problems, told her of Withymead. (Jo was originally from Birkenhead though she had Cornish connections, with relatives in Porthcurno.) She had also trained as a Froebel teacher, with

Rachel Macmillan in Deptford, and during the war had worked in nursery schools. Whilst at Withymead she attended Exeter Art School and studied under William Ruscoe. She entered into analysis with Mrs Scott-Maxwell. On her days off she worked with Dr Joyce Partridge in the nursing home she had established in Lymstone. Jo trained Ben Belton in pottery and left Withymead on her marriage to Desmond Sawyer in 1953.[163]

Norah Godfrey

Norah Godfrey heard of Withymead through another chance meeting with someone who told her of 'a lady at Countess Wear' who helped people. Norah visited Irene at her Barnfield Crescent consulting room and brought with her some art works. Irene suggested she come to Withymead to find some personal direction. After a preliminary visit she became resident in January 1945. Norah's background was in art. Norah had been educated at home by her mother in the countryside about seven miles from Exeter. She had studied at the Slade School of Art and then completed an art teaching

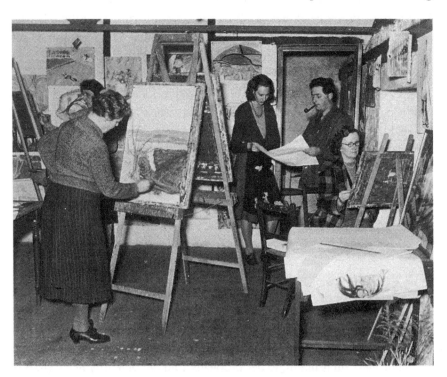

Figure 9.10 The painting studio with Norah Godfrey standing at the door

diploma at London University's Institute of Education. Her teacher there, Clarence Whaite, had been very influenced by the work of Marian Richardson. Norah had found this influence liberating after her academic art school training. She ran the painting room at Withymead for nine years, and between 1948 and 1955 also gave art classes at the Exeter Girls' Borstal and the senior approved school. Norah rejoined the Withymead staff again on a part-time basis shortly before its demise. She then taught pottery and painting in further education classes.

Peter Lyle

Peter Lyle was a former art student of Ealing and Hornsey art colleges and was a qualified art teacher, though he joined the community for mainly personal reasons. Peter first started to visit Withymead in 1953 during his vacation from his job in a London publishers' warehouse. Prior to leaving London he had had analytic sessions with Scott-Maxwell, Irene Champernowne and also with Inge Allenby. On his return to London he entered into analysis with Dr Culver Barker, a leading Jungian analyst, on an irregular basis because of the expense. Later he was able to acquire a residential post in Axminster teaching art in a residential school for disturbed children, and from there make more frequent visits to Withymead, prior to becoming a resident of the community in 1955.[164] Between 1955 and 1959 he was in full-time employment with an industrial design workshop based in Topsham. During this period he had regular analytic sessions with three Withymead analysts (Irene Champernowne, Hardy Gaussen and Joan Mackworth). Between 1959 and 1963 he worked as a full-time art therapist at Withymead.[165] During this period he also lectured on a part-time basis at Exeter College of Art. He also became a member of BAAT after its formation.[166]

Richard Fritzsche

As illustrated, a number of art therapists came to Withymead in personal distress. They learnt about art therapy by undergoing it and acquired knowledge of analytic psychology through their personal analysis and by participating in Withymead's many educational activities (reading groups, conferences, short courses) as well as participating in the community staff meeting and attending meetings of the Analytical Psychology Club in London. These art therapists joined the community as patients and had no

qualms about applying the term 'patient' to themselves since all were considered thus at Withymead to a certain extent.[167] Richard Fritzsche, for example, was another such person. He was born in Switzerland and came to England at the age of seven (when his father, an industrial chemist, was appointed to a firm of dye stuff manufacturers in Manchester). Richard suffered from health problems whilst undertaking his undergraduate science degree and returned to Switzerland at the age of nineteen. He was introduced to the work of C.G. Jung by his cousin C.A. Meier. Practising art therapy on his own he made a 'remarkable recovery' and was able to re-enter university. However, he suffered from further mental health problems. He described his experience at the time:

> I was clay modelling when I was gripped by a remarkable mystic experience which left its mark ever since. More years of being lost followed until finally at Withymead I found new aspects of my personality which finally healed me.[168]

Richard explained that Withymead provided him with the experience of 'taking part in a world founded on feeling which restored me'.[169]

Michael Edwards

Other art therapists, such as Michael Edwards, came less out of inner compulsion and more for the idea of developing credentials for working with people with psychological problems. He described this as an opportunity for vocational training in a therapeutic community setting. Michael had become interested in psychology during his post-war compulsory National Service. He had entered the RAF and worked giving psychological tests for the Personnel Selection Unit for officer training at Rambridge House near Andover airfield. He worked in a team which included a psychoanalyst. One of the projective tests used (the Murray Thematic Apperception Test) in the selection unit entailed showing the subjects ambiguous pictures by artists and asking them to write stories about the images. During his National Service Michael also started to attend Salisbury Art School. He then attended St Albans School of Art. The principal there, Mary Hoad, was interested in Jung's work and had a close friend who was a Jungian art therapist. Although Mary Hoad was the butt of some jokes, Michael described her as possessing a tremendous freshness and vitality. Having read an essay by Michael on visionary artists, Mary suggested to him that he might find it interesting to visit an art therapist who was a friend of hers. Michael was very impressed by

the powerful images that he saw in the studios during his visit to the art therapist. He described this as a vivid experience: 'I remember going into what seemed quite a large studio and seeing the walls covered with paintings ... really it was the paintings that made the impact more then her...it was like stumbling into a whole different way of experiencing painting.' It was during this 1953 meeting with Mary Webb that she told him about Withymead. Fired with enthusiasm from this encounter, Michael wrote immediately to Withymead, and subsequently visited for two months while he was still an art student. He was advised by Irene Champernowne to obtain a teaching qualification, which he did at Brighton College of Art. He visited Withymead again at Christmas and again the following Easter before joining the staff team in 1955.[170] Michael went on to teach at Newton Abbot College of Art and then at Dartington (where he taught art and served as a student counsellor) before entering into an analysis, which was Kleinian, at the Tavistock Institute, an approach he was to describe as 'arid'. He went on to become an important member of BAAT and was active in BAAT working parties and later with art therapy training.

Elizabeth Colyer

Some art therapists came knowing a great deal about Jung's work and others nothing at all. Elizabeth Colyer (later Wills) trained as an occupational therapist. She then attended Arthur Segal's art school in London (which had people with psychological problems, and those without, painting alongside each other) but found it unsatisfying because 'there was no scope for imaginative painting'.[171] Elizabeth Colyer was working in Birmingham as an occupational therapist when she read Adrian Hill's influential book *Art Versus Illness* and decided that she wanted to try art therapy herself. She saw art therapy as providing an opportunity for combining her interest in art and in people. Following her Jungian analysis in Birmingham, Elizabeth worked for Withymead until 1960.[172] Like other members of staff she continued to work privately outside of Withymead (in her case with students of Ruskin College, Oxford, who were completing a residential childcare course). After her marriage to David Wills she moved to the Cotswolds, but maintained contact with Withymead, later working for the Champernowne Trust after Withymead's demise.[173]

Rupert Cracknell

Rupert Cracknell was a painting student at Edinburgh College of Art. He was introduced to Withymead in late 1959 by Edward Adamson (who had became a friend of Irene's) and eventually became a replacement for Peter Lyle on his departure. Rupert had opted out of military National Service as a conscientious objector and had worked in a hospital for the elderly as a porter for his National Service. He described the hospital as 'gruesome' and 'appalling'. Around this time he started to read the works of Freud and Jung. He had also seen works by Surrealist artists which excited his interest. Rupert chanced across a magazine article which mentioned art therapy and alluded to Adamson's work at Netherne Hospital. This aroused his interest and he went to his local labour exchange (job centre) and said, 'I'm interested in art therapy'. They looked through their records but had no idea what art therapy might be. Shortly after this he wrote to Edward Adamson and then visited him at the hospital where he saw Adamson's impressive collection of patients' work. Very shortly after his visit to Netherne he received a telephone call from Adamson who told him of an opening at Withymead. He visited promptly and although he found Withymead very 'middle-class' he was also impressed by the 'warmth' of the place (he noted attention to detail in small touching gestures such as fresh flowers in one's room each day), and was sufficiently interested to join the staff team in the early 1960s.

Rupert's views were not entirely in accordance of those around him in the art therapy studio. He had been profoundly interested by modern art (as was Michael Edwards). He felt that modern art was about '"process", not rejecting chaos but working with it'. He described Irene as 'immensely encouraging' and willing to listen to his point of view. In this period after he arrived, and before Peter Lyle left, they both gave presentations on their views about art to the Withymead community, which were well received. Psychiatrist R.D. Laing also came and gave a talk and his ideas had a strong impact on Rupert, as did his analysis with Doris Layard, which he described as intellectually exciting and a 'revelation'.[174]

As well as the permanent art therapy staff various art therapists (such as Adrian Hill and Edward Adamson) visited or stayed for short periods throughout their careers in other institutional settings. Mary Webb, for example, the aforementioned artist with an interest in Jung's work, had spent some time at Withymead. She is notable for having been given the title 'art therapist' in 1947 at the Napsbury Hospital (where she worked from 8 May

1947 to 26 February 1960), making her the first person to work in the National Health Service with this designation.[175] Mary was also involved with the early working parties in art therapy at the National Association of Mental Health.

Winifred Gaussen (wife of Jungian analyst Dr Hardy Gaussen) had a long relationship with Withymead which has already been noted. However, when her children were older Winifred came to work part-time in the painting room, covering for staff on their days off. She also attended the staff meeting. She was particularly keen on still-life compositions and often arrived carrying flowers from her garden. She and her husband left Withymead when they moved to nearby Dartington Hall.

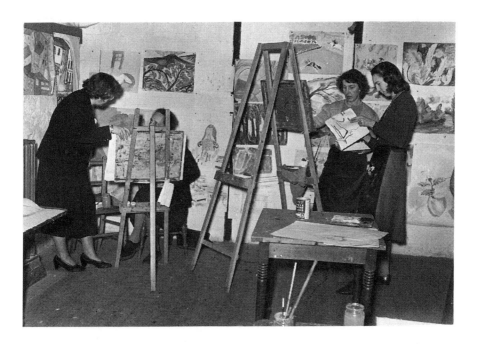

Figure 9.11 Withymead painting studio (from left to right: Irene Champernowne, Mrs Allenby, Joanna Hogg, Norah Godfrey)

Me·

The Withymead studios: Philosophy and approach

Anthony Stevens, describing his first visit to the Withymead studios, wrote:

From the pottery I climbed an outdoor staircase to the painting studio in the old stable loft. There I found Elizabeth Colyer with a group of five or six people sitting in front of easels, too absorbed by what they were

doing to be much bothered by me. The walls were covered with unframed pictures, some naïve and childlike, some bizarre, some banal...[176]

Norah Godfrey described the painting studio as very simple. In the centre of the room were big barn doors – double doors where the hay used to be thrown in. These doors were very often left open in the summer, giving the room a very open feeling.[177] The stone building itself was wreathed in white clematis in the summer. The doors in the centre of the wall overlooked the courtyard and the garden below, with apple trees and a quince tree nearby.[178]

Stevens in his account then talked to the art therapist who explained that it was not her function to 'interpret' the pictures made in the studios but to create an atmosphere in which it was possible for them to paint whatever they wanted. She saw her role as that of 'midwife whose job it was to facilitate a natural process as it occurred'.[179, 180] This was not a view entirely shared by all of the art therapists. For example, Michael Edwards is critical of the 'midwife' idea, 'that the art therapist is nothing but the hand-maiden of the *real* therapist'. (Edwards attributes this idea to Edward Adamson.) At Withymead he asserted: 'We were definitely seen as therapists in our own right, but it would have been felt dangerous if we were getting in to very deep waters with someone and not making some attempt to get connected up to the mainstream'.[181] Edwards' remark could equally well be applied to the analytic staff.

Irene saw her job of psychotherapist as 'not to analyse the artistic productions so much as to participate in the artistic language and process thereby supporting its continuous expression. Conscious understanding must come gradually but the process is *healing in itself*.[182] Richard Fritzsche, art therapist, confirmed this view. He regarded art therapy as a 'natural thing' and a 'natural form of language'. Art therapy was regarded as effective without fully conscious assimilation of the paintings' contents. He said of this process that 'the paintings speak to the people...they are put in touch with the lost part of themselves'.[183]

Irene's friend Dorothy Elmhirst understood this and in a letter to a friend she remarked on Withymead:

I can't help feeling it holds the key to a whole new development in the art of healing. It becomes so clear to me there, in the art studios, that not only the illness but the cure as well lies in the unconscious and that the arts provide a language whereby the individual spontaneously portrays the unrealised or repressed aspect of himself.[184]

Irene describes her own art therapy as representing 'visionary experiences, represent.. in paintings'.[185] From the early 1950s at the time of her analyst's death in 1953, Irene frequently painted pictures herself and either took them or sent them for analysis. She appreciated Wolff's 'intellectual penetration' of the images. Irene describes her experience of using the studios at a time in 1950 when the organisation of Withymead was causing her much stress:

> The unconscious gave me a picture to carry on with…in a fleeting hour spent in the studio. The peace and sincerity of the painting class drew it out of me despite the storm and stress of outer life, and emphasised for me the value of this atmosphere created in the art rooms with such fertilising presiding spirits as the art therapists.[186]

Elizabeth Colyer is recorded as having said: 'What you actually *say* about someone's painting doesn't matter as much as the *spirit* in which you receive it. I try not to forget that each painting is a unique expression of the individual who painted it – no one else could have done it. It has to be honoured as a unique creation'.[187] Michael Edwards concurred with this latter statement. He stressed that the pictures were 'honoured' at Withymead. He said, 'Sometimes it doesn't matter that you don't talk about the picture; its presence is recognised. It sounds like New Age nonsense, but it just doesn't feel like that … the fact that you are talking in the presence of a picture changes the way you are talking'. Pictures at Withymead he confirmed 'were treated with enormous respect'.[188] Norah Godfrey described the paintings as 'stages in development and living experience – part of the growth of the individual' and as functioning as 'a means of developing a more whole personality'.[189]

It would have been relatively unusual to have found an art therapist working alone as Dr Stevens describes. Although only one art therapist was formally on duty at any given time, other members of staff, including art therapists, might be working independently in their time off. Often there would be two or three therapists (or soon-to-be art therapists) in the painting studio such as Norah Godfrey, Elizabeth Wills, Winifred Gaussen and Euanie Tippett as well as Michael Edwards.[190] Indeed, many of the staff at Withymead used the studios to paint or sculpt, including Irene Champernowne and Norah Godfrey, who used to paint alongside patients.[191] She wrote:

> Many of the staff are younger than the patients. In the studios they often work side by side with them, making no secret of the fact that they were

exteriorising problems of their own; and experiencing the same technical difficulties.[192]

Irene liked to pop into the studios to keep in touch with what was going
on.[193]

Although Irene strongly encouraged all her staff to engage in artistic
activity this is something she had difficulty with herself. The demands of
Withymead ate up her time and energy. She wrote:

> I was torn and burdened by work of a colossal kind outside in
> Withymead, building, reshaping, staffing, restaffing, financial problems
> and difficulties beyond anything imaginable. I seemed tormented by
> trouble at every corner. So I had no time to paint or write, barely to live
> and work.[194, 195]

Figure 9.12 Painting by Irene Champernowne c. 1955

The attitude expressed by Elizabeth Colyer about the work in the studios is not unusual. Michael Edwards recounted that an art work might be discussed with a patient in a gentle, non-obtrusive way. If someone was visibly disturbed by what they had done then support would be at hand. This support might be quite exuberant. However, Michael Edwards revealed that if they were enjoying what they were doing the feeling was that the unconscious was at work and it was better not to interfere. The task of the art therapist was to 'maximise' a 'natural process' and 'muck about with it as little as possible' because it was felt that 'it is probably a better process than anything you're going to construct...' Michael Edwards emphasised that if someone was making images 'which seemed to represent some completely new dimension of their personality then that would not be interfered with'.[196] This view is shared by Norah Godfrey who came to Withymead as a patient in 1945 and later became a member of the art therapy staff. She described the studio users as expressing their inner struggles. She saw her role as supporting residents to 'gain contact with the inner healing process in themselves, which is self-regulating' and which 'would heal just as a cut is healed on the outside by nature'. Because of the 'tremendous force' of the unconscious this process should not be rushed. This reflected a view expressed by various institutions; for example, Cunningham Dax in the British Council for Rehabilitation Conference Report stated that 'to obtain these therapeutic effects the artist in charge must assume a passive role'.[197]

Irene described the mind as filled with images which function as suitable containers for emotions and ideas which are otherwise inexpressible. She wrote:

> The experience of these images was not only a means of communication between one human being and another, though that is something we experience here most strongly, but it is also a way of communication from the unconscious levels of experience to a more conscious understanding in the individual himself.[198]

The act of externalising images from the unconscious in art media was seen as putting them where they could be

> experienced more consciously and the creator can relate to them and live with them...no longer is there blind identification; what was inside is now out there...but one still hopes there is a sense of it belonging to its creator.[199]

The art therapy image was regarded as providing a form of self-expression to material which could not be expressed in any other way. Irene's analyst wrote in 1951, 'I only hope you continue to paint as there is certainly no other form to express these experiences'.[200]

Irene described her own experience of using the studio. She was about to set off to a meeting in London in 1951 at which she was to speak about art therapy. However, at the last moment before going she felt compelled to dash to the studio and make an image: 'I suddenly saw three women…a quick vision and I rushed into the painting room. At once they formed themselves, a trio standing on the earth gazing up.' Although she was not certain of the meaning of her picture she was 'satisfied that my picture said what my innermost self was struggling to say, and I went away in peace'.[201] Irene accepted that full interpretation of art therapy pictures was not always possible. This view was shared by her analyst who wrote in 1952: 'With symbols, as you know, interpretation is impossible, otherwise they would not have to be symbols. One can talk around them somewhat and add more or less parallel amplifications, but that is all'.[202]

The concrete nature of the media was seen as having advantages. Whereas spoken words are transitory and soon forgotten, working in paint or clay was seen as forcing the patient to reflect more fully upon the elements of the image. Jung was aware of this and wrote:

> …moreover the concrete shaping of the image enforces a continuous study of it in all its parts so that it can develop its effects to the full. This lends it greater weight and driving power. And these rough and ready pictures do indeed produce effects which I must admit are rather difficult to describe. A patient needs only to have seen once or twice how much he is freed from a wretched state of mind by working at a symbolical picture and he will always turn to this means of release whenever things go badly with him.[203]

Formation of the studios

Norah Godfrey, art therapist, described the formation of a painting group at Withymead:

> One person who was naturally that way inclined began painting and others gathered round her and wanted to do it too. A little group began painting in the loft of the outbuildings or in the garden. The loft was old

with rugged walls and wooden beams, dusty and a place for playing or finding solitude as much as for painting.[204]

When the studios were set up the easels were home-made – 'it was all very primitive'.[205] During the war sympathetic local art teachers visited, otherwise the artistic work was fairly unstructured and produced spontaneously. Much art work was made privately in peoples' rooms. It was, however, considered as important.

During the war period the Ashford School for Girls needed extra accommodation, and was housed in various Withymead dwellings. However, when the war ended more accommodation became available for both new residents and activities. Mary Howse, who had been helping in the painting room twice a week, returned to London. Norah Godfrey, who was resident and extremely well qualified, was asked to take over and develop a studio. Residents helped in the refurbishment of a stable block to create studio spaces. A kiln was installed in the old stables below the painting room by Jean

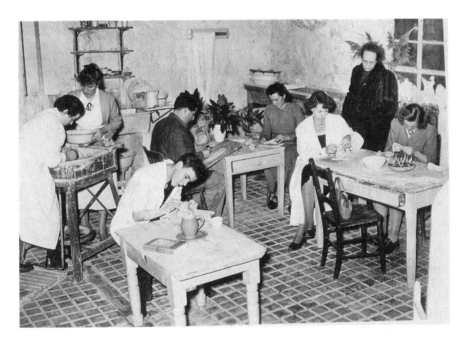

Figure 9.13 Pottery studio (promotional photograph) with, from left to right: Jo Guy, Des Sawyer, Mrs Allenby, Mrs Pye

Hope (owner with her husband of the Devonmoor Pottery, Bovery). However, during the first firing the building caught alight because the space between the two floors of the barn had been filled with chaff which had ignited! This was a minor disaster for the community. Fortunately the building was not completely destroyed and building work quickly resumed. As more residents arrived Jo Guy was asked to take over coordination of the pottery studio.

The decision to separate the pottery and painting studio was made for purely practical reasons.[206] The old stables had guttering for water drainage and a tiled floor. The heavy gas kiln needed to be at ground level. Upstairs the studio had better light for drawing and painting.[207]

Referrals to art therapy

Most patients were self-referring to art therapy. In other words they would simply walk into one of the studios. However, if an art therapist noticed somebody pop in and then disappear then they would have ample opportunity (this being a residential community) to talk to the person over lunch or in the gardens. For example, if the studio had been particularly crowded at the time the patient had popped in, the art therapist might make a point of explaining to that person that there were times the person could come in for a quiet session on their own, or offer a one-to-one session with an art therapist. This sort of intervention could be made quite casually and spontaneously or it might be orchestrated (discussed at the community staff meeting beforehand).[208]

Ben Belton recalled that the art therapists had an important role in helping with referrals to the centre. Because art therapy was believed to reveal the state of a person's psyche, art therapists were considered well placed to help decide whether the person was suffering from a psychotic state (which the art therapist was not thought able to help) or suffering from a neurotic disturbance which could be helped.[209]

Studio practice

In the painting studio there were different kinds of paint, a variety of materials, there were different qualities of paper and a variety of paint brushes. Everything was laid out so as to be accessible. Pastels, crayons, ink, pencils and charcoal were also available. A wide variety of colours were on

hand. The benefit of this was eloquently described by Norah Godfrey who wrote that

> colour is a language which expresses the subtlest tones of feeling; if the right shape and colour for our mood can be found, we can speak from depths which no words could reach. Through the resilience of the brush, the paint speaks from a range reaching from this tender delicacy to primeval power.[210]

Peter Lyle recounted that patients and staff were free to go up and use the studios and if they wanted help could ask for it. If a patient was new then help might be offered. In both the pottery studio and the painting studio there was a main area with an annex off it for those patients who wanted more quiet and privacy. Being able to offer different sorts of therapeutic space was considered important. Having the annex afforded an opportunity for a more private one-to-one discussion with the art therapist if this was desired.[211] Alternatively, residents could work in their rooms in the main house if they wished privacy for 'more personal, inner paintings'.[212]

Norah Godfrey described residents starting off in the studio. Many of the residents wished to express transitory moods, so poster paint was favoured for its immediacy over oils. The patient was given a large sheet of paper 'of the size she feels equal to facing – and any sheet seems frightening at this stage. Often the beginning is a tentative blot.' However, residents would quickly become involved and the painting would develop 'under its own momentum'.[213]

Anthony Stevens concurred that initially the art therapist was concerned with making the newcomer feel welcome and comfortable in the studio, and accepting whatever they produced. Responding to their 'need to impose form' upon the art work, art therapists might then offer more information about techniques. This was done, he confirms, with tact and sensitivity and without inhibiting the emotional power or distorting the intention of the work.[214]

How patients used the art therapy workshops varied in practice. Some people would come in and work quite intensively for some weeks and then stop using them altogether. Others would attend more regularly.[215] Norah explained that when a new person came to the studio she would show them the art materials and explain how to mix the paints. She would perhaps show them some examples of art work. She would then say, 'Just do what you like.' The communication to herself came, she said, through the art work. The 'level' of painting they were doing would determine the depth of verbal

exchange.[216] Norah would not make suggestions of subject matter because she emphasised the importance of patients finding their own direction in the studio through their contact with 'inner reality and the objective world'. Thus she felt that residents would learn to make their own way creatively. Producing an aesthetically pleasing picture was not considered important. Norah wrote:

> Paintings expressing a shattered psychological condition are obviously inartistic, and thus should be so. The patient should not be made to alter his work unless he wants to, indeed probably he cannot. However, the remarks one may make about lack of balance would actually speak to his unconscious mind as well. If he feels there is possibility of reintegration he may try to paint a sequel hypothesis which has more form.[217]

How patients used the space varied. Michael Edwards explained that, in his one-to-one art therapy sessions,

> some people stayed sitting in my chair. They'd get on better if I wasn't too close: other people had no problem with me sitting on the edge of the table, they'd chat all the time they're painting... Sometimes people would be giving off electric fence signals so you just kept well away from them. You could just see that they didn't want anyone near them. Other people would start talking about their paintings and draw you in...[218]

In addition to regular art therapy sessions, impromptu workshops were staged by visiting art teachers such as Gwen Jackson and by Ngarita Edwards (both practising artists and qualified teachers, the latter Michael's first wife). These might be to teach special techniques such as batik.[219]

Art therapy and analysis

Frequency of therapy could vary, though therapy staff were residential and having Jungian analysis for two one-hour sessions per week. This was in principle rather than in practice because sessions were cancelled or people were away.[220] Patients receiving full analytic treatment were encouraged to remain in residence or to stay nearby for at least two years. However, some would stay longer.[221] Peter Lyle, for example, had regular therapy sessions with Ben Belton and weekly analysis with an analyst and in addition to this he would see Irene once a week or more often for an hour. Peter produced art work in both of the studios. Occasionally Irene would visit to look at work in progress. There was no hard-and-fast procedure. In analysis with Irene, Peter

often talked about art work he had produced. The system was very 'flexible'. Michael Edwards, who described himself as a 'trainee art therapist', said that he was 'painting like crazy and taking my pictures to [analytic] sessions'.[222]

During the early development of Withymead a Jungian psychotherapist by the name of Florida Scott-Maxwell lived there, sharing analytic duties until she found the fracas and hurly-burly of residential life too much. She then came to the centre several times a week but lived in Exeter. A former actor who carried herself well, she was described by art therapist Norah Godfrey as a stately and beautiful person. Florida was a regular visitor to the studios and would chat to residents there but she did not paint herself.

The next resident analyst was Inge Allenby, who also visited the studios on most afternoons. (A German expatriate, Allenby had a training in art history prior to her training as a Jungian analyst.) There was therefore a close connection between the art therapy work done in the studios and resident's personal analysis.

Later analysts in residence included Paul Campbell who had been at the Davidson Clinic in Edinburgh and Joan Mackworth who later founded a psychotherapy centre at Witney.[223]

Some of the art work produced would be pinned up on the studio walls. Each patient had a folder of their own which they could consult as they wished. Work was also exhibited in the dining room and these pictures were changed every two or three weeks (this must to some extent have given community members an idea of the mental state of these artists though not all pictures were exhibited). Patients could take their folder to their analyst or not as they chose. Often patients would discuss the art works produced with the art therapists, but if they chose not to do so the art therapist would not consult their folder, which remained private. Although paintings could be destroyed by those who made them, Peter Lyle said that he urged patients to realise that the very impulse to destroy the art work could be an indication that there might be something significant in the work which should be shown to their analyst.[224]

Ben Belton confirmed that he would restrict himself in discussion of a patient's work to asking what it meant to its maker. He knew that if the work was of significance that this would be dealt with in the analytic session.[225]

Norah Godfrey explained that paintings were viewed as constituting part of an individual's personal life. Thus everybody had to be asked whether their work could be shown to others. She confirmed that some residents regarded their work as far too personal and declined to have it shown.[226]

Michael Edwards recounted in interview that Irene 'encouraged people to paint and would love to bring their pictures along to [analytic] sessions'. She fully encouraged this process and expected all staff to be likewise engaged with their patient's imagery, including the consultant psychiatrist on the staff team. Indeed, he remembered that

> …we would talk about the compensatory action of the unconscious and how that might be manifest. It was certainly an everyday experience to see some of these pictures looking very different from the personality of the person. There was something quite significant coming through.[227]

Irene was noted to have had a good capacity for 'reading' the images and was often able to notice things that the art therapists had overlooked. There was, he explained, always time made in meetings to look at something happening in somebody's paintings which was perhaps less evident in other aspects of their life.[228] At such a meeting pictures would be described by the art therapists to the group and a recommendation might be made by the art therapist for staff to visit the art studios to see a particular work in progress. If somebody did a 'very powerful or frightening picture' (one with chaotic elements or strongly emotively laden) the art therapist might intervene and suggest that the patient take the image to their analytic session. Alternatively, the art therapist could 'tip the wink and it would all be handled quite skilfully'. What was meant by this was that the art therapist would alert Irene to a significant picture and she would then drop into the studio as if by chance. Then on a suitable occasion, or in the analytic session with the patient in question, she would say something like: '"I happened to be in the painting room and I was very struck by this painting and I was told it was yours." She would handle it very diplomatically'.[229] Thus she was able to encourage discussion of the art work.

Perceptions of art therapy

The aforementioned 'flexibility' in the system makes sense if one can understand that at Withymead the 'unconscious' was seen as a 'self-regulating mechanism' which prevented too much unconscious material presenting itself at the wrong time. Norah Godfrey felt very strongly that nothing should be done to instigate the expression of unconscious material. For her it was much more a question of having faith in a natural process. She felt that modern art therapists 'probably do a bit too much stirring up of such material'. Irene Champernowne's description of paintings is very similar.

They represent, she said, 'a self-healing, self-regulating mechanism at work within the individual'.[230]

Norah Godfrey arrived at Withymead as a patient in a state of distress. Not long after her arrival Irene showed her an impressive series of 'inner paintings' done by a private patient of hers. Seeing the potential for self-expression, Norah then made many images in the painting studio. She said, 'When I started off my unconscious really came out in a big way. I did a great many unconscious paintings.' Consequently when she later became a therapist she 'knew what every one was up against'.[231] Quite often symbolism in reproductions of art work would be looked at and discussed with residents in the studios.[232] Thus the analytic faculties of residents could be stimulated and a capacity for 'reading' works of art developed. Norah felt that the studio environment was conducive to the production of 'inner paintings' because all the art therapists really understood how residents were feeling. She explained that it was the 'psychological rapport' in the place which was so conducive to self-expression – the paintings 'just happened' she recounted.[233]

Irene described the ability to use artistic media for free expression as not necessarily immediate. It was possible that someone new to the community might sit down and paint a very, what she called, 'conscious' picture at first: something self-conscious and probably figurative. She said of such a picture, 'It's a nice picture and it's saying something about their actual life and the next one will say something rather strange – it is really rather more like a dream. People begin to get able to do this... Somebody dreams through a painting – just paints...'

Irene described one of her patients' art work:

> It's a tunnel but there's a little light at the end of the tunnel and there's a little figure standing with this long tunnel to go down and I would say, 'Well there is light at the end of the tunnel – it's a long tunnel, you may have a long way to go, but you've painted a light at the end of your tunnel...' The picture was very useful.[234]

Writing probably of this patient or another patient using similar imagery, a refugee who had been in a concentration camp, Irene said: 'She represented her inner state after her breakdown. She is creeping out of her psychic dungeon...she is creeping along a passageway.' However, in a later work she depicted herself 'once more experiencing the imprisonment of the tunnel... The picture shows obvious distress and was painted at a very low level of consciousness when she could only paint happenings and not voice them. It is when words fail that artistic expression so often takes over'.[235]

Peter Lyle recounted an art therapy session with a young boy who created a house out of clay. His treatment of the house was analogous to his emotional state. His example illustrates the value of the art therapist being attentive to the client in the art therapy session by watching the process of something being made. (Otherwise the meaning of the object could be very easily lost if the art therapist just looked at the finished product.) Peter told me that after the boy had finished creating the basic structure of the house from clay ' all of a sudden he was taking little bits…and applying them, and applying them…little dabs of clay and I thought that was interesting and I just didn't quite know what it was, and I saw it was getting higher and higher and it was beginning to cover this house…I just asked him what it was and he said, "Oh, that's the water." His mother was the one who was really in some kind of crisis. There was his home on good firm ground, and then all of a sudden the water starts rising, and his poor home gets inundated. Incredible, you know he hasn't got a home that he can go to any more'.[236]

A quite similar example is given by Irene who described a 14-year-old boy who painted a picture of a sinking ship. His parents were divorcing and

Figure 9.14 Sinking Ship

the situation was very difficult. She said of this boy: 'He told us *through his picture* that he was a sinking ship although he was quite unable to convey his terrible situation in words.' Entering into the 'language' of the painting Irene suggested that 'lifeboats' could 'go to the rescue – entering into the drama and taking up the emotional state' of the boy. She was 'thus relieving the boy in fantasy' and 'sharing the problem at least emotionally'.[237] This method of entering into the 'language' of the image was important at Withymead. Irene wrote: 'It is possible to accept the material in the state of the subject [the same mood tone] at the moment, and discuss it from the experimental point of view, rather than from the intellectual interpretation of the symbols used'.[238]

Peter Lyle referred to this kind of art work which tapped unconscious sources as 'inner work'. Such paintings and sculptures can be 'very revealing about the state of the person'.[239] Peter describes patients as coming to the studios for a 'period of intensive work' in which

> there was a lot of deeply profoundly disturbing inner work to be done and it came out more in the paintings than in the analysis because perhaps they didn't dream and they weren't in touch with their dreams … It all poured out in the therapy studios but it was brought back into the analytic situation through the patients themselves taking it to the analyst and through the therapy [image] 'talking' to the therapist and the art therapist talking with the analyst about the patient's work…[240]

Norah described similar work being produced in which 'archetypes were encountered – a very frightening business…things did spring out but it was all treated with great respect'.[241]

Richard Fritzsche described an art work made by one of Irene Champernowne's patients at a conference. The patient is seen as illustrating the tug between 'instinctual' impulses and the power of the intellect. Since it is an evocative and detailed response to an image it is worth quoting at length. It gives a good indication of how art therapy staff responded to images:

> The patient has represented herself bound and floating above the city in the darkness of the night. A golden cord winds round her body beginning at one hand and ending at the other. Not so plain to see is her hair which is strangely blue and spreads far from her head like a fan. It suggests a kind of rootedness in the atmosphere and this quality evidently keeps her in a state of suspense. She is carried away out of the human world below by a breath of wind. Wind and atmosphere have a

natural association with the world of spirit…her eyes are points of vivid red: emotional intensity and passion is concentrated there in the intellectual faculty. All this corresponds to the state in which the woman found herself. The body bound, it has become forgotten, its demands unrealised. And it was night time. We see the stars, the cosmos itself. The ordinary world of daily life had given place to the dark background of the spirit-world. The patient is cut off and other worldly.

The picture suggests a return to a state before birth. The body is bound like the seed in the seed-case where life has drawn itself together into its smallest compass. Presently it will fall on the earth and initiate a new cycle of development. If this is so, we can see the powers of 'Heaven' and 'Earth' both as regressional urges, the one to the world of the spirit, the other to that of instinct.[242]

Dr Champernowne recalls saying to this woman in the analytic session, 'You cannot remain floating in space! You must come down to earth.'

One is aware in reading Fritzsche's analysis of this art work of the underlying religiosity of Withymead. It would be easy enough to interpret the image quite differently from a less spiritual perspective; for example, that she felt constrained in her feminine role and disenfranchised from the male-dominated city below her. The red in her eyes could denote suppressed rage, etc., etc.[243] It is hard not to read Fritzsche's analysis as being about spiritual rebirth. It reflects the type of work done in Withymead studios and gives an idea of the mood or even the 'spirit' of the place. Clients were encouraged to contact a spiritual dimension within themselves as part of the healing process, or rather spiritual dimension was seen as emerging from the unconscious.[244]

A range of arts on offer

At Withymead a spectrum of arts activity was offered ranging from those with an art and craft emphasis at one end to a more psychological emphasis at the other.[245] These different media differed qualitatively in what they could offer to patients.

The atmosphere in the studio was described by Norah as usually quite peaceful. However, this was not a library-like silence. Conversations took place and jokes were cracked. Although sometimes a resident would be visibly disturbed and require support, the studio often had a light-hearted mood. The routines were sometimes disrupted by special events. When the dance-movement therapist Rudolph Laban visited Withymead in 1949 he

caused a stir and had 'everybody' moving and dancing on the lawn. This was an ebullient scene, as Norah explained: 'There was a doctor chasing Mrs Scott-Maxwell around the lawn – our neighbours wondered have they all gone mad?'[246]

One of the few structured events in the painting studio was a life group. People took turns to sit for the group. Norah considered engagement in a group activity to be a positive thing. Having a mixed age range in the studio was also considered to be useful. The spontaneity of children was believed to have a disinhibiting effect on the adults.[247]

One-to-one art therapy sessions using paint or clay were considered to be extremely useful for residents who wished to work alone or who were self-conscious. At Withymead activities such as interpretive movement to music tended to be conducted in groups which were potentially inhibiting. Likewise 'anxiety and physical shyness' were noted as inhibiting factors in engagement in singing. However, the different arts were felt to yield complementary information about residents.[248]

Euanie Tippett, resident from 1948 and painting therapist from 1960, felt that the gradual nature of the process of painting or sculpting had advantages over other forms of creative therapy offered at Withymead. She said of the experience of working in the studios that one can 'move slowly into your clay or your picture. In a movement class you may have to go rather at the moment, you may not feel that you have sufficient freedom'.[249] Conversely, music lessons might be recommended to residents who were thought able to benefit from the 'discipline' of a more structured activity.[250]

Irene felt that painting was the most freeing or 'fluid' of the art forms offering the potential for raw or 'undeveloped' expression. Clay had some of the quality of painting, she felt, 'because the material is malleable and just something very simple comes out. But when you get to pottery or you begin music you've got to be more technically knowledgeable; I think intellect comes in there.[251] Extemporisation in music was noted as able to provide freedom but Molly Kemp, music therapist, pointed out that not many of the Withymead residents were 'willing to dare' this form of self-expression.[252]

Jo Guy, art therapist in the pottery studio, described a patient in deep psychological distress who carried the first pot he made in the studio around with him. She described his painting as too personal to be shown to other people. However, the pot, she explained, could be admired by everyone. She wrote: 'I think as his hand closed round the smooth shape in his pocket, he

felt a concrete talisman that he could create an inner life as solidly as he had made his little vase'.[253]

Even simple activities such as centring a piece of clay and throwing a pot on the wheel were seen as yielding useful information about the psychological condition of the patient, as Peter Lyle revealed. For example, whether or not patients were able to centre the clay on the wheel, Peter explained, 'was tremendously revealing at times'. There were some

> really disturbed people who could never get the pot centred...others would have it centred and made in seconds, but really centred...others don't worry about the fact that it's not centred...others who worry about the fact that it's not centred. Some who worry about it being centred, as though you know they don't feel right being centred. Other people who can live without it being centred – it's not any great hassle to them and they actually manage to make a pot...they run off two or three pots in half an hour, or even less...you let them go and take the amount of clay they want. Some people feel that they could only handle a little bit of clay. Other people are very ambitious...it's interesting just noticing what people selected what they liked. Some people, you know, didn't like getting their hands wet and dirty – other people feel quickly dissatisfied, they [don't achieve] the high standard they've got up here in their head and they get frustrated.[254]

Therapeutic interventions

It is clear from Peter Lyle's account that the attentive art therapist could glean all kinds of relevant information about patients by encouraging them to engage in quite simple creative tasks. The practical emphasis in the pottery (producing the cups and bowls needed for the Withymead community) was considered very useful for patients who were experiencing great inner turmoil. In such cases the art therapy might be seen as complementing the verbal analysis. In other words, the verbal analysis might be very intense so the art therapy might become more geared towards a greater emphasis on apprehending 'outer' reality (towards portraiture, still-life painting, or land-scapes). In this way art therapy was considered as providing a balancing or complementary experience to the 'tremendous disturbance that was going on inside' the person. Art therapy was seen as actually helping the patient's attempts at 'strengthening their ties with the outer world'.[255] Richard Fritzsche, pottery and sculpture therapist, emphasised the importance of

drawing natural forms as 'very valuable in helping to stabilise people who were psychologically disturbed or lost in fantasy'.[256]

On this subject Irene wrote:

When a person has worked through modelling or painting of an inner condition, more objective painting or work in other arts and crafts is quite often a *natural next step* which he may take without any pressure or even suggestion from a teacher or therapist. This is a further way of creating form out of inner chaos or blind emotion.[257]

Irene confirmed that sometimes the art therapist would intervene in a direct way and suggest to a resident that they try more objective work such as going to a life class or join a sketching group.[258]

Irene elaborated on this process further:

Because the arts are used so freely here and people are encouraged to be spontaneous (it doesn't matter at what level of childishness), there comes a point when they begin to feel abandoned to their own fluid emotions and then they begin to want a certain discipline.[259]

This discipline (in the form of technique) was introduced in such a way as to 'give security to the fluid colour or the chaotic form' but without inhibiting the 'emotional mood and emotional development' of the work. Thus the transition from a period of intense introspection to a more outward outlook can be achieved smoothly. It might be remembered at this point that the aim of this activity was not specifically to turn people into artists (though that might occasionally occur). Thus residents might arrive in a 'chaos' which is painted and then move on to a point where they are focused on developing 'different ways of living which are orderly and practical...such as making marmalade or growing plants, realistic things...'[260]

Art therapist Norah Godfrey confirmed this way of working. There was a strong link between the pottery and painting studios. Norah felt that this was beneficial as an intervention could be made when someone was getting 'too lost in their inner fantasy world'. She would suggest that they have a go with the clay. Its solidity she felt distracted the patient from their fantasy and towards the tangible objective facts of material existence.

Norah explained that there was a subtle relationship between artistic value which guides the art therapist's interventions in teaching and the psychological situation represented in the picture. Making the right intervention, she explained, 'can only be a matter of sensing the situation... sometimes conversation may lean more towards discussing the subject matter

of the picture with relation to expressing it satisfactorily, sometimes towards questions of manipulating the materials'. She described many of the residents' paintings in the studio being concerned with the outer world: 'Ideas suggested by natural forms are invaluable in making a good relation with the object and in bringing the inner and outer worlds together'.[261] Such a way of working plainly relied on the experience of the art therapist.

There was clearly some difference in attitude between Withymead staff towards the stimulation of unconscious material. Irene was described by a member of art therapy staff as 'very wary of any sort of analysis', either verbal of intellectual, which might 'split the personality'. If a resident did not understand their picture 'deep down' such analysis or interpretation was thought able to do more harm than good.[262] Irene emphasised the importance of being sensitive to the disposition of studio users. She said:

> One has to be very careful of a person who goes into the painting room and wants to keep everything in a straight line and a border with a pencil...won't use a brush — one has to be warned that this person may need to stay in a rather conscious framework, and the other [the unconscious] only let in with the greatest gentleness, and he may either split and fall into the unconscious. We've had that happen, or the unconscious *erupts* into the situation.[263]

This is a powerful statement warning of the potentially overwhelming nature of unconscious material. This quote illustrates an idea which came from Jung about the danger of unconscious material too abruptly aroused becoming split off from consciousness rather than assimilated.

Michael Edwards on the other hand felt that Irene sometimes evaded the intensity in the art work 'as if she couldn't cope' with it. Some of the work Michael was doing was very exciting to him as an artist and he felt that because of his art school training he was able to work reasonably comfortably with such material. The image, he felt, could act as a container for strong feelings. However, Irene felt that his work was getting too dominated by his unconscious. He explained that Irene had the idea that a picture could give 'negative feedback...you could be persecuted by your own picture'. He said, 'I can think of some quite disturbed paintings I felt able to paint'.[264]

Norah Godfrey's attitude to such unconscious material seems closer to Irene's when she voices her opinion that 'the unconscious is completely destructive and archaic as well as creative. It is a dangerous thing.' The therapist, she asserted, must not influence patients even if they seem to be

taking a long time to produce 'inner' paintings: 'If you feel they are being very slow they have to be slow,' she declared.[265]

Irene explained that she did not feel that a detailed analysis of the image was necessarily beneficial to the patient, as she believed many residents at Withymead were 'suffering from a divorce of their conscious life of the ego from the unconscious'. Therefore she argued it was more beneficial to respond to images in the same 'language' in which they were made because it could be 'dangerous for the subject to become too preoccupied with the intellectual understanding of the pictures in a detached way, which is an escape from the reality of the situation'. In other words, she was concerned with the process not becoming too distant and intellectualised. The role of the art therapist or analyst was to stay with the feeling tone of the emotional content of the art works. A detailed analysis of the content of images could, however, she believed, be useful to the analysts themselves.[266]

The notion of balance was very important. Norah described the open aspect of the studio as complementing the 'inner' psychological work being done. This sense of balance which the art therapist was able to intuit was emphasised by Norah Godfrey. At Withymead art therapits were constantly alert and sensitive to the mood shifts and psychological states of residents. There was not a set formula for how to proceed as an art therapist. However, if the inner fantasy life of an individual became 'too compelling' then asking them to engage in a practical task in the studio (such as helping to lay out the paints or tidy up) might be tried. A change of medium might also give an opportunity to disrupt the dominating effects of the unconscious if this was felt to be getting too overwhelming for the patient. Conversely, Norah described residents' preoccupation with arts materials as a reaction

> to the abstract depersonalisation of modern bureaucratic life...the individual can become as much bogged down and lost in this as in any intellectual desert unless consciousness is maintained. Here the art therapist can help the patient to relate to the matter [the material substance of the paint as well as actual content] in terms of experience and not only intellectually.[267]

By experience Norah is referring to an emotional engagement with the materials and the picture content as it is being made and then discussed. Intervention was always a delicate matter, as Norah Godfrey explained: on one occasion she complimented a patient on his 'lovely pillar box' to which he retorted disgruntledly: 'It's a bus!'

Therapeutic interventions with artists

Another technique used at Withymead with patients who were also artists was to invite them to try a medium with which they were not familiar. Painters would be encouraged to work in clay and sculptors asked to try paints or dance. The intention behind this was to move the patient into a medium where they could not become too preoccupied with aesthetics as this was thought to detract from expressing the unconscious. Michael Edwards said of Irene that she 'was very interested in working with artists. She was sympathetic to them, and would be very good at getting their creativity going again…but always with a view to getting their professional life re-established'.[268]

Patients with artistic training in a particular medium were regarded as having less potential freedom for art as therapy in that medium than in others in which they did not possess expertise. Irene wrote:

> …the more unconscious material, the more spontaneous, young side of themselves (which has probably been the repressed part), doesn't get a chance in the more trained medium. And so they would be transferred, or transfer themselves, to clay.[269]

Others might 'discover a gift' in a particular medium although they might not have previously developed a creative ability.

Therapeutic interventions: Function types

Jung's theory of function types was another factor determining possible therapeutic intervention and how work was viewed. People were perceived as painting differently according to their psychological type. Norah explained that 'Irene was extroverted feeling, intuitive… Hers were very flowing, rhythmic and colourful. People who were introverted in 'sensation' are inclined to do very finicky, little things, or sorts of symbols…twisty shapes often in outline'.[270]

The four function types, which refer to the functions of consciousness, are as follows: *thinking* (knowing what a thing is), *feeling* (a consideration of the value of something, a viewpoint or perspective), *sensation* (responsiveness to the sensations which tells us what something is), *intuition* (a sense of where something is going or of possibilities).[271] Norah Godfrey provided me with definitions similar to those above, though she emphasised the feeling function, describing feeling types as having 'great regard for others… They don't suffer the many ills of specialists with an often narrow outlook. This

allows the feeling types to see what is important and make value judgements, often lost on other types.' In her comments on this chapter, she wrote: 'With the coming of the scientific era both the intuition and feeling functions have been undervalued and leave us sadly out of touch with the emotional aspects of reality…' (1996). In addition, in the Jungian schema, individuals were seen as being 'introverted' or 'extroverted' in disposition.[272] Norah Godfrey's description of 'introverts' is as people who need 'knowledge of the outer world but also of that strange world within, the world of the spirit which today has been largely abandoned'.[273] In this theoretical framework people are considered to have an *inferior function* which is an area of consciousness which is underdeveloped. The inferior function is considered for the most part unconscious and 'contains enormous potential for change which can be brought about by attempts to integrate the contents of the inferior function into ego consciousness'. This is thought to result in a fuller development or 'rounding out' of the personality and a move towards *individuation*.[274]

Extroverted sensation types were considered to be less responsive to art therapy at Withymead. For art therapy to be effective, Stevens asserted patients must be willing to concede that symbolic experiences in their psyche are 'at least as important' as actual events taking place in their environment. Hence, it was felt that 'introverts' tended to do better in analysis and art therapy than extroverts, and 'feeling initiatives' often better than 'thinking' or 'sensation' types.[275] Although not a view shared unanimously by all art therapy staff, this theory certainly had some effect on the expectations of both the successes of therapy and what was likely to be produced pictorially in the art therapy session. 'Recognition of type differences,' explained Richard Fritzsche, 'was of value in relating to people and their needs'.[276]

Summary

Although much emphasis was laid on 'natural' and 'spontaneous' production of art work, I have illustrated that definite expectations existed about how art therapy would function in the painting and pottery studios. Although drawing on Jung's ideas about 'active imagination' and 'amplification', Irene believed that paintings could yield information about the patient's unconscious which was specific and personal. This in turn was explored in terms of the individual's place in community dynamics.

Art therapy was absolutely central, on a par with analysis, to the life of the community. Although conducted in studios which were set away from the main house, these art therapy activities were by no means peripheral. I have

shown that analysts made frequent visits to the studios, and that Irene Champernowne used art therapy for her own benefit. Likewise, other Withymead staff used the studios on a regular basis. Images were used as a vital part of analysis and played an important role in the community staff meeting, where interpersonal dynamics were explored.

Art therapists also played other roles, and had additional duties within the community. The therapeutic boundary between art therapists and residents was therefore extended into the community as a whole rather than contained within the art therapy session. Art therapists built up intimate and multi-faceted relationships with their clients.

Conclusion

The 'unconscious' and knowledge about it was central to Withymead. Different community members claimed to have different degrees of insight into the unconscious. Art therapy was important in the construction of the unconscious in the community because of its role as procurer of information about unconscious processes. It was therefore held in high regard within the community as a whole and on a par with 'active imagination' in analysis. This is in tune with the analytic psychology establishment of the period which regarded personal insight (particularly into unconscious processes) as more important than formal training, and/or qualifications, in giving status to the individual within the 'Jungian' framework. In this sense Withymead was essentially egalitarian in its structure. However, that the analysts were regarded to have had particular insight and knowledge into the unconscious, by virtue of their experience and training, was evinced by their having private meetings for in-depth analysis of patients which took place outwith the community staff meeting.

Art therapy was also seen as part of a natural healing process – essentially one of spiritual death and rebirth. These processes were seen primarily as self-regulating and 'natural' and interference as potentially very dangerous. The 'unconscious' was both admired and feared at Withymead. However, art therapists could have a positive regulatory role helping patients towards self-expression or intervening to stop them becoming overwhelmed. This intervention could be more or less sophisticated depending on the degree of experience and analysis the art therapist had had. For example, an art therapist who had a lot of knowledge about Jungian theory could start to work with a concept of function types and their interventions would be influenced by this theoretical underpinning. An art therapist who was less

initiated into that theoretical framework might respond in a generally supportive and encouraging way, asking clients about what they were doing, but would not be equipped to understand the work in the same way as the analysts. This is precisely what occurred at Withymead.

As I have pointed out there was no standard training for art therapists in this period. Art therapists came to Withymead with varying degrees of knowledge about analytical psychology. Many of them arrived as patients and proceeded to have years of Jungian analysis, as well as the day-to-day experience of being part of Withymead, before taking on the role of art therapist. Others had come from an art school background and commenced working as art therapists with far less preparation (in a Jungian understanding of unconscious processes) than the former group of patient/therapists. Therefore, art therapy staff varied in their working practices, their degree of empathetic communication with the analysts and their knowledge of analytical psychology.

I have pointed out that all were considered 'patients' in the community, whether working as staff or coming for therapy, and that rigid boundaries between 'staff' and 'patients' did not exist. This is because all members of the Withymead community were in analysis.

Art therapists were also able to give support, encouragement and friendship and to listen to problems. They were also actively involved in an analysis of art work in the community staff meeting and their reports of art therapy sessions were central to the meeting. This meeting had strong spiritual overtones as I have noted, specifically with regard to its sensitivity in terms of thinking, feeling and intuiting the needs of patients.

The central role of the art therapists at Withymead was, as I hope I have illustrated, much more complex than has hitherto been acknowledged.

Notes

1 Ingelby 1985, p.163.
2 Ulman 1963, p.94.
3 The term 'remedial art' was used rather than 'art therapy' until about 1949. The studios were referred to as painting and pottery rooms. Remedial artists or art therapists also engaged in a wide range of duties in addition to their role in the studios.
4 It was during the post-war expansion of Withymead that the 'family' became a 'community'.
5 There is a great deal of disagreement about what precisely constitutes a therapeutic community and who is entitled to use the term. I do not wish to get bogged down in this debate, which could easily become the focus of this chapter, but note that the staff of Withymead applied the term 'therapeutic community' to its activities.
6 My research focus is to 1966 and Withymead closed after this date.
7 Waller 1991, p.62.
8 Stevens 1986, p.20.
9 After his wife's death he lived in his house in Kusnacht attended by his housekeeper, Ruth Bailey, and his secretary Aniela Jaffé.

10 Henderson notes that Jung was not interested in supporting 'group' experiments and even declined to become involved in the formation of the C.G. Jung Institute in Zurich (Henderson 1980, p.1).

11 Dorothy Elmhirst's description of Gilbert in Young 1982, pp.210–211 cited in Waller 1991, p.62. Gilbert was described by Richard Fritzsche (an art therapist whose contribution to Withymead will be discussed in further detail) as possessing a 'natural dignity, dependability, sympathy for everyone and a sense of humour' (personal correspondence 26.02.96). Peter Lyle, an art therapist at Withymead, has suggested that the word 'frail' might give a misleading impression because Gilbert had great 'inner strength'. Peter describes Gilbert as 'a gentle and kindly man, very sensitive and wise, with smiling eyes…a quiet and understanding man and a good listener' (personal correspondence 26.4.00).

12 Stevens 1986, p.26.

13 H.G. Baynes makes a comparison between the collective psyche and schizophrenia. The 1914–1918 war he describes as a cataclysm and the result of 'irrational collective forces' (Baynes 1940, p.6).

14 Irene Champernowne, 1975, talking to Peter Firth (recorded interview).

15 C.G. Jung: *The Transcendent Function,* 1916 (published in German in 1958). This quotation is from the 1960 edition of *Collected Works,* Vol. 8, p.89.

16 Irene Champernowne: recorded interview, with Peter Firth, 1975.

17 Norah Godfrey in interview, 1995.

18 Godfrey: personal correspondence 28.02.96.

19 Ulman 1963, p.92.

20 Other buildings in the area were acquired as they came onto the market.

21 Champernowne 1963, p.94. Ulman categorised treatment into four headings: analytical therapy, art therapy, rehabilitation through work and communal living (Ulman 1963, p.94).

22 Some of those who had moved in during the Exeter 'blitz' moved in to other accommodation but some people stayed on.

23 This assumption is made by Stevens (1986, p.57). This is disputed as an accurate picture of Withymead by those staff that were there in the 40s and early 50s. Richard Fritzsche, for example, felt that a 'broad cross-section' of people were resident there. However, as financial constraints became more keenly felt this may have resulted in a more middle-class clientele.

24 Personal correspondence with Richard Fritzsche, 28.02.96.

25 Young 1982, p.213.

26 Stevens, citing Crosse and Loup, 1986, p.179.

27 Several of the staff of Withymead also worked for nearby Dartington Hall including Dr Culver Barker, Mrs Scott-Maxwell and Mrs Allenby (Henderson 1980, p.1).

28 From a letter to J.J. Van der Hoop, 14 Jan. 1946. Jung had written: 'I can only hope that no one becomes a "Jungian"… I proclaim no cut-and-dried doctrine and I abhor "blind adherents"'. (Jung, C.G., 1971, Letters, Vol. 1, RKP).

29 Stevens 1986, p.180.

30 Stevens 1986, p.178. Douglas Crosse, who for some time worked as a Trustee and Chair of the Management Committee, felt that a medically qualified director should be employed to whom Mrs Champernowne (it is interesting that the management committee always refer to her as Mrs rather than Dr) should be 'administratively and medically subordinate' (Crosse cited in Stevens 1986, p.186).

31 Eventually, the management committee prevailed and Irene was forced to resign (being given one year's notice in August 1966). She had by this time sold the property to the Trust so had lost control of it. In December 1966 those therapists who had opposed the management committee's plans were sacked. However in 1967 Withymead closed due to financial problems which were ironically exacerbated by the reduction of referrals made to it after the therapeutic establishment had got to hear about this debacle.

32 Waller 1991, p.61.

33 Waller 1991, p.72.

34 Waller 1991, p.63.

35 Other literature on Withymead includes a small number of articles by Irene Champernowne as well as leaflets and booklets on the work of the community along with local newspaper coverage.

36 Young was given a draft of Anthony Stevens' book on Withymead before its publication so he may have been influenced by this account.

37 Stevens 1986, p.36.

38 Stevens 1986, p.37.

39 McLaughlin 1988, p.226.

40 Champernowne cited in Stevens 1986, p.213.

41 McLaughlin 1988, p.226.

42 Stevens 1986, p.224.

43 Stevens 1986, p.224.

44 Stevens 1986, p.175.

45 Stevens 1986, p.110.

46 Stevens 1986, p.143.

47 Irene Champernowne was clearly ambivalent about women being intellectual. She mentions 'animus-ridden women' who are 'self-opinionated, dominant, strident, aggressive'. Since she thought that such women 'abound on the TV' perhaps she is referring to women who are merely forthright and assertive. Conversely (and tellingly about her definition of the feminine) a man 'overrun' by his feminine (anima) would be 'hysterical, petulant, childish, emotionally disturbed, moody' (interview with Firth).

48 Stevens 1986, p.24–26.

49 Samuels 1994, p.158.

50 Samuels 1994, p.163.

51 letter to Juliet Huxley cited in Young 1982, p.212.

52 letter from Dorothy Elmhirst to Irene Champernowne, cited in Young 1982, p.211.

53 1995 interview with Peter Lyle.

54 Irene Champernowne: recorded interview with Peter Firth. Irene had worked for Baynes in London prior to her move to Exeter.

55 Constance Long notes that the Swiss School advises that after an analysis the patient should remain 'in touch with his unconscious, that is, by paying attention to it and carrying on his own analysis to the best of his ability. "The real end of analysis is reached when the patient has attained adequate knowledge of the methods by which he can remain in such contact, and apply its results to his life" (Jung Analytical Psychology, p.471, cited in Long 1920, p.107). My interview with Peter Lyle confirms that this was the attitude of those at Withymead. He said that analysis was something that was regarded as important throughout one's entire life. Norah Godfrey noted that 'analysis' as a word did not convey the experience of 'on-going meditation'.

56 Interview with Peter Lyle, 1995.

57 Champernowne and Lewis 1966, p.164.

58 Champernowne 1963, p.104.

59 In addition to these events at Withymead, Irene gave lectures for the University Extra-Mural Department at Dartington Adult Education Centre in 1952 (Champernowne 1980, p.43). She was a tireless propagator of art therapy. As well as her involvement in early art therapy meetings which led to the formation of the British Association of Art Therapists she spoke at many events including conferences for occupational therapists.

60 Ulman 1963, p.93.

61 Norah Godfrey, art therapist at Withymead, kindly provided me with a description of how the concept of synchronicity was understood at Withymead. That 'people turned up at Withymead who fitted the creation of a new place of healing. This to modern ears sounds decidedly improbable, but this is only because people have lost their faith. People in "tao", "blessed" as the Bible has it, know this' (Godfrey 1996: Notes and Comments on Susan Hogan's Chapter on Withymead, p.1).

62 Interview with Norah Godfrey 1995. The salaries offered were very low.

63 Norah Godfrey: personal correspondence 31.08.95.

64 Sonu Shamdasani: personal correspondence 23.10.95.

65 Samuels 1994, p.157.

66 Norah Godfrey: interview 1995.

67 Irene and two Withymead residents (Jo Guy and Norah Godfrey) spoke about Withymead to the APC on one occasion. As well as links with the APC there were informal readings and discussions of Jung's work at Withymead. In the winter months Irene's senior psychology class for the Workers Educational Association (WEA) met in the sitting room at Withymead. Richard Fritzsche described this event as giving 'an opportunity for those undergoing analysis to view their problems more objectively' (Fritzsche: personal correspondence 28.02.96).

68 The guild described its aim in publications as 'concerned with investigating the relationship between religion and psychology in all its aspects'.

69 Peter Lyle, who was at Withymead between 1955–1963, described Gilbert as the 'grandfather figure' of the community and Ben Belton (an energetic and masculine man) as the 'father figure'. Gilbert tended to work more on the management of Withymead due to his age and invalidity (he had only one leg) (1995 interview with Peter Lyle).

70 Norah Godfrey: interview 1995.

71 Stevens 1986, p.3.

72 Norah Godfrey: personal correspondence 29.05.95.

73 Edwards: interview 1994. Ulman notes that patients included people with neurotic disturbances, depressive and obsessional states, 'hysteria' and 'milder schizophrenic conditions.' (Ulman 1963, p.92).

74 Champernowne and Lewis 1966, p.164.

75 Edwards: interview 1995.

76 There is a historical precedent for this. For example, Romantic psychiatrists such as Justinus Kerner took people into their homes, so did William James at a later date (Sonu Shamdasani: personal correspondence 23.10.95). The quakers at the York Retreat also had a system whereby patients would visit Quaker families on a regular basis, take meals with them and socialise in as normal a way as possible.

77 Diane Waller notes similarities between Withymead's structure and that of the 'therapeutic community movement.' For example, she cites 'communication and sharing of tasks, close patient–staff contact and decision-making being carried out through the staff meeting (Waller 1991, p.68).

78 Champernowne and Lewis 1966, p.163.

79 Samuels 1994, p.158.

80 McLaughlin 1988, p.226. This statement has been strongly refuted by my interviewees.

81 Champernowne and Lewis 1966, p.165.

82 David McLaughlin claims that the therapeutic community values of 'egalitarianism, permissiveness and democracy' were 'conspicuous in their absence' and that Withymead is therefore not entitled to use the term 'therapeutic community' (McLaughlin 1988, p.224). To respond specifically to McLaughlin's comments, they are contradicted by Elinor Ulman's descriptions of Withymead. It is also recorded that when Ulman invited Irene to write for the magazine she edited Irene insisted that 'the voice of painter, potter, musician and administrator must join with her own voice in dialogue to convey the feeling of life and work at Withymead'. Some kind of 'democracy' is surely implied by this attitude of 'eagerness to share openly the responsibility of authorship' which Ulman describes as 'unusual' (Ulman 1963, p.91).

 Although I am writing as someone who is sympathetic to the work of Maxwell Jones in particular, one may rightly question how 'egalitarian' many therapeutic communities actually were. Precisely what was meant by the term 'permissiveness'? After all 'permissiveness' was a justification used in some instances to allow middle–aged male psychiatrists to sleep with young, vulnerable women patients. Elaine Showalter is, for example, critical of David Cooper, who was associated with R.D. Laing's famous Kingsley Hall experiment, who 'exemplified the combination of charisma in the male therapist and infantilism in the female… Cooper seems blind to the ethical issues involved when he picks up a beautiful twenty-year-old schizophrenic Dutch woman named Marja, a mute whom he takes home, feeds and "makes love with". Here the promises of anti–psychiatry for women are pitifully betrayed…' (Showalter 1985, p.247). However, the Kingsley Hall experiment was of course by no means exemplary of the therapeutic community movement. More examples of abuse of 'permissiveness' or 'egalitarianism' are given by Jeffrey Masson (1993). If these are defining features of 'therapeutic communities' a large number of claims made about these social experiments must be called into question.

83 Champernowne and Lewis 1966, p.164.

84 Interview with Peter Lyle.

86 Champernowne and Lewis 1966, p.165.

87 Champernowne and Lewis 1966, p.166.

88 Peter Lyle recounted in interview that, with regard to intimate and sensitive material, he would first seek permission from the art therapy client prior to talking with the analyst about the disclosures made in art therapy sessions. Practices regarding confidentiality probably varied over time which may account for discrepancies in accounts of Withymead. Talking about the 1960s Irene wrote that a confidence would be held if it was of an 'embarrassingly intimate' nature and that this would 'not be betrayed even to the analyst or psychotherapist unless permission has been given' (Champernowne and Lewis 1966, p.166).

89 Peter Lyle went on to emphasise this point. He stresses that the work done in the painting and pottery studios as well as in music and dance movement (but especially painting and sculpture) was often carried out in very close conjunction with the analyst. The arts were seen as an integral part of the therapy programme: 'It was not a community where one worked solely in isolation with the analyst' (interview with Peter Lyle, 1995).

90 Champernowne and Lewis 1966, p.165.

91 E. Ulman in conversation with Withymead staff, 1966.

92 Champernowne and Lewis 1966, p.164. Again such statements would seem to contradict McLaughlin's aforementioned remarks about the low status of the art therapists.

93 Ulman 1963, p.95, drawing on extracts from informal memoranda written by members of the Withymead staff.

94 Dr Stevens: BBC broadcast on Withymead, citing Jung.

95 'The Practice of Psychotherapy' in Jung: *Collected Works*, Vol. 16, 1954, cited in Champernowne 1963, p.98.

96 Champernowne and Lewis 1966, p.6.

97 Irene Champernowne interviewed by Peter Firth, BBC c. 1975. Irene had been fairly unimpressed by her Freudian psychoanalysis at the Tavistock Clinic.

98 C.G. Jung: *The Transcendent Function* (1916), published in English in 1958.

99 Automatic writing might also be used and this was also advocated by Jung. Such techniques had been used in the 19th century by Hyppolite Taine, Myers and Janet (Shamdasani 1993, p.111).

100 Irene Champernowne: recorded interview with Peter Firth.

101 Irene Champernowne: recorded interview with Peter Firth.

102 Irene Champernowne: recorded interview with Peter Firth.

103 Joan Corrie, who was important in popularising Jung's work in the period under discussion, wrote: 'Every exaggerated quality in the conscious will be compensated for in the unconscious by its opposite.' She noted that unconscious motives frequently prompt actions that we consciously ascribe to other motives (Corrie 1927, pp.14–15). Corrie's work was known to the community. Lectures on Jung's work given at Withymead used slides of illustrations which appear in her book.

104 Long 1920, p.vi. Sonu Shamdasani has pointed out that Constance Long's descriptions of Jung's theories cannot be used as a general characterisation of them. Because she died in 1923 her work only deals with early formulations. However, hers was (along with Joan Corrie's work) the dominant early English account and taken together they 'hence reflect how Jung would have been understood' (Sonu Shamdasani: personal correspondence 23.10.95).

105 Long (1920, p.118) explains the difference between 'Jungian' and psychoanalytic perspectives. She argues that in Freud's view the unconscious knows no other aim than the fulfilment of wishes and exhibits only 'primitive tendencies', whereas Jung's idea is that *all* psychic phenomena, including the dream and the neurosis, are manifestations of psychic energy or 'libido' (which can be loosely defined as 'life force'). The unconscious is seen as providing significant information which can compensate for the 'one sidedness of consciousness' (Jung, *Transcendent Function*, p.73). Joan Corrie described libido as 'the creative principle of life animating all conscious purposes' (Corrie 1927, p.19). Certainly, Long is very critical of Freudian attempts to attach specific meanings to symbols (Long 1920, p.121).

106 The attempts of the Freudian Ernst Kris to identify different sorts of psychopathology in art is a logical extension of Freud's position and illustrates the divergent paths of psychoanalysis and Jung's analytic psychology. Joan Corrie (1927, p.ix), for example, describes the views of Freud and Jung as 'largely irreconcilable'. Although psychoanalysis and analytical psychology share in common too many basic concepts to be absolutely antithetical to each other, there are fundamental and irreconcilable differences of approach when it comes to the reception and theorisation of patient's imagery.

107 If an aspect of the personality was too neglected, Corrie explained, it could 'sink to a low level of the unconscious, to a primitive condition of culture', becoming potentially destructive in character (Corrie 1927, p.56). The recognition of unconscious mental processes and their interest to psychiatry was of course in evidence before the work of either Freud or Jung (Rycroft 1978, p. xviii in introduction to Prince, M. 1905).

108 *The Transcendent Function* 1916, p.75.

109 Long 1920, p.174.

110 Champernowne 1973, p.22.

111 *The Transcendent Function* 1916, p.87. My italics.

112 *The Transcendent Function* 1916, p.82.

113 *The Transcendent Function* 1916, pp.82–83.

114 Samuels, Shorter and Plaut 1986, p.9.

115 According to Irene this is a technique that Jung encouraged in his mature students (Champernowne 1973, p.22).

116 Jung 1964, p.136. Jung explained that the therapeutic effect of this 'is to prevent a dangerous splitting off of the unconscious processes from consciousness' which might then become symptoms. 'In contrast to objective or conscious representations, all pictorial representations of processes and effects are symbolic.'

117 Long 1920, p.120.

118 Archetypes are a sort of 'racial history' linked to our 'primitive history' and to the 'primordial images and instincts comprised in the collective unconscious' which Jung believed in (Long 1920, p.200). Corrie's description of the 'collective unconscious' goes thus: '...traces of experiences lived through ancestrally, and repeated millions of times, are imprinted in the structure of the brain, and, handed down through the centuries, reappear in dreams' (Corrie 1927, p.16). Thus, the brain of an infant is not seen as a tabula rasa, but as imprinted with 'primordial images' or 'archetypes' which evolve into myths. The 'collective unconscious' is also seen as the source of libido.

119 Kris 1953, p.15.

120 Baynes 1940, p.320. It is important to note that this was work analysed after its completion rather than a use of art as therapy.

121 Sonu Shamdasani: personal correspondence 23.10.95.

122 Henderson 1980, p.2.

123 Henderson 1980, p.2.

124 Henderson 1980, p.1.

125 Freud 1977, p.470.

126 Freud 1977, p.471.

127 Freud 1977, p.471.

128 Freud 1977, pp.471–473.

129 Samuels 1994, p.161.

130 cited by Samuels 1994, p.164.

131 A. Jaffé also asserts that Jung believed that the patient's religious attitude was relevant to their recovery. However, he does not advocate any particular form of established religion and is reported to have said, 'They would have burned me as a heretic in the Middle Ages!' (Introduction to *Memories, Dreams, Reflections*, 1961, pp.12–13.)

132 Jung 1984, p.233.

133 Jung 1984, pp.279–280.

134 Jung 1987, p.99.

135 Irene Champernowne: recorded interview with Peter Firth, 1975.

136 Champernowne, quoting Graham Greene, 1963, p.99.

137 Young 1982, p.211.

138 Norah Godfrey: interview 1995.

139 Godfrey 1968: 'Art Therapy' (unpublished paper).

140 Fritzsche 1964: unpublished paper.

141 Fritzsche 28.02.96. Some church going took place later on in Withymead's development with Sunday visits to a village church. At Christmas visits were made to Buckfast Abbey or to Exeter Cathedral.

142 Michael Edwards: interview 1995.

143 Fritzsche: personal correspondence 28.02.96.

144 Douglas 1994, pp.23–24.

145 The term 'projection' is literally a 'throwing in front of oneself'. In this concept it means 'viewing a mental image as object reality' (Rycroft 1968, p.125).) .

146 Rowe (1993, pp.13–16).

147 Art therapists at Withymead understood that Jung had taught that the therapist must be as open to change as the patient (Fritzsche: personal correspondence 28.02.96).

148 For example, the community was overtly homophobic. Homosexual and lesbian relationships were seen as giving grounds for concern rather than as an expression of individual choice and inclination (Champernowne and Lewis 1966, p.166).

149 Edwards: interview 1995. Challenging Jung's ideas would not have been acceptable.

150 Stevens 1986, p.229.

151 Peter Lyle has suggested to me that the studio may have been considered to have been the wrong environment for such a discussion which would have been seen as more appropriate in the analytic session (personal correspondence with Peter Lyle 1996).

152 1995 interview with Cracknell. This attitude is confirmed by Richard Fritzsche who wrote: 'Those of us who had discovered so much meaning and truth from Jung were keen to pass it on' (Fritzsche: personal correspondence 28.02.96).

153 Lyle: interview 1995.

154 Champernowne and Lewis 1966, p.166.

155 Champernowne and Lewis 1966, p.167.

156 Godfrey: interview 1995.

157 Jung: *Collected Works* (1930),Vol. 16, p.82f, cited in Champernowne and Lewis 1966, p.173.

158 If further justification is needed for Withymead's use of the term 'therapeutic community', then a
 striking parallel can be noted between this case and that of Mary Barnes. Mary regressed in the
 Kingsley Hall therapeutic community experiment some years later, though unlike the Withymead
 example (Champernowne and Lewis 1966, p.175) she was able to play, sculpt and paint with her
 own excrement (Showalter 1985, p.232).

159 Champernowne and Lewis 1966, p.175.

160 Champernowne: letter to Douglas Crosse, Chairperson of the Management Committee, cited in
 Stevens 1986, pp.181–182.

161 Douglas 1996, p.45.

162 Belton: personal correspondence 1995.

163 Personal correspondence with Norah Godfrey and Richard Fritzsche 28.02.96.

164 Peter Lyle: interview 1995.

165 He worked in both art studios as a patient and also engaged in Laban dance therapy offered at
 Withymead, as well as being a part of the 'men's working squad' and taking part in other community
 activities. Peter later became a member of staff working in both the pottery and painting studios.) .

166 Personal correspondence with Peter Lyle, July 1996.

167 Interviews with Lyle, Richard Fritzsche and Norah Godfrey.

168 Personal correspondence with Richard Fritzsche, 23.01.96.

169 Personal correspondence with Richard Fritzsche, 23.01.96.

170 Michael Edwards: interview 1994.

171 Waller 1991, p.85.

172 Norah Godfrey: personal correspondence 28.02.96.

173 Waller 1991, p.85.

174 Rupert Cracknell: interview 1995.

175 Waller 1991, p.83. This information comes from Waller's text but there is no mention of Webb's
 appointment or work at Napsbury in the hospital records, so this remains something of a mystery.

176 Stevens 1986, p.4.

177 Norah Godfrey interview, 1995.

178 Richard Fritzsche: personal correspondence 28.02.96.

179 Stevens 1986, p.4.

180 This view was shared by Richard Fritzsche in the pottery. He felt that the presence of the art therapist
 was 'therapeutic' in giving a sense of security to residents (Fritzsche: personal correspondence
 28.02.96).) .

181 Michael Edwards: interview 1995.

182 Champernowne 1963, p.99. Italics added.

183 Fritzsche: interview 1995.

184 letter to Margaret Isherwood 1952 cited in Young 1982, p.213.

185 Champernowne 1980, p.5.

186 Champernowne 1980, p.14.

187 Stevens 1986, pp.4–5.

188 Michael Edwards: interview 1995.

189 Norah Godfrey: unpublished paper 'Scope of the Work in the Painting Room at Withymead'.

190 Elizabeth Colyer and Euanie Tippett were noted as spending much of their time in the art studio
 prior to their taking on the role of art therapist.

191 Irene Champernowne was described as a regular studio user 'painting external subjects as well as
 visionary experiences' (Richard Fritzsche: personal correspondence 28.02.96).) .

192 Champernowne and Lewis 1966, p.172.

193 Peter Lyle: interview 1995.

194 Champernowne 1980, p.18 describing her experience of 1951.

195 Champernowne describes the studios as they were in 1951, 'The pottery room with its creations and
 Jo, always so valiant with Winifred besides her, creating beauty. The painting room has peace and
 sincerity filled by Norah's insight…' (Champernowne 1980, p.20).

196 Michael Edwards: interview 1995.

197 Cunningham Dax: BCR Oct. 1948, No. 3, p.11.

198 Champernowne 1963, p.97.

199 Champernowne 1963, p.98.

200 Wolff 1951 cited in Champernowne 1980, p.19.

201 Champernowne 1980, p.42.

202 Letter from Wolff, 14 June 1952, cited in Champernowne 1980, p.45.

203 C.G. Jung, *The Practice of Psychotherapy*, cited in Champernowne 1963, p.99.

204 Norah Godfrey: undated unpublished paper supplied by author.

205 Godfrey: interview 1995.

206 Also because, as Michael Edwards put it, Irene had a 'quaint idea that men were better at working with clay and the women with painting'. However, this gender divide was certainly not evident in the first fifteen years or so of Withymead's existence. Richard Fritzsche asserted: 'There was no discrimination between men and women apart from the fact that under Ben there was a building squad when the men worked together on structural enterprises. Even then, occasionally a woman would also take part'. Personal correspondence 28.02.96.

207 Richard Fritzsche, personal correspondence 28.02.96. This contradicts Diane Waller's account which assumes a gender divide with men working in pottery and women in painting.

208 Peter Lyle: interview 1995.

209 Belton: personal correspondence 1995.

210 Norah Godfrey: BCR Conference Report, 1949, p.16.

211 Peter Lyle: interview 1995. Lyle worked in both art studios as a patient who also engaged in Laban dance therapy offered at Withymead, as well as being part of the 'working men's squad' and taking part in other community activities. Peter later became a member of staff working in both the pottery and art studios.

212 Norah Godfrey: interview 1995.

213 Norah Godfrey: BCR Council Report 1949, p.16.

214 Stevens 1986, p.134.

215 Peter Lyle: interview 1995.

216 Norah Godfrey: interview 1995.

217 Norah Godfrey: BCR Conference Report 1949, p.17.

218 Michael Edwards: interview 1995.

219 Peter Lyle: personal correspondence, July 1996.

220 Michael Edwards: interview 1994.

221 For example, Peter Lyle joined the community as a 'resident patient' in February 1955 before becoming a member of staff in the spring of 1959. He remained on the staff team for a further four years before leaving in May 1963. Some adolescent patients who left and took up employment in nearby Exeter continued to visit the centre indicating that Withymead was essentially a home rather than a hospital (Ulman 1963, p.93).

222 Michael Edwards: interview 1995.

223 Fritzsche 28.02.96.

224 Peter Lyle: interview 1995.

225 Belton: personal correspondence 1995.

226 Norah Godfrey: interview 1995.

227 Michael Edwards: interview with Susan Hogan 1995.

228 Michael Edwards stressed that whenever an art work was brought in to a meeting or discussed, everyone would pay attention. He described it as the exact opposite of his later experience of working on clinical teams where art therapy is relegated to an inferior position (1995 interview).

229 Edwards: interview 1995.

230 Champernowne: BCR Conference Report 1949, p.14.

231 Norah Godfrey: interview 1995.

232 Godfrey: BCR Conference Report 1949, p. 17.

233 Godfrey: interview 1995.

234 Champernowne talking to Peter Firth: recorded interview 1975.

235 Champernowne 1963, pp.102–103.

236 Peter Lyle: interview 1995.

237 Champernowne 1963, p.99. Stevens' (1986) account of this picture is incorrect. Irene elaborated on its making some years later. She wrote that the boy *was* the sinking ship. As the boy painted the picture, he began to realise more about his depression and saw that he 'must put out life boats and somehow rescue values within himself' (Champernowne 1974, p.22). The mention of life boats was an appeal to the boy's resources but they were never painted as Stevens suggests.

238 Champernowne: BCR Conference Report 1949, p.14.

239 Peter Lyle: interview 1995.

240 Peter Lyle: interview 1995.

241 Norah Godfrey: interview 1995.

242 Fritzsche: 'A Series of Pictures Illustrating an Analytic Experience', 1964. (Unpublished paper supplied by author.) This series of images (of which this is one) was actually drawn before the formation of Withymead in 1939. However, they were shown to patients at Withymead and served as a strong indication of what might be produced in art therapy.

243 Peter Lyle has emphasised that interpretations of images have 'no value for the healing process' if they are not 'endorsed' by the patient. The imposition of an interpretation, however 'scholarly', may have a very detrimental effect. He wrote: 'Moreover, an interpretation may be correct in some measure but untimely (or insensitively handled) to the extent that the patient can not take it "on board" or accept it, either consciously or even subconsciously. Therefore, the only valid interpretation … will be one that genuinely furthers the healing process' (personal correspondence with Peter Lyle, July 1996).

244 I have already emphasised the spiritual dimension to the work of Withymead. This is also true of the work of the studios. The patient's art work was seen as evincing unconscious processes which were viewed as 'undeniably religious'. Fritzsche wrote: 'Not to recognise the spiritual source of such [picture] contents means faulty treatment and failure' (Fritzsche 28.02.96).

245 Edwards: interview 1995.

246 Godfrey: interview 1995.

247 Godfrey: 'The Scope of the Work in the Painting Room at Withymead' (unpublished paper).

248 Ulman in conversation with Withymead staff, 1963, p.107. Richard Fritzsche noted that for many people such sessions were 'inspiring' and 'releasing' (personal correspondence 28.02.96).

249 Tippett in conversation with Ulman, 1963, p.106.

250 Champernowne in conversation with Ulman, 1963, p.109.

251 Champernowne in conversation with Ulman, 1963, p.108.

252 Kemp in conversation with Ulman, 1963, p.109.

253 Guy: BCR Conference Report 1949, p.15.

254 Peter Lyle: interview 1995.

255 Peter Lyle explained that sometimes even in-depth analysis might be considered inappropriate for a very fragile individual who was too preoccupied with their unconscious. (Lyle: interview 1995).

256 Richard Fritzsche: personal correspondence 26.02.96.

257 Champernowne 1963, p.104. Italics added.

258 Champernowne in conversation with Ulman, 1963, p.112.

259 Champernowne in conversation with Ulman, 1963, p.110.

260 Champernowne in conversation with Ulman, 1963, p.111.

261 Godfrey: BCR Conference Report 1948, p.17.

262 Godfrey: interview 1995.

263 Champernowne in conversation with Ulman, 1963.

264 Edwards in interview with Susan Hogan 1995.

265 Godfrey: interview 1995.

266 Champernowne: BCR Conference Report 1949, p.14.

267 Godfrey: 'Art Therapy' (unpublished paper) 1968.

268 Edwards: interview 1995.

269 Champernowne in conversation with Ulman, 1963, p.106.

270 Godfrey: interview 1995.

271 Samuels, Shorter and Plaut 1986, pp.151–152.

272 These types are distinguished in terms of their libido, or psychic energy, or interest. In the extrovert libido flows outwards towards people, objects and events. The introvert is more concerned with subjectivity (Corrie 1927, p.33).

273 Norah Godfrey's definition is used, rather than modern texts, because as a long-time member of staff her understanding of these terms is an accurate reflection of how they were understood at Withymead. I have also used Corrie's work which, as I have noted, was known to Withymead.

274 Samuels et al. 1986, pp.151–152.

275 Stevens 1986, p.127.

276 Richard Fritzsche: personal correspondence 28.02.96.

Branch Street and Other Projects

Following the detailed exploration of Jungian art therapy presented in the previous chapter, I shall now explore general beliefs about the arts in greater detail. Francis Reitman's earlier reference to art therapy as occupational therapy at the *higher level* reflects the idea that the fine arts reach and enliven the more refined, subtle and sophisticated sensitivities of human beings; that somehow this process of elevated experience can be precipitated simply by engaging with, or attempting to make, certain art forms rather than others (i.e. the fine arts rather than the crafts). Such an attitude was also evident within the history of moral treatment as I have illustrated. These ideas were propounded quite unselfconsciously during this period by arts policy makers and the first generation of art therapists and their adherents.

It is worth noting that the arts took on a certain significance during the Second World War period. Professor Marwick said of the period that Hitler was seen as an 'obscurantist barbarian' and that 'the arts, as well as social welfare and economic democracy, came to symbolise the antithesis of Hitlerism'.[1] Indeed, the Committee for the Encouragement of Music and the Arts (CEMA), later the Arts Council of Great Britain (ACGB), was set up during the war to provide arts all over Britain and it was directly involved in the provision of mobile companies taking music and drama around the country.[2] Essentially CEMA was a wartime measure intended to boost morale, and it took on central control of cultural policy and administration.[3] CEMA also funded the British Institute of Adult Education (BIAE)'s 'art for the people' scheme, enabling BIAE to increase its number of touring exhibitions. In total CEMA and BIAE together exhibited in 208 established galleries and 522 other places.[4]

Art therapy emerged as a profession during this post-war period in which there was heightened support for the arts and a frankly romantic prevailing

sentiment about them. This, coupled with fears of *l'art officiel*, resulted in an emphasis on individual self-expression. Tom Jones of CEMA had a romantic definition of the artist:

> The artist walks where the breath of the spirit blows him. He cannot be told his direction; he does not know himself but leads us into fresh pastures and teaches us to love and so enjoy what we often begin by rejecting, enlarging our sensibility and purifying our instincts.[5]

These sorts of sentiments are evident in the writings of early art therapists. For example, such an attitude is discernible in Edward Adamson's approach, when he describes his work as a 'form of concurrent therapy' and as *going beyond* art as a 'diversion' or as an 'occupational therapy' to produce a 'unique contribution to the establishment of mental health'.[6] There is also an underlying pseudo-religiosity in the statements made by art therapists about clients 'pouring out their souls' or reaching a spiritual dimension to their lives through art practice. This is most evident in the writing of Jungian art therapists but it is also evident to a greater or lesser extent in much early art therapy writing.

A rather different attitude was propounded by the 'psychopathological school' and it is noteworthy that the report of the first meeting of the British Association of Art Therapists mentions that the organisation had been recognised by the 'International Institute of Psychopathological Art'. I have illustrated how modern art became conflated with ideas of degeneration and primitivism. However, primitivism was to have positive as well as negative connotations, conjuring up images of uncorrupted and 'natural' peoples living in harmony; in other words, idealised notions of so-called primitive society. These rather different discourses met within 'art therapy' with different kinds of appeals being made by different practitioners. The idea, promoted by writers such as Herbert Read, that all art was prompted by the workings of the unconscious was also beginning to take root.

This chapter will examine work conducted in the period in which the first art therapy posts were established. I shall present work done by those who believed in the civilising influence and therapeutic value of the arts. In particular I shall examine ideas about the arts expounded by educators who moved into the therapeutic arena. First, I will present an account of the work of a teacher, Marie Paneth, in London. Paneth's work inspired Ruth and David Wills, amongst others, who were the first art therapists to work in Scotland

(or at least the first to see themselves as art therapists). Ruth and David Wills used art therapy in a school which was run on progressive principles.

Art therapy work with delinquents

A little-known text which was to influence several art therapists was Marie Paneth's *Branch Street: A Sociological Survey* (1944). (Michael Edwards told me in interview that this text in particular influenced him.) The book is a fascinating account of Paneth's attempts to build a rapport with the Branch Street 'hooligans' during the Second World War period. Paneth, an Austrian 'alien' of independent means, had started her career with children working in the deep air-raid shelters of the East End in London. These shelters were used as dormitories by a large proportion of the population in an area of London which was badly bombed. Paneth, along with conscientious objectors, 'kept the children busy during the long blackout evenings'.[7]

Paneth started work at Branch Street, a deprived area of London, in 1940. She used an air-raid shelter which was no longer in use by the street's inhabitants, and then a condemned house given over to the project by the borough council. Paneth's use of the word 'hooligans' does not appear to have been an exaggeration. The following is a description of her first art session in the shelter:

> I spread out my material under a chaotic tumult. But after a while every child had what they wanted and there was a normal atmosphere of enjoyment of the work... But only too soon the bigger ones started using the painting materials as projectiles with which to shoot at the rest of us, and a battle of quite considerable dimensions started, accompanied by hooliganism and diabolic shouting. They tore pieces of canvas from the bunks and the capok out of the cushions. They produced pieces of wood and cardboard, and these and most of the material which I had bought into the shelter flew into the air. They upset the water jars. They climbed onto the top of the bunks and shot at us with all sorts of things, and at the few small ones who still sat at the tables, trying to paint in this turmoil. Dirty, wet canvas was slung into our faces when we passed them, they spat at us and tried to hurt us and showered gross indecencies at us with wild laughter. There was no stopping them. Some of the grown-ups tried, but it was no use. The men pushed some of them out by the front door, but they returned by some of the other entrances which they had forced...[8]

This would have put most people off, but Paneth's tenacity was amazing. Although Paneth did not use the term 'art therapy' she had developed a method of using art with 'difficult' East End groups in the shelters with much success. She described her approach:

> My method had been to bring the children paints, pencils, brushes, chalks, paper of different kinds, and crayons. These things I spread out near the entrance of the play room in a sort of buffet and left them to make their own choice of the material, to find themselves a space where they could work and to draw or paint or smudge whatever they liked. I never interfered with their work, except that I met every attempt to produce anything at all with approval. The only thing which was not permitted was the destruction of any work but one's own. Disturbances in the room in the way of fights, rowdiness or shouting I never tried to cope with. This made for very noisy working conditions at the beginning of each session, but in the course of an evening the children settled down astonishingly well. It is quite possible in this way for one person to deal with large numbers (50 to 60) in an absolutely free atmosphere. As this method had been a success with these groups, I had been asked to try it with the children from Branch Street.[9]

Despite Paneth's earlier successes in the East End she was unable to convince the management committee of the Branch Street Play Centre, as the house became known, to allow the children to manage the house themselves. Self-management, she felt, would develop the children's own sense of responsibility and engender the feeling in them that the house was theirs, run by them, and 'standing under their protection'.[10] Only such an approach, she believed, would be able to stem the constant vandalism, theft and burglaries they endured. She saw her inability to convince the committee of this way of working as responsible for the eventual downfall of the project though the 'experiment' itself is of considerable interest.

Paneth's account records her permissive attitude in the art room. On one occasion, as a provocation, a group of children started to paint on the windows. She did not try to stop them and they persisted in this activity for a few weeks. She wrote:

> I found that by permitting them to do these otherwise forbidden things, I created in the children a mixture of disrespect mingled with astonishment. They were not grateful for being allowed to misbehave. I had the impression that they felt relieved, but at the same time uncomfortable.[11]

In spite of Paneth's persistence and perseverance, along with the dogged support of a local voluntary organisation and several conscientious objectors, the work was rough going. The project and the staff experienced some success followed by rebellion. On several occasions the safety of staff came under threat. Paneth described one of many such incidents:

> They came down to the shelter prepared to 'give us Hell'. They announced this intention beforehand among their friends and they 'jolly well succeeded'. They found me alone... They trampled and shouted and stamped on the tables and broke them and screamed indecencies. For the first time I lost my temper with them, and shouted 'Get out!'
>
> They were so astonished that they flew out like birds and in a few seconds the shelter was empty. When I came out I found them waiting for me. They had joined up with a troop of boys and threw stones and pieces of wood at me. They surrounded me and lifted my skirts. I managed to get to the main road before I was badly hurt. When the children saw a policeman coming along they dispersed and were gone in a second.[12]

This incident led to increased security measures: '...we had made it a rule to leave the street in a body after our work. It was a safety measure which we thought it best to take...'[13] This group retreat entailed staff waiting together at the bus stop until those who were getting the bus were safely aboard. Then the remainder of staff made their way to the underground station together. However, on one occasion a member of staff broke the rule because of the bad weather, and went to the station without other members of staff. There she was sexually harassed by a group of the older boys and she promptly resigned after this incident.[14] Shortly after this event, the house was wrecked beyond repair, and shut down.

Amongst those who were influenced by Paneth's work were Ruth and David Wills. David Wills, who had previously worked in a children's borstal, first became involved in progressive education in 1936. Early in 1935 *The Friend*, the magazine produced by the Society of Friends (Quakers – a Christian religious denomination), published an article on young offenders by Dr Marjorie Franklin. Shortly afterwards, Franklin convened a small group, which they named the Quaker Camps Committee. The committee was set up with the aim of

> training in a free environment, on sympathetic and individual lines, young people who – mainly through environmental causes – present dif-

ficulties in social adjustment or have been in unfortunate circumstances (whether or not they are actually lawbreakers).[15]

After the evacuation of London Wills worked for this project. The Hawkspur Camp was opened in England in May 1936.

It was during his involvement with the camp that David Wills first came across the work of Arthur Segal, a Romanian refugee, who had started a studio in England's Lane, Hampstead, shortly after his arrival in Britain in 1936. There Segal taught painting, believing that it was therapeutic. His aim was to bring together patients, doctors and artists in his art classes. (Segal's art school receives further mention in the chapter on Withymead. However, Segal did not regard himself as an art therapist though he had patients and well people working together in his studio. There is a description of his particular approach in my discussion of the work of Elsie Davies.)

One of the psychiatrists connected with the Hawkspur Camp, Dr Helen Frank (who was herself seeing Segal on a weekly basis), referred one of the Hawkspur boys to see Segal, knowing that he was keen to treat various kinds of neuroses. After an assessment session with the boy, Segal proclaimed, 'Not only is this boy going to be helped in himself by painting; if you can improve his general education he may become a painter'.[16] David Wills became intrigued by Segal's methods because after only four months the boy in question 'was a different person... There was a different look in his eye, there was purpose in his movements,' he observed.[17]

At Hawkspur the autonomy of the children was emphasised. The Camp Council, the body developed for decision-making, was run by the boys with the aim of developing in them 'the capacity for personal judgment'.[18] Wills was also aware of other experiments in education such as A.S. Neill's Summerhill, a self-governing school.

During the evacuation of London Segal moved his art school to Theobalds Row, Oxford, and Wills, as a conscientious objector, relocated with the Hawkspur group to Bicester, where he and his wife Ruth stayed for six months. On their day off Ruth and David Wills visited the Segal studio, and under his guidance both learnt to paint. They were surprised how quickly they were able to develop skills in painting after only half-a-dozen lessons. Ruth continued to paint though David stopped soon after their move away from Segal. However, this experience convinced them both that 'The principal qualifications [to teach art] are enthusiasm and the conviction that there is no one who cannot learn' – presumably the qualities that Segal himself brought to bear on his work.[19] The experience of working with Segal

also convinced them, beyond doubt, that painting was 'in itself' therapeutic for people suffering from emotional disturbance.[20]

After their stint in Bicester Ruth and David Wills moved to Peebles in Scotland. They may therefore be regarded as the first art therapists working intentionally and self-consciously as art therapists in Scotland. The project for which they went to work was called Barns House, a residential scheme housing thirty 'maladjusted' boys, who were referred to at the time as 'unbilletable evacuees' from Edinburgh.[21] The project as a whole sounds like a more successful version of Paneth's Branch Street. Wills arrived

> eager to get them all painting 'à la Segal' and as Ruth lacked confidence enough to do it (though she was always much better than I), I had to do it myself. Like Segal I started them all with a pot of some kind in front of a tray or piece of cloth, and when Ruth saw what a hash I made of it she eventually, to my great relief, took over.[22]

Barns House was established in 1937 as a community which worked with an ethos of shared responsibility and self-government. It was established by the Quakers with financial assistance from the Edinburgh Corporation and Peebleshire County Council.[23]

Whilst Wills worked using confidential counselling sessions with the boys and acknowledges 'transference' in his dealings with them, he was very clear that he did not regard himself as either a psychoanalyst or a psychotherapist.[24] Wills practised a technique of offering unconditional acceptance of whatever the boys chose to confide in him. He did not indulge, in his words, in 'talking a lot of psychological clap-trap (such a temptation to the amateur psychologist!)' which he felt could be positively harmful.[25] He wrote:

> I should not for one moment like it to be thought that I regarded myself as a psychoanalyst, or as any other kind of psychotherapist. I depreciate most strongly any attempt by laymen to tinker about with the child's mind and my experience has been that those who know least about it are the most confident in setting themselves up as amateur psychotherapists.[26]

Indeed, as a committed Christian and Quaker, it was above all 'love' that Wills regarded as healing. The Quaker emphasis, 'That of God in every man', was a 'mainspring' of the work at Barns. Wills' belief that 'God is love' led him to argue that the boys 'must be loved in order that they may learn to love. That is not only Christian teaching, it is sound modern psychology,' he wrote.[27] For this reason he was resolutely opposed to corporal punishment.

Indeed, he felt that pacifism was not merely a reluctance to be a soldier but is 'an attitude to life' and one which he tried to inculcate in his charges.[28]

The art studio, run mainly by Ruth, offered three types of painting activity. The first was 'imaginative' painting using watercolours. Pots of paint were arranged in the middle of tables, and those who wished to paint were given a brush and paper and encouraged to go ahead. David Wills noted that the approach used was much the same method as used by Marie Paneth.[29] He wrote:

> It did seem to us that imaginative painting with water colours would provide greater cathartic opportunities... There was no instruction, no guidance, all suggestions about what to paint were firmly withheld. And there were some fascinating results aesthetically as well as therapeutically.[30]

Wills was amazed by the enthusiasm and energy that children were able to put into this occupation. He noted that a large number of the painters

> carry out a running commentary on their work all the time that they are at it. 'This is a giant and he's got a big stick...' Half a dozen boys might be chattering away like this, quite oblivious to everything and everyone except the world they are creating. It is fascinating to watch the imagination growing; or to be more accurate, to watch the boys overcome their fear of giving it free expression.[31]

Wills thought that this type of free painting illustrated to what degree emotional conflicts were being resolved, as well as providing a useful means of catharsis.[32] He would often observe a change in the boys' paintings. In his book on Barns he gives many examples, including one boy whose works contained an

> indescribable jumble of crosses, knives, daggers, explosions, bombs, aeroplanes, all in the most lurid or the most sickly of colours. Week after week these dreadful monstrosities were produced but very slowly, as Ginger began to get rid of some of his resentment – in paint and in other ways provided at Barns – his paintings gradually began to be slightly more coherent in design and less horrific in content.[33]

Another technique used in art therapy at Barns was self-portraiture. No matter how unlike the boy who painted the self-portrait in terms of physical likeness, the portrait always indicated 'the salient features of his character, or of his mood at that time', Wills asserted.[34]

The third technique used was oil painting. Wills felt that this was particularly useful to children in need of discipline and noted that some children who were not good at watercolours could excel in oil painting.[35]

The role of the art therapist (usually Ruth) was to create an atmosphere of freedom in the art room (within certain limits). Unlike Paneth, Ruth and David would not tolerate fighting or the application of paint to surfaces other than the paper. Technical advice might be given but the art therapist was never to succumb to a request from a child asking what he should paint.[36] This freedom coupled with enthusiasm and praise was considered sufficient. Although aware of the work of Cizek (who is supposed to have coined the term 'child art') he explicitly rejected Cizek's technique (described by his biographer Viola) of telling the children a story and then asking them to paint it. Of this approach he said: 'I have not yet found this to have valuable results'.[37] They were convinced that such a structured approach was not necessary:

> Any young child, unless discouraged by stupid adult teaching, can express himself in paint. But it must be borne in mind that young children's drawings are entirely different from those of older children or adults, and are to be judged by entirely different standards. A child will be perfectly satisfied with something that may look to you or me like nothing on earth.[38]

He explained that this was because

> the child does not yet very clearly distinguish between what he has put on paper and what he sees in his mind's eye. When he looks at the paper he is also looking at the mental picture he has formed and I expect that, taken together, they make a very significant sight.[39]

Therefore, Wills was against the idea of attempting to teach the children.

After the close of the Second World War Wills moved to Woodbrooke, the Quaker College in Birmingham, where he worked for a year as a research fellow. During his year at Woodbrooke he was invited by Elizabeth Colyer to give a lecture at a local chest hospital where she was working as an occupational therapist. She took great interest in Wills' account of his work at Barns. Ruth meanwhile conducted further study with the Segal school which had moved back to London by this time. Ruth Wills, after her year with Segal, was invited by Elizabeth Colyer to 'do art' with her patients, and as a result of this work a full-time appointment was made of a 'Segal–trained' art therapist to the hospital.

Ruth and David Wills went on to work with children at Bodenham Manor, a school for 'maladjusted' children. There Ruth took over responsibility for art activities until her untimely death in 1956. Some years later (in 1960) David married Elizabeth Colyer. Elizabeth was by this time working as an art therapist at the Withymead Centre.[40]

Another pioneer art therapist who started her career in educational settings was Diana Halliday. She was educated at the Lycée Francais de Londres in the 1930s where she took her baccalaureate. After attending the Cola Rossi in Paris and the Central School of Art in London (studying graphics and textiles) she trained as a teacher at London University. At this time she knew no one practising as an art therapist but 'discovered' art therapy whilst working with children as an art teacher.[41] In 1940 she married and moved to Canada and then to New York where she stayed to 1956. In the USA she met Edith Kramer and Margaret Naumberg, two important pioneers of art therapy there. She developed a close friendship with Naumberg in particular, whom she described as 'lovely' but 'rather self-important', though she did not adopt Naumberg's approach to art therapy.[42] However, she did enter into a Freudian analysis, abandoning this in favour of a Jungian analysis.

On her return to Britain in the late 1950s Halliday worked in a number of educational settings including an appointment at Barnardo's. She regarded drawing and painting as a 'natural and spontaneous' activity. She wrote in 1961:

> Skill comes with time and a little discreet guidance. With enjoyment comes self-confidence and from the visible results…a wonderful sense of fulfilment. Dreams and fantasies, feelings, both good and bad, needs and longings can be translated into paint and clay.[43]

It was around this time that she started to meet other British art therapists including Mary Webb at Napsbury, Irene Champernowne at Withymead, and Edward Adamson at Netherne, with whom she has a particular rapport.[44] Like Adamson, Halliday did not interpret the imagery of the clients she worked with. During the 1960s and 1970s Diana worked with children as an art therapist but was employed with the job title 'child psychotherapist'.[45]

Conclusion

In this chapter I have briefly surveyed attempts to use art therapy in libertarian educational projects. I have looked in detail at Marie Paneth's

work because she had a direct influence on three important art therapy pioneers (Michael Edwards, Ruth Wills and David Wills). In Paneth's work, and even more so in that of David and Ruth Wills, there was an endeavour to empower the children by letting them control the environment they inhabited. The emphasis of these projects was on trying to engender a sense of autonomy and personal responsibility in the children. Ruth and David Wills therefore did not attempt to try to teach the children in their charge, but gave them the opportunity for imaginative self-expression through art-making. They found that this technique provided both opportunities for the cathartic release of emotions and for the exploration of personal problems.

Notes

1 Marwick 1968, p.298.
2 The ACGB has had another recent name change and has now split off into regional organisations for Scotland, Wales and England.
3 The wartime provision of exhibitions by CEMA was described as illustrating that the 'faith in the creative joy-giving spirit in man is every bit as real as the destructive' (*The Times*: 'Art and War', 26 Feb 1942).
4 Arts Council of Great Britain, 11th Annual Report.
5 Jones cited in Donoghue 1983, p.81.
6 Adamson 1990, pp.152–153.
7 Paneth 1944, p.11.
8 Paneth 1944, p.12.
9 Paneth 1944, pp.9–10.
10 Paneth 1944, p.98.
11 Paneth 1944, p.60.
12 Paneth 1944, p.56.
13 Paneth 1944, p.96.
14 Paneth 1944, p.96.
15 Wills 1941, p.9.
16 Wills 1941, p.28.
17 Wills 1941, p.28.
18 Wills 1941, pp.57–60.
19 Wills 1945, p.95.
20 Wills *Inscape* Vol. 1, No. 7, p.11. Segal also promoted this idea to the medical profession with a 'psychiatrist's night' which was well attended by Harley Street practitioners and members of the psychoanalytic association.
21 Wills *Inscape* Vol. 1, No. 7, p.12.
22 Wills *Inscape* Vol. 1, No. 7, p.12.
23 Unlike Paneth, Wills was *in loco parentis* and had a statutory obligation to ensure that the boys attended school. Therefore, the self-government by the pupils of their activities had some limitations, but the school was brought in line with the house in 1942 (Wills 1945, p.103).
24 Wills 1945, p.69.
25 Wills 1945, p.21.
26 Wills 1945, p.79.
27 Wills 1945, p.81.

28 Wills 1945, p.103. In front of a tribunal Wills was asked whether he taught pacifism to the boys at Barns. He wrote: 'My reply was that I hoped so, and as I watched the several eyebrows of the tribunal rising in unison I explained that...I hoped the boys would in time tend towards that religion as a result of having seen it in action...' (Wills 1945, p.84).
29 Wills 1945, p.91.
30 Wills *Inscape* Vol. 1, No. 7, p.14.
31 Wills 1945, p.90.
32 Wills 1945, p.92.
33 Wills 1945, p.92.
34 Wills 1945, p.95.
35 Wills 1945, p.95.
36 Wills 1945, p.93.
37 Wills 1945, p.96.
38 Wills 1945, p.93.
39 Wills 1945, p.93.
40 Wills: *Inscape* Vol. 1, No. 7, p.14.
41 Halliday in interview with Susan Hogan 1996.
42 Halliday in interview with Susan Hogan 1996.
43 Raphael (her married name) 1961, p.553.
44 Halliday in interview with Susan Hogan 1996.
45 *Curriculum vitae* supplied by D. Halliday.

The Historical Roots Revisited
A Conclusion

In the introduction to this text I discussed what art therapy is, in terms of it constituting a range of practices, and I attempted to explore some of the problematic assumptions underlying it. I noted that art therapy practices are fraught with philosophical difficulty and involve art therapists in making decisions about issues of power and control in assessing what is normal and abnormal behaviour, and interpreting their clients' demeanour. (That the interpretation of cultural and gender norms play an important part in such subjective assessments is undeniable.) In this history I have been able to discern far-reaching differences in attitude among practitioners about the role of the art therapist, differences which are irreconcilably opposed to one another. In particular, attitudes towards the question of interpretation of clients' art work by the art therapist are a good indicator of the therapists' theoretical position.

It has been noted that the art therapy agenda may or may not be discussed with patients, that it may be the result of institutional norms, or a reflection of the particular theoretical persuasion of the art therapist. Different structures (one-to-one, small group, open studio, therapeutic community), which may be the therapists' preference or prescribed by the institution, can also have an influence on the art therapy experience. Whilst some art therapy patients may themselves have a very clear idea about what they wish to explore in art therapy, others may not be at all clear as to what they want to get out of art therapy, or indeed why they have been referred.

Some art therapists use psychological paradigms as a basis for their work (Freudian, Kleinian and so forth) and conceptualise the art therapy encounter within the terms of these theoretical frameworks, which may or may not be explained to, or explored with, the patient. I observed that the imposition of fixed theoretical frameworks in this manner is potentially undermining to

patients and can result in the production of dogmatic interpretation of their art work by the therapist. I am not suggesting that all art therapy which employs psychoanalytic concepts is necessarily abusive, but that it is the extent to which the client is interested in, and enthusiastic about, an exploration employing such theory which is a significant factor. Also relevant is whether the theories are used in a critical or uncritical manner. (See Hogan 1997 for a feminist critique of some psychoanalytic approaches.) Examples have been given in the text of therapists (mainly analysts and psychologists using art, some of whom employed the term 'art therapy') furnishing interpretations in a reductive manner which is potentially abusive or disempowering. The introduction emphasised that issues of control and power should be central to debate about art therapy.

Chapter Two, 'Taming the Passions: Moral Contagion, the Curative and Transformative Power of the Arts in Moral Treatment', surveyed the development of the 'moral treatment' method, which arose in a non-orthodox religious context, from the end of the eighteenth century and examined the use of the arts as part of this method in Britain. I asserted that this is a subject that has been largely overlooked by historians. The chapter began with an examination of morality as a system of rules defined by culture. It suggested that psychotherapy is concerned with the same terrain: the internalisation and assimilation of cultural rules, an idea implicit in group therapy.

The chapter argued that the moral approach functioned as an early form of behavioural therapy, modifying techniques developed in religious cults and moving away from an emphasis on physical causes of, and cures for, insanity. There was a particular emphasis on self-restraint in this approach. This chapter presented some dominant ideas associated with moral treatment, including the idea of the authority of the physician, the subjugation of the 'mad' subject, and Foucault's idea of 'abasement', which is the idea that in order to be cured the insane person must recognise themselves as mad. I also suggested that there are links to be made between the notion of 'abasement', the psychiatric photography of the nineteenth century, and modern art therapists' insistence that the art object reflects back the clients' condition to them: it is only through recognition of their frame of mind that the art therapy client can hope to recover. I have suggested that there is a fundamental similarity between Foucault's concept of 'abasement' and twentieth-century art therapists' often stated belief that the art work can function as a 'mirror'. Both ideas assume that the patient will see themselves more objectively, and that delusions can therefore be overcome and rationality brought into play.

Drawing on my reading of archival material at the York Retreat and the Crichton Royal Hospital archives, the chapter examined statements made about the use of the arts in the eighteenth century. Whilst I have noted that the unrestrained expression of the imagination was not thought to be useful by all moral practitioners, I provided positive examples of the early use of the arts which were regarded as being curative. Indeed, the very art works themselves were conceptualised in one example as uplifting through a process of moral contagion. In another example the approbation received for the art works produced was emphasised in the account of how the art work had therapeutic benefit. These kinds of responses were evident in the work of modern art therapists, some of whom also had doubts about the unrestrained use of art-making. Examples of this attitude have been provided in this chapter but are also evident in other chapters, such as that on Withymead, where attempts were made by the art therapist to moderate the violent expression of the unconscious in art works by encouraging clients to engage in more prosaic activities.

In *Chapter Three*, 'Mad, Bad and Degenerate: Art Therapy, Degeneration, Psychoanalysis and the "Psychopathological School" ', I examined the discourse of degeneration in which madness and artistic expression became conflated. Expressive types of art (that of so-called 'primitive' peoples and certain forms of modern art) came to be seen as indicating, or coming from, a degenerated or pathological person or people, and as illustrating a primitive level of mentality. The chapter examined how degeneration as a concept became linked to notions of social progress and fears about the decline of civilisation in the nineteenth and early twentieth centuries. It was also noted how these ideas about primitivism and degeneration were linked to class, race, and gender, and perpetuated through misinterpretations of Darwin's work in popular evolutionism. Social groups lacking in social power were equated because of their purportedly similar mental characteristics: a tendency towards dissimulation, impulsiveness, and lack of self-discipline being notable characteristics. Socially defined and constructed behavioural differences were believed to be hereditary.

The chapter examined how in early psychological and anthropological writings symbolism in art and language was linked to theories of degeneration and assumptions about the hierarchy of races. A.C. Haddon's work assumed that the geometric art of the primitives he presented evinced degeneration because of plagiarism. It is clear when he talks about the primitives being 'dull and uninventive' in comparison with Europeans that he antici-

pated them engaging more in acts of plagiarism than their European counter-parts.

The chapter went on to examine the work of Lombroso, one of the first psychiatrists to pay an interest in the art of the insane, whose work was well known in Britain. Lombroso equated symbolism in art and language with primitive mentality, and thought that the insane had a particular predilection for the use of symbols in their art work. Such ideas were further popularised by Max Nordau. I argued that these ideas had an impact on the work of Sigmund Freud, founder of psychoanalysis, who propagated the idea that symbols in dreams evinced primitive aspects of the human psyche. Like Lombroso, Freud saw symbolism as having its origins in 'Man's' early devel-opment, explicitly as a survival of prehistoric modes of expression. Freud assumed, with other theorists of the period, that these primitive ancestors were primarily interested in sex and that human language developed to assist in the process of procreation. He believed that when language became used in other contexts it retained its sexual connotations. Thus dreams as an atavistic form of self-expression were abundant in sexual symbols.

I went on to argue that the implications for art therapy of such theorising were essentially quite negative because expressive art work came to be viewed as either degenerate or psychopathological or both. The effect of such thinking was, I suggest, abundantly clear in the treatment of Expres-sionist artists in Germany during the Second World War. There Expressionist artists were prevented from painting and their art works burnt. The 'Degen-erate Art' exhibition ridiculed their work but its intention was more than mere mockery, as it sought in its organisation to make clear the links between the insane, primitives and the work of the modern artists on display. Works by now esteemed artists such as Chagall or Emil Nolde were labelled as racially degenerate.

Although events in Germany prompted a critique of the racist assump-tions inherent in biological determinism, I suggested that the link between pathology and artistic expression was by that time firmly established, resulting in a 'psychopathological school' in the first half of the twentieth century.

In the second part of the chapter I explored the influence of psychoanaly-sis in Britain, and British psychiatry in particular. I then explored the psychopathological approach to the reception of art work, examining the work of a group of analysts, psychiatrists and others who saw symbolic images in dreams and paintings as evidence of underlying neurotic conflicts.

I presented an outline and critique of the work of prominent theorists in the field such as Pfister, Klein and Fairbairn, noting how they took up Freud's theories and applied them in different ways to the art work of their patients. I then moved on to look at *a priori* interpretive approaches, giving examples of reductive and potentially abusive conduct by Pickford and Pailthorpe. I argued that such work was not particularly influential in terms of the development of art therapy (many art therapists practising today would not have read their work) but it is interesting to note the range of activities carried out. The use of dogmatic interpretations, based on psychoanalytic theory, does represent one strand of thinking and activity in the development of art therapy. I also examined the work of Ernst Kris who applied Freud's theories both to art work and certain creative professions but who was not a practising art therapist, and Susan Bach, an art therapist, who was particularly interested in the use of art as a diagnostic tool. Again, Bach's work in particular has received very little attention in writing on art therapy. I argued that her approach was not embraced by other art therapists in the period but was indicative of diversity in early art therapy.

I then moved on to look at Freudian therapists whose work has had some impact on the development of art as therapy in Britain: Milner and Naumberg. Milner never regarded herself as an art therapist, though her work is often cited by art therapists. Naumberg was particularly significant, as she developed a psychoanalytically based model of clinical practice in art therapy. However, her response to psychoanalysis was not rigidly orthodox, as she was influenced by the Jungian notion that interpretation of art work, or even discussion of art work, was not necessary to therapeutic success. Thus she was able to provide a palatable application of Freud's theories to art therapy which was tremendously influential, particularly in the USA, where she is now heralded as the founder of art therapy.[1]

I argued that had the psychopathological approach become the dominant theoretical model in Britain we could expect to see the interpretation of images by the art therapist as the norm within the therapeutic encounter, rather than the province of a few isolated eccentrics as is the case today. Likewise, art therapists very rarely attempt to use art works for diagnostic purposes, though there continues to be some small interest in this line of activity and the possibilities for developing interpretive schema.

Chapter Four, 'Casting off the Shackles of the Intellect: Is Modern Art Mad Art?', is an attempt to address a subject which could easily constitute a book in its own right. My work on this subject is therefore of necessity, both provi-

sional and cursory. However, it was important not to ignore the interaction between art therapy and modern art, though it is impossible to do the subject justice in one short chapter. I hope to conduct further, more detailed research on this topic in the future. This chapter looked briefly at how the arts were perceived in the period in which the first art therapy posts were developed.

The chapter then moved on to look at the development of Surrealism and the 1936 International Surrealist Exhibition in particular. I noted that the Surrealists shared with many art therapists an interest in seeing modern art as capable of evincing unconscious processes. Two of the organising committee of the 1936 exhibition were influential to art therapy developments. Herbert Read was an open advocate of art therapy, and Roland Penrose, as chair of the management committee of the ICA, hosted high-profile art therapy exhibitions. Press reaction to the exhibitions differed but most acknowledged similarities between the work of psychiatric patients and modern artists.

In *Chapter Five*, entitled 'In the Tradition of Moral Treatment' I examined a selection of views of twentieth-century practitioners and noted similarities between the approach of the moral practitioners and the modern art therapists. The chapter surveyed the work of a number of modern art therapists whose work provides a reasonably broad cross-section of attitudes to art therapy from the 1940s to the 1960s. All of the art therapists discussed are trained occupational therapists but their work was not dissimilar to that of other art therapists who had not completed occupational therapy training. Indeed, the occupational therapy movement provided an important impetus to the development of art therapy.

I provided fairly detailed accounts of these pioneers' work, as it is not documented elsewhere. Bruce Godward's contribution in particular has been entirely overlooked in Waller's (1991) text, and the other therapists mentioned have received only very cursory attention. Both the moral practitioners and the twentieth-century art therapists saw art as appealing to the higher sensibilities of their patients. Although I noted differences in approach between these early art therapy practitioners, in a close examination of these therapists' views two common factors emerge quite clearly: one is a spiritual emphasis in their work, and the other is a general reluctance to furnish interpretations of the client's art work. Indeed, this is more than mere reluctance, these therapists were very wary about the matter of interpretation. Godward, who was most sympathetic to the idea of interpretation, felt that such analysis should only be for the benefit of the therapist, to help them understand the art work and client better; he was against the idea of the art

therapist furnishing interpretations to the client. The chapter provides further support to my argument that art therapy did not emerge exclusively out of psychoanalytic thinking. It also illustrates the role of occupational therapists in the development of art therapy, who have received less acknowledgement than they are due.

Chapter Six, entitled 'Beyond X-Rays: Adrian Hill and the Development of Art Therapy within Sanatoria', explored how, during the Second World War and post-war period, art therapy was used in the rehabilitation of sufferers of tuberculosis as well in rehabilitating soldiers. The chapter presented a detailed account of the work of Adrian Hill, a visual artist, who coined the phrase 'art therapy' in 1942.

Hill began practising art therapy whilst he was himself recovering from tuberculosis in 1938. He managed to convince the hospital authorities of the benefits of this method, and continued to work as an art therapist after his discharge as a patient, visiting patients at their bedsides. The chapter recorded how Hill was responsible for the development of the first institutional supports for art therapy as a profession, and assisted in the creation of sessional posts through the auspices of the British Red Cross Society and the National Association for the Prevention of Tuberculosis. The chapter surveyed these professional developments in detail, along with Hill's work in promoting art therapy through exhibitions of patients' art work, inter-sanatoria competitions, and conferences. The chapter also provided an account of the work of some of these early art therapists and how they viewed what they were doing. This included an acknowledgement of a spiritual dimension to the work, as well as recognition that Hill and the other art therapists perceived their work as providing far more than mere diversion, as Waller's text seems to suggest. The chapter indicated that Hill's influence over early art therapy developments may now be underestimated.

Chapter Seven, entitled 'Pioneers of Art Therapy: Research at Maudsley and Netherne Hospitals', looked at art therapy developments in the context of medical research being carried out in the areas of neuroscience and visual perception. Psychophysiological research being completed employed artists to make paintings whilst under the influence of mescaline. In addition to this, the art works of psychiatric patients were analysed to yield information about the perceptual disturbances they experienced during the course of their illness.

The chapter moved on to present a detailed account of an art therapy research post established at Netherne Hospital in 1946. The research objec-

tives of those who established the position were presented. Edward Adamson, who was appointed to this position, worked using standard conditions capable of being reproduced elsewhere for research purposes. The research, conducted by Dr Cunningham Dax, represented an attempt to ascertain the usefulness of art as therapy. It is of significance because Dax concluded that the spontaneous production of images and interpretation of them by the patient could be regarded as a legitimate therapeutic treatment.

Like Hill, Adamson was significant as a pioneer and promoter of art therapy in Britain. Also like Hill, Adamson was vehemently opposed to the therapist interpreting the client's art work. Indeed, he was vociferous in his criticisms of such interpretive work and the chapter provides a detailed account of his views on this subject. However, unlike Hill, he promoted a non-interventionist approach in which the therapist passively accepted whatever the client presented to them. This has sometimes been misinterpreted as an atheoretical stance. However, Adamson was very sympathetic to the spiritual model of art therapy used at Withymead in which the art therapy process was seen as essentially self-regulating and not requiring interference from the art therapist. It is this Jungian influence which led him to concentrate on providing a safe space in the hospital setting in which an unprecedented level of self-expression and self-exploration could take place. Adamson believed, with many other Jungians, that art was healing. Although, when first appointed, restrictions were placed on his role (which I explored in the chapter) Adamson outlasted Dax at the hospital and therefore had the opportunity to change his working practices. That he chose not to do so clearly illustrates that he was happy with the model of art therapy practice he had developed. He had strong feeling about psychiatric care and was deeply critical of mental hospital regimes of which he regarded himself very much as an outsider.

Chapter Eight, entitled 'Pioneers of Art Therapy: The Development of Art Therapy within Psychiatry and Related Settings', provided a brief historical outline of the development of psychiatry and social psychiatry in order to provide a context for art therapy developments. The chapter presented the work of a number of art therapy pioneers: Tatiana Manuilow, Jan Glass, Alexander Weatherson, Hubert Parkin, Besley Naylor and others, who worked between 1935 and 1965. The aims and objectives of early art therapists were scrutinised through an examination of their work, as well as through an analysis of applications for membership received by the British Association of Art Therapists. Despite a plurality of approaches being evident

in art therapy, clearly discernible was a general reluctance amongst art thera-
pists to interpret patients' art work (constituting an implicit rejection of psy-
choanalytic psychotherapy), along with a general emphasis on the empower-
ment of patients, which was sometimes at odds with the restrictive practices
of the psychiatric environments in which art therapists worked. Indeed, the
dominant model of art therapy evident in such settings during this period
was primarily directed to the personal empowerment of patients, and consti-
tuted an approach which was essentially subversive in relation to psychiatric
control. I suggested that this essentially libertarian emphasis on giving the
institutionalised and disenfranchised patient a voice militated against the
development of art therapy as a profession in psychiatric hospitals. Art thera-
pists were largely critical of psychiatric practices and institutional norms, and
the profession's development has been extremely slow compared to that of
occupational therapy, for example.

Developments within social psychiatry settings were also examined,
including accounts of the work of Rita Simon and Sigmund Henrich Foulkes.
Foulkes's contribution in particular appears to have been overlooked in
writing on art therapy (he receives no mention in Waller's 1991 text).

The chapter ended with an account of early art therapy meetings which
took place prior to the first AGM of the British Association of Art Therapists
in 1966, which is the cut-off point for this research. These early meetings
evinced tensions within art therapy regarding whether it should be regarded
as a specialised form of occupational therapy or a discrete profession in its
own right. There were also a number of art therapists towards the end of the
1960s who became interested in aligning their work to particular psycho-
logical models, moving away from a generally libertarian and spiritual
emphasis in art therapy which was characteristic of its early development.

Chapter Nine looked at a development which was of pivotal and central
importance to the professional development of art therapy in Britain.
Withymead, 'Britain's First Therapeutic Community Dedicated to Art
Therapy', was undoubtedly the single most important institution for art
therapy in the first half and mid-twentieth century. It provided a model of art
therapy practice, trained artists as art therapists, and did a great deal of
outreach work. This included putting on short courses there and elsewhere,
as well as providing speakers for conferences and interested organisations.
The centre had particular links with the Guild of Pastoral Psychology in
London: an organisation established to bring together thinkers with an
interest in both religion and psychology. Members of staff were regular

attenders and guest speakers at these meetings. They were also active in the analytical psychology establishment with both members of staff and patients attending meetings. Withymead was very much an open community so that anyone with an interest in analytical psychology or art therapy could arrange to visit the centre, or stay for a time on a residential basis, and fully participate in the life of the community. Consequently it was of tremendous importance in promoting art therapy as a concept.

The chapter presented a literature review, a brief history of the formation of Withymead, along with a short biography of its founders, Irene and Gilbert Champernowne. Irene, who had practised as an analytical psychologist in London prior to setting up Withymead, had good contacts in London which yielded referrals, but financial problems were ongoing.

Although it was not my intention in the chapter to prove that Withymead was the first residential therapeutic community in Britain, there is a strong argument to be made that this was the case. Withymead certainly applied the term 'therapeutic community' to its activities. It was therefore necessary to give an account of the community as a whole, and explore how it functioned in order to provide a contextualised indication of how the art therapy studios functioned. The notion of community living was emphasised as a remedial factor and all patients took part in a variety of activities in addition to analysis and art therapy.

To have a proper understanding of Withymead I have argued that it is necessary to have some insight into how the analytic psychology establishment functioned at the time. Analysands were permitted to attend the meetings of the analytic psychology clubs only with a reference from their analyst. There was no formal training and attendance of the clubs was a necessary part of the analysands' transformation into a therapist. At Withymead there was no tidy boundary between therapists and patients, all of whom were called residents, and all of whom were in analysis. This was not mere rhetoric, and a genuinely egalitarian atmosphere prevailed at Withymead, though distinctions between types of resident did exist (the analysts' exclusive meeting was a concrete expression of the hierarchy of knowledge about the unconscious in the community). Like the analytic psychology establishment, Withymead would permit, and indeed positively encourage, patients to become therapists. This was not necessarily an overnight transformation but a gradual development of skills, empathy, and analytic capabilities coupled with the process of taking on more responsibilities within the community.

Central to its functioning was the community staff meeting which was attended by all staff. At this meeting all patients would be discussed in detail and all staff would contribute to the discussion. The underlying idea was that different parts of the patients' personality could be manifested in response to their relationships with various members of staff. The work done in the studios would receive attention and paintings might be brought in and talked about. Therefore the therapeutic relationship between art therapist and patient was shared with the community as a whole. This was important because a patient at Withymead could be in analysis with more than one analyst and seeing more than one art therapist at any given time. However, an exploration of the relationships between staff members, and their emotional reactions to events in the community, also formed an important part of this group's activity. A clear dichotomy between the staff team's 'transference' relationships and those of the patients did not exist and both received equal attention.

A detailed examination of the power relationships operating at the centre was also provided. Of particular importance within the community was knowledge about the unconscious. This knowledge established the individual's status within the community and was considered of more importance than formal training or qualifications. Knowledge about the unconscious was not merely intellectual knowledge or assimilation of the commmunity's *idées reçues*, but self-knowledge acquired through feedback from the community meeting and personal therapy. The staff meeting was the driving force of the community and was essentially egalitarian in its operation.

I also argued that it is imperative to understand the interaction between analysis and art therapy, because these were the principal methods employed. Irene Champernowne agreed with Jung that the individual's ego could assimilate the contents of pictorial symbolism *without every detail becoming conscious*. Therefore detailed verbal analysis of images was not considered necessary. The chapter explored Jungian theory, emphasising the importance of the complementary and regulatory function of the unconscious in this model. In particular, I examined the work of Corrie and Long who, after the death of H.G. Baynes in 1943, were the most important proponents of Jung's ideas in Britain in the period of Withymead's early development. However, as I noted, Irene Champernowne's method was not entirely orthodox in that she was more interested in finding literal and personal meanings in art work, rather than emphasising their archetypal significance. There is also evidence to suggest that she convinced both Jung and Toni Wolff of the value of this

approach to art therapy. However, because Jung was by this time retired and had largely withdrawn from public life these ideas did not filter down to the emerging Jungian establishment. Consequently, Jung's change of viewpoint on art as therapy is not well known.

Although the chapter focuses on what today is called art therapy (painting, sculpture and clay work), other creative methods were employed, including music, drama, dance and mime. The chapter provided a detailed analysis of how 'Jungian' art therapists understood their work, along with a profile of the art therapists.

Withymead was also a pseudo-religious community in the sense that the unconscious was regarded as a manifestation of God. This mirrored developments within the Analytical Psychology Club in London which was reported to have become a quasi-religious group. Mental illness was viewed positively as an opportunity for spiritual renewal. Art works produced were seen as evincing religious experience. Indeed, in this conceptual model, religious or spiritual expression was viewed as the ultimate form of freedom of expression. The importance of Withymead to art therapy developments in Britain has hitherto not been recognised.

Finally *Chapter Ten*, entitled 'Branch Street and Other Projects', is a brief examination of a large topic. However, the subject of art therapy within education could not be entirely overlooked. The chapter looked in detail at the work of Marie Paneth in London, and Ruth and David Wills who were the first art therapists to work in Scotland.

A fundamental re-evaluation of art therapy history is required. Art therapy should be seen as emerging out of quite different discourses which have distinct residual connotations and different implications for the type of art therapy practice offered. Although, as noted, Waller's text on the history of art therapy only touches on the period under discussion here, and is, in any case, addressing a different question (the professionalisation of art therapy), it conjures up quite a different picture of early art therapy: one in which pioneer art therapists embraced psychoanalysis or psychoanalytic psychotherapy rather than almost universally rejecting it (particularly with respect to interpretation) and mistrusting it. Major figures who did not fit in to Waller's schema – for example, Edward Adamson and Adrian Hill – are misrepresented in Waller's text; Adamson is portrayed as an 'artist' with a fundamentally atheoretical stance.[2] Her treatment of Hill is rather more complex, but she sees his emphasis as on 'distracting' patients.[3] Of course in the context of Waller's research, which is concentrating on the subject of

professionalisation, looking at art therapy in relation to the more established practices of psychoanalysis and psychotherapy is perfectly logical. It is, however, historically misleading. (A detailed appraisal of Waller's contribution to the subjects under discussion has appeared at relevant points in the text.)

Given the general pseudo-religiosity of art therapy generally in all contexts in the period under discussion in the twentieth century, which has hitherto been ignored in historical accounts of the subject, it is clear that moral treatment provided a more important impetus for art therapy development than did orthodox psychoanalysis. Those art therapists (mostly artists) who did develop a curiosity about psychoanalysis gained this through their interest in modern art in general and the Surrealist art movement in particular, though this is not evident (or even mentioned) in Waller's account. Most pioneer art therapists working in psychiatric and other environments, as this text illustrates, were not particularly conversant with or interested in psychoanalytic theory. The most 'theorised' contingent were those art therapists interested in analytic psychology, with its spiritual and pseudo-religious flavour, which was much more influential than ideas emerging from other sources such as those developing within radical education, for example. Analytical psychology as a major influence in art therapy development is not emphasised in Waller's text, and the importance of the religiosity of the analytic approach unacknowledged.

This research has distinguished a plurality of approaches to the curative effects of image-making: the endurance of a moral approach and the permeation of psychoanalytic concepts into the practice of some art therapists. However, in the twentieth century the overwhelming dominance of spiritual and subversive approaches has not received proper recognition. This research has, I hope, created a more balanced view of the intellectual precursors of art therapy in Britain.

Art therapy today

Art therapy today is a small profession with less than 2000 registered members in the UK. Training to become an art therapist is now a two-year, full-time postgraduate diploma. There are a number of recognised art therapy training centres in Britain; some of these refer to themselves as 'art psychotherapy' units rather than 'art therapy' centres, and students leave the courses with a credential in 'art psychotherapy' rather than in 'art therapy'. (I addressed the issue of nomenclature in the introduction.) All of the courses

are slightly different in emphasis, but follow guidelines developed by the British Association of Art Therapists.

The attitudes of many art therapists practising today are not dissimilar from those of the pioneer art therapists, though the spiritual emphasis so characteristic of early art therapy has become rather muted. The dominance of the Jungian approach in general has dwindled to the extent that many art therapists do not realise that it was once the dominant paradigm. Some art therapists seem to think that art therapy developed exclusively out of psychoanalysis and this text has repudiated this idea.

There is still a strong emphasis on an empowerment or libertarian manner of working, though there has also been a steady drift towards approaches which rely on psychodynamic theories, which may be more compatible with the ethos of many psychiatric services and advantageous to the growth of the profession – at least this is one of the arguments put forward for their use. In Britain there is a small but vocal analytic lobby, a group of art therapists who use concepts from psychoanalysis as a basis for their work. (The term 'analytic' is not used here to indicate adherence to Jung's ideas as it is in the rest of the text.) As already noted, these 'analytic' art therapists tend also to be trained psychotherapists or psychoanalysts. Mainly these are art therapists who then go on to complete a psychotherapy training, and perhaps their allegiance shifts during this process. There are a minority of art therapists who assimilate psychoanalytic theories in an uncritical way and attempt to apply them in a crude manner, but fortunately the interpretation of clients' images is still largely taboo and the province of a few eccentrics. There have been some recent attempts to describe art therapy using particular psychological schemas, but such reductionism, though worrying, is still the province of the minority.

The future for art therapy in general is uncertain and the future for art therapy as a form of cultural criticism and a tool for the empowerment of the dispossessed more uncertain still.

Notes

1 Borowsky Junge and Pateracki Asawa's (1994) account of the history of art therapy in the USA emphasises Naumberg's influence over that of Edith Kramer.
2 Waller 1991, p.9.
3 Waller 1991, p.7.

References

Books and book chapters

Abercrombie, J. (1837) *Culture and Discipline of the Mind.* Edinburgh: William Whyte and Son.

Adamson, E. (1970) 'Art for mental health' in J. Creedy (ed) *The Social Context of Art.* London: Tavistock.

Adamson, E. (1990) *Art as Healing.* London: Coventure.

Auden, W.H. (1935) 'Psychology and art' in G. Grigson (ed) *The Arts Today.* London: Jone Lane and The Bodley Head Press.

Bach, S. (1990) *Life Paints Its Own Span: On the Significance of Spontaneous Pictures by Severely Ill Children.* Switzerland: Daimon Verlag.

Barlow, J. (1843) *Man's Power over Himself to Prevent or Control Insanity.* London: William Pickering.

Bassuk, E.L. (1986) 'The rest cure' in Sulieman, S. (ed) *The Female Body in Western Culture: Contemporary Perspectives.* Harvard University Press.

Baudouin, L.C. (1924) *Psychoanalysis and Aesthetics.* London: George Allen & Unwin.

Baynes, H.G. (1940) *Mythology of the Soul.* London: Routledge.

Beilharz, P. (ed) (1992) *Social Theory.* London: Allen & Unwin.

Berger, J. (1972) *The Past as Seen From a Possible Future: Selected Essays and Articles.* London: Penguin.

Berrios, E. (1991) 'British psychopathology since the early 20th century' in H.G. Berrios and H. Freeman (eds) *150 Years of British Psychiatry, 1841–1991.* London: Gaskell.

Bettelheim, B. (1982) *Freud and Man's Soul.* London: Flamingo.

Bierer, J. (1949) *Therapeutic Social Clubs,* reprinted in Bierer (1964).

Bierer, J. (1951) *The Day Hospital: An Experiment in Social Psychiatry and Syntho-Analytic Psychotherapy,* reprinted in Bierer (1964).

Bierer, J. (1951) *Therapeutic Social Clubs.* London: Institute of Social Psychiatry.

Bierer, J. (1958) 'Vision, dream or misconception' in *International Journal of Social Psychiatry,* reprinted in Bierer (1964).

Bierer, J. (1961) 'Day hospitals: Further developments' in *International Journal of Social Psychiatry,* reprinted in Bierer, J. (1964).

Bierer, J. (1964) *Innovations in Social Psychiatry and Social Psychology.* London: Avenue Publishing Co.

Blair, D. (1949) 'The formation and organisation of therapeutic social clubs' reprinted in Bierer (1964).

Boas, G. (1940) 'The Mona Lisa in the History of Ideas' in *Journal of the History of Taste,* April, 207–224.

Borowsky Junge, M. and Pateracki Asawa, P. (1994) *A History of Art Therapy in the United States.* Illinois: The American Art Therapy Association Press.

Bourdieu, P. (1989) *Distinction: A Social Critique of the Judgment of Taste.* London: Routledge.

Bourneville, D.M. and Régnard, P. (1887) *Iconographie Photographique de la Salpêtrière.* Vol. 1. Paris: Bureaux du Progrès Mèdical & Adrian Delahay.

Brown, T. (1993) 'Mental diseases' in Bynum, W.F. and Porter, R. (eds) *Companion Encyclopaedia of the History of Medicine.* London: Routledge.

Browne, W.A.F. (1837) *What Asylums Were, Are and Ought to Be: Being the Substance of Five Lectures Delivered before the Managers of the Montrose Royal Lunatic Asylum.* Edinburgh: A & C Black.

Bryder, L. (1988) *Below the Magic Mountain: A Social History of Tuberculosis in Twentieth Century Britain.* Oxford: Clarendon.

Budd, S. and Sharma, U. (eds) (1994) *The Healing Bond: The Patient–Practitioner Relationship and Therapeutic Responsibility.* London: Routledge.

Bullen, J.B. (ed) (1988) *Post-Impressionism in England.* London: Routledge.

Burrows, G.M. (1828) *Commentaries on the Causes, Forms, Symptoms and Treatment, Moral and Medical of Insanity.* London: Thomas and George Underwood.

Bynum, W.F. and Porter, R. (eds) (1993) *Companion Encyclopedia of the History of Medicine.* London: Routledge.

Bynum, W.F., Porter, R. and Shephard, M. (eds) (1988) *The Asylum and Its Psychiatry.* Vol.3. London: Routledge.

Calder, A. (1969) *The People's War. Britain 1939–1945.* London: Jonathan Cape.

Carter, M. (1990) *Framing Art: Introducing Theory and the Visual Image.* Sydney: Hale & Iremonger.

Case, C. and Dalley, T. (1990) *Working with Children in Art Therapy.* London: Tavistock and Routledge.

Case, C. and Dalley, T. (1992) *The Handbook of Art Therapy.* London: Routledge.

Chamberlin, E.J. and Gilman, S.L. (eds) (1985) *Degeneration: The Dark Side of Progress.* Columbia University Press.

Champernowne, H.I. (1973) *Creative Expression and Ultimate Values.* London: The Guild of Pastoral Psychology.

Champernowne, H.I. (1974) *Searching for Meaning: The One and Only Me.* Surrey: Denholm House University Press.

Champernowne, H.I. (1980) *A Memoir of Toni Wolff.* C.G. (Carl Gustav) Institute of San Francisco.

Churchill, W. (1948) *Painting as a Pastime.* London: Odhams Press.

Clark, M. (1988) 'Morbid introspection, unsoundness of mind, and British psychological medicine 1830–1900' in Porter, R., Bynum, W.F. and Shepherd, M.(eds) *The Anatomy of Madness.* Vol. III. London: Routledge.

Cohen, S. and Scull, A. (eds) (1985) *Social Control and the State: Historical and Comparative Essays.* Oxford: Basil Blackwell.

Cole, G.D.H. (1968) in Seligman, E.R.A. (ed) *Encyclopaedia of the Social Sciences.* Vol. XI.

Corrie, J. (1927) *ABC of Jung's Psychology.* London: Kegan Paul, Trench, Trabner and Co.

Crook, P. (1994) *Darwinism, War and History.* Cambridge University Press.

Dalley, T., Case, C., Schaverien, J., Weir, F., Halliday, F., Nowell Hall, P. and Waller, D. (1987) *Images of Art Therapy.* London: Tavistock.

Dax, E.C. (1953) *Experimental Studies in Psychiatric Art.* London: Faber & Faber.

Dax, E.C. (1961) *Asylum to Community.* Melbourne: F.W. Cheshire.

de Giustino, D. (1975) *Conquest of the Mind: Phrenology and Victorian Social Thought.* London: Croom Helm.

Digby, A. (1985) 'Moral Treatment at the Retreat 1796–1846' in Porter, R., Bynum, W.F. and Shepherd, M. (eds) *The Anatomy of Madness.* Vol. I. London: Routledge.

Donoghue, D. (1983) *The Arts without Mystery.* London: BBC.

Douglas, M. (1980) *Evans Pritchard.* New York: The Harvester University Press.

Douglas, M. (1994) 'The construction of the physician' in Budd, S. and Sharma, U. (eds) (1994).

Douglas, M. (1996) *Thought Styles*. London: Sage.

Durkheim, E. (1925/1961) *Moral Education: A Study in the Theory and Application of Sociology of Education*. New York: Free Press.

Ellenberger, H.F. (1970) *The Discovery of the Unconscious: The History and Evolution of Dynamic Psychiatry*. New York: Basic Books.

Erickson, M.H. (1980) *Innovative Hypnotherapy. The Collected Papers of Milton H. Erickson on Hypnosis*. Vol. IV. New York: Irvington Publishers.

Ferrero, G.L. (1911) *Lombroso's Criminal Man According to the Classification of Cesare Lombroso: Summarised by His Daughter Gina Lombroso Ferrero*. London: G.P. Putnam's Sons: The Knickerbocker Press.

Forrester, J. (1980) *Language and the Origins of Psychoanalysis*. London: The Macmillan Press.

Foucault, M. (1965) *Madness and Civilisation: A History of Insanity in the Age of Reason*. London: Tavistock.

Freud, S. (1939) *Moses and Monotheism*. Trans. Katherine Jones. New York: Knopf.

Freud, S. (1948) *An Autobiographical Study*. Trans. James Strachey. London: Hogarth.

Freud, S. (1963) *Introductory Lectures on Psycho-Analysis (1916–1917). The Standard Edition*. Vol. XV. Trans. James Strachey. London: Hogarth Press.

Freud, S. (1971) *New Introductory Lectures Vol 15*. London: Hogarth Press.

Freud, S. (1977) *The Interpretation of Dreams*. Harmondsworth: Penguin.

Freud, S. (1983) *Sigmund Freud: New Introductory Lectures on Psychoanalysis*. Vol. 2. Harmondsworth: Penguin.

Gascoyne, D. (1970) *A Short Survey of Surrealism*. London: Frank Cassell and Co.

Gay, P. (1977) *The Enlightenment: An Interpretation. The Rise of Modern Paganism*. New York: Norton and Company.

Gilman, S.L. (ed) (1976) *The Face of Madness: Hugh Welch Diamond and the Origin of Psychiatric Photography*. New York: Brunner-Mazel.

Gilman, S.L. (1982) *Seeing the Insane*. New York: John Wiley & Sons.

Gilman, S.L. (1986) *Difference and Pathology: Stereotypes of Sexuality, Race and Madness*. Ithaca: Cornell University Press.

Gilman, S.L. (1988) *Disease and Representation*. New York: Cornell University Press.

Gilman, S.L. (1993) 'Psychotherapy' in Bynum, W.F. and Porter, R. (eds) *Companion Encyclopaedia of the History of Medicine*. London: Routledge.

Gilman, S.L. (1995) *Health and Illness: Images of Difference*. London: Reaktion Books.

Gilman, S.L., King, H., Porter, R., Rousseau, G.S. and Showalter, E. (1993) *Hysteria Beyond Freud*. University of California Press.

Gilroy, A. and Dalley, T. (1989) *Pictures at an Exhibition: Selected Essays on Art and Art Therapy*. London: Tavistock & Routledge.

Gobineau, A. (1854) *The Inequality of the Human Races*. London: William Heinemann.

Goldstein, J. (1993) 'Psychiatry' in Bynum, W.F. and Porter, R. (eds) *Companion Encyclopaedia of the History of Medicine*. London: Routledge.

Gorman, J. (1992) *Stress on Women*. London: MIND.

Gould, S. (1981) *The Mismeasure of Man*. New York and London: Norton.

Haddon, A.C. (1895) *Evolution in Art*. London: Walter Scott.

Hartley, I. (1983) *Goodnight Children … Everywhere*. New York: Midas Books.

Henderson, D.K. (1964) *The Evolution of Psychiatry in Scotland*. London and Edinburgh: E. and S. Livingstone.

Henderson, J.L. (1980) 'Foreword' to *A Memoir of Toni Wolff*. C.G. Institute of San Francisco.

Henzell, J. (1997) 'Art, madness and psychiatry: A memoir' in K. Killick and J. Schaverien (eds) *Art, Psychotherapy and Psychosis*. London: Routledge.

Hill, A. (1945) *Art Versus Illness: A Story of Art Therapy*. London: George Allen & Unwin.

Hill, A. (1951) *Painting Out Illness*. London: William and Norgate Ltd.

Hobsbawm, E. (1994) *Age of Extremes: The Short Twentieth Century 1914–1991*. London: Michael Joseph.

Hogan, S. (ed) (1997) *Feminist Approaches to Art Therapy*. London: Routledge.

Hunter, R. and Macalpine, I. (1963) *Three Hundred Years of Psychiatry*. Oxford: Oxford University Press.

Ingelby, D. (1985) 'Mental health and social order' in Cohen, S. and Scull, A. (eds) (1985).

Ingram, A. (1991) *The Madhouse of Language: Writing and Reading Madness in the Eighteenth Century*. London: Routledge.

Jones, E. (1923) *Papers on Psychoanalysis* (3rd edition). New York: William Wood.

Jones, G. (1980) *Social Darwinism and English Thought: The Interaction between Biological and Social Theory*. Sussex: The Harvester Press.

Jones, K. (1960) *A History of Mental Health and Social Policy 1845–1959*. London: Routledge and Kegan Paul.

Jones, K. (1972) *A History of Mental Health Services*. London: Routledge and Kegan Paul.

Jones, K. (1991) *The Making of Social Policy in Britain 1930–1990*. London: Athlone.

Jones, K. (1991(b)) 'The culture of the mental hospital' in H.G. Berrios and H. Freeman (eds) *150 Years of British Psychiatry, 1841–1991*. London: Gaskell.

Jones, S. (1994) *The Language of the Genes*. London: Flamingo.

Jung, C.G. (1928) *Two Essays on Analytical Psychology*. Trans. H.G. and C.F. Baynes. London: Balliere Tyndall & Cox.

Jung, C.G. (1939) *The Integration of the Personality*. Trans. Stanley Dell. New York: Farrar & Reinehart.

Jung, C.G. (1954) *The Practice of Psychotherapy: Essays on the Psychology of the Transference and Other Subjects*. The Collected Works of Jung. Vol. 16. London: Routledge and Kegan Paul.

Jung, C.G. (1960) *The Structure and Dynamics of the Psyche*. The Collected Works of Jung. Vol. 8. London: Routledge and Kegan Paul.

Jung, C.G. (1963) *The Secret of the Golden Flower*. London: Routledge and Kegan Paul.

Jung, C.G. (ed) (1964) *Man and His Symbols*. London: Aldus.

Jung, C.G. (1967) *The Spirit in Man, Art, Literature*. London: Ark.

Jung, C.G. (1971) *C.G. Jung Letters*. Vol. 1. London: Routledge and Kegan Paul.

Jung, C.G. (1983) *Memories, Dreams, Reflections*. London: Flamingo.

Jung, C.G. (1984) *Modern Man in Search of a Soul*. Trans. C.F. Baynes. London: Ark.

Jung, C.G. (1987) *Dictionary of Analytical Psychology*. London: Ark.

Keddie, K. (1985) *The Gentle Shetlander*. Edinburgh: Harris & Shetland Times.

Kevles, J.D. (1985) *In the Name of Eugenics and the Uses of Human Heredity*. London: Penguin.

Klein, M. (1989) *Narrative of a Child Analysis: The Conduct of the Psycho-Analysis of Children as Seen in the Treatment of a Ten-Year-Old Boy*. London: Virago.

Kris, E. (1953) *Psychoanalytic Explorations in Art*. London: George Allen & Unwin.

Kuper, A. (1975) *Anthropologists and Anthropology*. Harmondsworth: Peregrine Books.

Kuper, A. (1988) *The Invention of Primitive Society*. London: Routledge.

Layton, R. (1991) *The Anthropology of Art*. Cambridge University Press.

Lombroso, C. (1891) *The Man of Genius*. London: Walter Scott.

Long, C. (1920) *Collected Papers on the Psychology of Phantasy*. London: Balliere, Tindell & Cox.

Lupton, D. (1994) *Medicine as Culture, Disease and the Body in Western Societies*. London: Sage.

Lupton, D. (1997) Foreword. In S. Hogan (ed) *Feminist Approaches to Art Therapy*. London: Routledge.

Lydiatt, E.M. (1971) *Spontaneous Painting and Modelling: A Practical Approach to Therapy*. London: Constable.

Lynton, N. (1980) *Roland Penrose*. London: Arts Council of Great Britain.

MacCormack, C. (1993) 'Medicine and anthropology' in Bynum, W.F. and Porter, R. (eds) *Companion Encyclopaedia of the History of Medicine*. London: Routledge.

MacDonald, M. (1990) 'Insanity and the realities of history in early modern England' in Murray, R.M. and Turner, T.H. (eds) *Lectures on the History of Psychiatry*. London: Gaskell.

MacGregor, J. (1989) *The Discovery of the Art of the Insane*. Princeton University Press.

Maclagan, D. (1995) 'The Better Bit: Subjective Features of Research in Art and Therapy' in Gilroy, A. and Lee, C. (eds) *Art and Music Therapy and Research*. London: Routledge.

Marwick, A. (1968) *Britain in the Century of Total War: War, Peace and Social Change*. Bodley Head.

Marwick, A. (1974) *War and Social Change in the Twentieth Century: A Comparative Study of Britain, France and the United States*. London: Macmillan.

Masson, J. (1986) *A Dark Science: Women, Sexuality, and Psychiatry in the Nineteenth Century*. Farrar, Strauss and Giroux.

Masson, J. (1993) *Against Therapy*. London: HarperCollins.

McDougall, W. (1933) *An Outline of Abnormal Psychology*. Methuen.

Milner, M. (1957) *On Not Being Able to Paint*. London: Heinemann.

Milner, M. (1969) *In the Hands of the Living God*. London: Hogarth Press.

Mullan, J. (1990) *Sentiment and Sociability: The Language of Feeling in the Eighteenth Century*. Clarendon: Oxford University Press.

Naumburg, A.M. (1987) *Dynamically Orientated Art Therapy: Its Principles and Practice*. Chicago: Magnolia Street Publishers.

Naumberg, M. (1950) *Schizophrenic Art: Its Meaning in Psychotherapy*. London: William Heinemann.

Naumberg, M. (1973) *Introduction to Art Therapy*. Columbia University, Teachers College Press.

Neill, A.S. (1962) *Summerhill: A Radical Approach to Childrearing*. London: Gollancz.

Nochlin, L. (1989) *Women, Art, Power and Other Essays*. London: Thames and Hudson.

Paneth, M. (1944) *Branch Street: A Sociological Study*. London: George Allen and Unwin.

Park, E.A. (1968) in E.R.A. Seligman (ed) *Encyclopaedia of the Social Sciences*. Vol. 11.

Pearson, N. (1982) *The State and the Visual Arts*. Milton Keynes: Open University Press.

Pelling, H. (1970) *Britain and the Second World War*. London: Collins.

Penrose, R. (1981) *Scrap Book 1900–1981*. London: Thames and Hudson.

Perkin, J. (1993) *Victorian Women*. London: John Murray.

Petrie, M. (1936) *Modelling for Children*. Leicester: The Dryad Press.

Petrie, M. (1946(a)) *Art and Regeneration*. London: Paul Elek.

Pfister, O. (1922) *Expressionism in Art: Its Psychological & Biological Basis*. London: Kegan Paul.

Pick, D. (1989) *Faces of Degeneration: A European Disorder, c. 1848–1918*. Cambridge University Press.

Pickford, R.W. (1963) *The Pickford Projective Pictures*. London: Tavistock.

Pickford, R.W. (1967) *Studies in Psychiatric Art*. Illinois: Charles C. Thomas.

Pickford, R.W. (1972) *Psychological and Visual Aesthetics*. London: Hutchinson.

Pines, M. (1991) 'The development of the psychodynamic approach' in H.G. Berrios and H. Freeman (eds) *150 Years of British Psychiatry, 1841–1991*. London: Gaskell.

Pointon, M. (1991) *Naked Authority: The Body in Western Painting 1830–1908*. Cambridge University Press.

Pollock, G. (1988) *Vision and Difference*. London: Routledge.

Porter, R. (1987) *Mind Forg'd Manacles: A History of Madness in England*. Harvard University Press.

Porter, R. (1987(b)) *A Social History of Madness: Stories of the Insane*. London: Weidenfeld and Nicolson.

Porter, R., Bynum, W.F and Shepherd, M. (eds) (1988) *The Anatomy of Madness: Essays in the History of Psychiatriy*. London: Tavistock.

Prince, M. (1905; 1978 edition) *The Dissociation of a Personality*. Oxford University Press.

Prinzhorn, H. (1923) *Bildnerei der Geisteskranken*. Berlin.

Rabinow, P. (ed) (1984) *The Foucault Reader*. New York: Pantheon.

Ray, C.P. (1971) *The Surrealist Movement in England*. Ithaca and London: Cornell University Press.

Read, H. (1945) *Art and Society*. London: Faber & Faber.

Read, H. (1952) *The Philosophy of Modern Art*. London: Faber.

Reitman, F. (1950) *Psychotic Art*. London: Routledge and Kegan Paul.

Reitman, F. (1954) *Insanity, Art and Culture*. London: Wright.

Renvoize, E. (1991) 'The AMOAH, MPA and presidents' in H.G. Berrios and H. Freeman (eds) *150 Years of British Psychiatry, 1841–1991*. London: Gaskell.

Ress, L. (ed) *General Bibliography of C.G. Jung's Writings*. Collected Works Vol. 19. London: Routledge & Kegan Paul.

Riley, D. (1983) *The War in the Nursery: Theories of the Child and the Mother*. London: Virago.

Rivers, W.H.R. (1923) *Psychology and Politics and Other Essays*. London: Kegan Paul, Trench, Trubner & Co.

Roberts, M.M. and Porter, R. (1993) *Literature and Medicine during the Eighteenth Century*. London: Routledge.

Rose, N. (1985) *The Psychological Complex: Psychology, Politics and Society in England 1869–1939*. London: Routledge and Kegan Paul.

Rose, N. (1990) *Governing the Soul: The Shaping of the Private Self*. London: Routledge.

Rosenburg, A. (1936) *The Final Fight between Europe and Bolshevism: Address Delivered at the Party Rally, Nüremberg 1936*. Berlin: Muller & Sohn.

Ross, C. (ed) (1992) *Therapy is Political*. Race & Culture Group of the British Association of Art Therapists.

Rousseau, G.S. (1980) 'Psychology' in Rousseau, G.S. and Porter, R. (eds) *The Ferment of Knowledge: Studies in the Historiography of Eighteenth-Century Science*. Cambridge University Press.

Rousseau, G.S. (1993) 'Medicine and the muses: An approach to literature and medicine' in Roberts, M. and Porter, R. (eds) *Medicine and Literature*. London: Routledge.

Rowe, D. (1993) 'Introduction' in Masson (1993) *Against Therapy*. London: HarperCollins.

Rushforth, W. (1984) *Ten Decades of Happenings*. London: Gateway Books.

Russell, D. (1995) *Women, Madness and Medicine*. Cambridge: Polity.

Russell, J.I. (1938) *The Occupational Treatment of Mental Illness*. London: Bailliere, Tindall & Cox.

Rycroft, C. (1968) *A Critical Dictionary of Psychoanalysis*. London: Penguin.

Samuels, A., Shorter, A. and Plaut, F. (1986) *A Critical Dictionary of Jungian Analysis*. London: Routledge and Kegan Paul.

Sass, L.A. (1992) *Madness and Modernism: Insanity in the Light of Modern Art, Literature, and Thought*. New York: Basic Books.

Searle, G.R. (1976) *Science in History: Eugenics and Politics in Britain 1900–1914*. Leyden: Noordhoff International Publishing.

Scott, J.W. (1988) *Gender and the Politics of History*. Columbia University Press.

Scull, A. (1979) *Museums of Madness: The Social Organisation of Insanity in Nineteenth-Century England*. London: Allen Lane.

Scull, A. (ed) (1981) *Madhouses, Mad-Doctors and Madmen: The Social History of Psychiatry in the Victorian Age*. London: Athlone.

Scull, A. (ed) (1991) *The Asylum as Utopia: W.A.F. Browne and the Mid-Nineteenth Century Consolidation of Psychiatry*. London: Routledge.

Showalter, E. (1987) *The Female Malady: Women, Madness and English Culture 1830–1980.* London: Virago.

Simon, R. (1949) 'The art circle' in Bierer (ed) (1949).

Simon, R. (1992) *The Symbolism of Style.* London: Routledge.

Skultans, V. (1975) *Madness and Morals: Ideas in the Nineteenth Century.* London: Routledge and Kegan Paul.

Spector (1972) *The Aesthetics of Freud.* London: Allen Lane.

Stevens, A. (1986) *The Withymead Centre: A Jungian Community for the Healing Arts.* London: Coventure.

Stocking, G. (1987) *Victorian Anthropology.* New York: The Free Press.

Storr, A. (1973) *Jung.* London: Fontana.

Symons, J. (1960) *The Thirties: A Dream Resolved.* London: Cresset Press.

Teich, M. and Porter, R. (1990) *Fin De Siecle and Its Legacy.* Cambridge University Press.

Thompson, K.M. (1949) 'The in-patient club: Runwell Hospital,' reprinted in Bierer (1964).

Thompson, P. (1988) *The Voice of the Past: Oral History.* Oxford University Press.

Tilly, C. (1990) *Reading Material Culture.* Oxford: Basil Blackwell.

Titmuss, R. M. (1950) *Problems of Social Policy.* H.M.S.O.

Tong, R. (1989) *Feminist Thought.* London: Routledge.

Torgovnick, M. (1991) *Gone Primitive.* Cambridge University Press.

Tuke, W. (1796) *State of an Institution Near York Called Retreat for Persons Afflicted with Disorders of the Mind.*

Ussher, J. (1991) *Women's Madness.* Hemel Hempstead: Harvester Wheatsheaf.

Viola, W. (1942) *Child Art.* University of London Press.

Wallace, E. R. (1983) *Freud and Anthropology: A History and Reappraisal.* New York: International Universities Press.

Waller, D. (1984) 'A consideration of the similarities and differences between art teaching and art therapy' in Dalley, T. (ed) *Art as Therapy.* London: Tavistock.

Waller, D. (1991) *Becoming a Profession.* London: Routledge.

Waller, D. (1993) *Group Interactive Art Therapy.* London: Routledge.

Walmsley. (1991) 'Psychiatry in Scotland' in H.G. Berrios and H. Freeman (eds) *150 Years of British Psychiatry, 1841–1991.* London: Gaskell.

Weiss, A.S. *Shattered Forms: Art Brut, Phantasms, Modernism.* New York: State University.

White, E. (1975) *The Arts Council.* Poynter.

Whyte, L.L. (1978) *The Unconscious before Freud.* London: Julian Friedmann Publications Ltd.

Williams, G.L. (ed) (1976) *John Stuart Mill on Politics and Society.* London: Fontana.

Williams, R. (1983) *Keywords.* London: Fontana.

Wills, D. (1945) *The Barns Experiment.* London: George Allen and Unwin.

Wills, W.D. (1941) *The Hawkspur Experiment.* London: George Allen and Unwin.

Young, M. (1982) *The Elmhirsts of Dartington Hall: The Creation of an Utopian Community.* London: Routledge and Kegan Paul.

Yow, V.R. (1994) *Recording Oral History: A Practical Guide for Social Scientists.* London: Sage.

Articles

Adamson, E. (1962) 'Darkness into light', *The Observer,* 17 June, 1931.

Adamson, E. (1963) 'Art and mental health', *Mental Health: Journal of the National Association for Mental Health 22, 2.*

Adamson, E. (1965) 'Review of artistic self-expression in mental disease: The shattered image of schizophrenics', *Mental Health* December 272–274.

Balme (1948) BCRS Report on the Picture Library Scheme: 28.01.1948.

Bierer, J. (1966) 'The movement towards social psychiatry', *The British Journal of Social Psychiatry 1*, 1.

Bohm, H. (1958) 'An experiment at Shenley Hospital', *Occupational Therapy*, August, 11–18.

Bohm, H. (1958(b)) 'Art therapy at Shenley Hospital', *Occupational Therapy*, September, 21–25.

Brett, G. (1959) 'Art as communication', *The Times*, 7 Aug.

British Red Cross Society Quarterly Review, *Resurgam, 33*, 2, 1946, 55.

Browne, W.A.F. (1864) 'The moral treatment of the insane: A lecture by W.A.F. Browne, Commissioner in Lunacy for Scotland', *The Journal of Mental Science*, Vol.X, 51, 309–337.

Browne, W.A.F. (1880) 'Mad Artists', *Journal of Psychological Medicine and Mental Pathology*, pp.34–35.

Buller, M. (1947) 'Pictures that heal', *BRCS Quarterly Review*, 1, 42–43.

Calder, R. (1949) 'Private worlds', *The New Statesman and Nation*, 28 May, 550.

Cane-Detre, K., Frank, T., Kniazzah, C., Cane-Robertson, M., Rubin, J. and Ulman, E. (1983) 'Roots of art therapy', *American Journal of Art Therapy*, 22, 4.

Champernowne, H.I. (1963) 'Psychotherapy and the arts at Withymead Centre', *Bulletin of Art Therapy*, Spring Issue.

Champernowne, H.I. (1963) 'Art therapy in the Withymead Centre', *American Bulletin of Art Therapy*, Spring Issue.

Champernowne, H.I. and Lewis, E. (1966) 'Psychodynamics of therapy in a residential group', *The Journal of Analytical Psychology, 11*, 2.

Collee, J. (1995) 'Dr John Collee reflects on the soul of medicine under socialism', *Observer Life*, 24 December 1946.

Crichton Royal Hospital Annual Reports.

Davies, H.S. (1936) 'Extracts from the lecture: Biology and Surrealism', *International Surrealist Bulletin*, 4.

Dax, E.C. (1948) 'Art therapy for mental patients', *The Nursing Times*, 14 August, 592–594.

Dax, E.C. (1949) 'Exhibition review', *British Medical Journal*, 23 July.

English, A.M. (1946) 'Art versus illness: A review', *Journal of the Association of Occupational Therapists*, 26, 12–14.

Fairbairn, W.R.D. (1938 (a)) 'Prolegomena to a psychology of art', *British Journal of Psychology XXVIII*, 288.

Fairbairn, W.R.D. (1938(b)) 'The ultimate basis of aesthetic experience', *British Journal of Psychology, XXIX*, 167.

Glass, J. (1963) 'Art and therapy', *Mental Health. Journal of the National Association for Mental Health, 22*, 2.

Gordon, C.J. (1947) 'London commentary', *The Studio 137–138*.

Gosling, N. (1968) 'Patient's progress', Review of 'Art and Mental Health' exhibition, *The Observer*, 18 Aug, 46.

Groundes-Pearce (1957) 'An outline of the development of occupational therapy in Scotland', *The Scottish Journal of Occupational Therapy, 30* (Anniversary Issue 1932–1957).

Guttmann, E. and Maclay, W.S. (1937) 'Clinical observations on schizophrenic drawings', *British Journal of Medical Psychology, 16*, 184.

Higgins, D. (1950) 'Painting and the sanatorium patient', *NAPT Bulletin, 11–14, 401–403*.

Hill, A. (1943) 'Art as an aid in illness', *Studio Magazine 125*, 48–49.

Hill, A. (1944) 'Art as an aid in illness', *NAPT Bulletin*, Oct.

Hill, A. (1944(b)) 'Art and the army', *Studio Magazine. 127*, 55–57.

Hill, A. (1946) 'Art and the invalid', *NAPT Bulletin*, Feb.

Hill, A. (1947) 'Art in hospitals', *Studio Magazine, 133*, 54–55.

Hill, A. (1947(b)) 'The human factor', *Tuberculosis in the Commonwealth. Complete Transactions of the Commonwealth and Empire Health and Tuberculosis Conference*, London, NAPT.

Hill, A. (1948) 'Art therapy in illness', *Nursing Mirror*, 27 Nov., xii.

ICA Bulletins 1964–1968.

Hogan, S. (1992) 'The cultural melting pot: Multiculturalism in Australia', *Aesthetex: Australian Journal of Arts Management, 4*, 2, 77–84.

Hogan, S. (1995) 'Ars longus vita brevis – Ars medica: Exploring interactions between medicine and the visual arts', *Inscape. Journal of the British Association of Art Therapists 2*. 1, 19–23.

Hogan, S. (1996) 'Pioneer of art therapy Susan Bach (1902–1995)', *Inscape. Journal of the British Association of Art Therapists, 1*. 1, 36–37.

Jock (1950) 'Pyjamas were my civy suit', *BRSC Quarterly Review 8*, 184–187.

Jordanova, L. (1995) 'The social construction of medical knowledge', *Social History of Medicine 8*, 3, December.

Jones, E. (1921) 'War shock and Freud's theory of the neurosis', *Psychoanalysis and the War Neurosis*, The International Psychoanalytical Library, 2, 44–59.

Kohlberg, L. (1968) in Sills, D.L. (ed) *International Encyclopaedia of the Social Sciences 9 & 10*. London: Collier-Macmillan.

London County Council Asylums Committee Hanwell Asylum Minutes.

Lucie-Smith, E. (1968) 'Things seen: Flight from the unconscious', *The Times*, 27 Aug, 9.

Lukas, N.B.C. (1945) 'Adrian Hill RBA', *Studio Magazine 129*, 78–81.

Middlesex County Council Reports 1947–1948.

Middlesex County Council Mental Health Committee Minutes 1947–1948.

McLaughlin, D.P. (1988) 'Withymead: A Jungian community for the healing arts', Book review. *International Journal of Therapeutic Communities 9*, 3.

Maclay, W.S. and Guttmann, E. (1941) 'Mescaline hallucinations in artists', *Archive of Neurology and Psychology 45*, 130.

Maclay, W.S., Guttmann, E. and Mayer-Gross, M.D. (1937) 'Spontaneous drawings as an approach to some problems of psychopathology', *Proceedings of the Royal Society of Medicine XXXI*.

Marshall, M. (1948) 'Experiment with art in therapeutics: Pictures in the rehabilitation of geriatric patients', *The Nursing Mirror,* 31 July, 277–278.

National Association of Mental Health Annual Reports 1946–1964.

National Association for the Prevention of Tuberculosis (NAPT) Annual Reports 1942–1958.

NAPT Bulletin, Oct. 1944, editorial, 'Healing through art', *6–9*. 1–2.

NAPT Bulletin, Feb. 1946, 'Art therapy', 101.

NAPT Bulletin, Feb. 1946, Report on the British Red Cross Picture Library Scheme.

NAPT Bulletin, Feb. 1946, Review (unnamed) of Hill's *Art Versus Illness*.

NAPT Bulletin, Aug. 1948, 'NAPT Art Therapy Scheme'.

NAPT Bulletin, 1949, 'Art Therapy Commonwealth and Empire Health and Tuberculosis Conference Report', *11–14*, 104–105.

NAPT Bulletin, Dec. 1950, Report: 'NAPT Art Therapy Schemes'.

NAPT Bulletin, Feb. 1952, 'The NAPT Art Therapy Scheme', *15–18*, 679–680.

Netherne – 'Art at Netherne Hospital' Anon. *British Medical Journal*, 23 July 1949, 228.

Netherne Hospital Management Committee Minutes 1938–1954.

Nordau, M.S. (listing) *The Encyclopaedia Britannica* (eleventh edition) *19*, 739 (d).

North West Metropolitan Regional Hospital Board Mental Health Committee Minutes and Papers 1947–1949.

O'Mennell, R. (1955) 'Auxiliary forms of therapy', *The Friend: Friends and Mental Nursing. A Special Edition. 113*, 17.

Pailthorpe, G.W. (1938–1939) 'The scientific aspects of Surrealism', *London Bulletin 7*, 10-16.

Petrie, M. (1946(b)) 'Art therapy in hospitals', *Athene 3*, 4. (Winter),

Pickford, R.W. (1948) 'Form and expressionism in art', *Scottish Art Review 2*, 1, 7–11.

Pickford, R.W. (1975) 'Psychiatric art and art therapy', *Inscape: Journal of the British Association of Art Therapists 11*.

Raphael, D. (1961) 'Art therapy and technique', *Barnardo Staff Magazine 6*, 2, 553–555.

Read, H. (1936) 'Speech by H. Read', *International Surrealist Bulletin*, 4, 23 June.

Samuels, A. (1994) 'A Jung club not enough: The professionalisation of analytical psychology 1913–1957 and its implication for today', *Harvest: Journal for Jungian Studies 40*, 155–168.

Segal, H. (1953) 'Art therapy at Tehidy', *BRCS Quarterly Review*, 4, 56–57.

Shamdasani, S. (1993) 'Automatic writing and the discovery of the unconscious', *A Journal of Archetype and Culture, 54*.

Shamdasani, S. (1995) 'Memories, dreams and omissions', *A Journal of Archetype and Culture, 57*, Spring Issue.

Simms, L.H. (1949) 'Modelling as a way of release', *Journal of the Occupational Therapy Association 38*, 18–19.

Simon, R. (1988) 'Marion Milner and the psychotherapy of art', *Winnicott Studies*, 48–52.

Smith-Rosenberg, C. and Rosenberg, C. (1973) 'The female animal: Medical and biological views of woman and her role in nineteenth-century America', *Journal of American World History 60*, 2, 332–356.

Spencer, S. (1946) 'Art therapy: Art competitions', *NAPT Bulletin* Feb.

Spencer, S. (1947) 'The murals at Redhill Chest Clinic', *NAPT Bulletin 4*, 2, 33–35.

The Artist [anonymous] 'Art Therapy: Hyman Segal's work in Cornwall', *54*, 32–33.

Timlin, J. (1996) 'Art as a panacea', Obituary in *Guardian Newspaper*, 12 Feb. 1996.

Tredgold, R.F. 'Editorial foreword', *Mental Health. Journal of the National Association for Mental Health 22*, 2.

Turpin, E.M. (1949) 'Jo's pictures', *British Red Cross Society Quarterly Review 1*, 21.

Ulman, E. (1963) 'Introduction', *Bulletin of Art Therapy 2*, 3, Spring Issue.

Ulman, E. (1963) 'Transcript of a conversation [with Staff of Withymead]', *Bulletin of Art Therapy 2*, 3, Spring Issue.

Weatherson, (1962) 'Seeing insanity through art', *New Society 8*, 18.

Williams, H.S. (1911) 'Civilisation', *The Encyclopaedia Britannica* (eleventh edition) *6*, 408 (d).

Wills, D. (undated) 'Some early attempts at art therapy', *Inscape: Journal of the British Association of Art Therapists*, 4, 2, 33–35.

Other sources

(exhibition catalogues, personal correspondence, interviews, pamphlets, tape recordings)

Adamson, E. (1964) *Art as Communication*. ICA exhibition catalogue (without page numbers).

Adamson, E. (1968) *Art and Mental Health*. Commonwealth Institute, London, exhibition catalogue, 12.

Adamson, E. (1994) Interview with Susan Hogan (unpublished tape recording).

Annual Reports and Commissioners Reports, as listed in text.

Arnold, A. (1964) *Art as Communication*. ICA exhibition catalogue (without page numbers).

British Association of Art Therapists (BAAT) – Working Party to Consider Standards of Training and Selection of Art Therapists (minutes), Feb. 1951

BAAT–Constitution of BAAT, 1966.

BAAT–Minutes on the First Meeting of the British Association of Art Therapists (undated c. 1964).

BAAT–First Newsletter (including a report on the first annual general meeting), July 1966.

BAAT–Letter from Hon. Sec. 11 August, 1966.

BAAT–Questionnaires for Membership of BAAT (1966–1968).

Belton, B. (1995) Personal correspondence, 26 August.

Beswick, M. (1995) *Recollections of Susan Bach* (unpublished paper), courtesy of M. Beswick.

Bohm, H. (1986) *In Conversation with Stan Roman* (unpublished interview), courtesy of Stan Roman.

Breton, A. (1936) Preface to *The International Surrealist Exhibition Catalogue.*

British Red Cross Society Planning Sub-Committee: *Information Sheet. No. 30: BRCS Picture Library Scheme, October 1945.*

British Council for Rehabilitation 1946: Art and Music Therapy, October, No. 3.

British Council for Rehabilitation 1949: Programme for Art Therapy Conference.

Carstairs, G.M. (1968) Introduction to *Art and Mental Health* (exhibition catalogue).

Champernowne, I. (1951) Report on staff, internal Withymead document.

Champernowne, I. (1952) Letter to staff, courtesy of Norah Godfrey.

Champernowne, I. (1975) Unpublished tape recording, Peter Firth.

Constitution of the Withymead Association (undated).

Cracknell, R. (1995) Interview with Susan Hogan (unpublished tape recording).

Cracknell, R. (1995) Personal correspondence, July.

Edwards, M. (1994) Interview with Susan Hogan (unpublished tape recording).

Edwards, M. (1995) Interview with Susan Hogan (unpublished tape recording).

The Foulkes Papers (The Wellcome Institute Library, London): Notes on Therapeutic Group Sessions, October 1944–November 1945 (ref: PP/SHF/C.3/2)
 Confidential Psychiatric Reports (ref: PP/SHF/C.3/7)
 Discussion on Group Therapy (24.5.45)
 Group Meetings (ref: PP/SHF/1.3/8).

Friends of Withymead Newssheet, 1 February 1963.

Fritzsche, R. (1964) *A Series of Pictures Illustrating an Analytical Experience* (unpublished paper).

Fritzsche, R. (1972) *Withymead* (unpublished paper).

Fritzsche, R. (1995) Interview with Susan Hogan (unpublished tape recording).

Fritzsche, R. (1996) Personal correspondence, 23 January.

Fritzsche, R. (1996) Personal correspondence, 28 February.

Godfrey, N. (c.1955) *Scope of the Work in the Painting Room at Withymead* (unpublished paper).

Godfrey, N. (1968) *Basis of Art Education (Painting)* (unpublished paper).

Godfrey, N. (1995) Interview with Susan Hogan (unpublished tape recording).

Godfrey, N. (1996) Personal correspondence, 28 February, 29 May and 30 November.

Godfrey, N. (1996) *Notes and Comments on Susan Hogan's Chapter on Withymead.*

Godward, B. (undated c.1960) Case notes on a patient who was sexually assaulted.

Glass, J. (1964) *Art as Communication,* ICA exhibition catalogue (without page numbers).

Halliday, D. (1996) Interview with Susan Hogan (unpublished tape recording).

Harling, M. (1996) Personal correspondence, February.

Henzell, J. (1964) *Art as Communication,* ICA exhibition catalogue (without page numbers).

Hill, A. 'Art on trial', *The Times* Letters page, Dec. 1939.

Hill, A. 'A record of damage', *The Times* Letters page, 13 January 1941.

Hill, A. 'Art societies', *The Times* Letters page, 11 April 1942.

Hill, A. 'Art in illness', *The Times* Letters page, 21 Aug. 1943.

Hill, A. 'Pictures in hosptials', *The Times* Letters page, 2 May 1946.

Hill, A. 'Untitled letter', *The Times* Letters page, 9 Aug. 1946.

Hill, A. (1946(b)) 'Art and the invalid', *Art for Everyone* radio broadcast transcript.

Hill, A. (1951(b)) *Art Therapy: A Message to Art Teachers* (paper).

Hill, A. 'The teaching of painting', *The Times* Letters page, 28 June, 56.

Hill, A. 'The teachings of painting', *The Times* Letters page, 6 July, 56.

ICA exhibition catalogue (1955) *Aspects of Schizophrenic Art: An Exhibition of Work by Patients of Mental Hospitals.*

ICA exhibition review (anon.) 'Portraits of madness', *The Sunday Times*, 3 May 1964.

Kimber, W. and Colquhoun, N.C. (1948) 'Foreword' to *Paintings by Patients: The Path of Progress* (exhibition catalogue), Foyles Art Gallery, London.

Kimber, W. and Colquhoun, N.C. (1949) 'Foreword' to *The Patient with the Paint Brush: Paintings by Patients from the Mental Treatment Centre, Hill End Hospital, St. Albans* (exhibition catalogue), Foyles Art Gallery, London.

Laing, J. (1995) Interview with Susan Hogan (unpublished tape recording).

Leaflet (c.1954) *The Retreat York: Medical and Spiritual Aims.*

Lydiatt, E.M. (1964) *Art as Communication*, ICA exhibition catalogue (without page numbers).

Lyle, P. (1995) Interview with Susan Hogan (unpublished tape recording).

Lyle, P. (1996) Personal correspondence, 11 November.

Manuilow, T. (1964) *Art as Communication*, ICA exhibition catalogue (without page numbers).

Milner, M. (1994) Interview with Susan Hogan (unpublished tape recording).

Murphy, J. (1995) Biographical note on Bruce Godward. Courtesy of June Murphy.

NAPT leaflet: *Art Therapy: What It Is and How It Works* (undated c.1946).

Naylor, B. (1995) Personal correspondence to Susan Hogan (9 Dec. and late Dec.).

Naylor, B. (1996) Personal correspondence to Susan Hogan, 6 May.

Paterson, I. (1994) Interview with Susan Hogan (unpublished tape recording).

Paterson, I. (1995) *Moral Treatment – A Great Idea of Nineteenth Century Medicine*. College of Occupational Therapists 19th Annual Conference, 12–14 July, Edinburgh. Unpublished paper supplied by author.

Pope, M. (1996) Personal correspondence to Susan Hogan, 4 March.

Pope, M. (1999) Interview with Susan Hogan (unpublished tape recording).

Read, H. (1936(b)) International Surrealist Exhibition catalogue.

Robinson, R. (1964) *Art as Communication*, ICA exhibition catalogue (without page numbers).

Roman, S. (1986) *Art Therapy and Its Relationship to Clinical Investigations*, unpublished thesis, Goldsmiths College.

Rumney, R. (1980) *Art Therapy at the Netherne Hospital*, unpublished thesis, Goldsmiths College.

Royal Society of Arts (1946) anonymous review: 'Notes on books. Art versus illness. A story of art therapy', *94*, March.

Scottish Society of Art and Psychopathology 1978–79: leaflet.

Segal, A. (c.1950) *Everyone Can Learn to Paint* (undated pamphlet).

Shamdasani, S. (1995) Personal correspondence, 23 October.

Simon, R. (1964) *The Social Significance of Art Therapy*. Paper presented to the First International Congress of Social Psychiatry, London. Courtesy of Rita Simon.

Simon, R. (1971) 'A brief introduction to art therapy in Britain', Reprinted from *Beacon House News*, Part I, 1.

Simon, R. (1972) 'A brief introduction to art therapy in Britain', Reprinted from *Beacon House News*, Part II (Spring).

Simon, R. (1986) In conversation with Stan Roman at her home in London, 7 June (unpublished interview transcript). Courtesy of Stan Roman.

Simon, R. (1994) Interview with Susan Hogan (unpublished tape recording).

Simon, R. (1995) Interview with Susan Hogan (unpublished tape recording).

Simon, R. (1996) Interview with Susan Hogan (unpublished tape recording).

Smith, J. (1994) *List of the Papers in the Contemporary Medical Archives Centre*, Wellcome Institute Library, London.

Stevens, A. (1984) *On the Life and Work of Irene and Gilbert Champernowne*, BBC broadcast, 27 January.

The Robert Gordon University, Dept. of Occupational Therapy: *Key Events in the Development of Occupational Therapy in the 20th Century* (undated report). Courtesy of Irene Patterson.

Tait, F. (1968) 'Children's paintings.' *Art and Mental Health* Commonwealth Institute exhibition catalogue, London.

The Times: 'Art and therapy', 22 August 1947.

The Times: 'Psychotic "art" work of schizophrenic painters', Review of ICA exhibition, 24 Nov. 1955.

The Times: 'Things seen: Schizophrenia and inspiration', 21 August 1956.

Timlin, J. (1991) 'Revised text of a lecture given at the Kfar Saba Cultural Centre, Israel, 23 June 1991.' The British Council (paper supplied by author).

Timlin, J. (1994) Interview with Susan Hogan (unpublished tape recording).

Timlin, J. (1995) Interview with Susan Hogan (unpublished tape recording).

Tippett, E. (1995) Interview with Susan Hogan (unpublished tape recording).

University College of the South West, Institute for Teachers (1953) *Child Development* (pamphlet).

Walsh, W.P. (1968) Letter to John Henzell.

Weatherson, A. (1964) *Art as Communication*, ICA exhibition catalogue (without page numbers).

Wills, E. (1951) *Corsham Painting Holiday* (report), Society for Education in Art.

Wills, E. (1986) Elizabeth Wills in conversation with Diane Waller and Stan Roman, 14 August (unpublished interview transcript). Courtesy of Stan Roman.

Withymead Centre: *The Withymead Centre for Remedial Education through Psychotherapy and the Arts* (undated brochure).

Withymead Centre: *Withymead* (undated brochure c.1955).

Withymead Centre: *Therapy and the Arts* (course information), 1953.

Subject Index

aesthetics 11, 240, 266, 297
analogies 15, 51, 57, 60, 62–3,
 78, 145, 168–170, 175–6,
 184, 204, 269–71
analytic psychology (Jungian) 17,
 23, 49, 62, 65, 73, 81–2,
 84, 86–7, 93, 107, 111,
 114, 123, 125–6, 128 133,
 141, 156, 175, 184, 206,
 208, 211–2, 215, 219,
 222–3, 226–7, 229–31,
 235–41, 244–5, 249, 253,
 255–6, 258, 261, 266–8,
 271, 277–86, 289, 291,
 306, 309, 311, 313–4
 active imagination
 (transcendent function;
 unconscious, dreams,
 fantasy, aesthetics, drawing
 and painting) 29–30, 126,
 239–40, 244, 258,
 279–80, 285
 amplification 242
 archetypes 241
 clubs 311
 organisation of 233, 243
 social 213–4
Analytical Psychology Club 222,
 233, 251, 253, 313
anthropology 10–11, 17, 26–7,
 53, 55–6, 59, 61–2, 94,
anti-psychiatry 14, 256, 284,
 287
art
 abstract 134, 170, 207
 active imagination 258, 261,
 279–80 see also imagination
 Adamson Collection of Art
 (the) 180, 256
 art brut (naïve art) 46, 96, 99,
 165, 183, 258
 art-making 35
 arts and crafts movement 45
 avant-garde 62
 cathartic 137–8, 142, 151,
 178, 195, 201, 205,
 261–2, 297
 ceramics, pottery and clay work
 121, 125, 127, 233, 239,
 247, 252–3, 263–4, 273–4
 civilising influence of 44, 87,
 117, 119, 128 see also
 spirituality
 competitions (patients' art) 29,
 143, 148–9, 153, 164, 166
 crafts 118
 diagnostic 137
 disciplined art 123, 151–2 see
 also art, civilising influence
 of

in education 30, 179, 253,
 292–9
Expressionist 66, 305
expressionistic 14, 16–17,
 27–8, 66, 109, 122, 125,
 143, 151, 168, 174, 183,
 199, 201, 205, 239, 258,
 261–2, 269, 271, 277,
 280, 297–8, 304
fine arts 45, 128
hospitals, art in 146, 193
image making 25,
imagery and images 86, 160,
 178–9, 183, 193–6, 205,
 275–6, 285
impressionism 169
modern art 14–16, 25, 88, 90,
 93–4, 97–8, 102, 104,
 106–9, 133–4, 140, 169,
 174, 200, 214, 256, 304,
 306–7, 314
murals 149, 157, 168
Post-Impressionism 97–8
physiology 160, 162
primitive art 10, 27–8, 57, 59,
 63, 85–7, 96, 99, 103,
 106, 165, 206, 239
Prinzhorn Collection (the) 183
as propaganda 291
'psychiatric art' 163, 165, 182,
 184, 214
psychotic art 13
realism 122, 138, 166, 275,
 277
spontaneous (also
 doodles/scribbles) 14, 81,
 87, 105–7, 109, 115,
 121–2, 126–7, 129,
 137–8, 143, 164–6, 168,
 172, 174, 183–4, 193,
 206, 210, 239, 258, 261,
 264, 267, 271, 278–9,
 297–8
studios see art therapy, studios
study of art 73
Surrealist art 14–15, 17, 27–8,
 70–1, 76–8, 92, 94–5,
 97–105, 108–9, 214, 256,
 307, 314
teaching 93, 115,
visionary 258, 262, 272
Art Galleries 41
 Foyles Art Gallery 14
 Guggenheim Jeune Gallery,
 London 83
 National Gallery, London 139
Art Schools
 Beckenham and Bromley Art
 School (now Ravensbourne)
 169
 Birmingham School of Art 123
 Brighton College of Art 255
 Central School of Art and
 Design 203
 Chelsea School of Art 193
 Croydon Art School 184
 Dartington College of Art 255

Edinburgh College of Art 112,
 256
Exeter Art School 252–3
Hornsey School of Art 133,
 253
Newton Abbot College of Art
 255
Richmond Art School, Surrey
 203
Royal College of Art 182, 133,
 144
Ruskin College, Oxford 255
Segal Art School 151, 155,
 184, 210, 255, 295–6,
 298, 300
Slade School of Art 198, 252
St. Albans School of Art 254
St. John's Wood Art School
 133
St. Martin's School of Art 92,
 147, 155
Westminster School of Art 133
art therapy (and antecedents) 11,
 13, 16–17, 23–6, 29, 43–5,
 47–8, 52, 68, 71, 73, 74,
 77, 82, 83–4, 86–88, 91,
 99, 105, 107, 109–116,
 119–122, 125–6, 129, 135,
 160, 173, 186, 193, 206–7,
 210, 226, 229, 231, 236–8,
 240, 245, 256, 258–62,
 265, 268, 272, 275, 277,
 282, 288, 290, 293, 295,
 302–3
 Advisory Committee 139, 210
 after care 145
 analytic 21
 appointment of art therapists
 79, 256–7, 287
 art therapists (and art
 psychotherapists) 21, 251
 development of 28–9, 80
 development in sanitaria
 132–156
 in education 294–300, 313–4
 first art therapy conference 158
 function types 278–9
 group interactive art therapy
 model 219
 history of 28
 industrial 117, 142, 148, 211
 interventions 278
 materials 172, 264, 270
 models of 76
 nomenclature 127, 131, 135,
 170, 179, 184, 213
 patients becoming therapists
 145
 philosophical bases 213
 pottery (use of) 270 see also art,
 ceramics
 professionalisation 27, 30, 128,
 139, 149, 160, 177, 180,
 186–7, 191–2, 194, 197,
 210–12, 219–220, 309,
 314
 promotion of 143, 150

329

Name Index